JOSEPH CORNELL AND ASTRONOMY

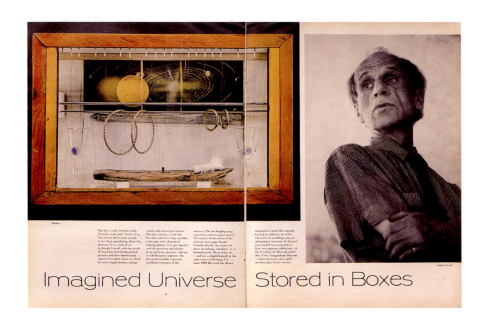

Imagined Universe Stored in Boxes

JOSEPH CORNELL AND ASTRONOMY

A CASE FOR THE STARS

Kirsten Hoving

PRINCETON UNIVERSITY PRESS | PRINCETON AND OXFORD

Published by Princeton University Press,
41 William Street, Princeton, New Jersey 08540

In the United Kingdom: Princeton University Press,
6 Oxford Street, Woodstock, Oxfordshire OX20 1TW

Library of Congress Cataloging-in-Publication Data

Hoving, Kirsten A.
 Joseph Cornell and astronomy : a case for the stars / Kirsten Hoving.
 p. cm.
 Includes bibliographical references and index.
 ISBN 978-0-691-13498-7 (hardcover : alk. paper) 1. Cornell, Joseph—
Criticism and interpretation. 2. Cornell, Joseph—Knowledge—
Astronomy. 3. Astronomy in art. I. Title.

N6537.C66H68 2009
709.2—dc22 2008000862

British Library Cataloging-in-Publication Data is available

This book has been composed in Aldus and Victoria Titling

Printed on acid-free paper. ∞

press.princeton.edu

Printed in Italy

10 9 8 7 6 5 4 3 2 1

For all who gaze at the stars in wonder

CONTENTS

List of Illustrations ix

Preface and Acknowledgments xvii

I. Cross-Indexing the Cosmos 1

II. The Celestial Science of Soap 27

III. Movie Stars 57

IV. Astronomia Fantastica 89

V. Observatories 120

VI. The Science of the Stars 158

VII. The Twilight Zone 202

Notes 243

Selected Bibliography 289

Index 299

ILLUSTRATIONS

FIGURE 1.1. Miscellaneous books, clippings, and printed materials collected by Cornell. 4

FIGURE 1.2. Constellation chart, engraved by W. G. Evans under the direction of E. H. Burritt, from E. H. Burritt, *The Geography of the Heavens* (New York: F. J. Huntington, 1835). 6

FIGURE 1.3. Joseph Cornell, cover design for *Town and Country* (March 1939). 7

FIGURE 1.4. Trimmed photostat reproductions of Hevelius constellation figures of Andromeda and Auriga, from Camille Flammarion, *Les Etoiles* (Paris: C. Marpon et E. Flammarion, 1882). 8

FIGURE 1.5. Georgie Starbuck Galbraith, "Enigmas," *Christian Science Monitor*, March 4, 1958, as notated by Joseph Cornell. 8

FIGURE 1.6. Joseph Cornell, Cassiopeia diary notation, 1951. 9

FIGURE 1.7. *La Cassiopée de l'atlas de Bayer (1603); Le Bouvier de l'atlas de Bayer (1603); Constellations zodiacales.—Le Taureau.—Les Gémeaux; Constellations zodiacales.—Les Poissons.—Le Bélier*; in Camille Flammarion, *Les Etoiles* (Paris: C. Marpon et E. Flammarion, 1882). 13

FIGURE 1.8. Joseph Cornell, untitled, c. 1934. 14

FIGURE 1.9. *Galilée présentant la première lunette astronomique au doge de Venise; Apparition subite de l'étoile nouvelle de 1572, observé par Tycho Brahe; Un jeune homme de 23 ans, Newton, rêvait un soir; William Herschel découvrant la planète Uranus*. 16

FIGURE 1.10. Max Ernst, *Mon Petit Mont Blanc*, 1922. 17

FIGURE 1.11. Joseph Cornell, *Story without a Name—for Max Ernst*, c. 1934–35. 18

FIGURE 1.12. Man Ray, *Electricity—The World (Electricité—Le Monde)*, 1931. 21

FIGURE 1.13. Pierre Roy, *The Electrification of the Country*, 1930. 22

FIGURE 1.14. Maud Granger as Astronomy, collected by Joseph Cornell. 25

FIGURE 2.1. Joseph Cornell, *Soap Bubble Set*, 1936. 28

FIGURE 2.2. Joseph Cornell, *Soap Bubble Set*, as reproduced in Alfred H. Barr, Jr., *Fantastic Art, Dada, Surrealism* (New York: Museum of Modern Art, 1936). 29

FIGURE 2.3. Installation view of Joseph Cornell's *Elements of Natural Philosophy*, from the exhibition Fantastic Art, Dada, Surrealism, Museum of Modern Art, New York, December 9, 1936–January 17, 1937. 30

FIGURE 2.4. Center of gravity clippings, "Natural Philosophy" source material file. 32

FIGURE 2.5. *Ombre des anneaux de Saturne sur la planète*, in Camille Flammarion, *Les Terres du ciel* (Paris: C. Marpon et E. Flammarion, 1884). 33

FIGURE 2.6. Georges Méliès, film still from *The Eclipse (The Courtship of the Sun and Moon)*, 1907. 34

FIGURE 2.7. Woodcut engraving of the moon after drawing by Galileo, first published in *Sidereus Nuncius*, 1610; as illustrated in *Petri Gassendi Institutio astronomica* (London: Jacobi Flesher, 1653), 19. 36

FIGURE 2.8. *Telescopes—Modern and Ancient* and *Transparency of Moon in Gibbous Phase*, in *The Hayden Planetarium* (New York: American Museum of Natural History, 1937). 37

FIGURE 2.9. Specific Gravity Beads, manufactured by Angelo and/or Isabella Lovi, Glasgow, c. 1805. 38

FIGURE 2.10. "Changing Conceptions of the Universe: A Riddle Still," *New York Times*, April 17, 1932. 39

FIGURE 2.11. Joseph Cornell, *Cabinet of Natural History (Object)*, 1934, 1936–40. 41

FIGURE 2.12. Joseph Cornell, *"Imperious Jewelry of the Universe" (Lunar Baedecker): Portrait of Mina Loy (Daguerreotype Object)*, 1936. 45

FIGURE 2.13. Joseph Cornell, untitled, 1930s (Coll., William Kistler, New York). 48

FIGURE 2.14. Edwin Hubble at the 48″ Schmidt Telescope, Mount Palomar Observatory, c. 1947. 49

FIGURE 2.15. Joseph Cornell, *Object (Soap Bubble Set)*, 1941. 51

FIGURE 2.16. Theater of Time and Space, New York World's Fair, 1939. 53

FIGURE 2.17. Joseph Cornell, announcement for Objects by Joseph Cornell, Copley Galleries, Beverly Hills, CA, 1942. 54

FIGURE 2.18. Joseph Cornell, *Soap Bubble Set*, c. 1947–48. 55

FIGURE 3.1. Joseph Cornell, eclipse sequence from *Rose Hobart*, c. 1936. 58

FIGURE 3.2. Donald H. Menzel, "Science Again Turns to the Sun," *New York Times*, June 14, 1936. 59

FIGURE 3.3. Joseph Cornell, opening frame, *Rose Hobart*, c. 1936. 61

FIGURE 3.4. Rose Hobart and George Renavent in *East of Borneo*, 1931. 63

FIGURE 3.5. Joseph Cornell, untitled book object (*Histoire des Temps Modernes*), 1939. 65

FIGURE 3.6. "They're Ready to 'Shoot' the Sun's Eclipse," *Christian Science Monitor*, June 18, 1936. 66

FIGURE 3.7. Joseph Cornell, film stills from *The Children's Party*, c. 1938, finished by Lawrence Jordan, 1965–68. 68

FIGURE 3.8. *Circular into Rectilinear Motion*, in Tom Tit, *Scientific Amusements* (London: Thomas Nelson and Sons, [n.d.]). 71

FIGURE 3.9. Joseph Cornell, *Hommage à Tamara Toumanova*, December 1940. 75

FIGURE 3.10. Joseph Cornell, untitled illustration to Charles Henri Ford, "Ballet for Tamara Toumanova," *View*, ser. 2, no. 4 (January 1943): 36. ["Americana Fantastica" issue]. 77

FIGURE 3.11. J. J. Grandville, *L'Etoile du soir*, in Joseph Méry, *Les Etoiles* (Paris: Gonet et Twietmeyer, 1849). 77

FIGURE. 3.12. Georges Méliès, film still from *The Eclipse (The Courtship of the Sun and Moon)*, 1907. 78

FIGURE 3.13. Hedy Lamarr as a spiral nebula, film still from "You Stepped Out of a Dream," in *Ziegfeld Girl*, 1941. 78

FIGURE 3.14. Hedy Lamarr paper dolls for *Ziegfeld Girl*, 1941; negative photostat portrait of Hedy Lamarr; collage with photograph and railroad ticket. 79

FIGURE 3.15. "The Great Whirl of Stars in the Andromeda Nebula, A Million Light Years Away," in "Strolling Among the Stars," *Christian Science Monitor*, December 20, 1941. 80

FIGURE 3.16. Isamu Noguchi, *Miss Expanding Universe*, 1932. 82

FIGURE 3.17. "Spectra of the Stars and Nebulae," unidentified source, collected by Joseph Cornell. 84

FIGURE 3.18. Joseph Cornell, untitled (*Celestial Fantasy with Tamara Toumanova*), c. 1941. 86

FIGURE 3.19. Joseph Cornell, *Untitled (for Tamara Toumanova)*, c. 1940. 87

FIGURE 4.1. Joseph Cornell, *The Crystal Cage [portrait of Berenice]*, *View*, ser. 2, no. 4 (January 1943): 10–13 ["Americana Fantastica" issue]. 90

FIGURE 4.2. Joseph Cornell, *The Crystal Cage [portrait of Berenice]*, *View*, ser. 2, no. 4 (January 1943): 14–16 ["Americana Fantastica" issue]. 91

FIGURE 4.3. J. J. Grandville, *Astronomie des Dames*, in Joseph Méry, *Les Etoiles* (Paris: Gonet et Twietmeyer, 1849). 94

FIGURE 4.4. Albert Einstein, Edwin P. Hubble, Walther Mayer, Walter S. Adams, Arthur S. King, and William W. Campbell on the footbridge leading to the 100" telescope at Mount Wilson. 95

FIGURE 4.5. *Tycho Brahe's Observatory of Uraniborg, Island of Hven,* 1580. 96

FIGURE 4.6. Joseph Cornell, *Untitled (La Cassiopée),* 1930s. 97

FIGURE 4.7. *Coney Island by Night,* folding postcard set, labeled "Joe Aug. 9, 1936." 101

FIGURE 4.8. *Le Bouvier, la Couronne boréale, les Chiens de Chasse, la Chevelure de Bérénice,* in Camille Flammarion, *Les Etoiles* (Paris: C. Marpon et E. Flammarion, 1882). 102

FIGURE 4.9. Joseph Cornell, *Americana Fantastica, View,* ser. 2, no. 4 (January 1943): front and back cover. 103

FIGURE 4.10. Source material for *View* cover and corresponding constellations. Carte-de-visite and cabinet card photographs, Joseph Cornell Study Center, Smithsonian American Art Museum; constellations in Camille Flammarion, *Les Etoiles* (Paris: C. Marpon et E. Flammarion, 1882). 105

FIGURE 4.11. Joseph Cornell, *The Crystal Cage, View,* ser. 2, no. 4 (January 1943): 15 ["Americana Fantastica" issue], with comparative constellations. 107

FIGURE 4.12. Joseph Cornell, Cassiopeia source material box, c. 1961–62. 109

FIGURE 4.13. Joseph Cornell, *The Crystal Cage [portrait of Berenice],* c. 1934–67, valise with printed materials. 113

FIGURE 4.14. Joseph Cornell, detail of Flash Gordon montage housed in *The Crystal Cage [portrait of Berenice],* c. 1934–67, valise with printed materials. 114

FIGURE 4.15. Joseph Cornell, prints and photographs mounted on construction paper, from *The Celestial Theater,* c. 1940–60. 118

FIGURE 5.1. Joseph Cornell, *Central Park Carrousel, in Memorium,* 1950. 122

FIGURE 5.2. 200" mirror for the Hale Telescope, Mount Palomar Observatory, c. 1948. 124

FIGURE 5.3. Joseph Cornell, *Observatory Colomba Carrousel,* 1950. 126

FIGURE 5.4. The Hale Telescope, Mount Palomar, c. 1948. 127

FIGURE 5.5. Joseph Cornell, *Observatory Corona Borealis Casement,* 1950. 129

FIGURE 5.6. "The 200-inch Hale and (Right) 'Slice' of a Spiral Nebula," unidentified clipping. 130

FIGURE 5.7. Jackson Pollock, *Galaxy,* 1947. 131

FIGURE 5.8. Announcements for Night Voyage exhibition, Egan Gallery, 1953, and Winter Night Skies by Joseph Cornell, Stable Gallery, 1955. Christmas card designs for the Museum of Modern Art: Virgo, 1945; Bird and Stars, 1954; Monocerous, 1957. 133

FIGURE 5.9. Joseph Cornell, *Carrousel,* 1952. 134

FIGURE 5.10. Joseph Cornell, diary entry, October 16, 1970. 135

FIGURE 5.11. Joseph Cornell, *Les Constellations Voisines du Pôle,* c. 1951–53. 136

FIGURE 5.12. *Les Constellations voisines du pôle*, in Camille Flammarion, *Les Etoiles* (Paris: C. Marpon et E. Flammarion, 1882). 137

FIGURE 5.13. Printed materials explaining zodiacal light collected by Cornell. 138

FIGURE 5.14. "Eclipse to Test Einstein Theory," *Christian Science Monitor*, February 13, 1952. 139

FIGURE 5.15. Joseph Cornell, *Untitled (Grand Hôtel de l'Observatoire)*, 1954. 141

FIGURE 5.16. *L'Andromède de l'atlas d'Hévélius (1690)* in Camille Flammarion, *Les Etoiles* (Paris: C. Marpon et E. Flammarion, 1882). 142

FIGURE 5.17. "Jackie Andromeda" notation and Jackie Lane clipping. 143

FIGURE 5.18. Joseph Cornell, diary notation, July 2, 1969, 2:30 a.m., "Allegory of Faith" file. 144

FIGURE 5.19. Fred Hoyle, "Changing Concepts of the Universe," *New York Times*, June 1, 1952. 145

FIGURE 5.20. Joseph Cornell, *Hôtel du Nord*, c. 1953. 148

FIGURE 5.21. "Star Types," "Lunar Eclipse," and "Sunlight and Rainbows," in Herbert S. Zim and Robert H. Baker, *Stars, A Guide to the Constellations, Sun, Moon, Planets, and Other Features of the Heavens* (New York: Golden Press, 1956). 150

FIGURE 5.22. Joseph Cornell, small boxes with astronomical charts and objects. 151

FIGURE 5.23. Joseph Cornell, Untitled *(Window Façade)*, c. 1953. 152

FIGURE 5.24. Bible House on Astor Place, in J. Lossing, *The Hudson from the Wilderness to the Sea* (New York: Virtue and Yorston, 1866). 156

FIGURE 6.1. Joseph Cornell, *Untitled (Soap Bubble Set: Système de Copernic)*, c. 1950. 160

FIGURE 6.2. Joseph Cornell, Untitled *(Système de Descartes)*, c. 1952. 161

FIGURE 6.3. [François Nicolas] Martinet, *Système de Descartes*, 1761. 162

FIGURE 6.4. Joseph Cornell, untitled cardboard box covered with print material. 164

FIGURE 6.5. Joseph Cornell, *Untitled [Yellow Sand Tray, Sun and Planet Images]*. 166

FIGURE 6.6. Joseph Cornell, *Untitled [Blue Sand Box with Starfish]*, c. 1952. 167

FIGURE 6.7. Frontispiece, Sir Thomas Heath, *Archimedes* (London: Society for Promoting Christian Knowledge, 1920). 168

FIGURE 6.8. Photograph of subatomic particles at Brookhaven National Laboratory. Unidentified clipping, c. 1952–53. 170

FIGURE 6.9. Joseph Cornell, *Untitled (Blue Sand Box)*, early 1950s. 171

FIGURE 6.10. *Meson Star*, in Sergio DeBenedetti, "Mesonic Atoms," *Scientific American* 195 (October 1956). 172

FIGURE 6.11. Joseph Cornell, *The Birth of the Nuclear Atom*, c. 1957. 173

FIGURE 6.12. "Atomic Theory Is Based upon Indirect Evidence," in "The Atom, a Primer for Laymen," *Life* (May 16, 1949): 6–7. 174

FIGURE 6.13. Joseph Cornell, *Cassiopeia #1*, c. 1957–58. 176

FIGURE 6.14. "Texas and Northern Mexico May Look Something Like This to the Sputnik," *Christian Science Monitor*, October 12, 1957. 179

FIGURE 6.15. "Enough Here to Challenge a Hundred da Vincis!" *Scientific American* 195 (September 1956). 181

FIGURE 6.16. Joseph Cornell, *Untitled (Soap Bubble Set)*, c. 1957. 183

FIGURE 6.17. "Lively as a Walk on the Moon," *Scientific American* 201 (October 1959). 185

FIGURE 6.18. Joseph Cornell, *Untitled (Phases de la lune)*, c. 1957–58. 186

FIGURE 6.19. Joseph Cornell, *Suzy's Room (In Mem. Judy Tyler)*, 1957. 187

FIGURE 6.20. Joseph Cornell, *Untitled (Solar Set)*, c. 1956–58. 189

FIGURE 6.21. Joseph Cornell, *Celestial Navigation*, c. 1956–59. 191

FIGURE 6.22. Joseph Cornell, *Radar Astronomy*, early 1960s. 192

FIGURE 6.23 Joseph Cornell, *Soap Bubble Variant*, c. 1959–60. 194–95

FIGURE 6.24. Joseph Cornell, source materials and notes from Marilyn Monroe file. 198

FIGURE 6.25. Joseph Cornell, *Untitled (Custodian II, Silent Dedication to MM)*, 1962–63. 199

FIGURE 7.1. Joseph Cornell, *How to Make a Rainbow (for Jeanne Eagels)*, 1963. 206

FIGURE 7.2. Joseph Cornell, *Weather Satellites*, 1965. 210

FIGURE 7.3. "Sixty-foot Telescope of Harvard University," *Scientific American* 195 (October 1956). 211

FIGURE 7.4. Joseph Cornell, untitled, c. 1966. 212

FIGURE 7.5. Joseph Cornell, *Triangles and the Distance to the Moon* and *Surface and Volume in Nature*, in Irving Adler, *The Giant Golden Book of Mathematics* (New York: Golden Press, 1960). 213

FIGURE 7.6. Joseph Cornell, *Untitled (Triangles and Distance to the Moon)*, c. 1965–72. 214

FIGURE 7.7. Robert Rauschenberg, *Skyway*, 1964. 215

FIGURE 7.8. Joseph Cornell, *Now Voyager II*, 1966. 216

FIGURE 7.9. *Mars*, in Herbert S. Zim and Robert H. Baker, *Stars, A Guide to the Constellations, Sun, Moon, Planets, and Other Features of the Heavens* (New York: Golden Press), 1956. 218

FIGURE 7.10. Joseph Cornell, *"Penny Arcade" series, re Autumnal*, October 14, 15, 1964. 221

FIGURE 7.11. Joseph Cornell, *Rapport de Contreras (Circe)*, 1966. 223

FIGURE 7.12. Joseph Cornell, untitled, c. 1970–71. 225

FIGURE 7.13. Joseph Cornell, untitled, c. 1964. 226

FIGURE 7.14. Joseph Cornell, *A Rainbow Is a Spectrum*, c. 1964. 227

FIGURE 7.15. Joseph Cornell, *Untitled [Ship with Nude]*, mid-1960s. 228

FIGURE 7.16. *L'Andromède de l'atlas de Bayer (1603)*, in Camille Flammarion, *Les Etoiles* (Paris: C. Marpon et E. Flammarion, 1882). 229

FIGURE 7.17. Untitled nude, unidentified magazine source. 230

FIGURE 7.18. Joseph Cornell, *Constellations of Spring / The Model*, May 3, 1970. 231

FIGURE 7.19. Desargues's Theorem, in Morris Kline, "Geometry," *Scientific American* 211 (September 1965). 233

FIGURE 7.20. Joseph Cornell, untitled, 1960s. 236

FIGURE 7.21. Joseph Cornell, untitled, late 1960s. 237

FIGURE 7.22. Joseph Cornell, diary entry, October 16, 1970. 238

FIGURE 7.23 Joseph Cornell, *Les constellations voisines du pôle*, May 2, 1971. 240–41

PREFACE AND ACKNOWLEDGMENTS

A VIVID CHILDHOOD MEMORY FROM THE EARLY 1960s: I stand with my father in our front yard on a warm summer night as we watch the communications satellite *Echo* blink its way across the sky. It is an intimate moment. Neither of us can really comprehend how the satellite got there, why it stays up, how it knows where to go, or what it means for the future. Nor can we do anything but marvel at the infinite universe in which *Echo* is just a tiny, man-made speck. So we just hold hands and look until our necks get stiff, marveling at our place among the stars, at that moment, in our yard.

My businessman father liked to look at the stars, although the telescope we gave him one Christmas was still in its dusty box when he died. He taught me the few constellations he knew: the Big Dipper with its Pole Star, Orion's bright belt, and Cassiopeia, whose W-shaped form I could almost always find. On hot nights I would sit up in bed and try to see them from my window, looking between the branches of the trees that blocked my view. There was nothing terribly scientific about it. It was just something I liked to do.

Like many young girls of my era, I firmly resisted math and science, putting my energies instead into drawing and writing. Still, the space age seduced me: in fourth grade I taped pictures of astronaut Alan Shepard on my closet door; in sixth grade I painted copies of the Redstone rockets illustrated in my *Golden Book of Space Flight*; in junior high I belonged to a girls' club called "Friendship 7," named after the space capsule in which John Glenn became the first American to orbit the Earth. If algebra hadn't been so hard, I might have dreamed of becoming an astronaut. Instead, in college I majored in art, primarily because it was the only course of study that exempted students from my university's math and science requirements, which I firmly believed would sink my academic career. In my first art history course—Modern Art—I encountered the work of Joseph Cornell, who had been given a retrospective

exhibition at the Guggenheim Museum four years earlier. As a frustrated ballerina, I identified with his dancing lobsters, and many years of playing with my neighbor's dollhouse prepared me for a shock of recognition when I encountered his miniature worlds.

Not until much later did I find the link between Cornell's work and my own fond memories of the stars. By then, as a historian of modern art and photography, I had begun to tiptoe ever-so-gingerly into the field of art and science. I published articles about Man Ray's surreal photographs of mathematical objects and Jackson Pollock's paintings of the night sky. I discovered a scholarly group of scientists and humanists who met to present their interdisciplinary research, and I delivered several papers at universities and planetariums. I became increasingly intrigued by the possibilities of examining art in relation to science, and I thought I might write a short article on Cornell and astronomy. The result is this book.

Research on Cornell can be both exciting and daunting. Scholars have access to a prodigious wealth of archival material: letters, diary notes, and source material files in the Smithsonian Institution's Archives of American Art (formerly twenty-four and a half running feet of documents available on over twenty rolls of microfilm, now, thankfully, available in digitized form with a comprehensive finding guide), as well as over two hundred large boxes of notes, additional source materials, clipping files, and books that belonged to the artist, housed in the Joseph Cornell Study Center of the Smithsonian American Art Museum. Painstaking study of these materials has enabled me to understand Cornell's fascination with astronomy, and I have learned what I now know about science by following in his tracks: reading the same books he did, examining the newspapers and magazines of his day, studying the sources from which he clipped materials for his artworks. In the process, Cornell has taken me on marvelous journeys back and forth in time and space, on paths illuminated by his fascination for science, his spiritual convictions, and his creative genius.

Along the way, many individuals have shared their expertise and enthusiasm for Cornell with me. At the Joseph Cornell Study Center, Betsy Anderson spent countless hours overseeing my examination of the Cornell materials in her care. I could not have written this book without her good-humored support, and she has my deepest thanks. The staff of the Archives of American Art supplied me with a long summer's worth of microfilm, fulfilling my requests with prompt efficiency, and more recently Wendy Hurlock Baker has assisted me with scans for this book. In Washington, DC, collector Robert Lehrman shared his knowledge about Cornell with me, and I am indeed grateful to Aimee and Robert Lehrman for access to their wonderful collection. Many staff members of museums and galleries enabled me to examine Cornell's works first-hand, and I appreciate their assistance. I also thank the private collectors who permitted me to reproduce works from their collections. Curators at museums and observatories were instrumental in providing information and illustrations,

and I am especially grateful to Richard Sorenson, Robin Witmore, John Grula, Lynda Hartigan, and many others for their efforts. Ed Blomquist at the *Christian Science Monitor* efficiently aided with images and permissions. At Middlebury College, I have been helped by able and enthusiastic research assistants, including Gale Berninghausen, Ljudmila Bilkic, Jessica Brozyna, Susanna Gorski, Elisabeth Emmons Hahn, and Sara Blaise Huddleston.

I am extremely fortunate to have received several grants in support of this project. A fellowship from the National Endowment for the Humanities helped fund a sabbatical year (any views, findings, conclusions, or recommendations expressed in this book do not necessarily reflect those of the National Endowment for the Humanities). My appointment as a Short-Term Visitor at the Smithsonian American Art Museum enabled me to spend an extended period of time at the Joseph Cornell Study Center. A course-release grant from the Andrew W. Mellon Foundation provided welcome time to complete the manuscript. In the early stages of this project, research funds attached to my position as Charles A. Dana Professor of the History of Art and Architecture at Middlebury College enabled me to publish an article about Cornell's 1936 *Soap Bubble Set* in the journal *American Art*; an expanded version of that article appears in chapter 2. Support from the Voyager Foundation, courtesy of Aimee and Robert Lehrman, Washington, DC; the Society for the Preservation of American Modernists; the Middlebury College Publication Subvention Fund; and funds related to my Charles A. Dana Professorship also helped underwrite the costs of illustrations and permissions.

I sincerely thank my colleagues in the Department of History of Art and Architecture at Middlebury College for their forbearance as I single-mindedly immersed myself in Cornell and his art. Special thanks go to Dana Barrow for her enviable expertise and attention to detail in scanning illustrations and other digital matters. This book would not have been completed without her hours of skillful help with illustration preparation. My appreciation also goes Mary Lou Splain, Megan Battey, and Monica McCabe for their assistance with administrative matters and image technology, and to the staff of the Middlebury College Library for seeing to my research needs. I am especially indebted to several individuals at the college who deserve thanks for having read and commented on portions of my manuscript as it took shape: Dana Barrow, image technologist; Leger Grindon, film historian; Helen Reiff, editor; George Todd, musician and composer; Andy Wentink, dance historian; and Rich Wolfson, physicist. Their comments enabled me to consider Cornell's art from a wide variety of perspectives. Conversations with other Cornell scholars, especially Stephanie Taylor, further expanded my view of the artist and his work. At Princeton University Press, Hanne Winarsky believed in this book from the outset. I owe her a deep debt of gratitude for her enthusiastic support and wise guidance. My heartfelt thanks also go to copyeditor Anita O'Brien and the production staff at Princeton University Press, who helped make this book a reality.

My deepest appreciation is reserved for art historian Wendy Grossman and her husband, John Greathouse, who supported this project every step of the way. Their hospitality and friendship made my many trips to Washington especially enjoyable. Wendy's contagious enthusiasm about art and her careful reading of my manuscript were invaluable, while John's humor never failed to provide a needed lift at the end of a long day. Finally, I thank my children, Emma and Annie Powell, who almost always remembered to ask "How's Joseph?" when they called home from college, and, most of all, my husband, Rick Clark, whose steadfast love and quiet companionship sustain me. To Rick, I dedicate this book.

JOSEPH CORNELL AND ASTRONOMY

CROSS-INDEXING THE COSMOS

THE AMERICAN ARTIST JOSEPH CORNELL (1903–72) devoted his career to constructing collages and assemblage boxes that juxtapose pictures and objects in playful and poetic ways. He created boxes with butterflies and birds, ballerinas and actresses, children from Renaissance paintings and characters from eighteenth-century books, and, above all, the Moon and the stars. He produced hundreds of works with references to astronomy: enigmatic early collages, found-footage films, three-dimensional "space-object boxes," and late collages combining science and popular culture. Cornell called the tiny kitchen where he sometimes worked at night his "observatory," and in his diaries he often recorded sightings of the stars from his backyard.[1] He amassed a large collection of books about astronomy, ranging from eighteenth-century European texts to recent works, and throughout his life he was a dedicated clipper and organizer of newspaper and magazine articles about new discoveries. His interests were broad, although far from technical, and he was as fascinated by cosmic metaphors as he was by astronomy's facts and figures.

From his own stargazing, he developed a deep knowledge and love of the stars, and in his art he sought to convey the historical constancy that astronomy represented to him. He studied star lore and knew the myths behind even the most obscure constellations, many of which appear as details in box constructions and collages. He admired famous astronomers of the past, saving pictures of and articles about the great men of astronomy—Nicolaus Copernicus, Tycho Brahe, Johannes Kepler, and Galileo Galilei—and he alluded to their contributions in his works. At the same time, like many of his contemporaries, he was caught up in the excitement surrounding twentieth-century findings that offered new conceptions of the cosmos.

In the literature and lore about Cornell, the artist is often presented as a shy recluse, a nineteenth-century romantic trapped in a twentieth-century

CHAPTER I

body, an individual out of touch with reality and living in a fantasy world. To be sure, Cornell loved nineteenth-century literature and culture, and his papers are filled with references to figures such as poet Stéphane Mallarmé and ballerina Fanny Cerrito. However, he was equally intrigued by his own era, especially by new discoveries expanding our understanding of the universe. Cornell came of artistic age in the 1930s, a golden decade in the history of astronomical research marked by such milestones as the discovery of Pluto, verification of Albert Einstein's general theory of relativity, and confirmation that the universe is expanding. From the early years of his career until his final days, his fascination for astronomy fueled his art. Far from being vaguely "eccentric," "nostalgic," "magical" creations, as critics and art historians have described them, Cornell's astronomy works reveal a direct and profound engagement with modern science.

In 1949 Cornell scribbled the following description: "fleecy clouds bringing an opening sprinkled with stars the moon thru the dark green leaves over the houses. A moment of supreme and transc[endent] beauty."[2] This book investigates Cornell's efforts to capture the "supreme and transcendent beauty" of the cosmos in his art. It examines specific works of art against the backdrop of the history of astronomy and contemporary explorations of the universe. It considers the importance of science in Cornell's creative process and positions his astronomy works within the contexts of significant individuals and movements in modern art. Above all, it seeks to convey the deep connection the artist felt to the stars and to the scientific and spiritual forces that determine their paths.

COLLECTING ASTRONOMY

Apart from a high school physics course, Cornell had no formal education in astronomy. Instead, he taught himself by reading and observing. Over the course of four decades, he gathered more than a hundred books about astronomy for his library. Initially he turned to nineteenth-century volumes on natural philosophy, physics, and astronomy, although he was probably more attracted by their detailed engravings than he was to the science explained in exhaustive detail. After the Second World War, his book collecting escalated. Around midcentury, he began purchasing children's books expressly to be cut up for collage materials, including over two dozen copies of the little Golden Nature Guide, Herbert Zim and Robert Baker's *Stars: A Guide to the Constellations, Sun, Moon, Planets, and Other Features of the Heavens*.[3] He updated his library with recent publications for adults about the history and philosophy of astronomy, including Arthur Koestler's biography of Johannes Kepler, *The Watershed*, published in 1960, and Max Planck's meditations on the metaphysical implications of modern astrophysics, *The New Science*, published in

1959. From notes he penciled in the margins, underlined sentences, and pages marked with scraps of paper, it is clear that he read these books carefully. However, the majority of astronomy books in his collection were directed to children or young adults, with simple explanations of complicated phenomena and colorful illustrations.

At some point in the late 1920s or 1930s, Cornell began to amass clipping files filled with illustrations cut and torn from old science books and magazines.[4] He compiled collections on "Natural Philosophy," "Natural History," "Astronomy," and "Instruments," with pictures illustrating such subjects as electricity, optics, magnetism, and gravity. Astronomical topics received special attention, with numerous clippings showing astronomers, instruments, lunar and solar phenomena, characteristics of planets, shapes of nebulae, and the positions and configurations of the stars. The visual compendium ranges from old telescopes to modern observatories, from ancient astronomers to Einstein, from entries in old German encyclopedias to recent explanations about modern science, from serious studies to cartoons and advertisements. Throughout his life he added to these files, later updating them with articles from *Scientific American*, *The Sky Reporter*, and *National Geographic*, as well as from daily newspapers. Together with his books, these files constitute an impressive, if idiosyncratic, collection of data about the history and science of astronomy (fig. 1.1).

Cornell was particularly interested in celestial maps. His collection ranges from reproductions of constellation charts from early printed celestial atlases, Johann Bayer's *Uranometria* of 1603 and Johannes Hevelius's *Uranographia* of 1690, to modern diagrams made using the latest technology. In addition to hundreds of star maps clipped from books and magazines, he owned a complete edition of Elijah Burritt's *Atlas of the Heavens*, first published in 1825 and based, in turn, on Johann Bode's *Uranographia* published in 1801 (fig. 1.2).[5] Bode's *Uranographia* featured familiar ancient constellations, alongside more recently devised ones describing modern objects, such as the constellation Telescopium Herschellii, Herschel's Telescope, located above Gemini. Although these newer constellations were discredited in 1922, when the International Astronomical Union codified the eighty-eight constellations recognized by astronomers today, from Burritt's atlas and other sources Cornell knew these obsolete star formations and incorporated them in his works.[6]

He also collected other kinds of charts, some illustrating single constellations, others presenting entire cosmological systems. He owned a set of nineteenth-century celestial maps for children, with constellation figures punctuated by pinpricks marking stars that could be seen when the maps were held up to light. He also acquired a group of large, beautifully hand-colored eighteenth-century French engravings depicting theories of the cosmos, such as "Le Système de Descartes," which appear as backdrops in several assemblage boxes (see figs. 6.2 and 6.3). He tore and clipped charts from books and

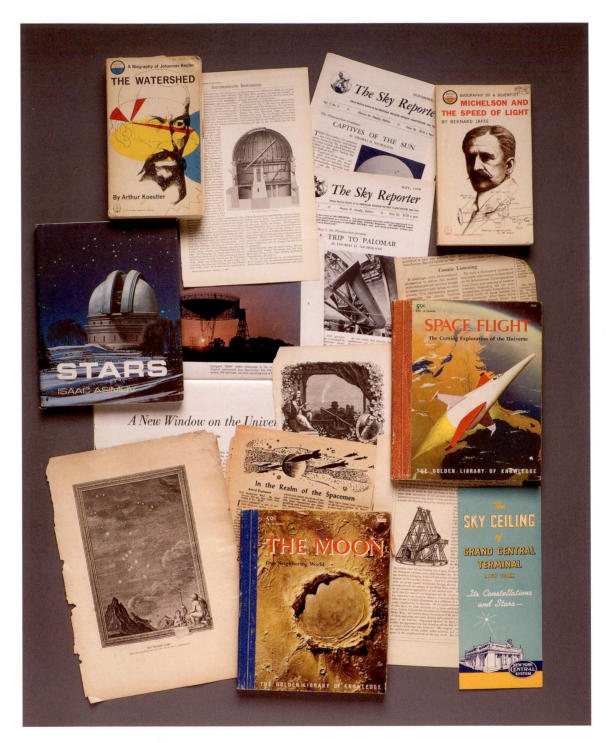

FIGURE 1.1.
Miscellaneous books, clippings, and printed materials, Joseph Cornell Study Center, Smithsonian American Art Museum. Mark Gulezian/QuickSilver Photographers.

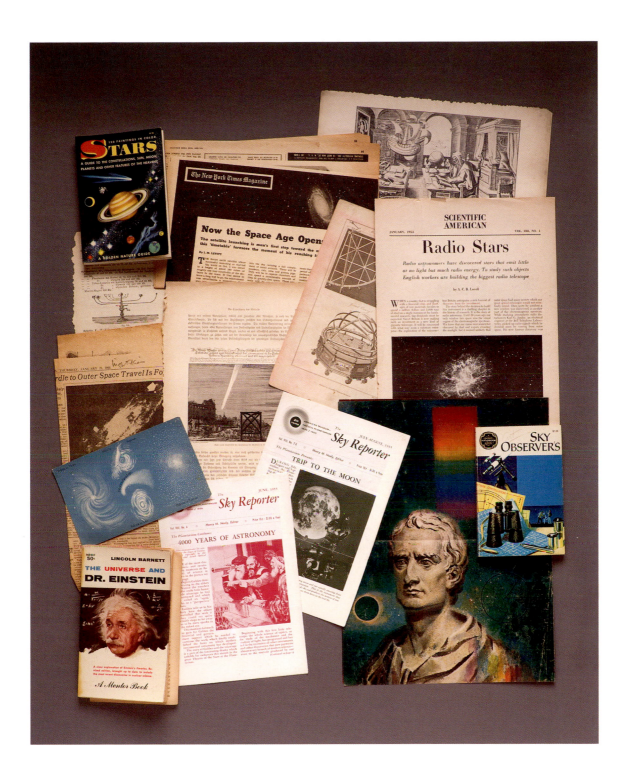

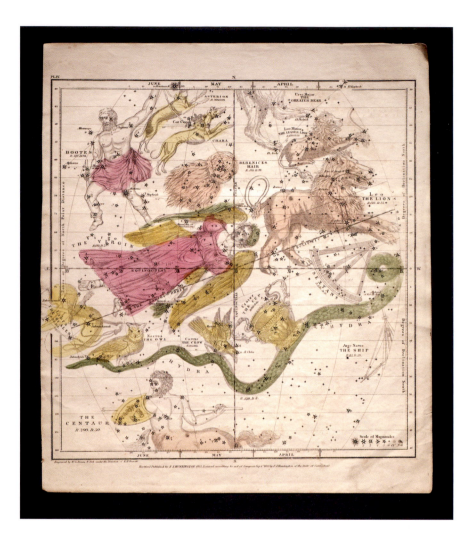

FIGURE 1.2.
Constellation chart,
engraved by W. G. Evans
under the direction of
E. H. Burritt, from
E.H. Burritt,
*The Geography of the
Heavens* (New York:
F. J. Huntington, 1835).
Joseph Cornell Study
Center, Smithsonian
American Art Museum.
Mark Gulezian/
QuickSilver
Photographers.

magazines illustrating a broad spectrum of topics, from Newton's theories to the paths of satellites in outer space. With materials as diverse as detailed scientific diagrams and pictures removed from children's books, he assembled a rich visual data bank from which he chose, reproduced, and manipulated items in a variety of forms.

Cornell embraced the age of mechanical reproduction with enthusiasm. In many instances, in boxes and collages he used black-and-white photographic copies in place of actual illustrations and charts. Not a photographer himself, he would take pictures he wished to consider as collage elements to a professional photostat maker for reproduction in negative or positive form on thick, slightly glossy paper.[7] Working with photostat technicians, he experimented with varying levels of contrast until he was satisfied with the result,

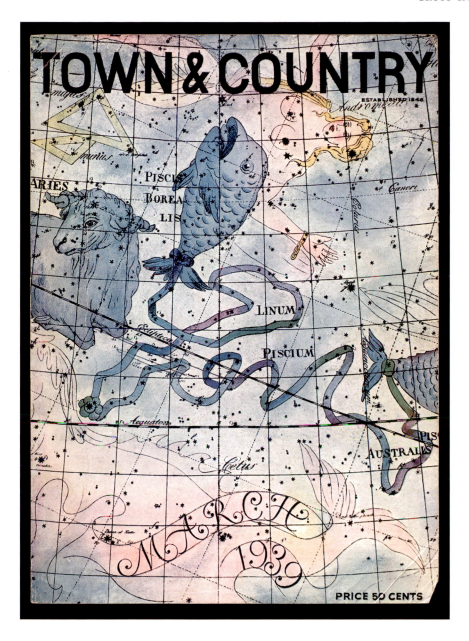

FIGURE 1.3.
Joseph Cornell, cover design for *Town and Country*, March 1939. Joseph Cornell Study Center, Smithsonian American Art Museum. Mark Gulezian/QuickSilver Photographers.

sometimes reversing an image or radically altering its size. While his familiarity with photostat reproduction probably stemmed from his work as a commercial textile designer at the Traphagen Commercial Textile Studio from 1934 through 1940 and from other commercial work he did as a magazine layout artist (fig. 1.3), he found the photostat process well suited to his artworks, which he often made as nearly identical multiples. In his files, along with the

FIGURE 1.4.
Trimmed photostat reproductions of Hevelius constellation figures of Andromeda and Auriga, from Camille Flammarion, *Les Etoiles* (Paris: C. Marpon et E. Flammarion, 1882). Joseph Cornell Study Center, Smithsonian American Art Museum. Mark Gulezian/QuickSilver Photographers.

items cut and torn from books and magazines, are scattered photostat copies of the original sources, such as those illustrating personifications of the constellations Andromeda and Auriga (fig. 1.4).

In addition to visual material about the cosmos, Cornell also collected a broad range of articles from the popular press. He was a dedicated reader of the *New York Times* and *Christian Science Monitor*. Over the years, as he browsed through newspapers and magazines, he tore and clipped articles on a wide variety of subjects, including astronomy, and he added them to piles of newspaper articles he saved and periodically reviewed.[8] Often he circled headlines, paragraphs, or poems of special interest and penciled notes in the margin (fig. 1.5). Until he began to read *Scientific American* on a regular basis in the 1950s, articles in the *Times* and *Monitor* were Cornell's most important source of information about recent developments in astronomical research and

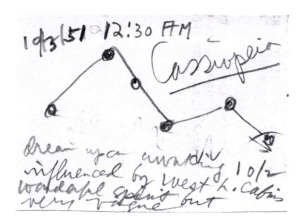

technology, and the care that he put into reading and collecting articles from these publications attests to their significance. Examination of contemporary newspapers and magazines reveals that his fascination for astronomy was directly in line with popular interests of his day, and the metaphors he used to construct a visual poetry of the stars are ones that would have been familiar to anyone who read the daily papers.

Cornell's involvement with the stars is also evident in diary entries that he made throughout his life, although the term "diary" is somewhat misleading when it comes to Cornell. Rather than keep an organized record of daily experiences in a bound book, he jotted notes on scraps of paper and old envelopes, in the margins of newspapers and magazines, even on the backs of collages. Usually dated, these notes provide a glimpse into Cornell's daily life, his creative process, and even his stargazing (fig. 1.6). Although they occasionally mention books, music, movies, and other artists and their work, for the most part his diary notes chronicle transformative moments when simple experiences became special, even otherworldly. Often astronomical elements played a part in his articulation of these ineffable moments. Take, for instance, an entry written on October 8, 1968:

> *"Lesser Dog" treading the pinnacle of*
> *a maple-top out front, part of him*
> *through the leaves. . . .*
> *the thrice-familiar proffering revelation*
> *again in the night skies*
>
> *but nearing time of fade-out now at 6—*
> *the brighter of the Twins will linger as morning star*[9]

Such musings demonstrate how important "revelation," to use Cornell's term, was for him. In his notes, he translated the astronomical information

OPPOSITE PAGE:
FIGURE 1.5.
Georgie Starbuck Galbraith, "Enigmas," *Christian Science Monitor*, March 4, 1958, as notated by Joseph Cornell. Joseph Cornell Study Center, Smithsonian American Art Museum. Reproduced with permission from the March 4, 1958 issue of *The Christian Science Monitor*. © 1958 *The Christian Science Monitor*. All rights reserved. Mark Gulezian/QuickSilver Photographers.

FIGURE 1.6.
Joseph Cornell, Cassiopeia diary notation, 1951. Courtesy of the Joseph Cornell papers, 1804–1986, Archives of American Art, Smithsonian Institution.

that filled his clipping files into evocative moments of companionship with the stars. He refined this process in his collages and box constructions, creating works that place the facts of science at the service of the imagination.

The Flammarion Years

When did Cornell first see the stars as more than just scattered points of light in the night sky? Perhaps as a child he learned to pick out a constellation on the lawn beside his family's elegant home in Nyack, New York. Perhaps as a student he marveled at the physics of astronomy at Phillips Academy in Andover, Massachusetts, where he was sent in 1917 after the death of his father. Perhaps as a young man he considered the poetic aspects of the night sky while trudging the sidewalks of Manhattan as a textile salesman after financial losses necessitated his family's move to small houses, first in Bayside, Queens, and then on Utopia Parkway in Flushing, New York. Perhaps as a budding artist he realized that the stars could set off chain reactions of associated meanings. One thing is clear: from an early moment the stars stimulated his imagination in ways that nourished him throughout his life.

Ironically, Cornell's first recorded response to the cosmos was fear. According to his sister Betty, after having returned from Andover for a Christmas vacation, he woke her one night, "shaking like a leaf," and stood at the window while confessing his anxiety about the concept of infinity. He had just started to study astronomy. After returning to school, she recalled, "he really got into astronomy. And he loved it."[10] There are no records at Phillips Academy of Cornell having taken a specific course in astronomy; indeed, none was offered. He did follow the science curriculum, and, since the school had no observatory, he may have studied the stars in classes that used the telescope at Abbott Academy, a nearby girls' school. Among his books are a number of textbooks about natural philosophy and astronomy, perhaps kept from his student days. However, it was not until the 1930s, when he began producing small collages made of engravings cut from old books, that his interest in astronomy manifested itself in a tangible form.

Cornell's works are difficult to date and title. Often scholars are content to fit them into a decade, but that broad dating can be tentative or incorrect. Even when he affixed dates to the backs of boxes or collages, those are not always trustworthy, since he frequently returned to a work years later, sometimes making slight revisions, sometimes major ones, sometimes destroying a work altogether and creating a new one from the remains. Titles, too, pose problems. He often assigned various titles to a work, changing the title presented in a rough exhibition checklist, to that appearing in printed form, to the title used in his own notes, to pet names he sometimes devised. His alternate titles sometimes appear in parentheses in titles of his work.

Complicating things further, Cornell regularly produced variants of works, using the same title for several nearly identical boxes, distinguishing between them with numbers. Sometimes he titled works by a general category, such as "soap bubble set," rather than giving a specific name to a specific work. Occasionally titles have been assigned after the fact by curators or collectors, simply on the basis of a fragment of material pasted on the back of a box or collage; these assigned titles appear in brackets. In some instances, however, a title could be of great importance to the artist, and he would be consistent in his use of it for a unique work of art. Even the question of whether or not a work should be considered finished is problematic: the artist often dithered for months or years before deciding a box or collage was done, only to change his mind and return to a work again, sometimes after several more years had passed. For Cornell, creation was a fluid process, enriched by the passage of time. Assigning specific titles and dates could impede that flow.

Nevertheless, it is possible to consider some of Cornell's earliest astronomy-inspired work. In the early 1930s he began producing small collages made of pictures clipped from nineteenth-century books and mounted on paperboard. When gallery owner Julien Levy examined a few of these in 1931, he recognized Cornell's potential and invited him to exhibit at the newly opened Julien Levy Gallery in New York. Although Levy inaugurated his gallery with an exhibition of nineteenth- and twentieth-century photographs, he soon expanded his scope to include showings of avant-garde art, especially Surrealist works.[11] Cornell became one of Levy's most frequent exhibitors, as one of only a few Americans whose work was compatible with that of such cutting-edge Europeans as Max Ernst and Marcel Duchamp. Levy included several of Cornell's collages, as well as an assemblage of objects covered with a glass bell, in Surréalisme, an exhibition that opened in January 1932, for which Cornell designed the announcement.

Levy's importance for Cornell has been widely acknowledged by scholars, who have underscored the introduction Levy's gallery provided Cornell to the international avant-garde art scene. What has gone unnoticed, though, is the important part Levy played in the imagery of astronomy in Cornell's art. In 1961 Cornell recorded an early memory in a diary note:

> Julien + Allen unpacking outside on sidewalk—602 Madison Ave. no coats in cold weather [flashing imagery retiring to bed 1 am] took FLAM-MARION ASTRON. Bks from up in Gallery—notified Julien who nodded + went on working— no coats in cold weather it must been the dream feeling—FEMME CENTS TETES (strong at time) lending to the unexpectedness of the scene its own character.[12]

Thus it was Levy who provided Cornell with what would become his most significant source of information and imagery about astronomy: books by the nineteenth-century French astronomer and popular writer Camille Flammarion.

Opposite page:
Figure 1.7.
*La Cassiopée de l'atlas de
Bayer (1603);
Le Bouvier de l'atlas de
Bayer (1603); Constel-
lations zodiacales.—Le
Taureau.—Les Gé-
meaux; Constella-
tions zodiacales.—Les
Poissons.—Le Bélier;* in
Camille Flammarion, *Les
Etoiles* (Paris: C. Marpon
et E. Flammarion, 1882).

Born in 1842, Flammarion was the author of more than seventy books that did more to encourage public interest in astronomy than any other publications of his day. Based for many years at the Paris Observatory and at the French Bureau of Longitudes, as a respected astronomer he participated in the cataloguing of more than ten thousand double stars. In his writing, however, he combined impartial scientific research with passionate speculation about life on other planets. Flammarion's first book, *La Pluralité des mondes habités,* published in 1862, established his reputation as an advocate and popularizer of pluralism, the conviction that other worlds harbor intelligent life. In subsequent publications he expanded his belief in extraterrestrial life to include the notions of the transmigration of souls and the reincarnation of human souls on other planets. In 1880 he published *Astronomie Populaire,* a richly illustrated, fact-filled tome about the history and current state of astronomy. Two years later he added a weighty supplement, *Les Etoiles et les curiosités du ciel.* Both books include detailed explanations of astronomical facts, as well as speculation about life in outer space. In 1884 he added *Les Terres du ciel,* further marshalling scientific information to support his pluralist beliefs.[13] Each more than seven hundred pages long, with hundreds of engravings, maps, color charts, and photographs, these books constituted a sumptuous trilogy designed for serious amateur astronomers. Although Flammarion also wrote science fiction and, shortly before his death in 1925, published studies about psychic research, his reputation rests on *Astronomie Populaire.*

Astronomie Populaire, Les Etoiles, and *Les Terres du ciel* were probably the "Flammarion Astron. Bks." that Cornell obtained from Levy, no doubt chosen by the art dealer to appeal to Cornell's Francophile interests. Clipped illustrations from each of these books made their way into the artist's astronomy files, along with chunks of a battered copy of *Les Etoiles.* In all likelihood, Levy brought these books from Paris for Cornell to cut up for collages, which he seems to have promptly proceeded to do. Thus began a lifelong creative process of appropriating for his own works constellation charts from Flammarion's books (fig. 1.7). Among Cornell's early works is a collage created from Flammarion's reproduction of the constellation Boötes, the Herdsman or Ploughman, originally published in 1603 in Bayer's *Uranometria* (fig. 1.8).[14] Cornell hand-colored the figure's tunic and added two collage elements: a box into which Boötes places his right foot and a box containing a loaf of bread in the upper right corner.

Irrational as these minor manipulations may seem, they demonstrate how carefully Cornell considered his subject. According to one of the legends of Boötes's origin in the sky, Ceres, the goddess of agriculture, was so pleased with Boötes's invention of the plow that she asked Jupiter to place him among the stars in gratitude. Another story explains that Boötes is the guardian of the Ursa Major, the Great Bear, and Taurus, the Bull. Bayer pictures Boötes in these roles, holding a crook and sickle and wearing his signature boots. Further

Left column (page 53):

en lui présentant la tête hideuse de Méduse, et de délivrer Andromède

Fig. 22. — La Cassiopée de l'atlas de Bayer (1603).

évanouie. C'est un effet de scène dont la peinture a tiré parti dans

los changements de mode. — Cette figure est très correcte quant au Bouvier, entre les jambes duquel on voit briller Arcturus. Il ne faudrait pas croire cependant que la Gerbe ou la Chevelure n'existaient pas avant cette époque, car, sur un autre ouvrage de ma bibliothèque, le *Poeticon astronomicon* d'Hyginus, imprimé à Venise en 1485, c'est-à-dire aux premiers temps de l'imprimerie, soixante-quatorze ans

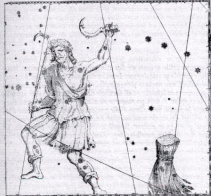

Fig. 88. — Le Bouvier de l'atlas de Bayer (1603).

avant l'ouvrage précédent, cette même constellation du Bouvier est dessinée telle qu'on la voit (*fig.* 87), avec une faucille à la main et une gerbe à ses pieds. L'atlas de Bayer (1603) a conservé la même tradition (*fig.* 88), et nous représente le personnage dans l'attitude d'un moissonneur qui vient de couper la gerbe; ici, ce n'est plus le gardien des bœufs, « le Bouvier », ni le gardien de l'Ourse « arcto-phylax », comme on l'appelait. Son caractère change de nouveau dans l'atlas d'Hévélius, qui, dessinant là les deux Chiens de chasse, enlève

Fig. 136. — Constellations zodiacales. — Le Taureau. — Les Gémeaux.

Fig. 138. — Constellations zodiacales. — Les Poissons. — Le Bélier

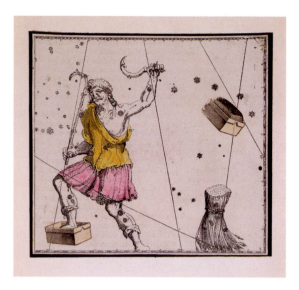

underlining the constellation's association with agriculture is a sheaf of wheat to the right of the figure. In his collage, Cornell went a step further, turning the wheat into the loaf of bread in the box at the upper right. Moreover, in Cornell's version, Boötes places his boot into a box, perhaps signifying the constellation Mons Menalus, the Mountain of Menalus, on which Boötes stands in later atlases, including Johann Bode's *Uranographia* of 1801, illustrated in Flammarion's *Les Etoiles* (see fig. 4.8).

In this unassuming early collage, Cornell already associated the stars with boxes. In addition to serving as visual puns for objects ("breadbox" and "shoebox"), the boxes contrast the concept of containment with the limitless expanse of outer space. Like the polygon created by the grid overlaid on the figure in Bayer's chart, the shoebox cannot fully contain Boötes, who easily exceeds its boundaries. Indeed, the perspective system used to create the illusion of a three-dimensional cube is strangely at odds with the two-dimensional grid lines of the celestial map. After adding his boxes to the illustration of Boötes, Cornell was careful to continue the lines of the map over them, to show that the boxes are behind (and in dialogue with) the overlay of the grid.[15] The two spatial systems intersect: the two-dimensional attempt to impose abstract order on the vastness of the night sky and the three-dimensional attempt to create the illusion of objects as we see them. But an expanding universe can be measured or mapped only for a moment, and there are no vanishing points in an infinite cosmos. These little boxes not only act as metaphors for the limitations of Renaissance geometrical perspective systems in depicting a boundless universe, but they also symbolize the limitations of human knowledge when facing the four-dimensional complexities of a universe predicated on a continuum of space and time.

Along with adding the boxes, Cornell colored the clothes of the figure in Flammarion's illustration. The choice of reddish-pink and yellow for Boötes's garments may reflect Cornell's early awareness of the importance of the colors of stars. After Joseph von Frauhofer mapped the dark lines in the solar spectrum in 1814 and Gustav Kirchoff and Robert Bunsen discovered that each chemical element was associated with a set of spectral lines in the 1850s, spectral analysis of starlight preoccupied astronomers throughout the nineteenth century. Among the stars in the constellation Boötes is yellow-orange Arcturus, the fourth brightest star in the sky, a point that Flammarion emphasized as part of an extended discussion of the ways in which the brightness of various stars in the constellation has changed over time. In *Les Etoiles*, Flammarion included a chart showing different types of colored double stars, including yellow stars in Boötes, as well as a colored chart of spectral light from various stars, comets, and nebulae, as part of his discussion of the composition of starlight.

Flammarion's books provided other sources of information and inspiration for Cornell. The artist collected numerous portraits of astronomers from *Astronomie Populaire* and *Les Etoiles*, mounting some of them on paperboard without further manipulation: a long-robed stargazer in ancient times, a medieval astrologer with his charts, Tycho sighting the nova that still bears his name, Galileo presenting his telescope to the doge of Venice, Isaac Newton and his apple, and William Herschel discovering Uranus (fig. 1.9). Cornell also removed and mounted illustrations that envisioned impossible sights: Earth as seen from outer space, the rings of Saturn observed from the surface of the planet, and a close-up view of the mountains of the Moon. With their combination of carefully presented scientific data and imaginative speculation, Flammarion's books intrigued Cornell, who shared their author's fascination with fact and fantasy throughout his life. Especially in the early years of his career—"the Flammarion years" as Cornell later called them—the texts and their illustrations provided him with ample raw material from which to construct his own visions of the cosmos.

As Cornell himself readily acknowledged, his collages and even the act of clipping and combining prints from old books were inspired by the work of the German artist Max Ernst, particularly his collage-novel, *La Femme 100 Têtes*.[16] As art historians have shown, Ernst frequently turned to magazines and old science books, including ones by Flammarion, as starting points for his art.[17] In his collages, Ernst transformed the dispassionate visual language of science into a vehicle for eroticism, creating sexy codes for aspects of astrology, alchemy, and the occult.[18] For instance, in *Mon Petit Mont Blanc*, an illustration in Ernst's and poet Paul Eluard's collaborative book, *Les Malheurs des immortels*, published in 1922 (fig. 1.10), the artist contrasts the clothed arm of a man holding a dart pistol with the crouching nude body of a woman whose vulnerable posterior pokes up through the rings of Saturn, an engraving of the planet perhaps appropriated from Flammarion's *Les Terres du ciel*. As William

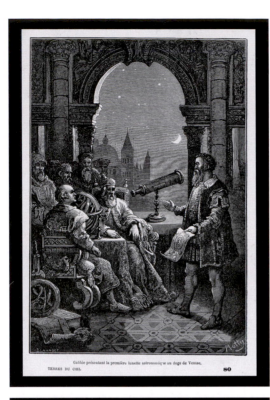

Galilée présentant la première lunette astronomique au doge de Venise.

80

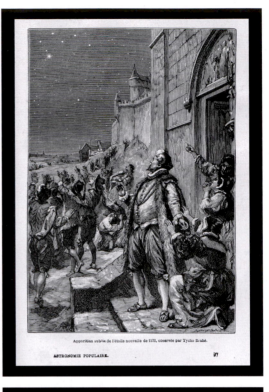

Apparition subite de l'étoile nouvelle de 1572, observée par Tycho Brahé.

37

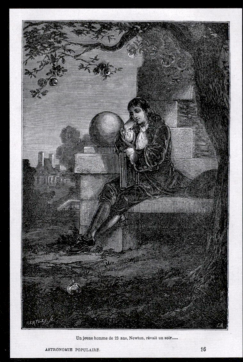

Un jeune homme de 23 ans, Newton, rêvait un soir.....

15

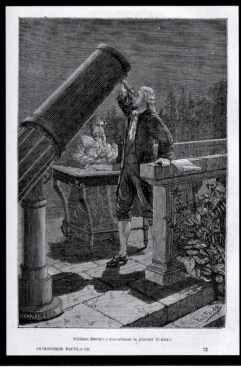

William Herschel découvrant la planète Uranus.

72

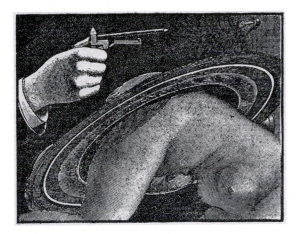

Camfield has proposed, here the erotic encounter may function as a metaphor for alchemical transformation, with the taboo subject of anal intercourse justified by its symbolic alchemical subtext.[19]

Cornell admired Ernst's collages; however, the erotic and alchemical content must have disturbed the reticent American. When he created a series of sixteen collages in homage to Ernst in the 1930s, he, too, turned to the planet Saturn, although in place of Ernst's bold erotic statement he offered a gentle fantasy about space travel (fig. 1.11). A giant bird pokes its head through the rings of Saturn, as if propelling the planet past the Moon, the stars, and a distant spiral nebula. Cornell was no doubt referring to the role played in Ernst's creative process by Loplop, the birdlike character that frequented his paintings and collages, including *La Femme 100 Têtes*, between 1928 and 1932.[20]

From Ernst, through the intermediary of Levy, Cornell realized that old science texts could provide a treasure trove of collage materials, which, when taken out of context, offered innumerable opportunities for wonderful juxtapositions of strange objects and marvelous ideas. In fact, Cornell even utilized some of the very same clipped items that Ernst did. The impetus underlying each artist's results differed, however. Ernst's appropriation of the cool visual language of scientific illustration for erotically charged subjects was, in large part, a confrontational attack on the intellectual establishment, originating with Dada notions of challenging authority. Cornell's incorporation of physics illustrations originally stemmed from a desire to achieve a certain Surrealist "look" in his art, with unexpected encounters between systems of knowledge leading to heightened states of awareness. Realizing that he could not simply mimic Ernst's style, and probably discomfited by the German artist's erotic and confrontational content, Cornell soon abandoned flat collage in favor of box constructions and object sculpture. Nevertheless, for the remainder of his life he remained deeply indebted to Ernst's example of using material clipped from science texts in his art.

OPPOSITE PAGE:
FIGURE 1.9.
Left to right: Galilée présentant la première lunette astronomique au doge de Venise, in Camille Flammarion, *Les Terres du ciel* (Paris: C. Marpon et E. Flammarion, 1884); *Apparition subite de l'étoile nouvelle de 1572, observé par Tycho Brahe; Un jeune homme de 23 ans, Newton, rêvait un soir,* and *William Herschel découvrant la planète Uranus* in Camille Flammarion, *Astronomie Populaire* (Paris: C. Marpon et E. Flammarion, 1880).

FIGURE 1.10.
Max Ernst, *Mon Petit Mont Blanc*, 1922. Photomechanical reproduction, 9¾ × 7½ in. Reproduced in Max Ernst and Paul Eluard, *Les Malheurs des immortels* (Paris: Librarie Six, 1922). Metropolitan Museum of Art. © 2007 Artists Rights Society (ARS) / ADAGP, Paris. Photograph, all rights reserved, The Metropolitan Museum of Art.

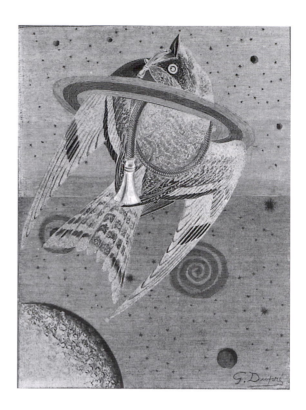

Cornell and Surrealism

Cornell liked his things in piles. Photographs of his basement studio show shelves filled with boxes of source material perched on top of each other, with labels indicating contents as varied as "Plastic Shells," "Bottle Museums," and "Flotsam and Jetsam." Balanced on studio shelves are games and toys and balls and tubes of glitter and porcelain parrots. Photos of his living room reveal more piles. There are stacks of old newspapers, towers of books, and, tucked nearly out of sight, vast hoards of pages and clippings from newspapers, magazines, and books. The sheer quantity of stuff is staggering. The newspaper piles imply an inability to discard the past; the naked dolls and box labeled "Mouse Material" (clumps of dust) border on the perverse.

Cornell lived and worked in a *merzbau* constructed of ready-made items, each one of which, on its own, had little meaning beyond itself, but when combined artistically with other objects or ideas could participate in a kind of mental pinball game of ingenious associations. "Go thru everything in house creatively," he ordered himself in a note written in 1961.[21] From the start, Cornell's artistic mission was to find unlikely links between things and ideas and to suspend them in delicately arranged collages and assemblages. It is a creative process derived from Surrealism's delight in the mental charge that could

result from the juxtaposition of apparently unrelated things, and it sustained Cornell for his entire career. In his notes, many terms describe the piling up and interconnectedness of associations in his work: sprinkled throughout are references (some borrowed from the language of science) to "unfoldment," "illumination," "enrichment," "distillation," "extensions," "sparkings," "quickening," and "crystallization." He marvels at "sublime ethereality" and "compounded interest." In one note he describes a "ricocheted" conceptual encounter; in another he fumbles to express the "transcendent something that comes with object activity"; in yet another he records, "Had satisfactory feeling about clearing up debris on cellar floor—'sweepings' represent all the rich cross-currents ramifications etc. that go into the boxes but which are not apparent (I feel at least) in the final result." Above all, his process was one of "cross-indexing"—piling up associations to create a visual poem that exceeds the sum of its individual collage and assemblage elements.[22]

Cornell's relationship to Surrealism is complex. His entry into the world of art was via the Julien Levy Gallery, where he found his niche as a maker of Surrealist collages and objects.[23] His work was viewed and reviewed along with that of other important European Surrealists, including Ernst, Salvador Dalí, and American expatriate Man Ray, and Cornell knew these artists personally. However, his frequent attempts to distance himself from the Surrealist movement have all too often led scholars to discount the role of Surrealism in his work. To be sure, he had little desire to be pigeonholed as a Surrealist, writing Alfred Barr, Jr., in 1936, "I do not share in the subconscious and dream theories of the Surrealists. While fervently admiring much of their work, I have never been an official surrealist, and I believe that surrealism has healthier possibilities than have been developed. The constructions of Marcel Duchamp who the surrealists themselves acknowledge bear out this thought, I believe."[24] In particular, he did not want to be associated with the "black magic" of French Surrealism, preferring the "healthier possibilities" of his own "white magic," which skirted the emphasis on the occult and the perverse found in certain strains of Surrealist art and literature. Significantly, he associated his own interest in "healthier" alternatives with Duchamp, whose work also creatively merged science and art.

But Cornell's denied identity as a Surrealist was probably more complicated. By the later 1930s, when the artist was most directly associated with the movement, Surrealism was equated with Communism in the minds of many Americans. A writer in the *Christian Science Monitor* put it succinctly: "Should the Surrealists adhere to their love of wonder and the marvelous, their irrationality and fantasy, we would acknowledge them, but their insistence upon a social program and a logical basis is beyond the understanding of this reader. The authors have attempted too emphatically to establish a link with Freud and Marx."[25] Most likely it was the politicization of Surrealism in the 1930s that Cornell wished to avoid, especially its associations with

Communist atheism that conflicted directly with his deep-seated religious faith, reflected in his adherence to the teachings of Christian Science.

While Cornell's negative comments about Surrealism were directed toward its identity as a movement, Surrealist creative process was something quite different, and to it he readily acknowledged his profound debt. Throughout his career, he remained steadfastly true to his interest in Surrealist art, clipping and annotating articles about artists (for instance, snipping bits about René Magritte, Joan Miró, Jean Arp, Alberto Giacometti, and Dalí), making diary notes about books he was reading (Marcel Jean's *History of Surrealist Painting* in 1960 and Anna Balakian's *Surrealism, The Road to the Absolute* in 1965), and commenting on the poetry of André Breton and Eluard well into the 1960s.[26] Over thirty years after the fact, he still mourned his loss of a particular issue of the journal *Documents*, edited by dissident Surrealist Georges Bataille.[27]

Despite his protestation to the contrary, Cornell was particularly drawn to the Surrealist belief in the power of the unconscious, as expressed in dreams and visions. He bookmarked and annotated his copy of Freud's *The Interpretation of Dreams*, and his long-standing recording of his own dreams and "hypogogic musings," as he called them, was, in fact, a common Surrealist practice.[28] For instance, late in life he reminisced about his walks down "nightmare alley" on lower Broadway in the 1930s, filtering his experience through the nineteenth-century writer Gérard de Neval, also admired by Breton and Eluard. Typical of Cornell's vexed relationship with Surrealism, his "nightmare alley" memory begins with the uncanny and ends with the spiritual:

> [a strong sense of having witnessed these areas illuminated (also in waking hours just as much as dream) in the same way as Gérard de Nerval but without his classical sense of form + genius of expression to help out.] But this dormant and latent force must have some kind of present significance to evoke images of such splendid terror. Not just "going back" to the "Chien Andalou" days but feeling this renewal albeit tinged by Pascal's well known feelings about the "abyss."[29]

Cornell also embraced other aspects of Surrealist creative process. In particular, his fascination with layers of meanings and his juxtaposition of seemingly unrelated subjects have their roots in Surrealism. He acknowledged this, for instance, on a label accompanying his dossier "Ondine," in which he explained that work's "subtle evocative development reminiscent of the associative theme process as often revealed in surrealist art."[30] Like other Surrealist artists and writers, Cornell saw vast creative potential in the concept of "chance encounters" first articulated by the proto-Symbolist writer Isidore Ducasse (better known by his nom de plume, le Comte de Lautréamont), later adopted as a creative creed by Surrealists. References to Lautréamont are sprinkled

FIGURE 1.12.
Man Ray, *Electricity—The World (Electricité—Le Monde)*, 1931. Photogravure, 10¼ × 8¹/₁₆ in. The J. Paul Getty Museum, Los Angeles. © Man Ray Trust ARS-ADAGP.

throughout Cornell's notes.[31] Cornell credited the importance of Surrealism's validation of the poetic object for his own work, writing in 1967, "Exposure to Surrealism's philosophy relative to, concern with, the 'objet,' a kind of happy marriage with my life-long preoc. with things."[32] Indeed, it was with sincere appreciation that he looked back on the "revelation world of surrealism—a golden age—one of white magic without which I don't know where in the world I'd be to-day without it."[33]

Surrealism not only provided Cornell with a framework for his creative process, it also offered ways to link art to science. In addition to Ernst's example, Cornell was familiar with works based in science and technology such as Man Ray's Rayograph series, *Electricité*, exhibited at the Julien Levy Gallery in 1932 (fig. 1.12), as well as paintings such as Pierre Roy's *Electrification of the Country* (fig. 1.13), reproduced in *Creative Art* in 1931 and on view in New York in the early 1930s.[34] Perhaps he even heard talk of an early work by Dalí, *The Marriage of Buster Keaton*, in which photographs of the film star are combined with clippings of astronomy charts showing solar eclipses, the phases of the Moon, and the relationship of the planets to the Sun.[35]

Astute American followers of Surrealism were keenly aware of the pairing of science and art to be found in Surrealist quarters. As Dorothy Adlow wrote in 1936 in a review of the Boston showing of the Museum of Modern Art's landmark exhibition Fantastic Art, Dada, Surrealism, "The [Surrealist] artist has furthermore been influenced by scientific and pseudo-scientific ideas in relation to thought and the study of mental processes. He has explored his thoughts, analyzed his dreams. Ideas of the universe promulgated by such thinkers as Jeans and Eddington have excited further still the imagination of

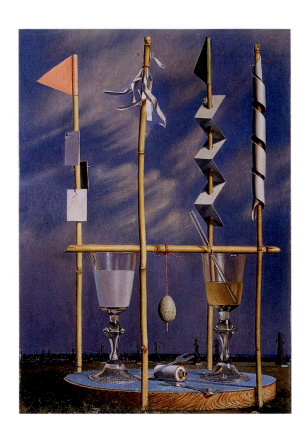

the artist."[36] Adlow referred to astronomers Sir James Jeans, whose popular book *The Universe Around Us, Through Space and Time* traced the evolution of theories of the universe from Galileo to the present, and Sir Arthur Eddington, whose book *The Nature of the Physical World* also explained scientific principles to general readers. That Adlow linked both of these important scientists with Surrealism indicates how clear the connection between science and Surrealism was to the general public, as well as to Cornell.[37]

PLAYFUL ASTRONOMY AND SPIRITUAL SCIENCE

In the art of Marcel Duchamp, Cornell had an especially important model for avant-garde statements built upon the language of science. Although Cornell probably met Duchamp at a Brancusi exhibition held at the Brummer Gallery in 1933, their close association did not begin until August 1942, when Cornell began assisting with the assembly of miniature versions of Duchamp's works, known as the *Boîtes-en-valise*, an edition of reproductions of sixty-nine principal works by the artist, mounted on paperboard and housed in a small leather valise. Cornell worked with Duchamp until January 1946, and his frequent

personal interaction with Duchamp and intimate acquaintance with Duchamp's works resulted in an artistic give-and-take that Cornell experienced with no one else. He paid homage to their interaction with a boxed collection of his own: a "Duchamp Dossier" consisting of objects, notes, and scavenged detritus commemorating their artistic collaboration and friendship.[38]

Among the many things they had in common was their shared interest in the ways in which the visual, verbal, and conceptual aspects of science could enrich a work of art. As art historian Linda Dalrymple Henderson has shown, Duchamp's notion of "playful physics" undergirds his most important works, especially *The Bride Stripped Bare by Her Bachelors, Even (The Large Glass)*.[39] Fascinated by revolutionary discoveries, like X-rays and radioactivity, and new ways of understanding such physical forces as electricity, magnetism, light, and gravity, Duchamp engaged in a rigorous, yet ironic, dialogue about physics and metaphysics in his art. Culminating with the creation of the *Large Glass*, he produced works that function according to their own scientific laws, with physical forces and chemical reactions demonstrated by the imaginative invention of anthropomorphized laboratory instruments and machines. Cornell, too, found in the languages of science vocabularies for artistic expression, although he tended to illustrate known principles of science in his art, rather than imagine new ones as Duchamp did.

Both artists anthropomorphized science for the purpose of art: Duchamp, through his creation of human analogies for scientific actions and principles; Cornell, through his appropriation and transformation of age-old anthropomorphic star constellations. Both artists' scientific methods led to erotic results, although Duchamp's erotic content is more overtly sexual than Cornell's. Both sought to visualize the invisible: Duchamp, by giving form to unseen physical laws, principles, and phenomena; Cornell, by envisioning patterns and meaning in the apparent chaos of the cosmos. Both used the scientific vocabulary of diagrams, charts, and graphs, with their depersonalized lines and mechanistic forms, to endow their works with the aura of the laboratory and textbook. Both artists found more inspiration in repositories of science and technology than in art museums: Duchamp, at the Musée des Arts et Métiers, and Cornell, at the Museum of Natural History and the Hayden Planetarium. Both found an important precursor in Leonardo da Vinci, and both paid homage to the Renaissance master in their art and identities. And, like Leonardo, Duchamp and Cornell were both interested in mathematics, especially geometry and perspective.

But there are significant differences. Duchamp's intense investigation into modern science peaked in the 1910s, and, as Henderson points out, after World War I new scientific advances made much of Duchamp's knowledge outdated. Cornell's interest in astronomy lasted throughout his life, and he kept abreast of recent discoveries and technological advances and incorporated them into his art. As an artist-*cum*-scientist and engineer, Duchamp was primarily drawn

to the microcosmic unseen world of X-rays, radioactivity, magnetism, electricity, and subatomic particles. As an artist-astronomer, Cornell focused on the universe, making works of art that combined the history of astronomy with current findings. Whereas Duchamp indulged in "playful physics" in his works, by creating ironic transformations of the language and principles of science, Cornell countered with what we may call "playful astronomy," by couching references to astronomy's rich past and exciting present in terms of metaphor and metamorphosis. Nevertheless, Cornell learned many important lessons from Duchamp: how to use found objects to create works of art; how to appropriate the language and methods of science for aesthetic effect; and how to make artworks that could be both densely cerebral and whimsically witty.

Like many artists, writers, and even physicists of his day, Duchamp blurred the boundaries between science and the occult, finding in the language and metaphors of alchemy ways to conceptualize new discoveries such as X-rays and radioactivity.[40] Perhaps following Duchamp's lead, Cornell also dabbled in astrology and alchemy, filing away articles about Paracelsus and the history of alchemical traditions, saving packs of tarot cards, and designing a commercial layout for *Harper's Bazaar* about astrological signs of movie stars.[41] He clipped an article entitled "The Poet's Alembic" from the *Christian Science Monitor* in 1953, and in 1967 he wrote a diary entry entitled "The Chemistry // Alchemy of Collage."[42] However, in comparison to the vast quantity of materials about and references to the science of astronomy in his papers, these encounters with the occult are extremely rare, indicating only passing interest in subjects that were far more important to artists such as Ernst and Duchamp.

Even though Cornell did not share the deep-seated interest in alchemy demonstrated by his contemporaries, he did have a metaphysical framework in which he placed his art, his understanding of science, and, indeed, his very soul: the religion of Christian Science.[43] He became a Christian Scientist long before he emerged as an artist, first turning to the church between 1925 and 1926 after a healing experience. He taught Sunday school and worked in a Christian Science Reading Room. Although the intensity of his involvement with the church waxed and waned, his beliefs were an ongoing source of spiritual nourishment. A constant refrain in his notes are references to hymns, biblical texts, and the writings of the faith's founder, Mary Baker Eddy. On its most basic level, Christian Science provided Cornell with a belief system that superficially intersected with the interest in alchemy and the occult shared by scientists and artists, who likewise turned to metaphysics to understand the transformations of subatomic particles and the evolution of galaxies.

Throughout her writings, Eddy asserts that the material world should be viewed as a collection of symbols representing greater immaterial realities, and that life is a process of transmutation from substance to spirit. Like the language of alchemy, Christian Science discourse relies on symbols and

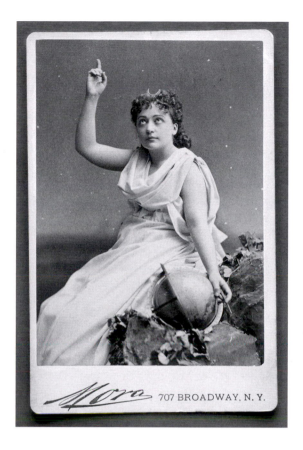

707 BROADWAY, N. Y.

analogies, with frequent recourse to physical science to explain the metaphysics of the spirit. In the central text of Christian Science, *Science and Health with Key to the Scriptures*, published in 1875, Eddy writes, "Copernicus mapped out the stellar system, and before he spake, astrography was chaotic, and the heavenly fields were incorrectly explored." Like Copernicus, Eddy presents a new cosmology. In it, astronomy is a metaphor for God. She observes, "astronomical order imitates the action of divine Principle; and the universe, the reflection of God, is thus brought nearer the spiritual fact, and is allied to divine Science as displayed in the everlasting government of the universe."[44]

In Christian Science, objects and ideas are symbols for greater metaphysical transformations. Consider, for example, lines from one of the many poems that Cornell clipped from the *Christian Science Monitor* for his files: "Symbol may be a refuge / for the substance meant / and parable—the passage / of truth from prisonment."[45] Among those symbols and parables were the stars and the scientific facts associated with them. As Eddy writes in *Science and Health with Key to the Scriptures*: "As astronomy reverses the human perception of the movement of the solar system, so Christian Science reverses the

FIGURE 1.14.
Maud Granger as Astronomy, Joseph Cornell Study Center, Smithsonian American Art Museum. Mark Gulezian/QuickSilver Photographers.

25

seeming relation of Soul and body and makes body tributary to Mind."[46] With its concern for the immaterial, or, to use a favorite term of Cornell's, the "ineffable," Christian Science offered him a model for using the facts of science as transcendent symbols.

· · · · ·

Among the many nineteenth-century photographs in Cornell's papers is a cabinet card portraying a woman holding a globe and pointing heavenward (fig. 1.14). An inscription on the back confirms her identity as the actress Maud Granger, posing as Urania, muse of astronomy. Perched on a rocky throne with her head among the stars, she is an intermediary between Earth and the heavens. The photograph was but one of many pictures of Urania that Cornell collected over the years, attesting to the figure's relevance to him as a cross-indexer of a number of important concepts. From a historical perspective, she embodies *Astronomia*, one of the seven liberal arts, with roots in astronomy going back to antiquity. As an allegory of science, she links the known, mapped Earth and the unknown, uncharted distances of the universe. Seen through the lens of Surrealism, she presents a bizarre merger of popular culture and science in the form of a character who seems to have stepped out of a dream. From a spiritual standpoint, like a Christian Scientist she turns her attention away from worldly things and focuses on infinite Heaven above. All of these meanings resonated with Cornell, who found an enduring source of symbols for physical and metaphysical existence in his lifelong engagement with astronomy. In his art and in his life, the stars were his guide as he investigated the far reaches of his own creative cosmos.

THE CELESTIAL SCIENCE OF SOAP

AFTER SEVERAL YEARS OF EXHIBITING small collages and object sculptures at the Julien Levy Gallery, Cornell was invited to participate in Alfred H. Barr, Jr.'s, groundbreaking exhibition, Fantastic Art, Dada, Surrealism, which opened at the Museum of Modern Art in December 1936.[1] The exhibition provided an opportunity for the artist to position himself within the context of international Surrealism; it also gave him a forum to convey his growing interest in astronomy. Probably at Levy's prompting, he began a work that summer, lining a shallow wooden box with now-faded cobalt blue silk and dividing it into compartments with sheets of glass (fig. 2.1). Into it went strange little objects: an egg in a wineglass, a gold doll's head, a white clay pipe, transparent flat glass disks, and hanging white cylinders. Dominating the background was a map of the Moon, positioned to suggest a large lunar bubble blown from the clay pipe below. Cornell titled it *Soap Bubble Set*, later describing the work's seminal importance as "a real 'first-born' of the type of case that was to become my accepted milieu."[2] And it was. It was his first object to be sold to a public collection, the first to be reproduced in a book, and the first of many astronomy-inspired soap bubble sets that followed over the next three decades.[3]

Cornell designed his contribution to the Museum of Modern Art exhibition with care, choosing objects with multivalent meanings to make a work that could hold its own among nearly seven hundred examples of avant-garde European and American modern art. To have something more impressive than the glass globes, small cardboard boxes, and cut-and-paste collages in the manner of Ernst he had produced up to this point, during the summer of 1936 he took a finely crafted wooden box with inset brass handles, filled it with objects, and designed a context for it.[4] He must have worked on it right up until the time of the exhibition—it was still unfinished at press time for Barr's catalogue, where it was reproduced as an unboxed arrangement of quirky items in a photograph taken by George Platt Lynes (fig. 2.2).[5]

CHAPTER II

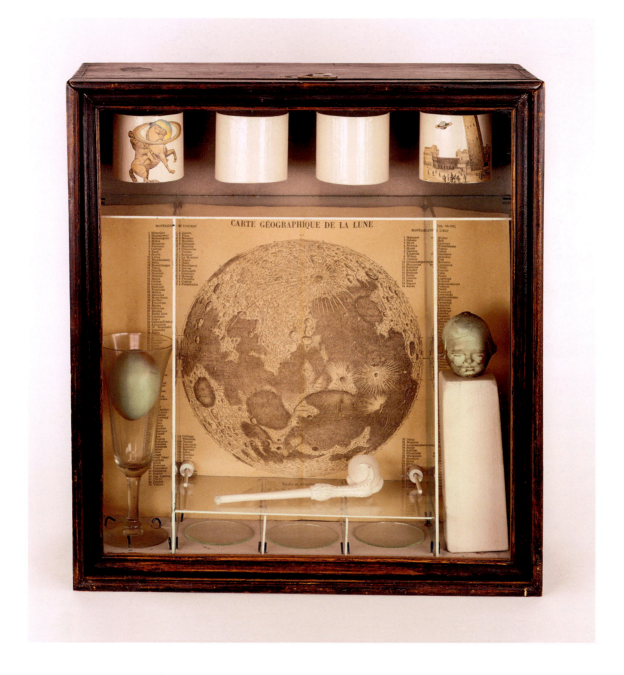

In both the cased *Soap Bubble Set* and the photograph of objects that pre-
ceded it, Cornell relied on things familiar to anyone versed in the stuff of
Surrealism—doll parts, wineglasses, eggs, maps, pipes, and soap bubbles—
already used by such artists as Hans Bellmer, Roy, Miró, and Man Ray. But
these evocative objects also established his awareness of the importance of

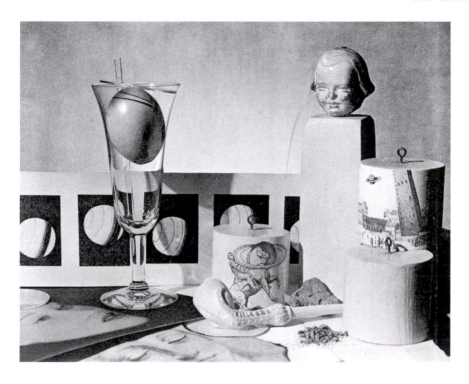

natural science within the context of Surrealism. At the Museum of Modern Art, the *Soap Bubble Set* was placed in a large glass vitrine, which in turn was given the overall title *Elements of Natural Philosophy* (fig. 2.3). There Cornell's *Soap Bubble Set* was paired with a second box, *Cabinet of Natural History (Object),* and additional small objects. The decision to exhibit the *Soap Bubble Set* in the *Elements of Natural Philosophy* vitrine was probably a last-minute one, designed to give Cornell's work greater presence, while also underscoring the centrality of the history of science in his creative process.[6]

Over the course of his life, Cornell never really explained what his soap bubble sets meant, preferring to leave analysis to the viewer. When he exhibited a group of them at the Copley Galleries in Beverly Hills, California, in 1948, his written comments linked astronomy to poetry, metamorphosis, and fantasy:

> Shadow boxes become poetic theatres or settings wherein are metamorphosed the elements of a childhood pastime. The fragile, shimmering globules become the shimmering but more enduring planets—a connotation of moon and tides—the association of water less subtle, as when driftwood pieces make up a proscenium to set off the dazzling white of seafoam and billowy cloud crystallized in a pipe of fancy.[7]

Even though Cornell chose not to articulate exactly why, the soap bubble theme was profoundly important to him. In particular, the first *Soap Bubble*

OPPOSITE PAGE:
FIGURE 2.1.
Joseph Cornell, *Soap Bubble Set,* 1936. Box construction, $15^{3}/_{4} \times 14^{1}/_{4} \times 5^{7}/_{8}$ in. Wadsworth Atheneum Museum of Art, Hartford, CT. Purchased through the gift of Henry and Walter Keney.

FIGURE 2.2.
Joseph Cornell, *Soap Bubble Set,* as reproduced in Alfred H. Barr, Jr., *Fantastic Art, Dada, Surrealism* (New York: Museum of Modern Art, 1936), no. 309. Photograph by George Platt Lynes. © Estate of George Platt Lynes.

29

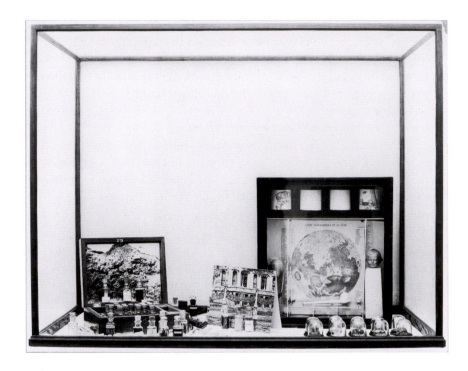

Set seems so charged with elusive meaning that scholars have tried to explain it either as autobiography, with objects representing his family, or as a vague cosmic reverie.[8] But the work is much more. Cornell placed objects in a shallow box to cross-index such apparently incompatible subjects as bubbles and astrophysics, with chance encounters between unlikely things creating a densely layered essay about scientific inquiry, from Galileo's study of the Moon to exciting new theories of an expanding universe.

CENTERS OF GRAVITY AND SATURN'S RINGS

Like Sir Isaac Newton before him, Cornell was fascinated by bubbles. Newton learned about bubbles through direct observation, and by studying their prismatic optics he refined his thoughts about the refraction of light. Cornell learned about bubbles from nineteenth-century books for children and young adults that explained the wonders of the natural world. Typical volumes in his library were *La Science Amusante*, by "Tom Tit" [Arthur Good], as well as two books about bubbles by the esteemed physicist Charles Vernon Boys.[9] In fact, Boys's volumes may have planted the seed for Cornell's union of bubbles and astronomy when the author lightheartedly cautioned his readers that, although bubbles look like planetary bodies, especially the Moon and Saturn,

the forces determining their shapes are unrelated. Also in Cornell's library were adult books about the natural world, including an English-language edition of Amédée Guillemin's comprehensive *Les Phénomènes de la physique*, translated in 1873 as *The Forces of Nature*. Although Cornell left Guillemin's book intact, he clipped and ripped identical illustrations from old schoolboy science texts as the core of copious source material files illustrating principles of physics that formed the conceptual framework for his 1936 *Soap Bubble Set*.[10] Foremost among these principles was gravity.

In his "Astronomy" file, along with portraits of Copernicus and Galileo, he saved a picture of Newton contemplating an apple, torn from Flammarion's *Astronomie Populaire* (see fig. 1.9), and he added explanations of different aspects of gravitation to his "Nat. Phil." file. From William B. Peck's *Introductory Course of Natural Philosophy for the Use of High Schools and Academies*, first published in 1860, he ripped a summary of Newton's law of universal gravitation,[11] which explains the mutual attraction of bodies toward one another as the result of the relationship between their mass and distance.[12] Peck used the Moon, so prominent a feature in the *Soap Bubble Set*, to illustrate Newton's law, explaining how Earth's gravitational pull determines the lunar orbit. From Cornell's own observations and from reading Boys's *Soap Bubbles and the Forces Which Mould Them*, he realized that a bubble could resemble the Moon, and, following Newton, he knew that even though both seem to float in space, bubbles are subject to the same laws of gravity that attract the Moon to Earth.

Cornell also tore out many pictures of familiar objects used to explain the concept of the center of gravity, the single point in a given body through which the direction of its weight passes (fig. 2.4). In *The Forces of Nature*, Guillemin illustrated the center of gravity by using an egg-shaped ellipsoid to show the vertical line passing through the point of support, recalling the *Soap Bubble Set* egg in the catalogue photograph and finished box. In text directly above the ellipsoid, Guillemin observed that the leaning towers of Pisa and Bologna offered unusual architectural examples of the center of gravity, a fact that was commonly cited in physics texts of the period and illustrated with engravings of the round Leaning Tower of Pisa and the square Leaning Tower of Bologna. Cornell cut prints of these towers from several different textbooks for his natural philosophy and other files.[13] He painstakingly trimmed one of them, keeping the square tower and clouds, and added a small planet Saturn when mounting it on the cylinder found in the upper right corner of the *Soap Bubble Set*.

Cornell's meditation on gravity continues in other parts of the box. In the upper left corner, he positioned a hanging cylinder decorated with an illustration of a man on a walking horse. Set at an angle to make the horse appear rearing, it was no doubt inspired by a page Cornell tore from a physics book and marked with "X"s. The text explains how the center of gravity of a

prancing-horse toy is kept at the point of support through the use of a counterweight. Cornell was interested enough in this concept that he clipped illustrations of several similar balancing toys.[14] On the cylinder, over and around the horse's neck, he superimposed the rings of Saturn, adding a gleaming blue and gold planetary body behind the horse's head. By combining images of Saturn with pictures illustrating centers of gravity, he cross-referenced a scientist whom he admired throughout his life: the physicist, astronomer, and natural philosopher Galileo.

Many of the books that Cornell collected or cannibalized over the years contain passages explaining Galileo's contributions to understanding the physical universe, especially citing his treatise on the center of gravity. These books also pointed out that Galileo made important discoveries about Saturn. In 1610 he became the first person to observe the planet's rings with a telescope, and in 1612 he noted a phenomenon called a "ring plane crossing," when Earth aligns exactly with Saturn's rings, visually reducing them to one thin line on Saturn's surface. To the delight of astronomers who linked it to Galileo's observations, a ring plane crossing occurred in June 1936.[15] By pairing the leaning tower and rearing horse illustrating the center of gravity with the planet Saturn on the cylinders, Cornell neatly summarized some of Galileo's most important discoveries in ways that were especially relevant in 1936. The rings of Saturn also made another appearance in Cornell's soap bubble universe. Behind the *Soap Bubble Set*'s objects in the photograph that appeared in Barr's catalogue for the Fantastic Art, Dada, Surrealism exhibition is a horizontal series of circular forms against a dark background. Arranged in varying heights as if to suggest

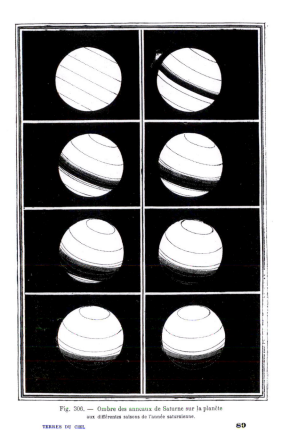

Fig. 306. — Ombre des anneaux de Saturne sur la planète
aux différentes saisons de l'année saturnienne.

TERRES DU CIEL 89

bubbles blown from the pipe, these circles actually represent shadows of the rings of Saturn falling on the surface of the planet at various seasons of the year, as originally illustrated in Flammarion's *Les Terres du ciel* (fig. 2.5).

In an odd twist that Cornell visually cross-indexed in the *Soap Bubble Set*, scientists directly related Saturn's rings to bubbles. During the 1840s the Belgian physicist Joseph Plateau made bubbles from a mixture of commercial soap, glycerin, and oil, manipulating their shape and longevity to demonstrate how spinning drops of liquid could generate separate circular rings—Cornell tore a page from a book describing Plateau's experiment for his "Nat. Phil." clipping file.[16] Plateau's experiments stimulated further research. James Clerk Maxwell used Plateau's "platonic suds" as a young mathematics student at Cambridge University to analyze Saturn's rings and later, as an esteemed mathematical physicist, to study microphysical energy distribution.[17] Special devices were needed to examine and demonstrate the properties of bubbles. In the early 1830s Plateau invented a "phenakistiscope," used to show successive images of bubbles changing form when disks were spun, and, in the 1860s Maxwell used a precinematic "wheel of life" to demonstrate his work on vortex rings,

FIGURE 2.5.
Ombre des anneaux de Saturne sur la planète, in Camille Flammarion, *Les Terres du ciel* (Paris: C. Marpon et E. Flammarion, 1884).

33

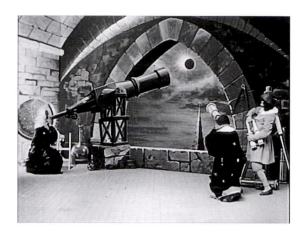

FIGURE 2.6.
Georges Méliès, film still
from *The Eclipse (The
Courtship of the Sun and
Moon)*, 1907.

like those of Saturn.[18] The British physicist and chemist Michael Faraday elaborated on Plateau's experiments by using bubbles to demonstrate, among other things, the magnetic behavior of gases, commenting, "We have a perfect right to take toys and make them into philosophy, inasmuch as nowadays we are turning philosophy into toys."[19]

GALILEO'S TELESCOPE

Throughout his life, Cornell was fascinated by the idea of "philosophical toys," those nineteenth-century constructions designed to teach as well as delight. With moving parts and miniature worlds, his own works suggested the idea of grown-up play from the outset, and Levy marketed Cornell's constructions as "jouets surréalistes" and "toys for adults." Cornell alluded to scientific play in his *Soap Bubble Set*, whose title suggests toys he might have known as a child or encountered in flea markets, but he also drew on more serious notions of play as a method of generating unexpected associations. Despite the suggestion of a child's game, the *Soap Bubble Set* is not particularly childlike. Instead, it harnesses the metaphors of scientific play for larger purposes.

By the early twentieth century, the thought that astronomy could be equated with play was clearly established in the public mind. The groundwork had been laid by popular art, through the protosurrealist films by Georges Méliès, many of which Cornell knew and owned. Méliès' well-known *Le Voyage dans la lune* of 1902, which was shown in the Fantastic Art, Dada, Surrealism exhibition's film program, combines science and slapstick when a group of goofy scientists take a rocket to the Moon, encounter ferocious Moon-men, and flee back to Earth. In other Méliès films, such as *L'Eclipse du soleil en pleine lune* of 1907, released to English-speaking audiences as *The Eclipse*

(The Courtship of the Sun and Moon), astronomers are not modern investigators. They are medieval alchemists whose experiments are tinged with tomfoolery when the amorous conjunction of the Sun and Moon is humorously presented (fig. 2.6).[20] For Méliès, science offered an excuse for play, and the historical and geographical distance that he established allowed him room to mock the scientific method with his cinematic tricks.

In the 1920s and 1930s, parodying science was a firmly established creative practice among Dada and Surrealist artists. For instance, the title of one of Ernst's Dada works listed in the Fantastic Art, Dada, Surrealism exhibition catalogue—*1 copper plate 1 zinc plate 1 rubber towel 2 calipers 1 drain telescope 1 roaring man*—sounds like a laboratory checklist gone amuck, and Duchamp's inventive creation of anatomical analogies for the laws and procedures of modern science underlies complex works like his *Large Glass*.[21] However, unlike Ernst and Duchamp, Cornell was not interested in parody. In his *Soap Bubble Set*, in place of humor he substituted homage, especially to the father of modern astronomy.

Just as the Moon is at the center of Cornell's collage, the Moon was at the center of Galileo's observations. Galileo published drawings of the Moon as observed through his telescope in his *Sidereus Nuncius* [the Starry or Sidereal Messenger] of 1610 (fig. 2.7), whose dissemination was a milestone in the history of astronomy. In it, Galileo described the Moon as few had seen it before, explained the principle of moonlight, identified the moons of Jupiter, and supported the Copernican assertion that the planets revolve around the Sun. While all of these aspects of Galileo's discoveries are important for Cornell's *Soap Bubble Set*, it is especially significant that in *Sidereus Nuncius* Galileo observed that the Moon was not smooth, as had been previously thought, but had mountains and valleys like those on Earth. He even calculated the height of one of the Moon's mountains.

The illustration that Cornell placed at the back of his box was not just any picture of the Moon. It was a nineteenth-century map of the mountains of the Moon taken from Flammarion's *Astronomie Populaire*, an example of the kind of mapping that Galileo had pioneered with his twenty-power telescope, although updated with such features as the famous crater at the top, named for the sixteenth-century Danish astronomer Tycho Brahe.[22] Detailed photographs of the Moon had been produced as early as 1851, and many of Cornell's late-nineteenth-century astronomy books reproduced them, but the engraved map evoked the direct touch of an artist's hand, approximating the look of Galileo's drawings.[23] By featuring this map of the mountains of the Moon, Cornell paid tribute to Galileo's use of the telescope to make astronomical discoveries. And, by framing an enlarged Moon in glass, Cornell offered a telescopic experience in his *Soap Bubble Set*, presenting the Moon as Galileo observed it in 1610, with the round glass disks at the bottom of the box perhaps even alluding to

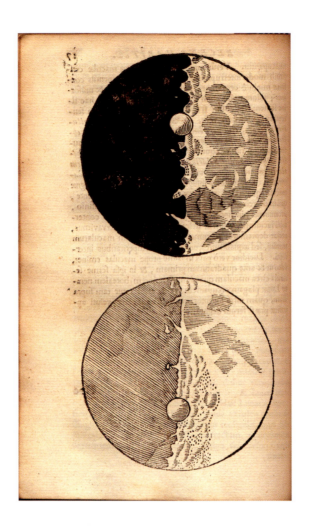

FIGURE 2.7.
Woodcut engravings of the moon after drawings by Galileo, first published in *Sidereus Nuncius*, 1610; as illustrated in *Petri Gassendi Institutio astronomica* (London: Jacobi Flesher, 1653), 19. Courtesy Rare Books and Manuscripts, Special Collections, Middlebury College Library.

telescope lenses. These were not esoteric references; rather, they echoed information available to the general public through exhibits at the newly opened Hayden Planetarium, whose inaugural displays in 1935 included an enlarged back-lit transparency of the Moon and exhibits of old and new telescopes, including a model of Galileo's instrument (fig. 2.8).

Cornell's interest in scientific apparatus was astute. The history of science is also a history of technology, and proper instrumentation, as Galileo demonstrated, is essential for making discoveries. From the passages about Galileo's telescope the artist marked in his books, he seems to have been aware of this. As scholars have noted, many of Cornell's box constructions have uncanny similarities to nineteenth-century scientific apparatus used in classrooms to teach the principles of physics and chemistry or exhibited in museums to educate the public.[24] In conceiving his *Soap Bubble Set*, Cornell may even have stumbled across a set of calibrated specific gravity beads, originally used in

TELESCOPES—MODERN AND ANCIENT
Model of Galileo's telescope. This famous Italian astronomer constructed in 1609 the first telescope ever used astronomically. The most powerful of his several crude instruments magnified only about thirty times. Yet he discovered with them the four large moons of Jupiter, the sun-spots, the mountains and craters on the moon, and he was first to see Venus as a waxing and waning crescent. The great 40-inch refractor of the Yerkes Observatory is shown in the transparency in the background

TRANSPARENCY OF MOON IN GIBBOUS PHASE
A telescopic view of this nearest neighbor of the earth reveals an impressive array of mountains, craters, valleys, and smooth plains formerly called seas. These features are beautifully shown in the large transparency, made from a photograph taken at Mt. Wilson Observatory

the mid-eighteenth century for testing the specific gravity of acids and alkalis (fig. 2.9). Also known as "philosophical bubbles," the delicate, hand-blown glass balls were carefully protected in beautiful wooden boxes, usually lined with silk or velvet.[25]

The items in Cornell's *Soap Bubble Set* and their presentation in a box resemble the instruments pictured in nineteenth-century engravings in the physics and natural philosophy books that he cut up for his source files. These are the tools of both the scientist and the artist, Cornell reminds us, instruments that, in the hands of such men as Galileo and Newton, led to remarkable insights and, in the hands of Surrealists, could spark unexpected associations and poetic dreams.

FIGURE 2.8. *Telescopes—Modern and Ancient and Transparency of Moon in Gibbous Phase*, in *The Hayden Planetarium* (New York: American Museum of Natural History, 1937), 53. © American Museum of Natural History.

A SOAP BUBBLE UNIVERSE

Cornell did not base his *Soap Bubble Set* simply on nostalgia for science of the past. With its map of the Moon positioned against what was originally a celestial blue silk background, he linked soap bubbles to the cosmos, a connection that might seem surprising today but would have made absolute sense to viewers in the 1930s, when soap bubbles were important metaphors for exciting new ideas about the expanding universe.[26] Building on Albert Einstein's discoveries, in 1927 the Belgian mathematician and Jesuit priest Georges-Henri Lemaître demonstrated mathematically that the universe is rapidly expanding, as Lemaître explained it, like a giant soap bubble, proposing what physicist

FIGURE 2.9.
Specific Gravity Beads, manufactured by Angelo and/or Isabella Lovi, Glasgow, c. 1805. Wooden box lined with silk, containing blown-glass balls and whalebone slide rule, 6⅘ × 4 × 1⅖ in. Scientific Instrument Collection, Middlebury College Department of Physics.

George Gamow much later dubbed the "Big Bang" theory. In 1929 the young astronomer Edwin Hubble confirmed Lemaître's findings through observations of distant spiral nebulae.

Throughout the 1930s the metaphor of a cosmic soap bubble was used in the popular press to describe the expanding universe. For instance, in an article published in 1932, the *New York Times* pictured Einstein and Lemaître as modern heirs to Newton and Galileo, with the caption beneath Lemaître stating, "Universe Expands Like Soap Bubble, Receding Outer Nebulae Prove It" (fig. 2.10).[27] Research at the Mount Wilson Observatory in California was explained in the *Christian Science Monitor* in the spring of 1936 as "intimately related to the picture which astronomers are drawing of the universe as a giant soap bubble."[28] Less than two weeks before Cornell's *Soap Bubble Set* was exhibited at the Museum of Modern Art, appearing in the *New York Times* was an article entitled "Expands Like Soap Bubble," which began, "There are an infinite number of possible universes. . . . The generally accepted universe of today is the Abbé Lemaitre's, which is dynamic. In other words, it is expanding like a soap bubble."[29]

The philosophical implications of the new cosmology were also considered. As the author of yet another article in the *Times* noted, "It is asking a

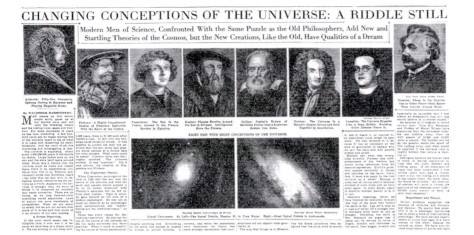

FIGURE 2.10.
"Changing Conceptions of the Universe: A Riddle Still," *New York Times*, April 17, 1932. Courtesy of the Observatories of the Carnegie Institution of Washington.

good deal of an ordinary man to believe that light falls to a large body as a stone falls to the earth, that the universe is expanding like a soap-bubble." The writer continued, "The scientific crisis of today may not rock the religion of men, as it did in Galileo's time, but it is assuredly changing the picture of the world and thus affecting the beliefs that sway poets, artists, thinkers—the leaders of the spirit."[30] Surely Cornell was one of those artists. Just as the general public would have been aware of the cosmic soap bubble as a metaphor for an expanding universe in the 1930s, so too would they have admired, as Cornell did in his first *Soap Bubble Set*, the debt modern physicists owe to their forebears.[31]

In Cornell's copy of Gottfried Honegger and Peter Van Kamp's book, *Space, the Architecture of the Universe*, which he acquired at least a quarter century after he made his first *Soap Bubble Set*, a loose page can be found inside the book's front cover. It features a portrait of Galileo with this passage:

> For Galileo Galilei, the highest principle of research was the unconditional liberty of the use of human reason. Thus he paved the way for the revolution of the natural sciences. This victory of reason over fear permitted the astronomer to replace the astrologer and the metaphysician. "Quando potrò io finir di stupine?" asked Galileo. "When will I stop wondering and start to know?"[32]

Perhaps asking that same question, the elderly Cornell removed this page and inserted it at the front of the book. And perhaps, as a much younger man, he read these lines in his copy of Guillemin's *The Forces of Nature*:

> To those who know how to observe, Nature has a magnificence which the skill of the most ingenious experimenter can never approach. That which makes the merit of the inquirer is not so much to reproduce her—to

multiply the phenomena, the pictures of which she shows us—as by dint of patience, sagacity, and genius to discover the reasons of things, and the laws of their manifestations. From this point of view, natural philosophy is one of the grandest studies which the human mind can pursue.[33]

ELEMENTS OF NATURAL PHILOSOPHY

In 1936 Cornell exhibited the *Soap Bubble Set* along with his *Cabinet of Natural History (Object)* in a large glass vitrine, and he titled the whole grouping *Elements of Natural Philosophy*. The term "natural philosophy" originated in the late fourteenth century but assumed the meaning that Cornell applied to it only in the seventeenth century, when it referred to what we now think of as the study of physics. Natural philosophy was a search for general explanations, as shown through research and observation, and Galileo, Newton, and Francis Bacon, among others, were all early natural philosophers. In particular, Bacon attempted to create a system for organizing and classifying all knowledge, published in 1623 as *De Augmentis Scientiarum* [The Advancement of Learning], in which he differentiated between natural philosophy, which was the search for explanations for the workings of nature, and natural history, which was the collection and classification of data in a systematic manner. In other words, natural history supplied the facts; natural philosophy proposed explanations on the basis of those facts.

By the early twentieth century, Bacon's contributions were well-known, summarized, for example, in books like Walter Libby's *An Introduction to the History of Science*, published in 1917 and in the library of Phillips Academy in Andover, where Cornell enrolled that year. Cornell could have encountered the idea of the classification of sciences as a student. In his general science class, students studied "some half-dozen of the greater doctrines of natural science . . . approached from the cultural rather than the technical side, with especial attention, on the one hand, to their historical development, and on the other, to their relation to every-day phenomena."[34] A copy of Bacon's *De Augmentis Scientiarum* was in Cornell's library at his death, and his admiration for Bacon's classification of the sciences was evident in material form in at least one later assemblage box: he covered the inside top of a lunar box, *Untitled (Phases de la lune)* (see fig. 6.18), made about 1957–59, with two pages of Latin text taken from a copy of Bacon's book.[35]

In Cornell's *Elements of Natural Philosophy* vitrine, he drew a Baconian distinction between natural philosophy, with its overarching search for underlying principles, and natural history, with its emphasis on the collection of data, all presented in the Surrealist idiom of irrational associations and unlikely juxtapositions. The *Cabinet of Natural History (Object)* (fig. 2.11) is embellished with two nineteenth-century photographs, one showing a jungle

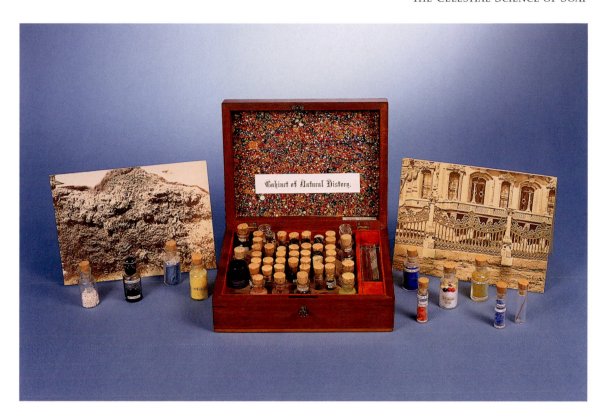

waterfall and the other featuring Sultan Abdul-Mecid I's Dolmabahçe Palace in Istanbul. Inside this box, as well as in front of and beside it, are cork-topped bottles and tubes with labels that refer to natural phenomena. Bottles are devoted to pockmarked rainbows (colored balls of cotton are labeled "Arc-en-ciel grêle"), the temperature of hibernating birds (there are feathers in a bottle labeled "Température des oiseaux hibernants"), and the spectral analysis of a frog in mild weather (a bright green bottle is labeled "Analyse spectral de la grenouille dans les temps calme"), as well as imaginary historical findings, including a bottle with dark gray powder purportedly containing dust from a falling star gathered on a ship by Edgar Allan Poe in 1827.[36]

At the left of the *Elements of Natural Philosophy* vitrine, the *Cabinet of Natural History* is a collection of surreal natural history "data" about optics, biology, and astronomy, while the *Soap Bubble Set* box at the right pays homage to two of natural philosophy's most important synthesizers of data, Galileo and Newton. Thus Cornell's *Elements of Natural Philosophy* demonstrates the marvelous capacity of the human mind to understand the natural world, a concept underscored by the disembodied doll's head placed in a position of honor on a pedestal in the *Soap Bubble Set*. Among the little bottles in the *Cabinet of Natural History (Object)* is one that contains shards of broken

glass. Its label, "Méthode de M. Duchomp," reminds us of another synthesizer. Cornell found an important role model in the sophisticated Frenchman Duchamp, whose penchant for punning with objects Cornell bitingly acknowledged with his "Duchomp" small glass.

Cornell paid further tribute to Duchamp in a "book object," probably made between 1933 and the mid-1940s. As Cornell specialist Lynda Roscoe Hartigan has explained in detail, taking the twenty-second volume of the *Journal d'Agriculture Pratique et Journal de l'Agriculture*, published in 1911, Cornell transformed the book by adding collage, drawings, inserted elements, and overlays and making other alterations.[37] Beneath a reproduction of the *Mona Lisa* embellished with such items as cutouts of French perfume bottles is a photograph of Duchamp superimposed on the book's illustration of a nineteenth-century electrical garden pump.[38] Cornell also inscribed the word "Mariée" in the lower left corner, alluding to Duchamp's *Large Glass*. Immediately after the title page of *Journal d'Agriculture*, Cornell inserted the dedication page from Flammarion's *Astronomie Populaire*: "Aux Génies Immortels de Copernic, Galilée, Képler, Newton Qui Ont Ouvert à l'Humanité Les Routes de L'Infini" [To the Immortal Geniuses of Copernicus, Galileo, Kepler, Newton Who Have Opened to Humanity the Routes of the Infinite]. Thus Cornell's scientific investigators included not only the natural philosophers of the past, but also modern artists, who likewise sought ways to open new paths to the infinite mysteries of creation.

SCIENCE, SPIRIT, SELF

Cornell was attracted to the metaphors of childhood and science as gateways to the world of the imagination. Drawing on his roots in Surrealism, throughout his career he sought ways to re-create the realm of the dream in his waking life. As a young man, he realized the importance of the visionary condition, and he used unexpected combinations of objects to suggest alternate states of mind. In the first *Soap Bubble Set*, he created a strange, hermetic inner space by alluding to the mysteries of outer space, and in his later soap bubble sets, science and surrealism join forces to suggest what he called "metaphysical ephemera," with substantial objects acting as conduits to transcendent dreams. To explore the realm of the dream, he had a skilled guide: the French Romantic writer, Gérard de Nerval.

"The dream is a second life," wrote Nerval in 1854, opening his strange, confessional novel, *Aurélia*. Much admired by Surrealists, Nerval was an important forebear for Cornell, not only as a writer who brought dreams to life, but also as one who found a key to the spiritual in science.[39] Nerval was one of Cornell's favorite authors: there are hundreds of references to Nerval in

his diaries, and he frequently used the adjective "aurélian" to encapsulate the mystery of revelations that came unexpectedly to him. Cornell was familiar with all of Nerval's literary productions, but it was *Aurélia* that resonated most powerfully, with its descriptions of the mental world of the narrator, whose ascent to visionary spirituality results from his descent into madness, all triggered by his "amour fou" for a woman named Aurélia.

Modern scholars agree that Nerval based *Aurélia* on his own experience with insanity fueled by his infatuation with the actress Jenny Colon—a stage-door obsession that Cornell certainly understood. Indeed, it is possible that Cornell's practice of developing crushes on actresses, about whom he constructed works of art and gathered materials in "dossiers," derived, in part, from Nerval's example. However, Nerval's story goes far beyond Cornell's gentle collage boxes for Lauren Bacall or Marilyn Monroe. In what one literary critic has termed "one of the most horrifying accounts of madness in all of literature," Nerval recounts the hallucinatory world of the narrator, a sublime state in which science—especially astronomy—and religion unite in apocalyptic splendor.[40]

Throughout the novel, Nerval uses astronomical references to chart the narrator's transition from rationality to a tormented dream world: the sight of a star predicts the place of his reunification with Aurélia; a celestial vision convinces him that his soul will leave his body; he is transported to a dark planet; on the brink of his suicide the stars are extinguished, the Sun turns black, and several Moons appear. When the narrator is institutionalized, he believes that his fellow inmates have the power to regulate the motion of the Sun and that he can control the Moon. Convinced that the Moon is the refuge of souls who are working toward the regeneration of the universe, Nerval's narrator begins to see spiritual meaning in the data of natural history, finding "hitherto-unrecognized harmonious patterns" in the configuration of pebbles, in the indentations of leaves, and in colors, odors, and sounds. Nerval's is an animate universe, and science vies with spirit to explain the meaning of existence. Nerval uses the metaphor of a bubble to express his fear that life is finite, asking, "Is my soul an indestructible molecule, a little globule inflated by a bit of air but destined to regain its place in nature, or is it that perfect emptiness, the image of nothingness, which will disappear into infinity?"[41]

In the first *Soap Bubble Set*, as is the case in virtually all of his works, Cornell produced a modernist reliquary for an idea, gathering significant objects with associations to science and surrealism and placing them in a special box, made precious with its beautiful silk lining. The eccentricity of Cornell's creative process, and particularly his chosen mode of presenting personal found objects in rarefied boxes—his "accepted milieu," as he put it—became his trademark. While other Surrealists used collage and created poetic objects, the box format, with the attendant aura it confers on the objects, was unique to

Cornell. Or nearly so. It can also be found in Nerval's *Aurélia*. In a passage that must have had extraordinary reverberations for Cornell, Nerval described the creation of a monument to his unrequited love:

> In a small box which had belonged to *her*, I had kept her last letter. In fact, I must confess that I had made of this box a sort of reliquary, keeping in it souvenirs from long trips during which thoughts of her had been always with me: a rose picked in the gardens of Schoubrah, a piece of mummy-wrapping brought back from Egypt, some laurel leaves gathered along the river Beyrouth, two gilded-glass miniatures of the mosaics of St. Sophia, a rosary bead, some other things . . . and finally, the piece of paper I had been given, the day her grave was being dug, to help me locate it.[42]

With words, Nerval constructs a Cornell box, filled with incongruous objects that resonate with each other as home-made fetishes designed to construct a history that never was, except in the mind of the maker. Nerval creates a collection of items that become the real objects of his affection, just as Cornell does with his boxes and dossiers devoted to film stars like Bacall, artists like Duchamp, and ideas like Galileo's mapping of the Moon. "I blushed," Nerval writes, "as I spread this crazy collection out before me."[43] Cornell seems never to have shared that blush; rather, he found great creative purpose in collecting source materials and assigning, cross-indexing, and arranging objects for his works.

Cornell's fascination with Nerval and the fetishistic reliquary box leads to yet another level of meaning in the *Soap Bubble Set*: a level of spirituality. In *Aurélia*, Nerval describes an animate universe, in which all beings are linked to the cosmos: "Captive for the time being on the earth, I am in touch with the sun, the moon and the stars, who share in my joys and my sorrows."[44] This animate vision of the cosmos was not Nerval's alone. Indeed, it was shared by two other figures who were guides for Cornell in the 1930s: the poet, painter, and lampshade maker Mina Loy, and the founder of Christian Science, Mary Baker Eddy. Both functioned as important spiritual mentors for Cornell, although in very different ways.

Mina Loy, the mother of Julien Levy's wife, Joella, was a kindred spirit for Cornell, beginning with her first exhibition at Levy's gallery in January 1933, directly following Cornell's one-man debut the previous December. Her works included paintings of the Moon, and a poem, "Apology of Genius," was printed on the announcement, although it was given the title of another poem, "Lunar Baedeker."[45] The exhibition profoundly affected Cornell, who wrote to Loy in 1946 that the celestial blue backgrounds of her paintings made such "indelible impressions" that they stayed with him for a decade.[46] Cornell acknowledged his acquaintance with Loy in 1936 when he created a "daguerreotype object" of her, inserting a photograph portrait by Man Ray against a starry field of glittering shards of glass (fig. 2.12). Inscribed on the back are lines from "Apology of Genius," which Cornell, following Levy's lead, misattributed to

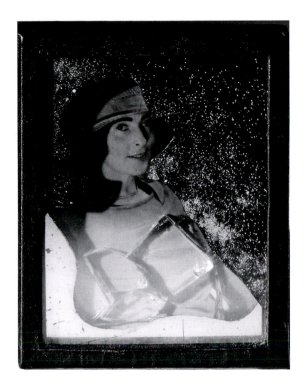

FIGURE 2.12.
Joseph Cornell,
*"Imperious Jewelry of the
Universe" (Lunar
Baedecker): Portrait of
Mina Loy (Daguerreotype
Object)*, 1936. Assemblage,
$5\frac{1}{2} \times 4\frac{1}{2} \times \frac{7}{8}$ in.
Philadelphia Museum of
Art, The Lynne and
Harold Honickman Gift of
the Julien Levy Collection,
2001–62–3.

"Lunar Baedeker." Both of Loy's poems use the Moon as images of spiritual longing and human decay. "Apology of Genius" opens:

> Lepers of the moon
> all magically diseased
> we come among you
> innocent
> of our luminous sores. . . .[47]

This rich lunar imagery is also apparent in the poem "Lunar Baedeker," which concludes:

> And "Immortality" mildews. . .
> in the museums of the moon
> "Nocturnal cyclops"
> "Crystal concubine"
> — — — — — —
>
> Pocked with personification
> the fossil virgin of the skies
> waxes and wanes — — — —.[48]

Encased in the *Soap Bubble Set*'s wooden box or exhibition vitrine, Cornell's own museum of the Moon was also a lunar Baedeker, a map of the Moon with

45

other relevant objects, like a doll's head, to guide us to the fossil virgin of the skies.

Loy was a woman sure to earn Cornell's admiration. When he made her acquaintance, she lived in Paris, where she, like Breton, haunted flea markets for inspiration. During the 1920s she used her finds to make objects, especially lamp bases and shades, which she sold in a shop backed financially by wealthy American art collector and entrepreneur Peggy Guggenheim. Loy's opalescent paper lampshades sometimes took the form of illuminated globes she called *mappemondes* and *globes célestes*, made from antique maps of the Earth and sky. Marketed as "L'Ombre féerique," Loy's map globes and other star-shaped lamps, in the words of her biographer Carolyn Burke, "evoked the enchantments of childhood—the ephemeral charm of the kaleidoscope or magic lantern."[49] Whether Cornell ever saw any of Loy's celestial globes is not known; if he had, it is easy to imagine his admiration for them. He continued to equate Loy with the Moon as late as 1951, when he wrote to her in a letter, "I could not help but think of you, looking up at the moon, when the first rays of the sun turn its gold into silver. A long time ago, you may remember, you told me that your destiny was ravelled up somehow with the lunar globe."[50]

Cornell's immediate attraction to Loy must have derived from their common interest in cosmic poetic imagery and flea market finds. Their enduring friendship, though, owed in large part to their shared identities as Christian Scientists. Loy adopted Christian Science in 1909; Cornell joined the church around 1925. Loy sought to heal her daughter Joella's polio; Cornell hoped for a cure for his own ills and his brother Robert's cerebral palsy.[51] Both found Christian Science's doctrine of the ultimate reality of the Divine Mind compatible with their own views of the power of human consciousness to surpass the limitations of the material world. For both, astronomy was an important metaphor for spiritual expansion. In her long, largely autobiographical poem "Anglo-Mongrels and the Rose," Loy presents herself as "Ova," who has a mystical vision of infinite space.[52] Perhaps Loy's cosmic imagery of Moon and egg undergirds Cornell's *Soap Bubble Set*, as well as her Christian Scientist's sense of the limitless, animate universe of the metaphysical Mind. If Loy's poetry did inspire Cornell, it was probably because of its basis in the writings of the founder of Christian Science.

Eggs, the Moon, bubbles, the mind, natural history, the history of astronomy, and the infinite cosmos—all these ideas are present in Eddy's explanations of Christian Science. Formulating her ideas during the great age of natural history research in the United States, in *Science and Health with Key to the Scriptures* Eddy frequently presented metaphysical religious concepts in a dialogue with natural philosophy. Critiquing Harvard University natural philosopher Louis Agassiz's microscopic examination of an egg, Eddy acknowledged, "Agassiz was able to see in the egg the earth's atmosphere, the gathering clouds, the moon and stars, while the germinating speck of so-called

embryonic life seemed a small sun."[53] Eddy, however, disagreed vehemently with Agassiz's notion that life begins with the formation of the nucleus in the egg, lamenting, "If this be so, whence cometh Life, or Mind to the human race? . . . If Life is God, as the Scriptures imply, then Life is not embryonic, it is infinite. An egg is an impossible enclosure for Deity."[54]

Throughout her writings, Eddy makes an impassioned argument that the Mind, or God, is divine Truth, and that matter is an illusion. Relying on traditional *vanitas* associations of bubbles with the brevity of life, she proclaims that Christ can "burst the bubbles of earth with a breath of heaven."[55] For an artist whose chosen form of expression was the glass-fronted box, Eddy's explanation of the presence of God would be especially meaningful: "The manifestation of God through mortals is as light passing through a window pane. The light and the glass never mingle, but as matter, the glass is less opaque than the walls. The mortal mind through which Truth appears most vividly is that one which has lost much materiality—much error—in order to become a better transparency for Truth."[56]

In her *Miscellaneous Writings*, Eddy posits gravity as an example of divine Principle. She observes,

> A falling apple suggested to Newton more than the simple fact, cognized by the senses, to which it seemed to fall by reason of its own ponderosity; but the primal cause, or Mind-force, invisible to material sense, lay concealed in the treasure-trove of Science. True, Newton named it gravitation, having learned so much; but Science, demanding more, pushes the question: Whence or what is the power back of gravitation,—the intelligence that manifests power?[57]

If Cornell did intend to allude to Christian Science in his *Soap Bubble Set*, his allusions were veiled. Conveniently, the objects he chose—the egg, the doll's head, the Moon map, the glass-fronted box—were multipurpose, also fitting easily into the contexts of science and Surrealism. Still, Cornell did not completely hide his belief in Christian Science. In Levy's recollection of first meeting Cornell, Levy claimed that the artist told him, "I am a Christian Scientist. You wouldn't know that, of course."[58] Cornell was savvy enough to understand that his religion was not entirely compatible with the beliefs of his Surrealist colleagues. How fortunate for Cornell to find a sympathetic art dealer, whose wife and mother-in-law shared his faith in Christian Science. And how serendipitous for Joseph Cornell's spiritual search to have led him to a religion whose central text mirrored his own interests in science and spirit, with a glossary that even included the following entry: "JOSEPH. A corporeal mortal; a higher sense of Truth rebuking moral belief, or error, and showing the immortality and supremacy of Truth; pure affection blessing its enemies."[59]

In "Joseph," the corporeal mortal, a final key may be found to explain why Cornell produced a Surrealist work with such strong associations to natural science for his grand debut at the Museum of Modern Art in 1936. Cornell's gender identity was complex and perhaps confused, with infatuations for unattainable ballerinas and movie stars, questionable obsessions with teenage girls, and firm friendships among the homosexual artistic community of New York. In early works Cornell projected a feminized persona redolent of fairy tales and nursery games (fig. 2.13).[60] However, with its allusions to great scientists, laboratory instruments, and the principles of physics, his *Soap Bubble Set* conveyed a distinctly male identity. Given the negative attitudes of

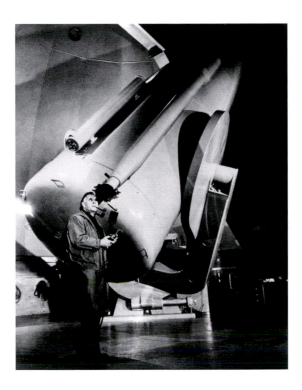

FIGURE 2.14.
Edwin Hubble at the 48″
Schmidt Telescope, Mount
Palomar Observatory,
c. 1947. Photo: American
Institute of Physics, Emilio
Segrè Archives. Repro-
duced by permission of
The Huntington Library,
San Marino, California.

Surrealists—especially Breton—toward the kind of gender uncertainty that Cornell evoked in his self and work, emphasizing the *man* in the Moon was a judicious approach for a young artist who wished to be taken seriously.[61]

The idea that science is mainly the purview of men is a notion that refuses to go away in the popular mind; certainly it was strongly established in the 1930s, when the superstars of astronomy featured in the press were predominately male. To be sure, women could appreciate the wonders of the cosmos (see fig. 2.8), but to the general public it was still men, like the astronomer Hubble (rarely photographed without a pipe in his mouth), whose tireless stargazing led to the magnificent discoveries that reshaped our understanding of the natural world (fig. 2.14).[62] By producing a gloss on old and new findings with his *Soap Bubble Set*, Cornell could implicitly align himself with the great men of science. Many years later, Abstract Expressionist painter Robert Motherwell seemed to position Cornell in the same way, oddly remarking, "You mustn't forget the depth of his deliberateness, nor the masculinity of his method."[63] To Cornell's credit, only a few years after he made his first *Soap Bubble Set* he created an ongoing work that countered the stereotype of the male astronomer. *The Crystal Cage [portrait of Berenice]*, first published in 1943 as an article in *View* magazine and later presented as a dossier with clippings, photographs, and other materials, describes the young astronomer Berenice, a little girl in a pagoda-observatory with her telescope trained on the stars.

Over a decade after he created his first soap bubble set, on January 9, 1947, Cornell wrote the following diary entry:

*Afternoon, setting Sun red ***
through thick branches.
Thoughts about scientific toys
(Civil War <u>Magic Wheel</u> phenakiston)
C.S. thoughts—spirituality of
world of <u>Romance of Natural Philosophy</u>
tie in with new <u>Einstein</u> ones?[64]

In this comment, he weaves the natural world, old scientific toys like Plateau's phenakistiscope, the spiritual basis of natural philosophy, and Einstein, the new master of modern physics, into a single train of thought. It is typical of the creative process that resulted in his *Soap Bubble Set*, which involved attentiveness to the power of memory and nostalgia, facility with the Surrealist language of poetic juxtaposition, familiarity with cutting-edge issues in astronomy, and awareness of the overlapping physical and spiritual worlds. Cross-indexing was key: enabling past and present, art and science, and spirit and self to meet in a little box containing the cosmos.

SOAP BUBBLE SET VARIANTS, 1939–1948

Purchased for the Wadsworth Atheneum's cutting-edge collection of contemporary art in 1938 and displayed there for years, the 1936 *Soap Bubble Set* represented an important signpost in Cornell's artistic development. Throughout his career he would continue to make soap bubble sets, building on ideas introduced in the prototype. He returned to the theme by 1939, making the first of at least three new soap bubble sets, each featuring a clay pipe "blowing" flat glass disks on which he pasted photostat copies of illustrations from science texts. With pictures of shells, coral, crystal, and cellular creatures arranged in dark boxes, at first glance he might seem to have discarded overt references to astronomy in favor of elements of natural history (fig. 2.15). Nevertheless, these objects also had cosmic associations. The dark background was analogous to the vast ocean of space with its island universes; the spiral seashells could recall the spiral nebulae and unfurling universe being studied by scientists like Hubble; and the combination of microscopic and telescopic outlooks paralleled contemporary research that hoped to explain the cosmos by studying the actions of atoms.

Symbols of eternity, seashells had long-standing spiritual associations as metaphors for the empty residue left behind when the soul departs the material body. But they also offered a conceptual link to Newton, who, in a line Cornell later transcribed in his notes, described his scientific pursuits as "only

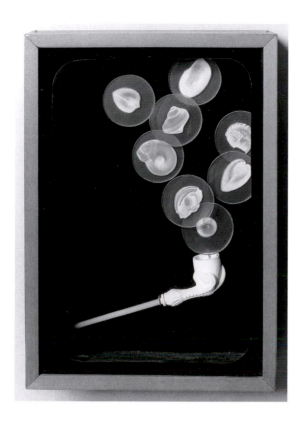

FIGURE 2.15.
Joseph Cornell, *Object
(Soap Bubble Set)*, 1941.
Box construction,
12⅜ × 18¼ × 3¾ in.
The Robert Lehrman
Art Trust, Courtesy of
Aimee & Robert Lehrman,
Washington, DC. Mark
Gulezian/QuickSilver
Photographers.

like a boy, playing on the seashore, and diverting myself in now and then finding a smoother pebble or a prettier shell than ordinary, whilst the great ocean of Truth lay all undiscovered before me."[65] And, surely Cornell knew William Wordsworth's description of Newton as a "voyager through strange seas of thought alone."[66] All of these meanings resonated with Cornell, and as he continued to make soap bubble sets throughout his career, he frequently combined shells with astronomy. In his complex creative universe of cross-indexed meanings, ideas sometimes even circled back to him in strange ways: in 1970 he clipped an illustration from the *Christian Science Monitor* of a seventeenth-century Dutch *vanitas* painting, *Boys Blowing Bubbles*, by Jacob van Oost. With one hand a boy blows a bubble; in the other he holds a shell.[67]

It is commonly noted in the literature on Cornell that he purchased at least some of the clay pipes he used in his soap bubble sets at the Dutch pavilion of the 1939 World's Fair in Flushing Meadows, New York. In addition to shopping, the fair held many other attractions for its more than forty million visitors, and Cornell took full advantage of its myriad offerings. He obtained a souvenir medal from the Christian Science Building, and he saw Dalí's Surrealist *Dream of Venus* pavilion, with its bare-breasted women costumed as mermaids swimming in a tank. He also toured the works of art on view in various settings,

where he could have seen Jean Siméon Chardin's eighteenth-century painting *Soap Bubbles*, on loan from the National Gallery in Washington, DC.

Most compelling for Cornell must have been the fair's emphasis on the wonders of modern science, which offered a counterpart to his fascination for natural philosophy of the past. In particular, he would have marveled at demonstrations of astonishing new advances in astronomy technology. The 1939 World's Fair was officially opened by cosmic ray impulses transmitted by way of the Hayden Planetarium. As a planetarium publication explained, "tiny unseen particles of energy that had been traveling across space for countless yesterdays were harnessed to light up the World of Tomorrow!"[68] The opening ceremonies were indeed impressive. Mercury arc lamps were attached to the upper part of the shaft of the Trylon. As each ray impulse was relayed from the planetarium on a special telephone circuit, the lamps flashed with the light equivalent to 18,000 hundred-watt bulbs while a bell tone sounded a note very low in pitch but loud enough to be heard up to twenty miles away. With the sound of each ray signal, various buildings were lit, and with the tenth and final ray a battery of additional lamps spread out a total of a billion lumens, equivalent to a million hundred-watt light bulbs. Two thousand balloons were let loose, fireworks exploded over Fountain Lake, and an electric carillon played "Joyous Bells." Via the public-address system at the Lagoon of Nations, Einstein himself explained cosmic rays to the dignitaries assembled for the fair's commencement.

Cornell may not have attended the opening-day ceremonies (although he could have heard the bells and seen the lights from his home on nearby Utopia Parkway), but at some point he certainly visited the planetarium's Theater of Time and Space, located along with Dalí's *Dream of Venus* pavilion in the Amusement Zone (fig. 2.16). After waiting in line in a hall displaying an exhibition of watches, chronometers, and chronographs used in the history of navigation and astronomical work, he would have entered the theater and experienced an imaginary voyage through space by watching a film replete with state-of-the-art visual effects. Projected on a forty-four-foot-high dome, the film enabled imaginary cosmic travelers to view celestial wonders through the window of a spaceship. A solar eclipse, a close-up view of the Moon, and a dramatic circuit of a spiral nebula preceded a ride through Saturn's rings. Returning home, participants were privileged to see Earth as it appears from outer space, growing larger and larger, before entering its atmosphere through meteor showers, the lights of the aurora borealis, and lightning bolts. Finally, as bright lights illuminated a large-scale model of the fair set in front of the projection screen, the virtual travelers returned to Flushing Meadows.[69]

Coupled with the opening of the Hayden Planetarium in New York in 1935, the displays at the 1939 World's Fair offered New Yorkers unprecedented opportunities to learn about the cosmos. In addition to these exhibits, a number of related publications also had public education as their mission. *Natural History*,

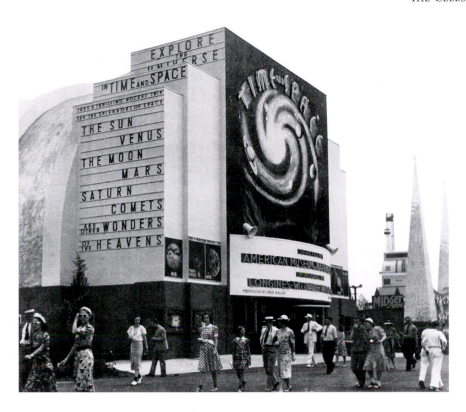

the journal of the American Museum of Natural History, included articles about the birth of the solar system, cosmic rays, cosmology, the Moon, and the theory of relativity in the October 1935 issue. *The Sky, Magazine of Cosmic News* began publication in November 1936 as the official organ of the Hayden Planetarium, later becoming *Sky Reporter*, to which Cornell subscribed. Among the contributions in the first issue were articles about sunspots, stars and nebulae, and celestial navigation—all topics about which Cornell later created artworks. With a public primed to appreciate and understand references to astronomy, Cornell forged ahead with his soap bubble sets.

Cornell's first *Soap Bubble Set* and its early variants were created within the context of intense public interest in cutting-edge science and technology. However, the scientific subtleties of his soap bubble sets were all too often overshadowed by the apparent naïve charm of his other work, with their miniature formats and references to fairy tales and ballerinas. In early December 1940, Joseph Cornell: Exhibition of Objects opened at the Julien Levy Gallery. Cornell's exhibition announcement listed categories of "minutiae," "daguerreotypes," "miniature glass bells," and "soap bubble sets," and it was decorated with a schematic drawing of a pipe blowing the planet Saturn as a bubble. Press coverage of the exhibition was minimal, with writers simply noting that the artist was again exhibiting Surrealist "toys for adults," like those he had

FIGURE 2.16.
Theater of Time and Space, New York World's Fair, 1939. From *The World of Tomorrow: The 1939 New York World's Fair*, ed. Larry Zim, Mel Lerner, and Herbert Rolfes. © 1988 by Sterling Publishing Company. Reprinted by permission of HarperCollins Publishers.

FIGURE 2.17.
Joseph Cornell,
announcement for Objects
by Joseph Cornell, Copley
Galleries, Beverly Hills,
CA, 1942. Joseph Cornell
Study Center, Smithsonian
American Art Museum.

shown the year before.[70] As World War II intensified, however, Cornell's art struck critics as increasingly irrelevant, and even at its close the situation did not improve. When he published his scenario *Theater of Hans Christian Anderson* in *Dance Index* in 1945, a reviewer in the *Christian Science Monitor* called it "most inappropriate," and when he showed his works at the Hugo Gallery in December 1946, critic Howard Devree simply referred to them as "various doodads in dada."[71]

Such comments must have stung, and it is not surprising that Cornell returned to the formula that had brought him early success. When Objects by Joseph Cornell opened at the Copley Galleries in Beverly Hills, California, in September 1948, at least five soap bubble sets were included among the forty-three works listed in the announcement, which itself capitalized on the soap bubble theme (fig. 2.17). A folding card with text and graphics on both sides, it featured the familiar bubble pipe and ringed Saturns, as well as the repeated silhouette of an old-fashioned tricycle and letters that, seeming impervious to gravity, float away from any linear alignment. Inside, on the left he centered a chart of the phases of the Moon, made from a negative photostat of an illustration in the English edition of Guillemin's *Le Ciel*, along with short texts streaking against the dark background like the trails of shooting stars and comets. On the right, he provided a catalogue list of objects that identified each

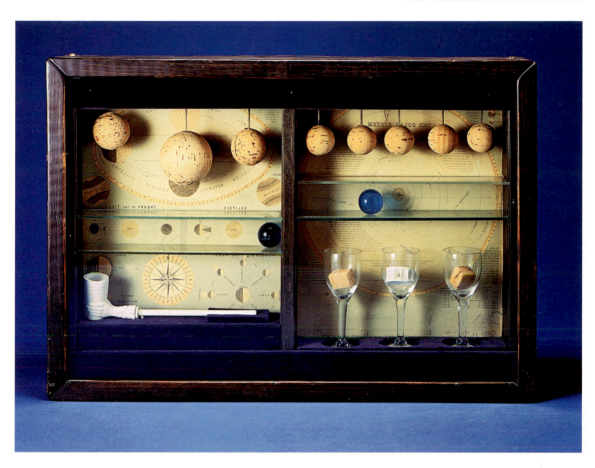

soap bubble set in the exhibition with a parenthetical subtitle: "Moon Map," "Solar System," "Spirit Level," "Driftwood," and "with drawer."

Probably among the works exhibited was a large diptych box that revived the astronomical chart, hanging elements, pipe, and wineglass of the original *Soap Bubble Set* (fig. 2.18).[72] On the right side of the box, the pipe appears to have blown the Sun, Moon, and planets illustrated in the charts backing the box and suggested by hanging cork spheres and rolling blue marbles. Lacking the whimsy of the exhibition announcement's design, this box conveys a soberly scientific view of the cosmos, whose deeper secrets are hidden from us. The lines of cordial glasses and marbles were motifs Cornell later used frequently in boxes he called "lunar levels," "solar levels," and "spirit levels," alluding to the instrument with a bubble in alcohol used to determine level surfaces. The glasses also echo "communicating vessels," the linked vessels familiar from laboratory illustrations that Cornell clipped. By using diagrams of eclipses, the tides, the seasons, and the solar system, he made his scientific

FIGURE 2.18. Joseph Cornell, *Soap Bubble Set*, c. 1947–48. Box construction, 12¾ × 18⅜ × 3 in. The Robert Lehrman Art Trust, Courtesy of Aimee & Robert Lehrman, Washington, DC. Mark Gulezian/QuickSilver Photographers.

leanings clear. Only the pipe, whose stem metamorphoses into a hand, and the marbles normally associated with play disturb the mood of seriousness created by the references to science.

Critical response to the Copley Galleries exhibition could not have been more disheartening for Cornell. Critic Arthur Miller had this to say:

> Cut out maps and pictures and tie them into neat packs. Add clay pipes, corks, brandy glasses, and frame in shadow boxes. Collect disintegrated sequins from Alicia Markova's ballet dress and box under glass. Put a feather and a tiny egg in a little container. Children do such things, but so does Joseph Cornell. . . . Here's a new low in chi-chi infantilism.[73]

In soap bubble sets made after this point, for the most part Cornell abandoned the whimsical elements that prompted Miller's accusation of "chi-chi infantilism," offering instead restrained meditations on the stars, couched in scientific terms (discussed in chapter 6). But he did not abandon his fascination with fantastic astronomy. Instead, he found new ways to merge scientific findings and imaginative correspondences.

MOVIE STARS

For his 1936 *Soap Bubble Set*, Cornell drew on his interest in science to produce a work with Surrealist overtones for a major exhibition of avant-garde art. The consideration of science—past and present—that lay behind the items in his *Elements of Natural Philosophy* led to many more science-based works, culminating in a series of box constructions and collages based on modern astronomy that Cornell made in the 1950s and 1960s. But the cosmos was also a source for reverie. Deeply cognizant of the ancient process of imagining people and animals in star patterns, Cornell set about the task of reviving and updating this practice for modern times. In his *Soap Bubble Set*, he reminded viewers of the rich tradition of celestial mapping; however, in the more private domain of experimental film, he went much further by producing cinematic works that combined the age-old practice of imagining a narrative for the stars with modern principles of physics and astronomical discoveries.

Eclipsing *Rose Hobart*

Cornell was an important collector of early films, owning examples of the work of Méliès and other cinematic pioneers. He was also keenly aware of developments in avant-garde cinema, especially via screenings of Dada and Surrealist films held at the Julien Levy Gallery. Throughout his career, he drew upon his joint interests in the pioneers of cinema and in the cinematic efforts of contemporary artists to make his own films, using discarded stock that he reputedly bought by the pound to piece together new creations.

Probably best known is Cornell's film *Rose Hobart*. This nineteen-minute compilation film was first shown together with his "Goofy Newsreels" at the Julien Levy Gallery in December 1936, a few days after the opening of

Figure 3.1.
Joseph Cornell, eclipse
sequence from *Rose
Hobart*, c. 1936. Photo:
Anthology Film Archives,
© The Museum of
Modern Art, New York.

Fantastic Art, Dada, Surrealism at the Museum of Modern Art. (Also on the program were Duchamp's *Anémic Cinéma* and Man Ray's *L'Etoile de mer*.) Composed largely of footage reassembled from a 1931 Hollywood B-movie, George Melford's *East of Borneo* starring the beautiful Rose Hobart, Cornell's film achieved a certain notoriety when, during the screening, Dalí reportedly leaped out of his chair and accused Cornell of stealing his own idea for a found-footage film.[1] From that time on, Cornell hesitated to show his films in public, and they instead became private, cerebral exercises in masterful editing.

In *Rose Hobart*, a series of views of the actress in different costumes interspersed with snippets of action combine to create a cinematic collage of emotional states, linked by a nearly nonexistent narrative. Seemingly unrelated cuts flash by: shots of figures in windows, in doorways, in mirrors, figures confronting each other, taking each other's arms, talking to each other. Many are virtually the same cuts, repeated at different times, with the film seeming to proceed in fits and starts, turning back before moving forward again. In the words of art historian Jodi Hauptman: "In place of a linear plot, Cornell gives us a spiral with action continually winding around itself."[2] At the center of that spiral is a cosmic event that, according to Hauptman, forms the film's "explicit narrative thread": a solar eclipse.[3]

Throughout the film are quick shots of the Sun, clouds in front of the Sun, and, near the end, documentary footage of an actual eclipse (fig. 3.1). The eclipse is followed immediately by the repeat of a quick cut, first seen early in the film,

Solar prominences are best observed during eclipse.

Times Wide World.

Something seems to be eating the sun!

FIGURE 3.2.
Donald H. Menzel,
"Science Again Turns
to the Sun," New York
Times, June 14, 1936.
Photo: courtesy UC
Regents/Lick Observatory.

showing a spherical object of the Sun's size falling into a body of water. As the ripples move back and forth, the reflected image of the Sun emerges in the center. Cornell must have culled these scenes from a scientific film about an eclipse, since none appears in East of Borneo.[4] In early films by Méliès, such as *The Eclipse (The Courtship of the Sun and Moon)*, solar eclipses were humorous metaphors for sexual union, and Cornell may have intended the eclipse in *Rose Hobart* to function, on one level, as a trope for the male characters' and the spectators' desire for the film's star, fueled by her skimpy dresses and smoldering looks. On another level, as Hauptman persuasively argues, the eclipse symbolizes the mysterious heroine, visible only in the shadow of the film, as well as the medium of film itself, with its images created when projected light is eclipsed by darkened shapes on celluloid.[5] But there is yet another way of cross-indexing *Rose Hobart*—as a metaphoric discourse on new findings in the field of solar research.

Cornell's reliance on scientific footage of a solar eclipse in a collage-film about a desirable woman was in keeping with Dada and Surrealist practice, as seen, for instance, in Ernst's collages combining scientific and sexually charged elements. It also underscores Cornell's awareness of contemporary astronomical events. As Hauptman notes, numerous eclipses and eclipse-related activities took place in the mid-1930s, prompting newspaper coverage (fig. 3.2) and even "eclipse month" at the Hayden Planetarium in February 1936, when film footage of a 1932 solar eclipse was shown.[6] More significant than the frequency and popularization of solar eclipses, however, was their importance for contemporary scientific research.

During 1936, when Cornell first showed his film, public interest in eclipses was high. Through programs and displays at the Hayden Planetarium, as well as articles in the popular press, the general public learned about the role of eclipses in cutting-edge scientific research. In particular, they knew that in 1919 a solar eclipse had radically revised the science of the universe, when British astronomer Arthur Eddington verified Einstein's general theory of relativity with measurable data by photographing the positions of stars during a solar eclipse. In Newton's system space was inflexible; in Einstein's it

had to bend and flex near massive bodies, producing a warping of space that would, in turn, be responsible for guiding objects, such as planets, along their orbits. The 1919 eclipse provided an ideal opportunity to test the theory. It was unusually long—around six minutes—and the Sun was in front of the Hyades, a cluster of bright stars. Teams were sent to two sites to photograph the eclipse: an island off the coast of West Africa and a site in northern Brazil. After the eclipse, Eddington himself carefully measured the positions of the stars that appeared near the Sun's eclipsed image on photographic plates exposed during the eclipse, then compared them with reference positions taken previously when the Hyades were visible at other times of the year.

The measurements agreed with the predictions of Einstein's theory of general relativity, and the press leaped to tell the world. Einstein was immediately propelled to the front pages, and, almost overnight, his name became a household word. After years of war, the public reveled in the thought that secrets of the cosmos far removed from earthly concerns could be unlocked. With subsequent eclipses, teams of scientists worked to confirm and refine Einstein's theory. Armed with huge cameras and spectrographic equipment, during the 1920s and 1930s researchers set off for remote corners of the world, seizing opportunities to examine the Sun, as well as nearby stars and planets, under eclipse conditions.

In many respects, *Rose Hobart* can be read as a surreal discourse on recent eclipse expeditions and their findings, as well as a metaphoric enactment of an actual eclipse. Cornell's starting point, Melford's *East of Borneo*, tells the story of a young woman named Linda, who journeys to the fictional tropical island of Marudu to find her husband, the court physician to the kingdom's ruler, a sadistic (Sorbonne-educated) prince, who claims to be a direct descendent of the island's volcano. Believing that his wife has been unfaithful, Linda's physician-husband has turned to drink. When the prince tries to seduce Linda, against the backdrop of the erupting volcano, she shoots him. The doctor realizes his wife's fidelity, and the couple escapes home, leaving the prince to die as the volcano destroys his kingdom.

Only irrational fragments of this story remain in *Rose Hobart*. In place of the original narrative, which unfolds logically over time, Cornell's film defies notions of cinematic temporal and narrative structure, offering instead a strange exegesis of modern science. This is clear from the opening moments of the film. Cornell apparently intended the viewing experience to begin in darkness, starting first with bouncy Latin music from a 78 RPM recording, Nestor Amaral's *Holiday in Brazil* (the music continues throughout the film, taking the place of *East of Borneo's* own sound track and dialogue).[7] Then the film begins, opening with a few-seconds' view of a crowd of adults and children holding sheets of dark glass or celluloid and looking skyward, with footage taken from a science documentary film, probably the film from which the eclipse footage also originated.

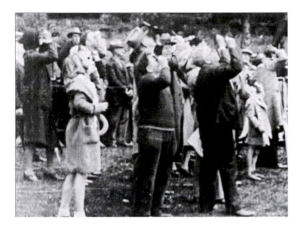

FIGURE 3.3.
Joseph Cornell, opening
frame, *Rose Hobart*,
c. 1936. Photo:
Anthology Film
Archives, © The
Museum of Modern Art,
New York.

In these initial moments, the film presents important contextual information. First the music evokes thoughts of Brazil, then people look through dark glass or plastic at the sky, following safe procedures for viewing a solar eclipse (fig. 3.3). Although today it may seem like a delightful example of a strange encounter between two distinctly separate concepts, to astute viewers in the 1930s and 1940s the pairing of Brazilian music with an eclipse would have triggered recollection of Eddington's verification in 1919 of Einstein's general theory of relativity, based in part on eclipse observations made in Sobral, Brazil. As the opening frames of *Rose Hobart* remind us, solar eclipses must be viewed under special conditions, through a darkened glass. Indeed, the film itself was viewed this way, with Cornell holding a piece of celestial-blue glass in front of the projector, repeating the precaution for the film's audience, who would themselves be viewing an eclipse.

After the introductory theme of eclipse viewing, the action in *Rose Hobart* shifts abruptly to footage from *East of Borneo*: multiple views of Rose Hobart in various costumes, the prince, and the doctor, as well as quick scenes of the island with its volcano, palm trees, and natives. Here, too, in the mid-1930s these scenes would offer obvious parallels to contemporary astronomical research undertaken during solar eclipses. In October 1930 newspapers were full of news of an eclipse expedition to the lonely, almost inaccessible island of Niuafou in the middle of the Pacific. A report in the *New York Times* described the active volcanic island rising out of the ocean, with a large lake in the crater where water bubbled continually, as if boiling. As the journalist noted, "Thus one of the world's most primitive islands, where the chief interest in life of the natives is to make two cocoanuts grow where only one grew before, is today the stage upon which the most advanced scientific equipment has been gathered for an attempt to learn something more about deep cosmic problems."[8] Much of the work to be done on Niuafou would be devoted to testing Einstein's theory of the deflection of starlight due to the attraction of the Sun's

mass. Other scientists were on hand to study the volcanic craters, and the king of Tonga was expected to visit the island to view the eclipse.[9]

Less than three months later the results were reported in the *Times*: "Members of that hardy band of astronomers, returned from their adventure to the isolated palm-covered speck of land in the Pacific which had never before seen a scientist, have also a word of cheer for Dr. Einstein, who is now preparing for new experiments in the realm of space-time. . . . The German scientist may be glad to know that his theories were tested during the October phenomena and received further substantiation." The island of Niuafou, it was surmised, "will gain immortal fame because of the unusual success of the October expedition."[10]

Niuafou was not the only tropical island ideal for eclipse observation. According to newspaper reports, in 1934 another total eclipse was observed on Valentine's Day, with the Moon's shadow first visible in Borneo, then with the path of totality sweeping eastward over the Celebes and Halmaheira, an island in the Dutch East Indies, reaching the optimal viewing site, Losap Island in the mid-Pacific, before seeming to plunge into the sea with sunset about two hundred miles off the coast of Alaska.[11] Once again, Einstein's theory was validated, this time with photographs taken by Japanese scientists at Losap Island.[12] As the newspapers made clear, the 1934 eclipse was best seen "east of Borneo."

Scientists rushed to sites like Niuafou and Losap Island to photograph and film the Sun's corona and nearby stars in order to test Einstein's ideas about relativity. In *Rose Hobart*, Cornell juggled footage from *East of Borneo* in ways that suggest additional, if fantastic, cinematic confirmation of Einstein's ideas under eclipse conditions. The first cut from *East of Borneo* that appears in Cornell's film is a quick view of the prince taking Linda's arm and drawing her closer, a scene that actually takes place near the conclusion of Melford's film (fig. 3.4). If we view the film as an eclipse, as Cornell implied when he held the blue glass in front of the projector, then, with his glittering turban and jewel-encrusted tunic, the prince is the Sun, who exerts his pull on another star, Rose Hobart, in the role of Linda. Thus, the prince and Linda "act out" Einstein's theories about the pull of the Sun on starlight, which can be observed only during an eclipse. Cornell repeats this theme many times in the film, by appropriating frames from the original film in which the prince enacts his hold on Linda and the doctor, either physically, by taking their arms or walking beside them, or psychologically, through his mesmerizing stares.

Moreover, the theme of the bending of light is reiterated in other ways. After the first glimpse of Linda being gently pulled along by the prince, there are two rapid images of light: a lantern and a close-up of candle flame that is blown slightly to the left. The latter is not included in *East of Borneo*. Thus Cornell considered this view of "bending" light important enough to splice it in from another source. Linda sits on a cot, mapped on a grid formed by

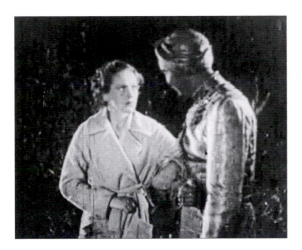

FIGURE 3.4.
Rose Hobart and George
Renavent in *East of
Borneo*, 1931.

mosquito netting behind her, then walks slowly from her tent. The film cuts to a quick view of the Sun in the sky, then to the prince and Linda looking skyward. Alone, Linda looks down. We see a body of water in a crater into which a spherical object falls and, after ripples move back and forth, appears as the reflection (that is, the abrupt change in the angle of light rays) of the Sun or another star, recalling newspaper descriptions of the actual eclipse "plunging into the Pacific" at the end of its viewing path.

Within the first minute of the film, it is clear that time is treated in a most unusual way. With rapid, unrelated glimpses of action and characters, the film is distinctly atemporal. In place of a narrative developed through logical sequences of actions taking place over time, scenes repeatedly loop back on themselves, and events that seem to have already taken place are continued or preceded later in the film. Costumes play an especially important part in establishing these time shifts, as Linda reappears in clothes that signify scenes that logically should have come and gone. Certain shots, like those of the Sun in the sky and the blowing palm trees, are repeated, like signposts that we circle past.

While Cornell may have intended this temporal hopscotch as a vague reference to Einstein's theories about relativity and the effects of the curvature of space upon time, his strange treatment of time also had parallels in news reports about recent eclipses. Accounts in the press explained an interesting fact about the eclipses viewed from Niuafou in 1930 and Losap Island in 1934. In both cases, the eclipse began in one part of the world a day *after* it ended in another. As the *Times* had reported in 1930, "The eastward sweep of the shadow carries it across the international date line. This produces the strange effect of an eclipse beginning in one part of the world on Wednesday and ending more than three hours later in another part of the world on Tuesday. Tin Can Island

[Niuafou] is exactly on the 174th meridian. To its inhabitants, 'today is not only today, but tomorrow also.'"[13] Four years later, announcing the findings made at Losap Island, the *Monitor* again underscored the effect of crossing the international dateline: "The eclipse of the sun and the moon cooked up on Feb. 13 was over before it started."[14] Even in the scientific domain of eclipse observation, time was jumbled.

But time is more than just jumbled in *Rose Hobart*. With the film's abrupt changes and repetitions of scenes, it is nearly impossible to gain any perspective on a plot—there is no conceptual "vanishing point," a narrative climax toward which all story lines lead. Instead, the viewer is caught up in a new kind of cinematic time and space, where those customary markers that unfold a linear narrative over time are gone. In place of cinematic boundaries, wherein plot lines start in different places and converge in a single point following a kind of Euclidean geometric logic, there is a boundless, four-dimensional universe of infinite combinations and possibilities. Action curves back on itself; time is relative; plot lines are snapped; new centers of cinematic gravity replace old ones. In its very structure, *Rose Hobart* seems to present a film version of the new cosmology of relativity, which, as viewers, we verify through eclipse observation.[15] Cornell underscored the importance of solar eclipses for new ways of thinking about time and space a few years later, in a book object he made around 1939 (fig. 3.5). Taking a nineteenth-century book entitled *Histoire des Temps Modernes*, he glued the pages together, hollowed out a central section, filled it with black sand, and added bits of text with references to Descartes glued on tiny pieces of glass.[16] The Sun on the cover is thus transformed into a solar eclipse, with "rays" visible when the sand is shaken.

One of the most compelling features of *Rose Hobart* is its psychological tension. This is created, in part, through the film's nonnarrative development. It also stems from the emphasis on the facial expressions and actions of the main characters. Hauptman discusses these expressions in the context of Surrealist interest in hysteria: "Cornell forces Hobart's body to act as a voice: to frown, smile, express fear and sadness, jerk back, move suddenly, dart down a hall, tell a story, convey character, and offer emotional response." Moreover, Hauptman sees a parallel between Rose Hobart's hysterical body and the "primitive" island kingdom, as "woman figured as dark continent or island paradise."[17] While Hauptman's reading helps place the film in the larger context of Surrealism's interest in hysteria and its variations on the theme of "primitivism," there are other ways to consider the psychological tone of the film.

The predominant emotion expressed throughout *Rose Hobart* is anxiety. Her anxious portraits are frequently linked to glimpses of clouds in front of the Sun, palm trees blowing in the wind, even an erupting volcano. These undercurrents and forebodings culminate in the eclipse at the film's end and the apparent fall of the Sun into the water. While the irrational quality of anxiety

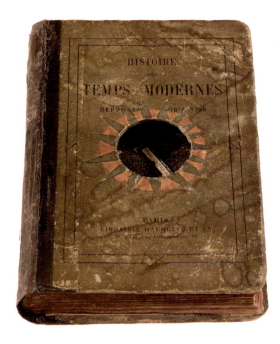

FIGURE 3.5.
Joseph Cornell, untitled book object (*Histoire des Temps Modernes*), 1939. Book object, book, glass, paper, sand, and rhinestone, 7⅛ × 4¾ × 11/16 in. Wadsworth Atheneum Museum of Art, Hartford, Connecticut. The Douglas Tracy Smith and Dorothy Potter Smith Fund.

contributes to a kind of Surrealist convulsive beauty, the psychological tension also relates to familiar aspects of solar eclipse research. In news reports about scientific expeditions to study eclipses, writers emphasized the scientists' anxiety in the days preceding the event. Would the weather cooperate? As one of the articles in the *Times* about the Losap Island expedition put it, "If clouds roll up for just two vital minutes, all the months of preparation, thousands of miles of travel and weeks of waiting will have gone for nothing."[18] Would equipment function properly? The huge sheets of film necessitated very large cameras, many of which, like those used on Niuafou, were constructed on the spot. Delicate spectroscopes and other instruments would also be employed in hopes of gleaning every possible bit of information during the brief moments of totality. Would the teams work efficiently? Scientists held dress rehearsals, making sure each person knew exactly what to do, and movements were carefully choreographed to ensure no second would be wasted.[19] With cameras and instruments in place, all energies were focused on "shooting" the eclipse (fig. 3.6).

In *Rose Hobart*, tension escalates when Linda puts her gun in her purse. She plays her role as a shooting star, and, although we do not see the gun fire, for a few brief seconds we observe the prince immobile on his bed. In the background the volcano erupts, spewing out lava like the solar prominences observed in the Sun's corona at the moment of totality; as one journalist put it, "If you imagine the surface of the earth covered with a billion active volcanoes,

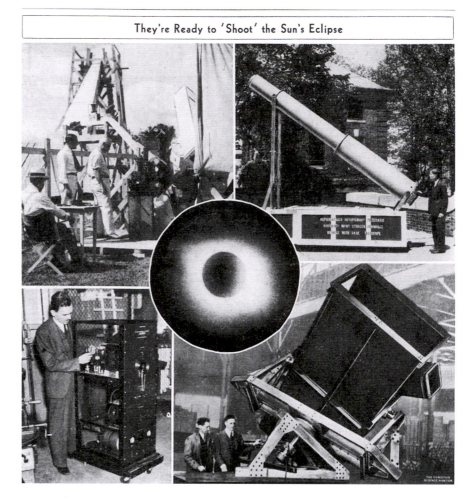

They're Ready to 'Shoot' the Sun's Eclipse

each spouting out fire and gases, you will gain some idea of the chromosphere's structure."[20] A few seconds later the danger has passed and, like the Sun after totality, the Prince is back in action. After a series of quick cuts from faces, to the Sun, back to faces, and back to the Sun, the actual eclipse footage puts what we have seen into scientific terms. The Sun drops into the water. Linda bows her head and lowers her eyes. The eclipse is over, and so is the film.

Cornell screened *Rose Hobart* in December 1936 at the Julien Levy Gallery together with his collection of "Goofy Newsreels," a general title that places his work in the context of the short news reports that preceded feature-length films. Recent scientific discoveries were often the topic of such newsreels. In addition, documentary films about astronomy for general audiences were popular during the 1930s, including several that contained footage of solar eclipses. One made under the auspices of Northwestern University was a

travelogue that leaves Earth and goes touring among the planets and galaxies; another shown at the Hayden Planetarium in 1935 included motion pictures of solar eclipses, sunrise on the Moon, and meteor showers.[21] With its inclusion of scientific film footage and allusions to relativity theory, *Rose Hobart* can be thought of as a Surrealist version of these science films: a newsreel report of current events in solar astronomy, as enacted by Hollywood stars liberated from their original context—aptly named "Universal" Pictures' *East of Borneo*.

Astronomy Amusements at *The Children's Party*

Cornell's *Rose Hobart* fit neatly into the context of Surrealism and science in 1936, but with Dalí's condemnation, the artist must have been uneasy about continuing cinematic work in this scientific-erotic-Surrealist vein. In place of the shadowy substance of cinematic anxiety and desire, he turned his attention to "healthier" pursuits: three playful films visualizing additional aspects of astronomy. Collectively known to scholars today as the "Children's Party trilogy," this group comprises three short films: *The Children's Party*, *The Midnight Party*, and *Cotillion*.[22] Cornell produced a draft of at least one of the films in November 1938, although he was still at work on them nearly three decades later.[23] On first viewing, the films seem to be a wacky mish-mash of documentary footage, vaudeville and circus acts, and home-movie scenes from a children's party. Upon close inspection, however, they offer a carefully designed cinematic essay on the wonders of the cosmos.

Of the three, *The Children's Party* is most tightly edited and seems most complete. A little over eight minutes long, it is a dizzying collage of rapidly shifting subjects and perspectives (fig. 3.7). The film opens with the words "The End," seen upside-down and backwards. Next, it presents the theme of stargazing, using footage from a didactic film about the cosmos—perhaps the same film from which he took the solar eclipse footage for *Rose Hobart*. After a few seconds' view of a window, a window shade rises to reveal the starry night sky, and a young boy gazes upward. An intertitle declares: "The Ancients, wondering what the stars were, pictured their heroes in the sky." A line traces the shapes of Orion, Ursa Major, and the Big Dipper, while text panels name the constellations.

The didactic mood abruptly ends as the film cuts to shots of children in party clothes, followed by a series of vaudeville acts. The first features an acrobat holding a chair in his mouth and swinging it around in a large circle. He is followed by footage of a boy holding an apple in his mouth and then dropping it. The film returns to the acrobat, who now stands with a prone woman spinning on his head. Next is a quick cut to a plump moon-faced child, then, back to the acrobat, who climbs a set of stairs with a woman on the chair

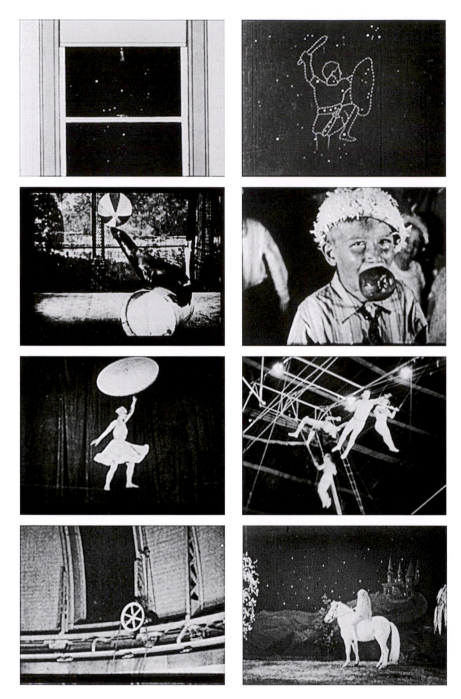

FIGURE 3.7.
Joseph Cornell, film stills from *The Children's Party*, c. 1938, finished by Lawrence Jordan, 1965–68. © Lawrence Jordan (Cornell / Jordan).

held in his mouth. The following act features a man dressed in a shirt with a large Sun on the back: the famous magician and knife-throwing Aztec Indian, Zat Zam, performing in his act called "The Sun Worshippers."[24] Aiming at points just beside his intrepid wife Helene, a blindfolded Zat Zam propels his knives with astonishing accuracy. Then we see a trained seal rolling on a barrel and balancing a spinning ball on its nose, followed by a tutu-clad acrobat who spins dizzily from a rope held in her mouth—perhaps footage of Frances Hanes's "Sensational Iron Jaw Act" performed at Coney Island's Luna Park, about which Cornell saved a playbill.[25]

The circus acts continue. From the spinning acrobat, the film cuts to another performer, the tightrope artist Bird Millman. Holding her parasol above her, she turns in circles across the rope. After another cut to the dizzily spinning tutu-clad woman clenching a rope in her mouth, we encounter a set of bodies streaking through space, a troupe of six flying trapeze artists performing amid spotlights high at the top of a dark circus tent. Then the film shifts abruptly from the interior of the circus tent to the interior of a strange domed space with a pulley wheel and rope mounted on the wall. As the wheel turns and a section of the dome slides open to reveal the night sky, we suddenly realize we are inside a modern telescope observatory. From the observatory, we view an amoeba-shaped filmy nebula in the distant sky.

Leaving the observatory, the film returns to the party, as children bob for apples and a sleepy baby gnaws on one, then drops it. We see another moon-faced child beside a large, grinning jack-o'-lantern. After a quick cut to the sleepy baby with the apple, action moves to two sets of dancers performing in a line. Even though the dancing becomes increasingly frenzied, the children at the table seem oblivious to its high-speed motion. A quick freeze-frame provides a telescoped view of a nineteenth-century photograph held by two hands. The sleepy baby yawns and yawns. The party seems to end. After a brief pause, the film cycles through many of the same images and themes. A group of ballerinas clad in filmy tulle metamorphoses into a line of tap-dancing showgirls, frenzied dancers moving at impossible speeds before the oblivious children. The boy again grins winningly after he drops his apple. Children pelt each other with paper streamers. The first moon-faced baby returns, seen full-face, crescent profile, and full-face again.

The film then shifts to its longest uninterrupted scene. Apparently culled from an Our Gang comedy episode, it features two little girls dressed in tutus, awkwardly dancing, twirling, and cartwheeling in unison.[26] The camera angle widens to reveal the children performing before a judge, a jail cell, and a female jail keeper. The next sequences repeat the theme of zooming and whirling bodies: rapidly moving, unfocused dancers, cutting to a quick shot of paired children dancing in circles. Finally, against a starry sky with a castle on a hill, a stunningly beautiful child enters riding a white horse. Her naked body is all but covered by long, blonde hair. She looks sadly back from where she has

come, looks down, and then looks in the direction of her exit. As she rides offstage, the film ends.

Like *Rose Hobart*, *The Children's Party* can be viewed as a Surrealist film that uses illogically juxtaposed fragments of found footage to create a dream-like sequence of scenes that defy conventions of cinematic time and space. And like *Rose Hobart*, it can also be considered within the context of the science of astronomy. The film opens by immediately questioning received notions of cinematic time and space. Beginning with the words "The End," seen upside-down and backwards, the film suggests that it is a circular, infinite loop to be seen in a way that defies our notion of cinematic gravity, in which words or characters are oriented according to certain conventions. The window shade goes up to reveal the stars in the sky, stars that in ancient times were assigned specific anthropomorphic identities as imagined shapes traced on a two-dimensional plane. As the action shifts to a series of vaudeville and circus acts, this ancient cosmology is updated.

The next few scenes illustrate aspects of gravity. Whirling a chair he holds in his mouth, the acrobat unwittingly acts out the Newtonian principle of universal gravitation. The force the acrobat exerts on the chair plays the role of Earth's gravity, while the orbital motion of the Moon is enacted by the chair. Holding an object and whirling it around was a common way to demonstrate this concept, as illustrated in many of Cornell's books about physics and astronomy.[27] The following segment in the film confirms the allusion to Newton: a boy holds an apple in his mouth, then he drops it. Indeed, Cornell drives this point home repeatedly with shots of children dropping apples throughout the film. Next is a quick cut to a round-faced boy, whose moon-face reminds the viewer that Newton's genius lay in realizing that the motion of the apple and that of the Moon are essentially the same motion, both influenced by the same gravitational force described by Newton's laws of motion. Returning to the acrobat, we now find him carrying a woman seated on a chair that he holds in his mouth. As he climbs a set of stairs, he struggles with the weight, which is a function of the force exerted by gravity on the mass in his mouth.

From gravity, emphasis shifts to the laws of mechanics. The Aztec "Sun Worshipper" Zat Zam throws knives at a target, illustrating Newton's first law of motion, that an object remains in a state of motion unless an external force is applied to it. As his knives streak across the stage, their ballistic motion abruptly ends as they find their mark. Next we see a trained seal rolling on a barrel and balancing a spinning ball on its nose, suggesting the movement of a planet making its way through space with another rotating celestial body in tow. The concepts of circular and elliptical motion were important for students of astronomy to understand, and they were often illustrated in science books with rotating balls, tops, and even tightrope walkers (fig. 3.8). Cornell adds other examples: film footage of a tutu-clad acrobat spinning in space and tightrope artist Bird Millman rotating in circles across the rope, with her parasol

21. CIRCULAR INTO RECTILINEAR MOTION.

THE geometry of motion tells us that if one circle roll in the interior of another of twice the radius, any point in the smaller circle will describe an ellipse which will take the special limiting form of a circle when the point is the centre of the circle, and the other special limiting form of a straight line when the point lies on the circumference of the smaller circle. This last case is of importance in mechanism, since it gives the means of transforming circular motion into rectilinear motion.

58

orbiting around her. Since the mid-nineteenth century, rope dancing had been used in books about natural philosophy to explain the importance of equilibrium in establishing a center of gravity, a fact that was not lost on Cornell.[28] Perhaps he even cross-indexed "Bird" Millman with the constellation Cygnus, the Swan, which he later recorded seeing "balanced" on the telephone wire in his backyard (see fig. 5.18).

The analogies between circus performers and the motions of celestial bodies in space continue in the film. Trapeze artists perform at the top of a darkened circus tent, amid blazing lights. They rotate their bodies and turn somersaults in the air before they catch the swinging trapeze and begin a new motion. Their actions illustrate Newtonian principles of mass and acceleration, and, as they leap from trapezes that swing back from them, they demonstrate that every action has an equal but opposite reaction. Up until this point, Cornell has presented a progression from ancient notions of the cosmos as a two-dimensional plane on which star shapes could be inscribed to a three-dimensional universe governed by Newtonian laws of motion and gravity. But now things begin to

FIGURE 3.8.
Circular into Rectilinear Motion, in Tom Tit, *Scientific Amusements* (London: Thomas Nelson and Sons, [n.d.]).

71

change. Flying among the bright lights at the top of the tent, the trapeze artists appear to be performing among the distant stars, freed from the constraints of terrestrial gravity. Cornell later specified this location in a diary note: "the darkened dome of the big top as the night skies."[29] Spatial markers diminish as the performers seem to move weightlessly through the dark reaches of the infinite cosmos.

This shift in perspective is clarified when, instead of belonging to a circus audience, we abruptly find ourselves inside an astronomical observatory. The window cranks open. In place of the linear constellations that we saw through the window at the opening of the film, now there is a filmy nebula in the distant space of an expanding universe.[30] We return to the party, but things have changed. A sleepy baby cannot maintain its hold on an apple—the age of Newton can no longer suffice. Now dancers kick and turn in a frenzy of motion, and the children seem as oblivious to them as they are to the motion of their planet as it streaks through space. At times, the footage of the dancers and the children is layered, dancers and children on top of each other, so that both are seen at once, as if in parallel universes. Time becomes relative. The freeze-frame of a nineteenth-century photograph held by two hands is a reminder of the astronomer's paradoxical dilemma of making modern discoveries by studying ancient light. As the film continues, the dancers move at impossible speeds, and the moon-faced boy turns his head from full face to crescent profile to full again, enacting the month-long phases of the Moon in a few brief seconds.

The Our Gang comedy footage reinforces the themes of bodies moving through space, with its awkward ballet of cartwheeling and spinning little girls. As the frame widens to include the judge and jail cell, we are reminded that the universe is governed by laws of physics. Time and space are relative in a cosmos of constant motion—a concept underscored by sequences of rapidly moving, unfocused dancers that cut to a quick shot of children dancing in circles in an indefinite space—but the laws of physics remain constant. The final scene in *The Children's Party* provides a glimpse of one last starry sight. Rather than illustrating the legendary tale of Lady Godiva, which the footage of a naked child covered only by her hair was originally designed to do, Cornell seems to have included it to call to mind the constellation Coma Berenices, Berenice's Hair. Against a star-filled background, she leaves her mortal body to take her ethereal place in the sky, as one of the traditional metaphysical heroes with which Cornell began the film. Amid the wonders of science, the old stories still hold their power. The film completes its circle.

In *The Children's Party*, Cornell dangles the viewer in time and space, underscoring the link between fantasy and reality that has traditionally enabled people to grasp the celestial theater performed each night in the starry sky. He relies on metaphors: the ancient constellations that make sense of the stars, as well as modern performers who offer analogies for the workings of the cosmos. The film presents new ways of thinking about the universe and the

forces that govern it, by means of a children's party, a metaphorical trip to the circus, and a visit to an observatory. Working in the tradition of wacky films about astronomy, established by Méliès' *Le Voyage dans la lune* and *L'Eclipse du soleil en pleine lune*, Cornell abandons narrative for association, depending on his audience's ability to see the parallels between popular amusement and scientific principles. Given that he did not screen his films publicly and that his audience was largely composed of himself and his brother Robert, those parallels are nuanced. They build on—indeed, they depend on—an evolving framework of ideas that Cornell also explored in other media, as part of his ongoing search for modern ways to envision the ancient wonders of the cosmos.[31]

NEBULA, THE POWDERED SUGAR PRINCESS

In addition to found-footage compilation films, like those in the Children's Party trilogy, Cornell also wrote scenarios for films that were virtually impossible to make. Around 1941 astronomy and fantasy would meet in a peculiar outline for a ballet-film, entitled *Nebula, the Powdered Sugar Princess*. Although the scenario never progressed beyond handwritten notes, embedded in it is an imaginative integration of art and science, given tangible form in collages made in conjunction with the project.

Nebula, the Powdered Sugar Princess consists of six pages of notes that describe three separate versions of an imagined performance.[32] Although Cornell initially conceived of it as a ballet, in the second version his conception shifted to a film to be produced in Technicolor. He may even have considered using animation, noting in the final version that he wished to adapt his outline to "a complete cinematic treatment; like the Walt Disney films," although he took pains to make clear that he was not influenced by *Fantasia*, which he had not yet seen. As Thomas Lawson has observed, the scenario takes the form of a mental collage, "in which the dynamics of connection and disconnection are of more significance than the actual images themselves."[33] Lawson's description of the scenario as collage is apt: the ballerina Nebula dances in a jerky narrative, repeating certain movements in each of the three versions, while other elements, like color and music, are overlaid or removed. However, the actual images *are* significant: they cast Nebula in the role of one of the era's most important objects of astronomical research.

The inspiration behind Cornell's scenario probably came from an actual ballerina, Tamara Toumanova, one of the famous trio of "baby ballerinas" dancing with Colonel Vassily de Basil's Ballets Russes de Monte Carlo.[34] Cornell met Toumanova in November or December 1940, when his friend Pavel Tchelitchew introduced them, and in December Tchelitchew brought George Balanchine and Toumanova to the Julien Levy Gallery to view a one-man exhibition of Cornell's work, which included several of his Romantic Ballet

OPPOSITE PAGE:
FIGURE 3.9.
Joseph Cornell, *Hommage
à Tamara Toumanova*,
December 1940.
Commercially printed
papers and gouache on
blue wove paper,
15⅜ × 9 in. Lindy and
Edwin Bergman Joseph
Cornell Collection, 1982.
1873, The Art Institute
of Chicago. Photography
© The Art Institute of
Chicago.

boxes. By December, Cornell felt bold enough to send the ballerina a collage, inscribed "Hommage à Tamara Toumanova," showing a tiny winged figure dancing amid shells and jellyfish in a starry underwater realm (fig. 3.9).[35]

Finishing his final weeks of work as an apprentice designer at the Traphagen Commercial Textile Studio, Cornell was just a block away from the 51st Street Theater, where he watched Toumanova rehearse during his lunch breaks. Among the ballets in progress was Balanchine's *Balustrade*, created expressly for Toumanova, with music by Igor Stravinsky and costumes by Tchelitchew. Cornell attended multiple times, and he kept three copies of the announcement in his "Tamara Toumanova Scrapbook."[36] For the ballet, which opened in New York on January 22, 1941, Tchelitchew dressed Toumanova in a black costume studded with diamonds and rubies and designed a stark backdrop that included a perspective balcony. Balanchine's ballet was not a story, but, in the choreographer's words, "a contrast of moods in movement and color."[37] While Cornell drew upon these aspects of the ballet and its staging for his *Nebula* scenario, he also turned to the facts and metaphors of astronomy.

Cornell's first version of the scenario for *Nebula, the Powdered Sugar Princess* opens with a rebellion against the classics, as a young ballerina named Nebula refuses to put on her costume and dance *La Sylphide* for the ten thousandth time. Her enraged ballet master conspires with a magician to turn her into a real Sylphide. As a winged spirit, the ballerina enters what Cornell describes as "the kind of world that one sees thru the microscope / Floating cells magnified to gigantic propor." With strange forms floating past, the ballerina is not able to dance as if she were still on Earth but moves the wings of her costume and her arms as though flying or swimming. Like many natural scientists, Cornell was intrigued by the parallels between the microscopic, undersea, and celestial realms, and he explored their interconnections in all three versions of the scenario, as well as in several collages with Toumanova's face pasted onto Nebula's body in aquatic and cosmic settings.

In Cornell's second version of *Nebula, the Powdered Sugar Princess*, he outlined a more impressionistic ballet-film, with three tableaux—"neigeux," "aérean," and "sous-marin"—and a "pyrotechnique" ending. Sound and color make their appearance. Claude Debussy's waltz *La Plus que Lente* requires snowy celestial blue lighting. Erik Satie's piano pieces "descriptive of underwater life" are paired with pale green lighting. Debussy's celestial *Nuages* and *Poissons d'or* and Maurice Ravel's *Le Jardin féerique* from *Ma Mère l'oye* call for midblue lights. Snow falls, and, as the princess floats and dances, she ecstatically spreads her arms open to welcome the snowflakes. The light shifts to green, and the set resembles a "glorified fairy aquarium." When the lights move to dark green, they flash like shooting stars. Perfectly at home with the heavenly bodies, Nebula now stands on a balcony "exactly the engraving in Grand's 'Les Etoiles,'" very slowly fading away to the strains of Debussy's *Nuages*. Looking straight into the camera, she blows a kiss to her viewers. She

Opposite page:
Figure 3.10.
Joseph Cornell, untitled
illustration to Charles
Henri Ford, "Ballet for
Tamara Toumanova,"
View, ser. 2, no. 4
(January 1943): 36
["Americana Fantastica"
issue].

Figure 3.11.
J. J. Grandville, *L'Etoile
du soir*, in Joseph Méry,
Les Etoiles (Paris: Gonet
et Twietmeyer, 1849). The
Metropolitan Museum of
Art, Gift of Lincoln Kirst-
ein, 1970 (1970.565.417).
Image © The Metropolitan
Museum of Art.

presses her hands over her heart, and, as the balcony disappears, she gazes adoringly into the eyes of the audience.

Cornell toyed with the idea of having just her head, her hair, and the stars left, and then only her glowing eyes, but realized that this ending needed "to be handled with extreme delicacy to prevent it from becoming over sentimental or ludicrous." As the view shifts from the close-up of Nebula to a more distant camera, the outlines of constellations appear and disappear. Against a midblue background, described as "Aeréan—'La voie Lactée,'" and floating through the clouds and starry night, the stars in Nebula's tutu, one or two in her hair, and one on her forehead become a constellation.[38] Clouds of fantastic animal and human shapes float past. With meteors flashing by, the second version ends. The image of Nebula disintegrating in space was important enough to Cornell that he also developed it in a collage, using a portion of a photograph of a woman's face, cut in the shape of the Orion nebula and pasted onto a deep blue page illustrating that nebula, removed from Flammarion's *Les Etoiles*.[39]

The third version of the scenario is a single page, with very few words struck out. As a film that Cornell underscored was "to be filmed in Technicolor," the ballet-film is now called *The Princess Nebula*. Cornell advises that the following outline should be adapted to "a complete cinematic treatment like the Walt Disney films. (P.S. not infl.)." The first tableau, *Neigeux*, begins with a celestial blue background. To the music of Debussy's *La Plus que Lente*, the ballerina floats and dances in adoration of the falling snow. Her arms continuously open to welcome the clouds of starry flakes (he later reprised this scene in a collage of the ballerina as a dancing nebula that appeared in *View* magazine in 1943, accompanying a poem by Charles Henri Ford entitled "Ballet for Tamara Toumanova" [fig. 3.10]). In the scenario, Cornell envisioned close-ups of the snow melting and glistening on Nebula's features and hair, with shapes floating by. At this point the third version abruptly ends. Whatever his reasons for abandoning the project, tantalizing hints about the role of astronomy in Cornell's fantasy world are embedded in each of the three versions.

In conceiving a cosmic ballet, Cornell relied on his sole dancer to play the part of a celestial body endowed with human actions and emotions. His approach was in keeping with the popularization of astronomy-as-fantasy in graphic arts and film of the nineteenth and early twentieth centuries. For instance, in his scenario, Cornell made clear that an important inspiration was an illustration by J. J. Grandville (Jean Ignace Isidore Gérard), *L'Etoile du Soir*, first published in Joseph Méry's *Les Etoiles* in 1849 (fig. 3.11).[40] Perched on her balcony in the clouds and floating over the turrets of a castle, Grandville's star holds a telescope, reversing the usual relationship of viewer to viewed—a gaze reversal that Cornell continued in his scenario, as Nebula looks adoringly at her audience rather than being the object of besotted spectators looking up to her. He may also have been inspired by the stellar ballerinas of Méliès' *The*

J.C.

L'ÉTOILE DU SOIR

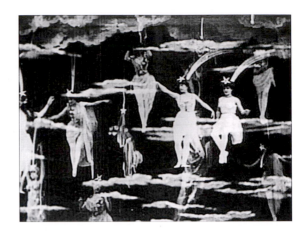

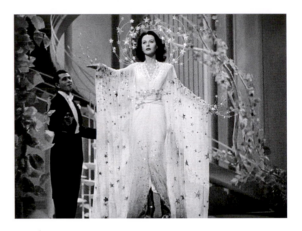

FIGURE 3.12.
Georges Méliès, film still
from *The Eclipse (The
Courtship of the Sun and
Moon)*, 1907.

FIGURE 3.13.
Hedy Lamarr as a spiral
nebula, film still from
"You Stepped Out of a
Dream," in *Ziegfeld
Girl*, 1941.

Eclipse (The Courtship of the Sun and Moon), who point their toes and pirou-
ette as filmy stars and constellations glide by (fig. 3.12).

The most likely cinematic celestial fantasy underlying *Nebula, the Pow-
dered Sugar Princess* featured Cornell's beloved Hedy Lamarr. Starring in the
1941 film *Ziegfeld Girl*, Lamarr was costumed as a nebula in the Busby Ber-
keley musical number, "You Stepped Out of a Dream."[41] Dressed in a gauzy
white gown sparkling with stars, with the curved arms of a spiral nebula and
a starry tiara, Lamarr was the only character in this ensemble number whose
costume, like Nebula's, included a star on her forehead (fig. 3.13). Not sur-
prisingly, Cornell treasured his fan magazine photographs of Lamarr in this
costume. He even mounted Hedy Lamarr paper dolls with the *Ziegfeld Girl*
nebula outfit on black construction paper. Perhaps because of this role, Cor-
nell continued to associate Lamarr with astronomy. After his first visit to the
Hayden Planetarium in New York on July 15, 1941, he jotted a diary entry
that Hedy was "at-one today with the night sky of the Planetarium. I wish

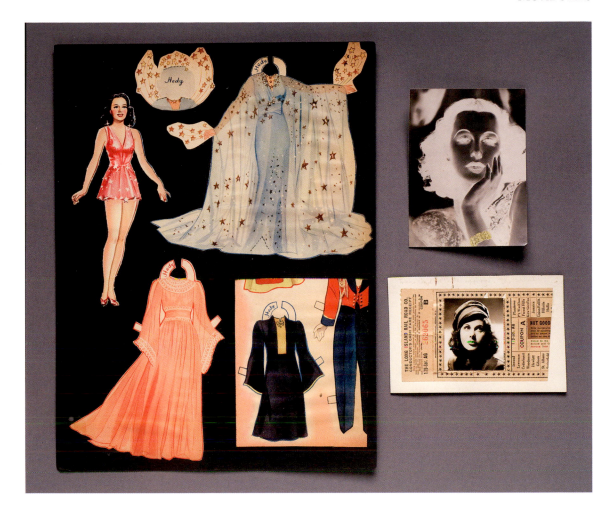

she could have done the lecturing, with her wonderful detachment."[42] A short while later, he wrote in jest to Tchelitchew: "The day I was [at the Hayden Planetarium] Hedy Lamarr was the lecturer and she spoke with a wonderful soft detachment that is her unique pictorial appeal."[43] He created a portrait of her as a solar eclipse, using a negative photostat to darken her face and create a shining corona of hair, and he even imagined Lamarr as a celestial conductor, creating an imaginary ticket to the cosmos by pasting a photograph of the actress (as a streetcar conductor in the 1940 film *Comrade X*) onto a Long Island Rail Road ticket and surrounded her face with a frame of stars (fig. 3.14).

If the visions of Toumanova in *Balustrade* and Lamarr in *Ziegfeld Girl* were likely sources of inspiration for Cornell's Princess Nebula, he did not simply produce a fan's homage to these stars in his imagined cosmic ballet-film. Rather, he related his scenario to the much larger context of cutting-edge discoveries about the size, shape, and evolution of the universe. The first clue

FIGURE 3.14.
Hedy Lamarr paper dolls for *Ziegfeld Girl*, 1941; negative photostat portrait of Hedy Lamarr; collage with photograph and railroad ticket. Joseph Cornell Study Center, Smithsonian American Art Museum. Mark Gulezian/QuickSilver Photographers.

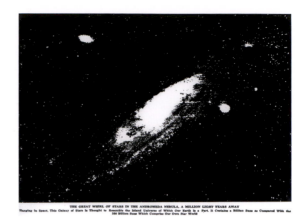

FIGURE 3.15.
"The Great Whirl of
Stars in the Andromeda
Nebula, a Million Light
Years Away," in "Strolling
Among the Stars,"
*Christian Science
Monitor*, December 20,
1941. Courtesy UC
Regents/Lick Observatory.

comes in the titles of the scenario. "Nebula, the Powdered Sugar Princess"
and "The Princess Nebula" locate Cornell's fantasy within both the fairy-tale
world of the Romantic ballet and the scientific nomenclature of astronomical
phenomena. While today a nebula is defined as a cloud of interstellar dust and
gas, until the middle of the nineteenth century it was thought that nebulae
were clusters of small stars, perceived as a cloud when observed by the naked
eye. Certainly this was the case in Elijah Burritt's *The Geography of the Heavens*,
a popular nineteenth-century astronomy text accompanied by an atlas—
Cornell owned three copies of it—which quoted a verse from John Milton:
"Seen in the Galaxy, that Milky Way, / Which nightly as a circling zone, thou
seest / Powdered with stars."[44]

In devising the character of his Powdered Sugar Princess, Cornell may
have been thinking of the Andromeda Nebula, found in the constellation Andromeda
(fig. 3.15). The mythological daughter of Queen Cassiopeia and King
Cepheus, the beautiful Princess Andromeda was punished for her mother's
boast that her daughter was more beautiful than the sea nymphs. Chained to
a rock at the edge of the sea, she was rescued by Perseus, and together they
were placed among the stars for eternity. Cornell had been fascinated enough
with this constellation in the 1930s to produce a small collage, using a tenth-
century illustration of the constellation superimposed with her neighbor, the
constellation Pisces, both taken from Flammarion's *Les Etoiles*.[45] With her sea
and sky associations, her royal status as a princess, her beautiful distant nebula,
and Cornell's ongoing interest in her, Andromeda seems a likely astronomical
model for Princess Nebula.

During the late nineteenth and early twentieth centuries, nebulae like
the one in Andromeda emerged from comparative obscurity to take center
stage in the science of astronomy, as astronomers turned their attention to the
mysterious formations, studying a set of nebulae known as spiral nebulae.

The nature of spiral nebulae had long fascinated sky watchers. Some, like Immanuel Kant in the mid-eighteenth century, thought they were very distant clusters of stars external to our galaxy, existing as separate "island universes." Others, following Pierre Simon Laplace, believed spiral nebulae were nearby swirling gas clouds within our own Milky Way. In the nineteenth century, these issues remained unresolved, and to the general public nebulae were only vague symbols of the vastness of the cosmos—for instance, Eddy wrote in *Science and Health with Key to the Scriptures* that "the light of spiritual understanding gives gleams of the infinite only, even as nebulae indicate the immensity of space."[46] By the end of the century, though, these opposing conceptions caused a major division in astronomy that continued into the early twentieth century.

To settle the question, in 1920 the National Academy of Sciences in Washington, DC, held a meeting on the topic of the scale of the universe, which became known as the "Shapley-Curtis Debate." Harlow Shapley, a young astronomer famous for his determination of the size of the Milky Way (100,000 light years in diameter, according to his estimate) and the location of its center, held that spiral nebulae were small objects scattered inside the Milky Way. Herber D. Curtis, an older, more experienced astronomer, believed in the "island universe" model, claiming that they were large rotating systems of stars far from our own galaxy. The problem remained unresolved at the meeting because no one could calculate the distance to the nebulae under discussion, but it set astronomers wondering. In 1924, as a young astronomer, Hubble used the 100-inch Hooker Telescope at Mount Wilson in Pasadena, California, to measure the distance to stars in the Andromeda Nebula, showing it to be more than 900,000 light years from Earth, far beyond the bounds of the Milky Way that Shapley had calculated. Thus Hubble proved that the Milky Way was only a tiny bit of an incomprehensibly vast universe.

Hubble kept nebulae in the news. In 1912 Harvard astronomer Henrietta Leavitt had analyzed Cepheid variables, pulsating stars whose pulsation frequency correlates directly with their actual brightness.[47] In 1929 Hubble announced an astonishing discovery. He combined Leavitt's use of Cepheid variables to calculate distance with spectral analysis of distant nebulae to calculate the velocity of the expanding universe. Astronomers knew that the light from distant nebulae was redder than it should be. Hubble realized that the cause of this red shift was motion away from the observer, with a red shift resulting from a Doppler effect in light waves. He began measuring the distances to these receding nebulae and formulated what is now known as "Hubble's Law": the farther away a galaxy is from Earth, the faster it is moving away. By studying the red shift patterns in the spectra of distant nebulae, Hubble optically confirmed what Lemaître had shown mathematically in 1927: the universe was rapidly expanding like a cosmic soap bubble. Hubble used the

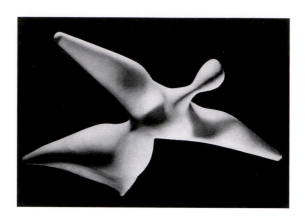

term "nebula," rather than Shapley's "galaxy," in the title of an explanation of his discoveries for the general public published in 1936, *The Realm of the Nebulae*. In fact, during this period, the terms "nebula" and "galaxy" were used interchangeably.

Astronomical findings about nebulae and their cosmological implications captured the popular imagination. Photographs of nebulae appeared in newspapers, and journalists described the latest theories about the location, origins, and composition of nebulae, with literally hundreds of articles in the *New York Times* and *Christian Science Monitor* in the 1930s mentioning the role of nebulae in understanding the size and shape of the cosmos. And artists translated these discoveries into their work. For instance, Isamu Noguchi's sculpture *Miss Expanding Universe*, exhibited in 1932 at the Reinhardt Gallery in New York, illustrated in *Creative Art* in 1933, and shown at the Fantastic Art, Dada, Surrealism exhibition in 1936, envisioned these new cosmological findings (fig. 3.16). Noguchi's sculpture, in turn, gave rise to a ballet entitled *Expanding Universe*, performed in New York in 1933 by Ruth Page wearing a Noguchi-designed sack costume.[48] Nebulae also made their way into popular entertainment, not only in *Ziegfeld Girl*, with nebular Hedy Lamarr dancing down a spiral-shaped staircase that, in the finale of the film, slowly begins to rotate against a starry spiral backdrop, but also on the façade of the building and in the film about the cosmos shown at the Hayden Planetarium's Theater of Time and Space at the 1939 World's Fair (see fig. 2.16).[49] Even Disney's *Fantasia* boasted a sequence featuring a spiral nebula, set to the music of Stravinsky's *The Rite of Spring*.

In Cornell's *Nebula* scenario and related collages, he demonstrated his keen awareness of how nebulae changed conceptions of the universe. Just as Einstein, Lemaître, and Hubble radically revised traditional beliefs about the forces that shape the universe, *Nebula, the Powdered Sugar Princess* opens with a rebellion against the classics. She is sent to a strange, extraterrestrial world, where terrestrial laws of gravity no longer apply, with undersea and

aerial images evoking weightlessness. In his scenario, Cornell initially invoked the microscope, an instrument that scientists and journalists alike used to describe the vastness of space. For instance, in the definition of "nebulae" given in the *Christian Science Monitor's* "A Word a Day" in 1939, the author quoted the eminent physicist Sir James Jeans, who observed that a telescope photograph of the Andromeda nebula "'would have to be enlarged to the size of the whole of Europe before a body of the size of the earth became visible in it, even under a powerful microscope.'"[50] As his ideas developed, Cornell moved away from the microscopic world to one of countless grains of sugar or snowflakes that better paralleled the starry cosmos. Here, too, he echoed current journalistic language about new discoveries: in 1941 the *New York Times* described the Milky Way as being like "snow on a wind-drifted highway."[51]

As Hubble proved, color was essential to nebula research: his examination of the degree of red shifting in the wavelength of specific spectral lines in spiral nebulae enabled him to compute the rate of expansion of the universe. Cornell was aware of the importance of color to nebula research, and he kept colored charts of spectra of the stars and nebulae in his natural philosophy source material file (fig. 3.17). For *Nebula, the Powdered Sugar Princess*, he steered clear of the red end of the spectrum, which scientists used to identify the most distant of visible nebulae. Instead, he opted for shades of green and blue, colors of the closer nebulae. Perhaps he drew upon reports of recent achievements in astro-photography: the observation of the bluish tint of the nebula around the Pleiades, the discovery of a very blue star in the double ring nebula in Lyra, and the observation of the soft, greenish hue of the Great Nebula in Orion, which all warranted mention in the press.[52] When Cornell envisioned his Princess Nebula looking directly into the camera, he may even have been thinking of the remarkable detailed photographs astronomers were taking to study celestial phenomena.

Cornell's creation of a ballet starring a powdered sugar Nebula also corresponded to the ways modern discoveries in astronomy were made accessible to the general public at this time. Metaphors were especially popular with scientists: Hubble resorted to describing the motion of bodies in the Milky Way as a "swarm of bees" buzzing about the universe; Shapley preferred to think of the galaxy as an enormous blueberry pancake; and Lemaître's universe expanded like a giant soap bubble.[53] Building on the ocean metaphor of the island universe, Harvard astronomer Bart J. Bok went so far as to describe the Milky Way investigator as being positioned like a bug located inside a potato in a sack in the hold of a ship who wants to get an idea of what the waves on the ocean outside the ship's hold look like.[54] Journalists followed suit by devising their own colorful language: one noted that, on occasion, "meteors have been as numerous as snowflakes,"[55] while another described the photographic plates used for counting shooting stars as looking like "so many grains of ground

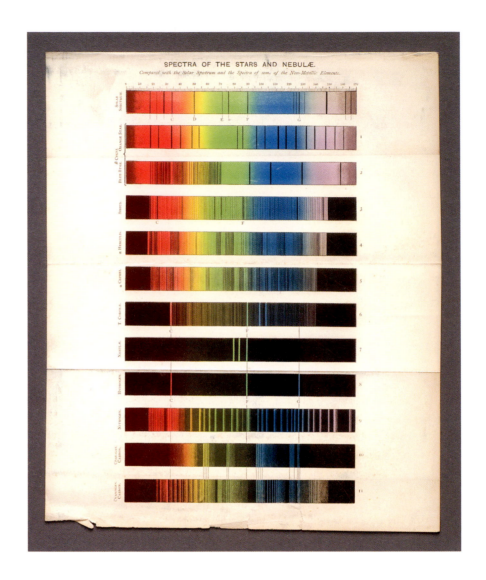

FIGURE 3.17.
"Spectra of the Stars and Nebulae," unidentified source, Joseph Cornell Study Center, Smithsonian American Art Museum. Mark Gulezian/QuickSilver Photographers.

pepper spread out on a sheet of white paper."[56] Cornell's powdered sugar cosmos fit right into the colorful language of the day.

Of the vivid metaphors used to grasp the workings of the universe, the language most suited to capture Cornell's interest was the repeated use of theater terminology. Writers employed such phrases as "the celestial drama" and "the eternal pageant."[57] Stars were "actors," and the movement of the cosmos was a "drama for the cosmic spectator."[58] A spectacular alignment of five planets in 1940 was heralded as "An 'All-Star' Drama of the Skies."[59] One journalist dramatically described the night skies as cinema: "Swinging across the sky in

marvelous patterns and in lovely misty nebulae, they provide a nightly motion picture with you as an audience de luxe."[60] Even ballet comparisons were used. As early as 1930, a writer in the *New York Times* referred to the mathematics of astronomy as "the astronomical *corps de ballet* . . . dancing up and down the scale of numbers,"[61] while in 1934 another described the twinkling of stars as the result of light passing through Earth's atmosphere, which "causes the rays to be bent and turned until they fairly dance."[62] And nebulae were anthropomorphized in the press, put into the language of fairy tales. In 1935 the *Christian Science Monitor* reported in a front-page story that a "New Cinderella" nebula had been identified:

> A tiny waif of the sky . . . has blossomed out of comparative obscurity in true Cinderella fashion to become the most talked-of object in the northern sky. Observers at the Mt. Wilson Observatory recently trained the "big gun" of astronomy on little Miss Nobody and found that this particular system was not speeding away from earth with the customary high velocity found for almost all external galaxies. They noticed the spiral arms, extensions of nebulous mass away from a central nucleus—the identification mark of a spiral nebula.[63]

In Cornell's scenario, Nebula "floats & dances in adoration to the falling snow as her arms continuously open in ecstasy to welcome the falling & drifting clouds of flakes." In a related Toumanova collage, she spreads her arms to play with a spiral-shaped chambered nautilus and wears a spiral shell on her head (fig. 3.18). His imagined film concludes with Nebula standing on a slowly fading celestial balcony, bidding farewell as the stars in her tutu and hair and on her forehead are transformed into a constellation. Cornell wanted this final tableau to be an intensely emotional moment, at one point imagining the balcony fading until only Nebula's glowing eyes remain, and then slowly disappear. An explanation for these details lies in Hubble's astronomical research on nebulae. In addition to studying nebulae to compute the rate of expansion of the universe, Hubble also examined their evolution, proposing that they progressed through a uniform process of unwinding, beginning as elliptical platters of light, like closed books, which opened by turning into spirals that spread their arms constantly wider until a finished star system appears. As reported in the *Christian Science Monitor*, Hubble explained: "'At first the central core is large and the spiral arms thin and closely coiled. The arms grow in bulk at the expense of the central region, unwinding as they grow. In the end the arms are widely open and the central nucleus is inconspicuous.'" He hypothesized that the birth of stars took place during this evolution, with condensations beginning to appear about the middle of the sequence.[64]

Cornell's scenario closely mirrors Hubble's theory. Nebula spreads her arms "continuously open." To the strains of Debussy's *Nuages*, amidst the falling

85

FIGURE 3.18.
Joseph Cornell, untitled (*Celestial Fantasy with Tamara Toumanova*), c. 1941. Collage with sprayed and spattered paint on paperboard, 14½ × 9¼ in. Smithsonian American Art Museum, Gift of The Joseph and Robert Cornell Memorial Foundation.

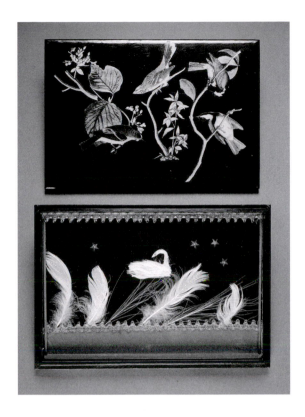

and drifting clouds of cosmic flakes, she sadly fades into the deep blue sky, leaving behind only a few of her stars to become a constellation. Along lines that exactly parallel the popular descriptions of Hubble's theory, she is a spiral nebula that has reached the stage of nebular disintegration, transforming instead into a star system, perhaps the new "feathered constellation" version of Cygnus, the Swan, that Cornell designed from bits of Toumanova's *Swan Lake* costume in late 1940 or early 1941 (fig. 3.19).[65] This is not to suggest that Cornell set out to illustrate Hubble's findings directly. But he does seem to have used them as the "plot" for his unrealized ballet-film. In so doing, Cornell was in touch with his times, creating a scenario for a film that drew on popular enthusiasm for the new discoveries about the universe. Just as Busby Berkeley could dream up an extravagant musical troupe of celestial stars and even a dancing nebula in *Ziegfeld Girl*, and Disney could include a nebula streaking across the sky to classical music in *Fantasia*, Cornell envisioned a production that put a human face on the wonders of the cosmos, cleverly alluding to recent discoveries through the language of popular culture.

In Cornell's early celestial film projects, he combined astronomy and fantasy to invent new ways to envision the cosmos. The visual language he devised

FIGURE 3.19.
Joseph Cornell, *Untitled (for Tamara Toumanova)*, c.1940. Painted wood box with lid and glass front, colored-paper images, velvet, braid trim, feathers, quills, plastic stars, and metallic beads, 11⅛ × 16 × 1½ in. Lindy and Edwin Bergman Joseph Cornell Collection, 1982.1863, The Art Institute of Chicago. Photography © The Art Institute of Chicago.

drew upon long-standing principles of physics, recent astronomical research, and popular culture to produce his own brand of scientifically inspired celestial dreams and movie stars. He continued this approach in two projects begun in the early 1940s in which astronomy and fantasy merge: his chronicle of a child-astronomer named Berenice and his creation of the *Celestial Theater*.

ASTRONOMIA FANTASTICA

THE JANUARY 1943 "AMERICANA FANTASTICA" issue of *View* magazine featured a wraparound cover designed by Cornell, along with a visual essay entitled *The Crystal Cage [portrait of Berenice]*. The cover and essay offer another glimpse into the part astronomy played in his creative process, now as a framework for a complex meditation on science, art, childhood, and the imagination. Published between 1940 and 1947 and edited by Charles Henri Ford, *View* was an avant-garde literary and art magazine with a decidedly Surrealist bent. With covers commissioned from prominent artists, including Man Ray, Magritte, and Duchamp, the magazine was an important link for Americans to European Surrealism. Cornell was well-acquainted with other respected *View* contributors, including Parker Tyler and Tchelitchew, whom he had encountered in film and ballet circles, and he had already published "'Enchanted Wanderer' Excerpt from a Journey Album for Hedy Lamarr" in the December–January issue in 1941–42. Given a prominent role a year later with a cover design and picture essay for "Americana Fantastica," he seized the opportunity to create an artistic statement that, like his unpublished Nebula scenario, merged fantasy and astronomy.

Cornell's centerpiece was *The Crystal Cage [portrait of Berenice]*, a seven-page spread of images and texts.[1] Organized more like a booklet than a traditional article, *The Crystal Cage [portrait of Berenice]* opens with a full title page, embellished with vignettes of the Sun and Moon above and below the text. Facing the title is a page of typed words arranged to form the silhouette of an ornate vertical tower. The third and fourth pages include five short texts and a photograph of a stone tower (fig. 4.1). The next two pages feature a nineteenth-century print, entitled *The Childhood of Blondin*, showing a young tightrope walker crossing a river, as well as a detailed collage including a variety of little girls, newspaper headlines, and constellation charts. The final page, captioned "Berenice of 1900 gazing into her own past and future," has a photograph of a little girl looking in a window, while below, in a block of text surrounded by stars, is a "Key to Preceding Page," which explicates some of the details of the collage (fig. 4.2).

CHAPTER IV

THE

Crystal Cage

[portrait of Berenice]

The Crystal Cage

The recent unearthing (1934-1942) of a wealth of paraphernalia, charts, photographs, manuscript notes, etc., a welter of "varia" of formidable proportions, finally establishes beyond any possibility of doubt the existence of the legendary PAGODE DE CHANTELOUP, that curious relic of scientific research in the nineteenth century.

* * *

PAGODE DE CHANTELOUP — The reader will search in vain in the literature of the past for briefest mention of this neglected phenomenon, and the conclusion may be drawn that it was pigeonholed with the countless hoaxes that abounded in the scientific field during the past century, of which E. A. Poe's "Balloon Hoax" is a classic example.

* * *

From newspaper clippings dated 1871 and printed as curiosa we learn of an American child becoming so attached to an abandoned chinoiserie while visiting France that her parents arranged for its removal and establishment in her native New England meadows. In the glistening sphere the little proprietress, reared in a severe atmosphere of scientific research, became enamoured of the rarified realms of constellations, balloons, and distant panoramas bathed in light, and drew upon her background to perform her own experiments, miracles of ingenuity and poetry.

* * *

[This research, with which few people are acquainted, may result in experiences such as those depicted in the excerpts of the following letters.]

Excerpt from a letter of Sept. 16, 1942:

* * * Last Thursday night I was invited to drive out to a secluded part of the south shore of Long Island after a sultry day spent in the city. Finishing dinner I wandered along towards the water in the hope of finding an interesting piece of flotsam before the light faded. Intent upon my mission, I almost collided with a child of about six years bent over the sands for the same purpose. In three or four minutes we were life-long friends, and there was just enough time before the darkness completely enveloped us for me to become impressed by the deep earnestness and sweetness expressed in her features. I was soon the recipient of the startling information that she was in the habit of getting up at dawn and picking up real stars on the beach before anyone was awake to discover her secret and that Indians from across the water had fashioned a shining white birch canoe solely for her use, which was carefully kept hidden in the woods. I might see it if I came back again sometime. Other revelations were forthcoming when a voice from the direction of her cottage shattered the twilight calm ordering her to bed quickly and on feeling about it seemed impossible to convey to you the effect her words had in the dark, especially as they died out wistfully in the distance as she kept up her earnest chatter. Right away for some reason I thought of the little girl and her glass tower that you told me about. * * * The easiest way for me to try to convey the emotion aroused by this experience is to ask if you have recently read Hawthorne's "SNOW IMAGE." * * *

P.S. I am saving a seashell for you that looks just like a star.

Letter of November 21, 1942:

* * * It may have been the biting cold that Saturday morning that made glow any routine trifle with the slightest glint of warmth; it may have been the desperate mood. Which still would not explain the first signs of activity in the brick tenement. A tenement observed almost daily for years and years from the vantage-point of the head of the first subway car with the skyscrapers starting to loom up across the river. Observed for the trimness of its windows and the embarrassing proximity of its red brick walls to the elevated tracks. It was over in a flash, a flash that didn't even reveal the faces as the car made a lurching turn and headed for the tunnel. But retained crystal clear the fragment of a tableau of three little girls scattered about the room, the oldest, a touch of red in her costume, with right arm outstretched in a gesture of command. It was the bareness of the room — an unexpected and confusing bareness never before observed — that etched the fragment of action of the scene panto so strongly, like a memory of childhood. And it was all over in less than a split-second as the serpentine cars straightened out and went under the river. * * * On the way in, the tableau persisted. Upon what business of solemn urgency had the oldest girl charged her aides with that imperious gesture? To scratch out their sisters in unknown lands in their seven-league boots? To seek to break the spell of the evil ogre who had transformed them into croaking frogs? It was a secret sealed forever. But none the less that little arm held a key that began to unlock dreams. In one other flash and with overwhelming emotion came the realization that your Berenice had been concentrated, leaving a scattering of star-dust in her train. * * *

The Crystal Cage

FIGURE 4.1.
Joseph Cornell, *The Crystal Cage [portrait of Berenice]*, *View*, ser. 2, no. 4 (January 1943): 10–13 ["Americana Fantastica" issue]. Layout with photomontage and text, open $10^{5}/_{16} \times 14^{1}/_{2}$ in.

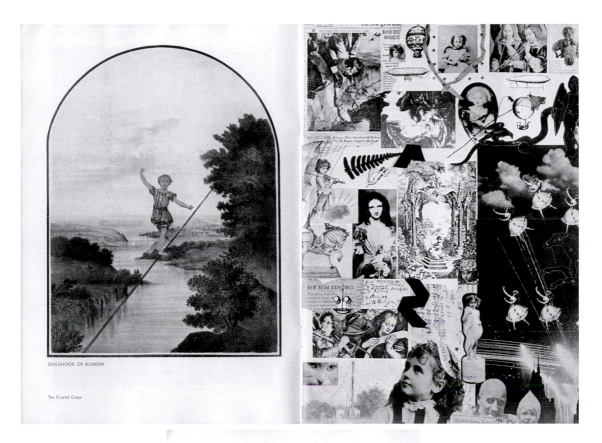

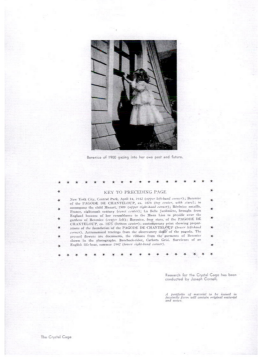

Figure 4.2.
Joseph Cornell, *The Crystal Cage [portrait of Berenice]*, *View*, ser. 2, no. 4 (January 1943): 14–16
["Americana Fantastica" issue].

A PAGODA OBSERVATORY FOR BERENICE

Cornell's "article" begins on the third page of the layout, with the first of three horizontal block quotations:

> The recent unearthing (1934–1942) of a wealth of paraphernalia, charts, photographs, manuscript notes, etc., a welter of 'varia' of formidable proportions, finally establishes beyond any possibility of doubt the existence of the legendary PAGODE DE CHANTELOUP, that curious relic of scientific research in the nineteenth century.

Here Cornell describes his own act of assembling source materials to create a "factual" basis for his *Crystal Cage* fantasy, a process he continued long after the *View* project. The second block text explains the obscurity of the subject, by comparing it to a story by Edgar Allan Poe:

> PAGODE DE CHANTELOUP—The reader will search in vain in the literature of the past for briefest mention of this neglected phenomenon, and the conclusion may be drawn that it was pigeonholed with the countless hoaxes that abounded in the scientific field during the past century, of which E. A. Poe's "Balloon Hoax" is a classic example.

Cornell then establishes the "facts" upon which his fantasy rests:

> From newspaper clippings dated 1871 and printed as curiosa we learn of an American child becoming so attached to an abandoned *chinoiserie* while visiting France that her parents arranged for its removal and establishment in her native New England meadows. In the glistening sphere the little proprietress, reared in a severe atmosphere of scientific research, became enamoured of the rarified realms of constellations, balloons, and distant panoramas bathed in light, and drew upon her background to perform her own experiments, miracles of ingenuity and poetry.

Thus we are introduced to Berenice, Cornell's child-astronomer, and her pagoda-observatory, seen in the photograph on the facing page. Excerpts from two letters dated 1942 offer different verbal pictures of her. The first describes meeting a child on a beach at sunset. She informs the narrator that she is in the habit of getting up at dawn to collect real stars. The second letter relates a glimpse from the elevated railroad, "all over in less than a split second," in which a young girl stretches her arm in a gesture of command: "In another flash and with overwhelming emotion came the realization that your Berenice had been encountered, leaving a scattering of star-dust in her train. * * * " Here, then, is Cornell's Berenice: a time traveler who lives in both 1871 and 1942, and whose connecting link is the stars.

Berenice's fate revolves around the "Pagode de Chanteloup," the tower presented in three forms: texts that position it as relic of research, hoax, and historical artifact; the photograph of a stone tower; and a tower of words. An actual construction, the Pagode de Chanteloup was built by the duc de Choiseul in 1775 and was all that remained after his estate was destroyed in 1823. It was not an observatory, however, until Cornell declared it so, in a gesture that borders on a hoax, like that perpetuated by Poe in his story "The Balloon Hoax," first published in 1850 as a "factual" newspaper account of a fictional trans-Atlantic balloon crossing. Scholars have grappled with the complexities of Cornell's *Crystal Cage* project, interpreting it as an intellectual prism; a metaphysical visualization of Christian Science concepts; an essay on childhood, innocence, and temporality; and an exploration of the marvelous in the everyday with links to popular culture, especially film.[2] While these explanations are valid ways of thinking about this deeply nuanced project, none examines its astronomical underpinnings in detail. To do so, we must turn to the history of astronomers and observatories.

Berenice is an unexpected addition to Cornell's pantheon of sky watchers, which featured famous male astronomers, from Galileo to Hubble. There were, however, significant women astronomers who paved the way for Cornell's imaginary Berenice, such as Caroline Herschel, who assisted her brother William Herschel, astronomer and discoverer of the planet Uranus, in developing a modern mathematical approach to astronomy. She catalogued some 2,500 nebulae before her death in 1848. In his papers, Cornell kept a page from *Astronomie Populaire* portraying Caroline and William Herschel (see fig. 1.9), together with pictures of their telescope.[3]

Cornell's fascination with a little girl who studies the stars probably also stemmed from his student days at Phillips Academy in Andover, which used the observatory at Abbot Academy, a nearby school for girls, for astronomy classes. The observatory was constructed in 1875 in consultation with prominent astronomers, including another prototype for Berenice, Maria Mitchell.[4] Born on the New England island of Nantucket, Mitchell grew up "in a severe atmosphere of scientific research," as she was trained by her father, a teacher and amateur astronomer. In 1847, from the roof of the Nantucket bank, she became the first person to discover a comet by using a telescope. Over a century later, scientists made a pilgrimage to Nantucket to honor her, an event reported in newspaper articles Cornell saved after scrawling Berenice's name in the margin of one of them.[5] As a professor at Vassar, Mitchell helped train a generation of astronomers, who, by the 1930s, comprised the famous "female galaxy" at the Harvard Observatory, led by Dr. Annie Jump Cannon. Cornell may have been further stimulated by Grandville's illustrations in Méry's *Les Etoiles*, which included an engraving showing women astronomers at work (fig. 4.3).

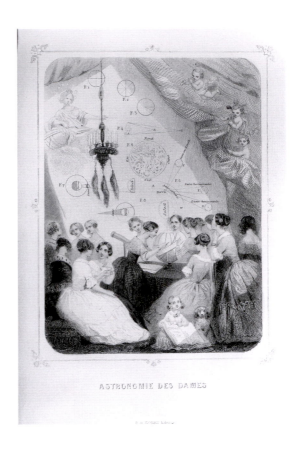

ASTRONOMIE DES DAMES

FIGURE 4.3.
 J. J. Grandville,
Astronomie des Dames, in
Joseph Méry, *Les Etoiles*
(Paris: Gonet et
Twietmeyer, 1849). The
Metropolitan
Museum of Art, Gift of
Lincoln Kirstein, 1970
(1970.565.417). Image ©
The Metropolitan
Museum of Art.

Cornell's fantasy of a glistening laboratory where Berenice could study the "rarefied realms of constellations" reflected contemporary interest in astronomy technology. In the nineteenth and early twentieth centuries, improvements in mirror making, glass grinding, and lens technology enabled the construction of increasingly large telescopes. These fascinated Cornell, and he placed pictures of many of them in his files, but they were all overshadowed by the 100-inch Hooker Telescope, built in 1919 at the Mount Wilson Observatory in California. With the largest reflecting telescope in the world, Mount Wilson became the world's foremost astronomical research facility for the next thirty years, issuing reports of findings that changed both scientific and popular notions about the universe (fig. 4.4).[6] Moreover, throughout the 1930s newspapers buzzed with stories about yet another new telescope that would make all of the others obsolete: the 200-inch telescope under construction for California's Mount Palomar Observatory.

Astronomers like the Herschels, Mitchell, and Hubble all had observatories, but none as ornate as Berenice's Pagode de Chanteloup. For its model, Cornell probably turned to an older castle of the stars: Tycho Brahe's observatory, Uraniborg, on the Danish island of Hven in the Baltic Sea. Tycho's best-known

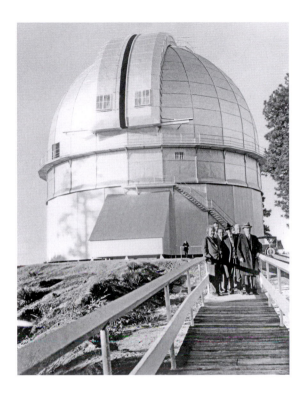

FIGURE 4.4.
Albert Einstein, Edwin P.
Hubble, Walther Mayer,
Walter S. Adams, Arthur
S. King, and William W.
Campbell on the foot-
bridge leading to the 100″
telescope at Mount
Wilson. Reproduced by
permission of The
Huntington Library, San
Marino, CA.

contribution to the history of astronomy was the observation in 1572 of a supernova, still known as "Tycho's nova," in the constellation Cassiopeia. The appearance and subsequent disappearance of a star bright enough to be seen during broad daylight proved that the universe could change and evolve, shattering the Pythagorean concept of the cosmos as a fixed cage of crystalline spheres circling Earth.[7] In recognition of Tycho's findings, King Frederick II of Denmark provided resources for an observatory. Tycho erected a multi-storied tower over a pavilion that contained instruments, including his great mural quadrant for plotting the positions of the stars (fig. 4.5). He even built a separate building for a printing press, disseminating his discoveries until 1597, when he fell out of favor and fled to Prague, where Johannes Kepler became his assistant. Working before the invention of the telescope, Tycho spent much of his life compiling a comprehensive set of astronomical tables, later published by Kepler, who used them to determine his laws of planetary motion. Cornell admired Tycho enough to mount an engraving on paperboard of him, taken from *Astronomie Populaire* (see fig. 1.9), to save clippings about Tycho's observatory, and to refer to the nova of 1572 and Uraniborg in numerous works throughout his life.

Cornell could very well have had Tycho in mind when he conceived his *Crystal Cage* project for *View*. By the 1940s Tycho's achievement was well-known from the place of honor given to it in star atlases, foremost among

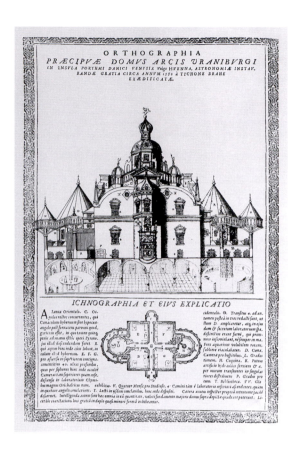

FIGURE 4.5.
Tycho Brahe's Observatory of Uraniborg, Island of Hven, 1580. Joseph Cornell Study Center, Smithsonian American Art Museum. Mark Gulezian/QuickSilver Photographers.

them Johannes Bayer's *Uranometria* of 1603. Bayer's engraving of Cassiopeia featured the familiar stars tracing the seated queen on her throne, as well as Tycho's nova, a huge star seen to the left of the figure (see fig. 1.7). While Tycho was frequently cited throughout the early twentieth century as a founder of modern astronomy, he appeared in the news less than two months before Cornell's contributions to *View* were published, when a new star exploded. The brightest stellar burst seen since 1918, it elicited frequent comparisons to Tycho's nova.[8]

Already in the 1930s, Cornell had produced a collage using a full-page reproduction of Bayer's drawing of Cassiopeia with Tycho's nova, taken from Flammarion's *Les Etoiles* (fig. 4.6). In addition to color and shading, Cornell added a thimble with a handle: a whimsical version of the Little Dipper. He also included a box with a naughty fish protruding between her legs.

Between 1910 and 1937, a variable star in Cassiopeia became an increasingly bright supernova, only to fade noticeably in the following three years, enabling backyard observers like Cornell to experience not only a new nova in 1942 but also the waning supernova in Cassiopeia between 1938 and 1941.[9]

The direct experience of observing these novae could have encouraged him to model Berenice's opulent observatory on Tycho's castle of the stars, drawing inspiration from the sixteenth-century woodcuts of Uraniborg frequently reproduced in books about the astronomer.[10] He may even have transformed the historical fact of Tycho's printing press into the dense tower of typed words that faces the opening page of *The Crystal Cage [portrait of Berenice]*.

FIGURE 4.6.
Joseph Cornell, *Untitled (La Cassiopée)*, 1930s. Collage, $7\frac{3}{16} \times 5$ in. Estate of Joseph Cornell, Courtesy L&M Arts. Photo: Christopher Burke Studio.

AN ASTRONOMICAL TOWER OF WORDS

Cornell's first mention of the Pagode de Chanteloup described an eight-year "unearthing" of a "welter of 'varia' of formidable proportions" that established the existence of the pagoda-observatory. In his *View* magazine essay, he envisioned the "welter of 'varia'" as a tower composed of 630 words or parts of words arranged in 114 lines of variable size, to form the silhouette of Berenice's observatory. The majority of the words are nouns that, with an occasional adjective, delineate a vast collection of things, although around 100 words are proper nouns, primarily names of scientists, writers, and visual and perform-

ing artists. At first glance the structure seems to be a Tower of Babel, a verbal enactment of the postcards and magazine reproductions of Pieter Bruegel's famous painting of the Tower of Babel that Cornell kept in his files. Words are piled upon words in a seemingly haphazard manner, so that their semantic meanings seem subordinate to their role as a pattern of marks on paper. A daunting outpouring of words creates architecture out of what Michael Moon calls Cornell's "oralia," his obsessive impulse to produce language, most often in the form of diary entries and long telephone conversations, but here, literally and figuratively, as clues to the mysteries of the universe.[11] However, the word tower is not gibberish. It is a carefully chosen collection of concepts that provide important clues to understanding Cornell's complex, often convoluted, scientific and spiritual cosmology.[12]

Not surprisingly, in Berenice's word-tower observatory Cornell emphasized aspects of astronomy, incorporating the word "constellation" and constellation names, "Cygnus," "Gemini," "Auriga," "Ursa Major," and "Andromed[a]." He specified planets and other astronomical phenomena, including the "mountains of the moon," "[p]hases of the moon," and the "Milky Way." He mentioned "Archimedes," "Leonardo," "Kepler," and "[C]olumbus," all natural philosophers, artists, or explorers who studied the stars. With other terms he named architectural structures associated with observatories, such as "skylights" and "look-outs windows." He cited buildings whose shapes or functions parallel Berenice's observatory: "palaces of light," "planetariums," and even the "World's Fair of 1940," with its focus on modern space exploration. He provided the tools for spectroscopic analysis by naming the colors of the spectrum. Light is spread throughout: "[sk]ylights," "star-lit fields," "[l]ighthouses," "[m]agic lanterns," "illumination," "[r]eflections," "golden," "stars," "searchlights," "luminosities," shafts of light." "Dramas of light," "rainbows," "radiance," "iridescent," and other illuminating words link earthly and celestial brightness. Cornell also mentioned optical technologies involving light: "magic lanterns," "zoetropes," and "cinematography." He even honored "Fresnel's system," naming the French physicist Augustin-Jean Fresnel, who first proposed a mathematically convincing wave theory of light in 1815 and invented a revolutionary device for lighthouses that transformed the light of an oil lamp into a blinding beam.[13]

As in his early soap bubble sets and *Children's Party* film, gravity is an important theme. In the tower, Cornell sprinkled words that suggest a momentary escape from gravity as part of his "unearthing." The words "Soap bubbles" recall aspects of gravity examined in his first *Soap Bubble Set*. Other familiar and arcane terms explore the theme of flight. He cited specific examples of humans who defy gravity, if only temporarily, and he mentioned "voyages celestes," hot-air "balloons," "ascensions," and "montgolfiers," as well as their inventors in 1783, the brothers Joseph Michel and Jacques Etienne "Montgolfier." Appropriately for a young girl's observatory, he reminded readers of the first lady of hot-air balloon flight, "[M]adame Blanchard,"

(Madeleine-Sophie Blanchard), who ascended to heights of twelve thousand feet and performed aerial fireworks shows from her balloon before plunging to a fiery death in 1819.

Feats that seem to defy gravity also appear in the "circuses" to which Cornell directed our attention. He announced "rope dancers" and "Bird Millman," famous for her balletic grace on the tightrope in the 1920s. Against the musical backdrop of twice-mentioned "calliopes," as well as a "[merry]-go-round," he took his audience on a flying trapeze by naming the Flying "Wallendas," headliners with Ringling Brothers, Barnum & Bailey Circus during the 1930s and 1940s. He reincarnated high-wire experts of the preceding century: "Madame Saqui" (Marguerite Antoinette Saqui), celebrated in the early nineteenth century for climbing the slack rope to heights of fifty feet or more amid displays of fireworks, and La Signorina Maria "Spelterina" and "Blondin" (Jean François Gravelet), both renowned for crossing Niagara Falls on a tightrope in the nineteenth century. Moreover, Cornell devoted a full page to Blondin's childhood in *Crystal Cage [portrait of Berenice]*.[14]

Cornell also found momentary release from the bounds of gravity in the arts. He mentioned the "aerial flights of Carlotta Grisi." He considered the uplifting qualities of music, and he cited a variety of composers, performers, and titles of musical works, such as "Mozart" and "Eine Kleine Nachtmusik." Visual art and literature also form part of the fabric of the tower. He named artists, among them "J. J. Grandville," and he paired painters and specific works, including the stargazing "magi of Gozzoli." He referred to tales and poems about imaginary wonders by Nathanial Hawthorne and Poe, citing Poe's stellar poem "Israfel." Admiring figures that walk among the stars on rooftops, he alluded to Charles Lamb's essay, "The Praise of Chimney Sweepers," by citing roof-walking "[c]himney sweeps."[15]

As a "welter of varia," Cornell's word tower provides a dense network of words that sets a kaleidoscopic variety of associations in motion, taking us to an imaginary site where we are barraged with people, places, lights, and sounds. Stimulated to the point of excess, we can hardly take it all in. In conceiving Berenice's observatory in words and images, Cornell offers a dizzying experience similar to a trip to an amusement park, specifically to the appropriately named "Luna Park" at Coney Island. Opened in 1903 and in business until the last buildings burned down in 1949, Luna Park was a fixture of Cornell's childhood and early adult years.[16] Along with millions of other annual visitors who played at this toyland for adults, he was entertained with a breathtaking array of lights, rides, performances, displays, fountains, and music. In fact, Cornell's word tower seems designed to replicate the Luna Park experience, not only in the onslaught of stimuli but also in its creation of a rich realm of fantasy.

As one entered, on the left was the premier attraction, A Trip to the Moon, in which visitors boarded an airship with flapping wings and rose over a panorama of Coney Island and the skyscrapers of Manhattan before

embarking on their imaginary journey to the Moon, echoing Cornell's themes of "skyscrapers," "ascension," and "voyages celestes." Another building housed Luna Park's Twenty Thousand Leagues Under the Sea attraction, balancing the aquatic with the celestial, and perhaps inspiring the word tower's references to "Atlantis voyages," "Neptunes," and "mermai[ds]." Along the edge of a man-made canal were long rows of hand-cranked mutoscopes where visitors could see moving pictures flip by for a penny, recalling the "zoetropes" and "flutter wheels" in Berenice's observatory pagoda. Nearby, two circus rings featured equestrians, trapeze artists, rope dancers, and high-wire acrobats, all of whom warrant mention in the word tower, and the sounds of the word tower's "fan-fares," "hurdy-gurdies," and "calliopes" filled the air. There were Ferris wheels, based on the principle of the word tower's twice-mentioned "Persian wheel." "Marvels of motion" could be found in the moving stairways, as well as "aerial" rides that offered "panoramas" of the "scenic railway" behind the Shoot-the-Chutes with its cascading "waterfall." Another display, A Trip to Niagara, featured a miniature replica of the falls, also named in the word tower.

The most astonishing feature of Luna Park came at night, when the lights went on.[17] Extravagant electrical lighting was a hallmark of Luna Park, and on this the word tower's emphasis is clear with its many allusions to light. In a normal Luna Park season there were nearly a million and a half electric lights in use, most of them mounted on over two thousand fanciful Orientalist towers and minarets. The focal point was the 200-foot-high Electric Tower, a pado-ga-like structure that slowly took shape at night, lighting line by line. In front of the crystalline Electric Tower, on a raised platform over a reflecting lagoon, a circus performed in an open cage lit by spotlights, with the starry sky as a back-drop. Cornell was clearly fascinated by this man-made galaxy of incandescent light, and he acquired a set of postcards picturing the park at night in 1936 and compiled other postcards and clippings illustrating Luna Park over the years (fig. 4.7). Prominently featured in nearly all of them is the Electric Tower, whose ornate shape is startlingly similar to Bernice's observatory, which Cornell later described in a note as a "crystal tower of lights looming alongside bay and over the water."[18]

Such was the brilliant Luna Park of the 1930s. However, when Cornell de-signed his contributions for *View* magazine in 1942, it was a drastically differ-ent place. With wartime regulations requiring that the lighting not be seen by overhead enemy planes or offshore boats, illumination was instead provided by soft blue and dark purple lamps. Although most visitors probably found this a dreary, even scary change from the glittering prewar scene, Cornell must have loved this dreamy, liminal world. Without land light to mar the view, the stars would have sparkled with rare depth and intensity. Indeed, the experience of visiting the park under wartime conditions may lie behind the many boxes fronted with deep blue glass that he produced from the mid—1940s on, as well as three gallery exhibitions of night-sky boxes that took place after the war.[19]

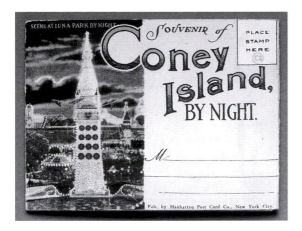

Certainly it lay behind his presentation of Berenice's observatory, a conceptual tower of words and images capable of taking viewers on a roller-coaster ride through time and space to the wonders of the cosmos.[20]

STARRING BERENICE

In addition to the observatory, presented as photograph and text, Cornell's contribution to *View* magazine included a collage entitled *The Crystal Cage*, a photographic reproduction of a dense collection of clipped headlines, photographs, engravings, written numbers and words, and, in the original, actual ribbons and even a pressed flower and leaf. As Cornell indicated in the "Key to Preceding Page" found on the next page in *View*, Berenice appears in a variety of forms: in the upper left corner she is in Central Park on April 14, 1942; at the top center she is surrounded by stars as Berenice of the pagoda around 1870; at the upper right she accompanies the child Mozart in 1909; in the center is "Berenice rocaille" from the eighteenth century; at the bottom he located "Berenice, four stars, of the Pagode de Chanteloup." Moreover, in his key Cornell specified that the astronomical tracings are from the observatory dome of the pagoda; the pressed flowers are documents; the ribbons come from the clothes Berenice wears in the photographs; the print of a pole with wires in the lower left corner shows "preparations of the foundation of the Pagode de Chanteloup." He noted the presence of "bareback-rider, Carlotta Grisi" and specifies that in the lower right-hand corner are "survivors of an English life-boat, summer 1942."[21] Cornell described his collage as the predecessor to another work, announcing at the bottom right of the *View* page, "A portfolio of material to be issued in facsimile form will contain original material and notes."

The collage reiterates many of the ideas introduced in the word tower. The observatory theme is underscored with constellations, as well as a photograph

FIGURE 4.7.
Coney Island by Night, folding postcard set, labeled "Joe Aug. 9, 1936." Joseph Cornell Study Center, Smithsonian American Art Museum. Mark Gulezian/ QuickSilver Photographers.

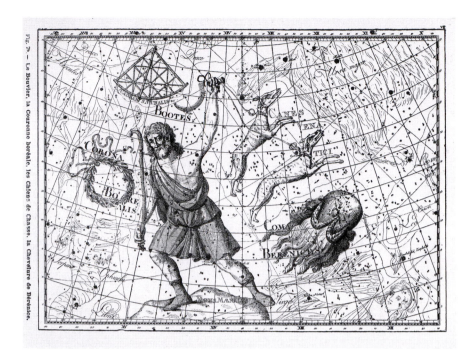

FIGURE 4.8.
Le Bouvier, la Couronne boréale, les Chiens de Chasse, la Chevelure de Bérénice, in Camille Flammarion, *Les Etoiles* (Paris: C. Marpon et E. Flammarion, 1882).

in the lower right corner of an illuminated night sky. A newspaper headline, "New Star Explodes," highlights the recent nova, while the list of numbers above Berenice at the bottom recalls the careful numerical records of star positions kept by astronomers like Tycho and Caroline Herschel. As in the word tower, Cornell implies the desire to escape the bounds of Earth's gravity. At the center top is Montgolfier's intricately decorated balloon, along with blimps, dirigibles, and fanciful flying machines. Other uplifting subjects reiterate this theme: accompanied by musical angels, ballerinas leap into the cloudy, starry sky, while an angel rests a banner bearing the word "Ascendet," the Latin verb "to ascend," on the hair of Berenice.

According to star lore, Berenice's hair did ascend to the heavens. Among the constellations of the night sky is Coma Berenices, Berenice's Hair, first recorded in Tycho's star catalogue and illustrated in Flammarion's *Les Etoiles* (fig. 4.8).[22] The name derives from Queen Berenice, wife of Ptolemy III of Egypt, who offered her hair in exchange for the safe return of her husband from war. When it disappeared from the altar, the court astronomer declared it transferred to the heavens as a glittering mass of stars. Cornell included the constellation in the upper right corner, in the form of a photograph of a woman's hair seen from behind, as well as in the name of his girl-astronomer. In related notes he specified the direct connection between his Berenice and the constellation.

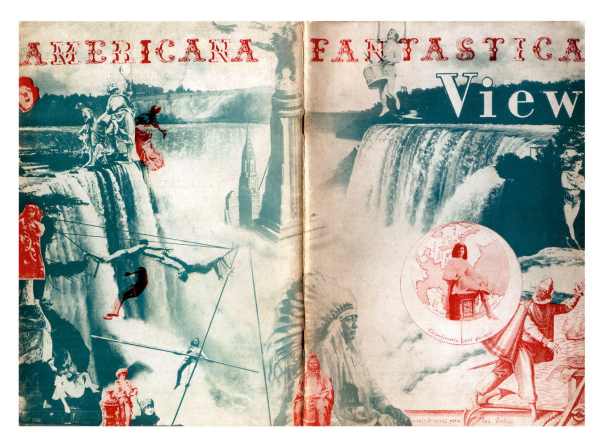

Cornell's Berenice may also have ties to her namesake in Poe's short story "Berenice," a terrifying tale of physical and mental disintegration.[23] Unlike Poe's Berenice, Cornell's Berenice is a picture of Christian Science health, reinforced by the references to the famous tightrope walker Blondin, whom Mary Baker Eddy used as an example of the application of "moral mind" to conquer fear.[24] While the characters in Poe's horrific story lack the faith to combat disease, Blondin's high-wire heroics in crossing Niagara Falls demonstrate the strength of the divine Mind that overcomes fear. Countering Poe's Berenice, a figurative spent meteor whose brilliance is only a memory, is Cornell's Berenice, a fearless celestial traveler, capable of transcending not only illness, but even time and space.

To fully understand the significance of the collage's details and organization, we must first turn to another of Cornell's creations for *View*: the wraparound front and back covers (fig. 4.9). Beneath the "Americana Fantastica" title and set against an aqua-tinted photograph of Niagara Falls is a collection of seemingly unrelated figures: Native American, circus performers, even King Kong. When the magazine is closed, the front cover simply reads "Fantastica

Figure 4.9.
Joseph Cornell, *Americana Fantastica, View*, ser. 2, no. 4 (January 1943): front and back cover, open 10⁵⁄₁₆ × 14½ in.

View," and this is just what Cornell gives us. Lacking a specific viewpoint, we look out at the falls, down on the boat, map, compass, and striding figure in the lower right corner, up at the drummer boy at the top. And if we turn to the back, we are below the tightrope walker, on the same level as the trapeze artists, and looking down at the boy beside the pedestal at the bottom center. But this is a fantastic view with a distinct, if unexpected, orientation that links the cover to the story inside of Berenice, the child-astronomer who finds her way to the stars, for what we are looking at is Cornell's own fantastic, American chart of the constellations (fig. 4.10).

The key to the puzzle is the central figure on the front cover: a woman high above a map, wearing a filmy white dress and a crown, seated with her legs crossed on a square throne. Her head is positioned against North Africa. Here is the American vaudeville actress Fanny Ward, cast by Cornell in the role of the boastful Queen of Ethiopia, Cassiopeia.[25] To her lower right, striding forward with one arm raised is a figure of Columbus, taken from an allegorical commemoration of his discoveries in the New World first published in 1621 and reprinted in a book honoring the four hundredth anniversary of his voyage. But here he also stands for a second constellation: Cassiopeia's husband, King Cepheus, whose pose, crown, and flowing cape are strikingly similar in Bayer's early star chart.

Above and to their right is a photograph of a circus muscle-man named "Little Todd" wearing short black boots, now filling in for the constellation Boötes, the booted strongman of the sky. To the upper left of Cassiopeia is a photograph of a man with a drum hanging in midair, the acrobat Verrecke, with a trapeze behind him. The shape of his body with the drum, like the shape of the thimble with the handle in the early Cassiopeia collage, mimics that of the Little Dipper. And what about the two Native Americans in the lower left? These are not anonymous figures, but readily identifiable photographs of the same person: the Lakota Sioux chief Sitting Bull, transformed into a fantastic American version of the constellation Taurus, the bull battled by the hunter Orion each night in the distant sky.

The back cover yields further celestial wonders. Paired trapeze artists stand in for the twins, Castor and Pollox, of the constellation Gemini. Below them, a tightrope walker's balance bar and rope form the shape of Cygnus the Swan, also known as the Northern Cross. Beside the tightrope walker is a young man with a garland across his chest, leaning on a pedestal shaped like the constellation Orion. To his left are a large rock, a monster, and a maiden, perhaps alluding to the story of Andromeda. In the upper center is a man with an arm outstretched standing on the rushing water while holding an inverted jar: the constellation Aquarius. At the top is King Kong, a furry monster familiar from American popular culture poised high in the sky, in the role of Ursa Major, the Great Bear.[26] At the extreme upper left is a disembodied face whose dark hair suggests Coma Berenices herself, the hair of the Egyptian Queen.

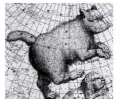

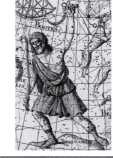

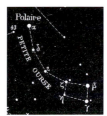

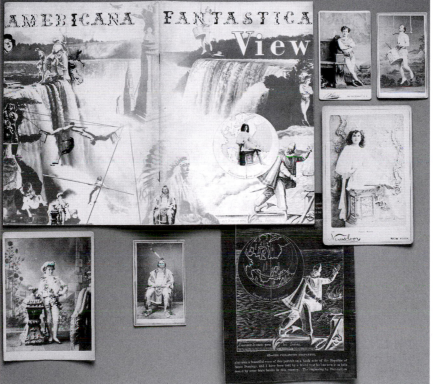

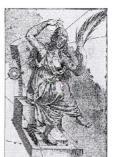

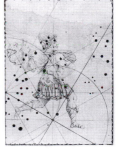

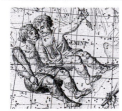

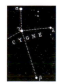

OPPOSITE PAGE:
FIGURE 4.11.
Joseph Cornell, *The
Crystal Cage, View*, ser. 2,
no. 4 (January 1943): 15
["Americana Fantastica"
issue], with comparative
constellations, *clockwise
from upper right*: Coma
Berenices, Globus
Aerostaticus, Equuleus and
Pegasus, Lepus, Felis, Leo,
and Perseus from Bode,
Uranographia, 1801; *at
center left*: Cassiopeia,
from Hevelius,
Selenographia, 1647.
Constellations in
Flammarion, *Les Etoiles*
(Paris: C. Marpon et E.
Flammarion, 1882).

Cornell took liberties with the constellations, recasting and Americanizing them by punning on their traditional representations. Although not all of their positions are accurate, they are surprisingly close enough to approximate a view of the winter sky for a January issue of a magazine. As in *Nebula, the Powdered Sugar Princess*, the aquatic and the celestial become interchangeable, and the foaming water of the Niagara River provides a down-home American equivalent to the galactic Milky Way. Set against the churning water are Cassiopeia, Cepheus, Cygnus, and Gemini: constellations all seen in the Milky Way on a winter night. Cornell may have also intended the roiling waters of Niagara Falls to cross-index the "Whirlpool Galaxy," a magnificent spiral galaxy known to astronomers as M[essier] 33. The first spiral galaxy found, M 33 convinced astronomers that spiral galaxies rotate, as announced in *Scientific American* in 1942.[27]

Positioning constellations above Niagara Falls also adds an additional layer of complexity to Cornell's constellation chart. In the history of celestial atlases, mapmakers chose to portray either an "internalist" or an "externalist" view, orienting the stars as seen from Earth, looking to the heavens, or from the heavens looking down to Earth. Thus, some maps show personified constellations from behind, while others show the figures frontally. Cornell combines both viewpoints: an internalist view, if Niagara Falls is the Milky Way, and an externalist view, if the falls are a feature on Earth's surface. He was fascinated by this idea, and in his papers he kept an envelope with a pile of thin sheets on which he wrote the names of constellations in calligraphy ink, then folded the papers to produce mirror views of the names, as if seen from behind. On the back of the manilla envelope Cornell wrote, "Constellar Names in Italic ~~Rohrschach~~," indicating the parallel he saw between the mirror image of constellation names and the abstract shapes used in Rohrschach tests, a topic that also interested him.[28] This duality was in keeping with Christian Science belief, where Eddy predicted, "The seasons will come and go with changes of time and tide, cold and heat, latitude and longitude. . . . The astronomer will no longer look up to the stars,—he will look out from them upon the universe."[29]

Returning to the *Crystal Cage* collage (fig. 4.11), again Cornell charts a vision of the stars. In the center is "rocaille Berenice," with one arm raised, wearing a crownlike hat, and seated on a raised platform. Once more we encounter Cassiopeia, perhaps inspired by the Rococo version in Hevelius's star atlas of 1690 reproduced in Flammarion's *Les Etoiles*. To her left is the headline "New Star Explodes," referring not only to the sighting of a nova in the autumn of 1942, but also, by extension, to Tycho's star of 1572, positioned just to the left of Cassiopeia's throne in star charts like Bayer's. Above the new star is a horse, with the negative space between his back and the legs of the figure standing on him forming the shape of a wing: the winged horse, Pegasus, appearing roughly where it actually is in the north-facing sky, to the west of Cassiopeia.

On his back is a young boy with an umbrella—perhaps a modern Perseus with an updated shield to defeat the Gorgon Medusa.[30]

To the upper right are the constellation tracings Cornell noted in the key to the collage: Virgo, the Virgin, Hydra, the Serpent, and Corvus, the Crow. Between Virgo's legs is a fluffy white kitten, a constellation that rarely

appears on star charts: Felis, the Cat, humorously invented in 1799 by the French astronomer Joseph Jérome de Lalande and included in Bode's *Uranographia* in 1801.[31] Above Virgo is the hair of Coma Berenices, while beneath her are five ballerinas superimposed on clouds, and the head and front legs of Pegasus. Taken from a print of Carlotta Grisi dancing the role of Giselle, the multiple ballerinas assume the shape of constellation Equuleus, the brother of Pegasus, traditionally represented as the head of a horse emerging from a cloud. The "aerial flights of Carlotta Grisi" evoked in the word tower and the "bareback-rider Carlotta Grisi" enumerated in the key to the collage merge as Cornell honors Grisi (and her back-baring costume) by making a constellation of her.[32] He clearly associated circus themes with constellations: an undated diary note specifies "bareback riders—LESSER DOG in American constellation," probably drawing the connection between circus performers and the dog pictured on the back of a unicorn in Bode's chart of the constellations Canis Minor and Monocerous, as reproduced in Burritt's celestial atlas.[33]

Other details in the collage loosely suggest additional constellations. Berenice with a sword surrounded by stars and a ribbon in the upper center hints at Orion the hunter with his famous belt. Mozart gestures toward the little dog he holds, perhaps Canis Minor. The rabbit of the headline at the bottom could correspond to the constellation Lepus, the Hare, one of Cornell's favorites. The cat's eyes peering out at the side call to mind Leo, the Lion. The little girl with the duckling in the upper left corner could allude to Cygnus, the Swan. Even the hot-air balloons recall the constellation Globus Aerostaticus, as illustrated by Bode in *Uranographia*. Combining old and new motifs, public and private associations, in this collage, Cornell again mapped the night sky.

Cornell continued this process of remaking familiar constellations long after the *View* magazine project was completed. Among the items found in his studio at his death was a whitewashed box marked "Casseopeia," containing items compiled around 1962 (fig. 4.12). He kept many of these boxes, some simply containing raw materials for assemblages. Although at first glance this one seems to house only an odd assortment of junk, it is actually an interactive map of the cosmos. A collection of little plastic boxes take us to Cassiopeia, and, as a tiny rolled up paper note tells us, to her neighbors, the Perseids. Other constellations also appear: Bootes, now as a cowboy boot, and Auriga, as a tiny scrap of paper rolled up in another box. A little cardboard box stamped "bear" contains more constellation charts, as well a ceramic bear, Ursa Major. A second bear box give us both Ursa constellations, big and little ceramic bears nestled in cellophane. A sweet little pink box opens to reveal Cassiopeia again, while deeper in the carton are sparkling stars and moons, in the form of sequins and trinkets. In a paper bag is Bode's constellation of the Crab, along with another version of it—a glittering rhinestone crab pin purchased at

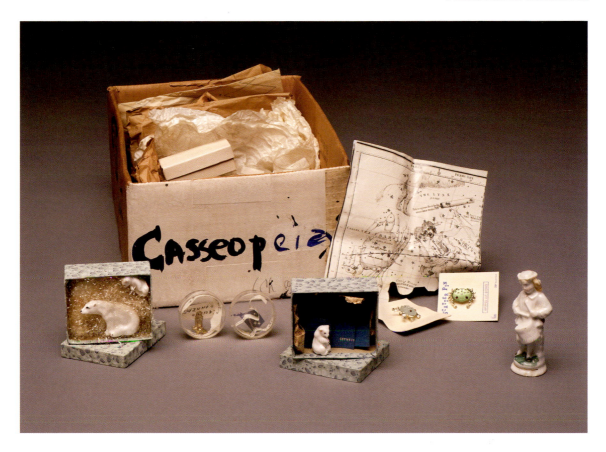

Woolworth's. Finally, carefully wrapped in tissue paper, hides a china figure: the drummer boy Little Dipper first seen on the cover of *View* magazine in 1943.

BERENICE: PRESENT, PAST, AND FUTURE

Cornell's invention of the child Berenice, his placement of her in a pagoda-observatory, and his imaginative re-creations of the constellations grew out of his personal fascination with astronomy. But the word-play, image-play, puns, found working materials, French words, and scientific references relate to another important context: his close relationship with Duchamp at this time. When Duchamp returned to New York from Paris in the summer of 1942, he hired Cornell to assist in the assembly of the *Boîtes-en-valise*, and the process of helping Duchamp must have boosted his confidence in his own densely layered creative process and products. Moreover, Duchamp's return to New York was indicative of a yet another context: the pervasive atmosphere of a world at war during which Cornell produced his contributions for *View*.

FIGURE 4.12. Joseph Cornell, Cassiopeia source material box, c. 1961–62. Joseph Cornell Study Center, Smithsonian American Art Museum. Mark Gulezian/QuickSilver Photographers.

With its aerial wonders and celestial marvels, the ascending world of *The Crystal Cage* proposes two kinds of antidotes to fear: one to the horrors of the imagination, such as those invented by Poe in the story "Berenice," the other to the real horrors of a world at war. Looking at Cornell's *View* project in retrospect, it is difficult to position its publication in the midst of World War II; nevertheless, Cornell subtly emphasized the times.[34] The word "camouflage" appears in the word tower; in the Berenice collage he referred to survivors of an English lifeboat in 1942; and, for the shooting stars in the collage's lower right corner, he used photographs of wartime flak against a night sky, with superimposed pictures of artificial towers that had been constructed in Red Square to protect the real buildings of Moscow. The collage's partial headlines, "Rabbit Joins Battalion," "War Gives a Break to the Office Boy," and "42 Square Miles of Brooklyn to Be Darkened for 20 Minutes Tonight in Blackout," put a brave face on the harsh realities of the times.[35] The headline "New Star Explodes" may have announced a new successor to Tycho's nova of 1572, but the war was an ever-present backdrop, even to scientific announcements about such phenomena. For instance, one news article reported that the new star could be best seen around 5:30 a.m., "Eastern war time," while another noted "the news of the discovery was flashed by Harvard by radio and telegraph to observatories in the Americas, Europe, and Asia. In Axis countries, however, listeners to this news would face the death penalty."[36] Newspaper and magazine articles described how the constellations themselves were enlisted to help guide bombers on their flights to enemy targets.[37]

In his Berenice collage, Cornell included fanciful flying devices, like "Lana's Airship" of 1670, pasted on the headline about the new star, and bullet- and bombed-shaped German dirigibles hover at the top of the collage, the "Häaleiss Luftschiff" of 1782 on the left and the "Luftschiff von Renard und Krebs" of 1884–85 on the right.[38] On one hand, these balloons stemmed from Cornell's own memories of New York City, including a sighting of "the Graf zeppelin with its superbly awesome evocation of the whole beautiful world of balloon flight."[39] On the other hand, he harbored fears that such flying machines could be used for dropping bombs. Among the many articles he saved about aerial bombing was one published in 1909 in *Century Magazine* that warned of attacks from hot-air balloons, "silent cruisers of the air, hovering like vultures over cities, harbors, and fortifications, dealing, with hawk-like swiftness, death and destruction, and then disappearing as suddenly."[40] In *View*, though, Cornell invited readers to participate with Berenice on a "voyage celeste," where angels blow horns in the direction of the German blimps and night horrors become a cosmic ballet.

The notion that astronomy could offer a release from anxiety had been in the air since the 1930s, when headlines reported: "The Vivid Story Blazoned in the Skies: An Astronomer Tells Why Cares Vanish When One Gazes at the Stars."[41] This was especially true during the war. A *Christian Science*

Monitor writer commented in December 1941: "During the past year one of the brightest beacons in a world beset with political tragedies has been the work of the world's astronomers who, despite national differences, have kept up friendly contacts and a measure of progress."[42] Moreover, in Christian Science terms, Cornell's cosmic escape represented a mastering of fear through a belief in the divine Mind, as Blondin demonstrated when he crossed Niagara Falls on a high wire. By creating an observatory and taking the readers of the aptly named *View* to the heavens, Cornell enabled his wartime viewers to see beyond bounds of the transparent cage of daily anxieties by journeying to the ever-constant stars.

The last page of *The Crystal Cage [portrait of Berenice]* closes the essay with a picture of a little girl looking in a window: "Berenice of 1900 gazing into her own past and future." While the date "1900" may have been intended to jog memories of the enormous celestial globe that rivaled the Eiffel Tower at the Paris Exposition of 1900, the references to past and future link this page to larger questions in modern science and philosophy.[43] Among the powerful ideas realized by modern physicists during the first three decades of the twentieth century was the concept that time itself is relative. By the 1930s this principle was easily accessible to nonspecialists. For instance in 1932 Waldemar Kaempffert, the *New York Times* science writer, explained that telescope observations enable deep space to be measured in terms of length, breadth, and thickness. Kaempffert added,

> With time it is the same—something absolute measured by past, present, and future. We say that we see a certain star by the light that left it when John Smith landed in what is now Virginia in 1607. But are we in 1932 or 1607 when we see the star? Is it 1607 or 1932 on the star? The star may have been extinguished last week, but we will not become aware of that for 325 years. Is it any wonder that men like Eddington distinguish between Here and Now and Here-Now? Or that the relativist asks, when we mention time: Of what particular point in the universe are you talking and relatively to what? A body is not only somewhere in the universe but somewhen. Space cannot be separated from time.

Kaempffert reassured readers: "We take most of our science on faith. At present it is more important to believe in relativity than to understand it." If Cornell read this article, the author's conclusion surely resonated with him: "Everywhere we see mind at work," concluded Kaempffert. "Our mind or some greater mind? No one can tell. And so the age-old question presents itself: Is the universe unknowable?"[44]

Looking at her past and future, Berenice plays a dual role, as an astronomer who studies questions posed by the starlight of the past, and as a star herself, the constellation Coma Berenices, whose light is relative, with its past and future merged into the moment of observation. Berenice at the window, like

the star who shares her name, is outside, "looking" in, there to be glimpsed "somewhen." Frozen in time through the photograph's moment of observation, she becomes a metaphysical symbol freed from material constraints, the embodiment of Cornell's concept of "metaphysique d'éphemera." Or, as Cornell later put it, by quoting the author Mary Webb, "The past is only the present become invisible and mute. . . . We are tomorrow's past. Even now we slip away like those pictures painted on the moving dials of antique clocks—a ship, a cottage, Sun and Moon, a nosegay."[45] Given the precarious times in which Cornell worked, this was a sobering thought.

BERENICE, "EN VALISE"

When Cornell published *The Crystal Cage [portrait of Berenice]* in *View* in 1943, he indicated that there was more to come: a portfolio to be issued in facsimile form containing original material and notes. He likely planned something along the lines of Duchamp's limited edition *Boîtes-en-valise*. Cornell included a small valise entitled *The Crystal Cage (Portrait of Berenice)* in his exhibition Romantic Museum: Portraits of Women, shown at the Hugo Gallery in December 1946. He described the contents in the gallery announcement: "Original documents, photographs, prints memorablia, etc. forming the basis of a boxed edition in facsimile. With additional material since originally presented," and below the title of the work and the explanation marched a collection of words familiar from the word tower, arranged in a pulsating pattern of text and empty spaces, bordered by stars. Thus the *Crystal Cage* project moved beyond the printed pages of *View* to become an evolving collection of materials housed in a valise on which Cornell worked until about 1967 (fig. 4.13), as well as related clipping files.

Some of the materials document the creative process leading to the *View* project: typescripts for *The Crystal Cage [portrait of Berenice]*, the original photograph of the Pagode de Chanteloup, other original photographs used in the Berenice collage, drafts of the text that appeared in the article, a draft of the tower of words.[46] Several notes link Berenice and constellations: one describes "Bérénice 'lost' constellation in the dome of Grand Central," another mentions a vision of a little girl "possessing fair blonde locks in which dis[covered] hidden a rhinestone decorated with the stones disposed identically in the constellation of tresses of Berenice," and a third simply jots "Berenice hair constellation." One halting notation seems like a recipe for the *View* sky charts: "Constellations from ephemera newspapers constellations from newspapers leaves etc." Other items relate directly to astronomy, with pictures of instruments, such as an engraving of Herschel's telescope, and diagrams of comets and shooting stars. An article about how to use star charts, copiously illustrated with drawings of constellations, echoes the celestial theme. A newspaper

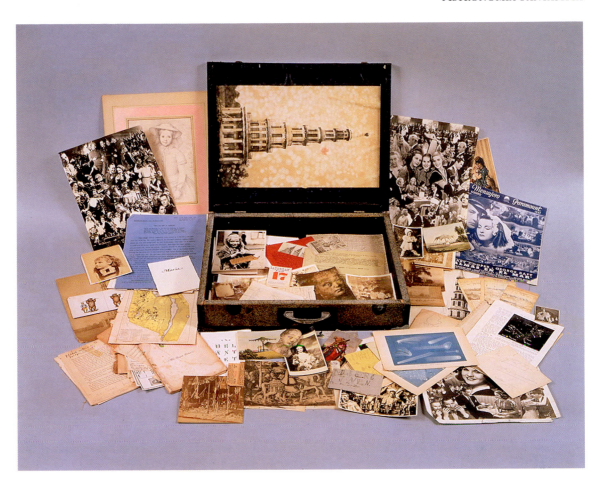

clipping describes a Berenice-like child prodigy, four-year-old Joyce Lavick who could read at two, add and subtract at three, and "now, it seems, she's heard some gossip about atomic fission, slow neutrons, and Einstein's $E = mc^2$."

Many items in the *Crystal Cage* valise underscore the transcendent nature of childhood. One note specifies: "The Pagode de Chanteloup is no ivory tower— . . . its myriad crystal panes come to symbolize the shining and touching purity of the child mind through which we may see the life of the world transformed into miraculous colors etc. the bright, unsullied colours of the child mind." Cornell's theme is the innate moral goodness symbolized by the purity of a child's mind. Key to realizing this moral goodness is a belief in the transformative power of fantasy. This is apparent in the *Crystal Cage's* story of a little girl in her observatory, as well as in Cornell's own fantasies about the little girls he spotted in passing and dubbed "Berenices." A number of these sighting are chronicled in the *Crystal Cage* valise, while others can be found in his diaries throughout his career. His fantasy life was rich, and, when it came to the little girls he spotted, admired, followed, and chronicled

FIGURE 4.13.
Joseph Cornell, *The Crystal Cage [portrait of Berenice]*, c. 1934–67. Valise with printed materials. Collection Richard L. Feigen, New York.

113

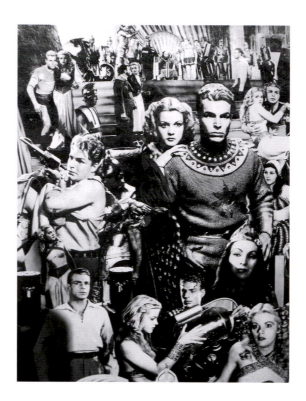

FIGURE 4.14.
Joseph Cornell, detail of
Flash Gordon montage
housed in *The Crystal
Cage [portrait of
Berenice]*, c. 1934–67.
Collection Richard
L. Feigen, New York.

in his obsessive notes, he admired his Berenices from afar, like an astronomer observing a constellation. In the innocence of swiftly glimpsed children, he found an antidote for his own dabblings in the gray area between the pure and the prurient.[47]

Another kind of fantasy alluded to in the *Crystal Cage* valise was the much safer, socially sanctioned desire for people and places encapsulated in the cinema. In the valise Cornell placed four photo montages, perhaps made by him, based on current films. Three portray female film stars, including Deanna Durbin, Hedy Lamarr, Virginia Weidler, and Frances Dee, but the fourth is especially germane to the pairing of astronomy and fantasy that underlies the *Crystal Cage*: a montage of scenes from *Flash Gordon's Trip to Mars*, released in 1938 (fig. 4.14). That Cornell included this reference to contemporary science fiction is surprising—his taste in popular cinema tended toward romances featuring beautiful female protagonists—but Flash Gordon's action-packed saga of saving the world from Queen Azura of Mars, the evil Emperor Ming of the planet Mongo, and a host of Martian Clay People offered fantasy parallels to wartime current events, as well as a variation on the topic of space exploration that so fascinated Cornell.

After the war, Cornell's *Crystal Cage* project moved in a different direction, and he set aside his interest in astronomy in favor of collecting materials about the plight of children in need, a topic that concerned him until the end

of his life. By no means did he abandon astronomy, however. Instead, after the war he directed those interests into another project on which he had also been working since the late 1930s: his *Celestial Theater*.

CORNELL'S *CELESTIAL THEATER*

As the role of astronomy diminished in the *Crystal Cage* project, Cornell redirected his interests to another clipping compilation: a dossier entitled *Celestial Theater* intended to draw attention to the beauty of the night skies. Although the May 1944 issue of *View* announced: "coming: JOSEPH COR-NELL'S CELESTIAL THEATER, a visual exploration by the creator of 'The Crystal Cage,'" the illustrated essay never appeared.[48] Throughout the 1940s and 1950s, Cornell wondered how to present his *Celestial Theater* to the public. He considered designing a magazine article with pictures in shadow boxes, taking the reader from "exhibit to exhibit," comparing it with the corridors of Coney Island or Dalí's *Dream of Venus* Pavilion at the 1939 New York World's Fair, but he did not follow through with this idea.[49] In the end, the project existed only in his mind, as a complex, sprawling set of notes, clippings, and associations that preoccupied him for over two decades.

His first conception seems to have been a gloss on an imagined exposition that took place on the grounds of the 1939 New York World's Fair a year or two before the actual fair opened. In notes written in 1945, Cornell recounted strange sightings at that exposition of Chaldean astronomers in long robes on the observatory towers of the tallest buildings (probably inspired by the illustration of an ancient astronomer he clipped from *Astronomie Populaire*), along with Chinese gentlemen releasing birds from exotic cages, the tightrope walker Blondin, "of Niagara Falls renown," and "the scholarly looking portrait of Nicolas Copernicus come to life."[50] This exposition was his imagined *Celestial Theater*, with wonderful sights to be seen at night: the fairground illuminated with lights, with performances by an ascensionist or an acrobat, exhibiting "the grace and dignity of a lost art." He added in a penciled note at the bottom of the page, "and so this fair within a fair the one exceeding the other as the heavens do the Earth."[51]

Another draft of the text written at the same time explained the project as a combination of visionary homage to astronomers and postwar protest:

Well, the New York World's Fair has come and gone, the Celestial Theatre has come and gone. But we have a theory about the latter. We like to think that strange assemblage that mingled with the motley of our city crowds was part of a numberless host, protagonists who throughout history from the Chaldean astronomers in flowing robes to our own time have played their part in the drama of the heavens. Theirs is a glorious heritage

confounding in its richness and beauty,—and they are jealous of it. Alarmed by the scientific innovations of our age, the approaching commercialization and standardization of man-made paraphernalia of the air, the barbarity of bombings whereby the surface of the earth has almost come to resemble the craters of the moon, in protest against the desecration of the skies was this assemblage drawn in common purpose from the far corners of time and space. To protest. And how better than the showing forth of the forgotten wonders with which they would appear with so much authority. We said that we had a theory. We have much more. We are fortunate in having a precious Souvenir Box, the official one, of the Exposition, herewith presented, known as THE CELESTIAL THEATRE.[52]

In the early 1950s he envisioned his *Celestial Theater* as an exhibition at the Wittenborn Gallery, "to give people some feeling about the beautiful fantasy involved in the early ideas of conquering the air, and some of the new fantastic continuation of such dreams."[53] He thought about including works with birds as a section called "CELESTIAL AVIARY," drawing attention to bird constellations, specifically Noctua, the Owl; Cygnus, the Swan; Colomba, the Dove; Turdus Solitarius, the Solitary Thrush; and Toucana, the Toucan.[54] At times he seems to have considered an alternate title, *Variétés Celestes*. At an unspecified date he envisioned creating a traveling exhibition, "presentation as mounted plates in folder for museums, galleries, schools, art courses, etc.—traveling unit."[55] In a note he typed a possible title, "In Defense of the Lost Art of Sky-gazing," but penciled beside it, "—no—not with A bomb scares."[56]

As someone who had lived through two world wars, Cornell deeply mourned that the starry night sky had become associated with fears of aerial bombing. By the 1950s this fear extended to the atomic bomb anxiety that gripped society as a whole, and he saved newspaper articles about test blasts at Bikini, photographs of mushroom clouds, editorials concerning the need to outlaw the bomb, and even a profile of a Brooklyn housewife hired to sky-gaze for enemy A-bombers from the roof of a Manhattan skyscraper.[57] In a note he jotted to himself, he located his project in anxiety: "With sky-gazing at this particular point in time (summer 1952), with world tension at an unprecedented high in the aftermath of the terror and destruction of WWII and the threat of the atom bomb . . . ," and he drafted the goal of his *Celestial Theater*: "designed as a reminder that the skies may be looked up to without a sense of impending doom, as well as a reminder of other times when the spectacle of the night skies inspired minds to the endless poetry. A foil to too much preoccupation with present phases of atomic activity (however necessary a certain amt. of it may be.)"[58] As he continued to work on the dossier well into the 1950s, he worried that it would be impossible to make the definitive statement he wanted, a statement that could provide, as he put it, an "antidotal overview" to counter modern terrors.[59] In the end, Cornell's *Celestial Theater* never

materialized. After fourteen years of work, he feared that the project was "too rich in ambitions" and despaired that he would never " 'nail down' definitively—bombing of the war—terror of the skies."[60]

The most finished component of the project is an unorthodox work by any artistic standard. Probably originally begun for *View* magazine and then continued as a dummy for the Wittenborn exhibition, it consists of twenty large pieces of construction paper designed to fit into a shallow black box, with mounted pictures depicting many forms of real or imagined human flight culled from newspapers, books, magazines, and other print sources (fig. 4.15). Judging by the dates on some of the clippings, Cornell began compiling materials in the early 1940s, reiterating interests already explored in the word tower and collages for the "Americana Fantastica" issue of *View*. Of the twenty construction paper pages with mounted pictures, ten form a subset of prints and photographs of circus performers. As in *The Crystal Cage [portrait of Berenice]*, the tightrope walkers Blondin and Bird Millman make their appearance. Contemporary trapeze stars are featured, while still other pages illustrate nameless high-wire artists. All but one of the remaining ten sheets comprise a second subset about the dream of human flight, repeating figures mentioned in the *View* word tower, including an engraving of famed balloonist Madame Blanchard (on the only blue sheet of construction paper), Grandville's personification of the morning star, and even roof-walking chimneysweeps. Other pictures feature winged humans wearing elaborate flying devices, some carried by or even turning into birds. Only one entry seems out of place: a mounted *Life* magazine photograph of streaks of light against a night sky, with the caption "Shelled British Pilot Reports 'A Wee Spot of Light Flak Here.'"[61] As it does in *The Crystal Cage [portrait of Berenice]*, the wartime context sounds a jarring note among the array of real and fantastic flying people. Over the years, Cornell continued to add materials to the black box—pictures of balloonists and rocket ships, as well as constellation charts and portraits of astronomers.

Beyond the confines of the shallow black box, Cornell created a conceptual collage of source material files with related clippings and notes compiled from the 1940s through the 1960s, as well as additional items marked "Cel. Th." sprinkled throughout other files and diary entries. Among these was a file titled "Circus Celestial Theater etc."[62] Here he gathered such items as magazine photographs showing teenaged tightrope walkers performing without a net over the bombed ruins of Leipzig; a 1942 newspaper story headlined "Girl Quits Flying Trapeze to Become Human Bullet"; and nineteenth-century German circus illustrations, including a drawing of a tightrope-walking elephant named "Blondin." In this file he also stored a program for the 1946 season of the Ringling Brothers and Barnum & Bailey Circus, with his penciled notations indicating that he attended a performance. He underlined the words "all-girl sky-ballet" in the description of a troupe of "scores of celestial bodies soaring in astronomical flights of cadenced beauty." He wrote "Celestial

117

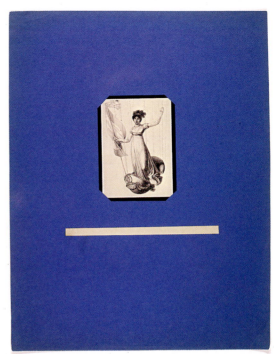

SHELLED BRITISH PILOT REPORTS:
"A WEE SPOT OF LIGHT FLAK HERE"

Theatre" in the margin beside the announcement of another act, "The High Priestess of Rhythm Aloft. The Incomparable Lalage," jotting a note about her "somersaults one arm around a rope" and her "dark pink sequin brassiere." He annotated a juggling act, with the margin scrawl "Celest. Th. * phosphorescent in dark 3 torches in dark," while the Flying Wallendas' trapeze performance earned his note " * Celest. Theatre at end of spotlights while aloft." The visual spectacle of these bodies spinning and hurtling through space clearly delighted him, and his comments indicate how directly he associated this big-top performance with his *Celestial Theater* project.

While the *Celestial Theater's* specific subjects varied wildly, its underlying theme remained constant: although humans are subject to the laws that govern the physical universe, the grip of specific gravity that roots us to Earth can be seemingly loosened through such activities as tightrope walking, trapeze artistry, ballooning, flying, traveling in spaceships, and imagining the weightlessness of outer space. Or, as Cornell put it in a note written around 1954, "strive for sense of elevation, suspension, the whole thing kept in the air 'without touching earth.'"[63] Although he never realized the project in a physical form that went beyond the mounted pictures and collected materials, he returned again and again to it in his notes and clippings. His project may have been unorthodox, but the impetus that lay behind it was shared by many of his contemporaries who called for similar spiritual approaches in the arts. As Lewis Mumford urged in 1950, in a *New York Times* article Cornell marked with a large star:

> If our civilization is not to produce greater holocausts, our writers will have to become something more than merely a mirror of its violence and disintegration; they will have, through their own efforts, to regain the initiative for the human person and the forces of life, chaining up the demons we have allowed to run loose, and releasing the angels and ministers of grace we have shamefacedly—and shamefully—incarcerated.[64]

If we substitute the word "artist" for "writer" in Mumford's comments, Cornell's mission could not have been more accurately described. Indeed, beginning in the 1950s, he devised new ways to honor astronomers and admire the stars in a series of box constructions that presented ancient constellations as antidotes to modern terrors of the night. These "Night Sky" boxes, as he sometimes called them, brought him his first sustained critical acclaim and positioned him as an important artist in the context of the emerging American avant-garde. But while they struck viewers as distinctly different in style and conception from the works that preceded them, the postwar boxes were actually a logical next step in his ongoing exploration of the marvels and metaphors of the cosmos.

OPPOSITE PAGE:
FIGURE 4.15.
Joseph Cornell, prints and photographs mounted on construction paper, from *The Celestial Theater*, c. 1940–60. *Clockwise from upper left*: Bird Millman, in *Playboy*, 1924; Madame Blanchard, unidentified source; "Shelled British Pilot Reports: 'A wee spot of light flak here,'" unidentified source; J. J. Grandville, "The Evening Star," from Joseph Méry, *Les Etoiles*. Joseph Cornell Study Center, Smithsonian American Art Museum.

OBSERVATORIES

DURING THE 1940S CORNELL'S ART moved in several directions simultaneously. He continued to explore the physical universe in a series of soap bubble sets and other works devoted to natural history. At the same time, he remained fascinated by American popular culture and based boxes and collages on themes derived from the world of Hollywood. He also immersed himself deeply in European culture, producing works devoted to the ballet, opera singers from Europe's past, and the novels of obscure writers like Jacques-Henri Bernardin de Saint-Pierre. With an introduction from Duchamp, he joined the constellation of international avant-garde artists orbiting Peggy Guggenheim, and, as the New York art scene expanded to include European artists in exile, Cornell's work became increasingly urbane and assured. Still, astronomy was never far from his mind. By the close of the 1940s, he trained his sights beyond Europe, even beyond planet Earth, to the skies above, focusing on the starry skies as he recast his *Celestial Theater* for a postwar age in a series of box constructions featuring constellations and star-filled vistas.

NIGHT SONGS

On December 1, 1950, a one-person exhibition of work by Cornell opened at the Egan Gallery. It was his second exhibition in Charles Egan's tiny space—he had presented Aviary by Joseph Cornell there in late 1949—and it marked his departure from the Julien Levy Gallery's rarefied atmosphere of European Surrealism. At the Egan Gallery, he forged a new postwar identity with the American avant-garde by showing alongside abstract expressionists Willem de Kooning and Franz Kline. He struggled to find the right title for his exhibition, in his diary suggesting "The Midnight Mocking-Bird," "Midnight Arias and

Midnight Echoes," "A Few Songs at Midnight," "A Little Night Music" (and even, in a moment of silliness, "A Niddle Light Music").[1] Eventually he hit upon the right one, noting, "During the creation of the boxes with 'changeable skies' during October–November 1950 the exhibition title 'Night Songs' evolved, or better, fell into my lap, during a radio broadcast on a Monday afternoon."[2]

Night Songs and Other New Work, 1950, by Joseph Cornell, as it was finally called, was an appropriate name for an exhibition that included a group of boxes the artist titled "Observatories," as well as other works with astronomical themes. More than just a reference to a radio broadcast, it encapsulated Cornell's own practice of stargazing late at night while listening to classical music. Moreover, for those in the know, it cross-indexed the early astronomer Johannes Kepler, subject of a biography published in 1940 entitled *Troubadour of the Stars*, a description of Kepler attributed to Tycho. At the same time, it alluded to an exciting new discovery in modern astronomy heralded in the *Christian Science Monitor* in 1949: "stars invisible to even the miraculous new optical techniques sing songs in broad daylight to the still newer instruments of radio-astronomy."[3] As he had so skillfully learned to do in his early Surrealist days, Cornell juxtaposed seemingly unrelated things, in this case "night" and "song," to suggest a rich complex of old and new associations.

Cornell's new astronomy work was larger and lighter than his previous boxes, especially the soap bubble sets shown at the Copley Galleries in Los Angeles in 1948. Then, critic Arthur Miller had devastatingly dismissed Cornell's creative process as "chi-chi infantilism." Now, two years later, Cornell set aside his fascination with fantasy and filmy ephemera for work that was less esoteric and less Eurocentric. The results were gratifying. Reviewing an Egan Gallery group show in May 1950, Stuart Preston wrote in the *New York Times*, "And as for Joseph Cornell's new composite objects, America's worthy challenge to the suitcases of Marcel Duchamps [sic], they have to be seen to be enjoyed, and enjoyed to be marveled at."[4] In response to Night Songs, Preston even praised Cornell's working method: "With wood and glue, with mirrors and old celestial navigation charts, airy little structures are turned into exquisite fantasies. They assault our sensibilities obliquely. They are semi-surrealist gambits that miss coyness and frivolity by a margin, now large, now tiny. And they must be seen to be believed."[5]

Among the works to be seen was *Central Park Carrousel, in Memorium* (fig. 5.1), a wooden box over twenty inches high, containing a piece of mirror, wire screen, and wood and paper elements. It was purchased directly from the exhibition by the Museum of Modern Art, representing that museum's first Cornell acquisition. He began the box late in the autumn of 1950, after a fire in Central Park on the eighth of November destroyed a wooden carrousel that had delighted children since 1871. In his diary, he observed that an editorial about the carrousel fire, combined with memories of the barrel-vaulted

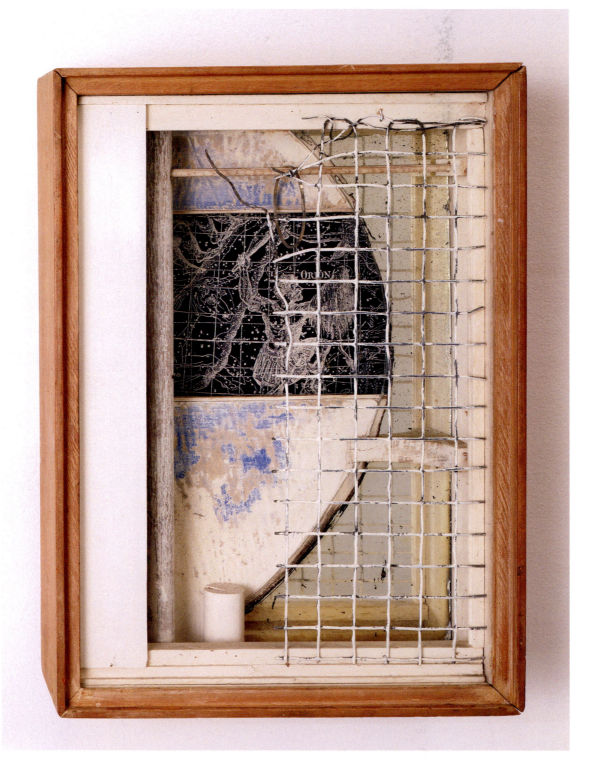

celestial ceiling of Grand Central Terminal, along with thoughts of the *Celestial Theater* project, led to the creation of the carrousel box.[6] He also noted that the carrousel construction, in turn, inspired at least three windowed constellation boxes that crystallized into shape on November 13 and 14, involving a process of reviving, according to yet another diary entry, "astronomical material laying dormant for many years."[7] With his typical layers of associations, Cornell moved from the actual carrousel, with its references to childhood, music, play, and even the illusion of temporary weightlessness, to Grand Central Terminal's ceiling, to his continuing engagement with the *Celestial Theater*.

As Cornell acknowledged in his title, *Central Park Carrousel, in Memorium* began as a memorial to the charred Victorian landmark mourned in the local papers. He faintly alluded to its melted metal decoration and peeling surface with a partial wooden disk covered with patches of white, blue, and gray paint, and he condensed memories of the animal seats and the circular shape and motion of the carrousel, as well as the games played on it, with the hanging brass ring and constellations Canis Minor, the Lesser Dog, and Monocerous, the Unicorn. However, the most striking aspect of the box is not the reference to the carrousel that inspired it, but the personification of the constellation Orion, picked out in white against the black sky and glimpsed through a rectangular opening in the disk. Here he drew upon the metaphor, often used in astronomical texts, of the vault of the heavens as a giant celestial carrousel.[8] Furthermore, as indicated in his diary note, Cornell associated the destroyed carousel with the ceiling of Grand Central Terminal, where 125 feet above the ground familiar constellations shone in gold paint and forty-watt electric lights against a dark blue sky, although for Cornell this, too, fit the category of "in memorium," as he specifically recalled "the ones now covered up as remembered from childhood, formerly of a far greater richness and execution."[9]

For the constellation Orion, Cornell used a negative photostat of a page from Flammarion's *Les Etoiles* that illustrated Bode's versions of Gemini, Taurus, and Orion (see fig. 1.7), and he extended the grid of the star map with a piece of white wire screen. He frequently had both positive and negative photostats made from Flammarion's books, and he no doubt chose the negative version in this case to approximate both the actual night sky and Grand Central's ceiling. Cornell had already used this rendition of Orion in schematized form at the beginning of his film *The Children's Party*, where it was also glimpsed from a white-framed window. In fact, the carrousel box neatly condenses the film into a single visual frame, distilling the film's spinning objects into the partial disk, its sequences of children's play into the carrousel, its emphasis on gravity into the hanging ring and vertical column, and its astronomical observatory into the single opening that reveals the constellation in the night sky. Just as the film opens with the upside-down and backwards words "The End" to challenge notions of time and space, the mirror on the inner right of the box, cut away to reveal the constellation, complicates what we see.[10]

OPPOSITE PAGE:
FIGURE 5.1.
Joseph Cornell, *Central Park Carrousel, in Memorium*, 1950. Box construction in wood, mirror, wire netting, and paper, 20¼ × 14½ × 6¾ in. Katharine Cornell Fund (5.1951). The Museum of Modern Art, New York, NY, U.S.A. Digital Image © The Museum of Modern Art/ Licensed by SCALA / Art Resource, NY.

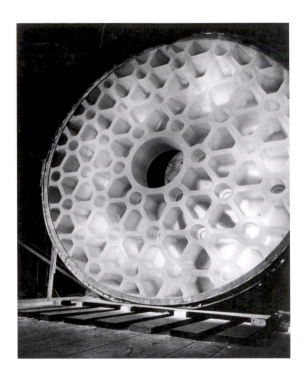

Positioned as though it is an extension of the actual mirror, the blue- and gray-painted partial disk on the inner back of the box suggests a circular mirror on which the night sky is reflected—the highly polished mirror of a reflecting telescope designed to catch the light of distant stars.[11] Reflecting telescopes had been in the news since the construction of the 100-inch mirror installed at the Mount Wilson Observatory in California in 1917, but they were especially on the minds of Americans in the late 1940s, as the new 200-inch telescope on Mount Palomar neared completion.

Throughout the 1930s the Palomar project had captured the public imagination: at the height of the Depression, thousands of people lined railroad tracks to see the mirror when it was shipped from Corning, New York, to California by a special slow train. Over an eleven-year period, the mirror (made of a durable new glass called "Pyrex") was painstakingly ground and polished in the optics laboratory at Caltech (fig. 5.2), and in November 1947, with the completion of the observatory building, it was finally transported to Mount Palomar. In one of his *Celestial Theater* clipping files, Cornell kept articles about the new observatory, with pictures of the shining dome and enormous reflecting telescope, as well as reports about other new "windows on the universe," as observatories in general were dubbed during the 1950s.[12] Still, despite his interest in cutting-edge astronomy technology, in *Central Park Carrousel, in Memorium* he combined both old and new forms of stargazing by suggesting the reflection of an ancient constellation on a modern telescope's mirror.

A December 1950 diary entry recorded Cornell putting "finishing touches on dark blue 'carrousel' box for pick-up (second group) for NIGHT SONGS exhibition at Egan Gallery."[13] This was probably the work known as *Observatory Columba Carrousel*, a box with a deep blue painted case (fig. 5.3). Again Cornell provided a view of the sky through a window opening at the back of the box, gridding and spattering the glass in front of the constellations Columba, the Dove; Monocerous, the Unicorn; and Canis Minor, the Lesser Dog—he later repeated the last two constellations for one of several Christmas cards commissioned by the Museum of Modern Art (see fig. 5.8). This time his photostat source was a page from Burritt's *Atlas of the Heavens* that showed the constellations of January, February, and March. Once more, curved shapes evoke both the movement of a carrousel and the stars in the night sky, with arcs of mirror extending the spatial realm of the box and a hanging metal ring suggesting both grand stellar motion and a child's free ride to be won. On the inner left side and back of the box, Cornell included the word "Hotel," announcing one of many more celestial hotels to follow.

Despite Cornell's reliance on the carrousel metaphor for the starry skies, he did not intend a box like *Observatory Columba Carrousel* to be perceived only as a childish plaything, and one wonders how he reacted to Stuart Preston's description in his glowing *New York Times* review: "Toys of genius these shadow-boxes bedecked with astronomical adornments are."[14] Toys, they definitely were not. Cornell made this point emphatically clear on the back of the box, where he created a collaged testament to the complexity of knowledge itself. Using pages from eighteenth-century French books, he built up a dense topography of words, with the paper varnished and painted to strengthen the feeling of age. The texts were clipped from several sources, including M. Valmont-Bomare's *Dictionnaire raisonné universel d'histoire naturelle*, published in Lyon in 1791. His choice of text from this book was carefully calculated: on the right side of the back of the box he pasted an excerpt with a definition of the word "Firmament," describing the fixed stars of the eighth celestial sphere and cross-referencing the words "ciel," "planète," and "quadrupède"—appropriate associations for a celestial carrousel.[15]

A diary entry indicates that Cornell bought his soon-to-be-cut-up French natural history dictionary on September 13, 1950, incongruously "after a lunch of pig's knuckles & sauerkraut, ball game on television-14th St. and Irving Pl."[16] There is, however, no sign of these mundane activities on the back of the box. Instead, the often illegible foreign text with its antiquated alphabet creates a feeling of moving back in time, just as the front of the box propels us forward in space. The text itself often loses its orientation, as it is pasted now upright, now sideways, suggesting a rotating reader whose motions mimic those of the celestial bodies on the other side of the box. This conceptual spinning is underscored in the upper center of the white title panel, where, pasted beneath the hand-written title *Observatory 'Columba'*, there is a tiny upside-down

125

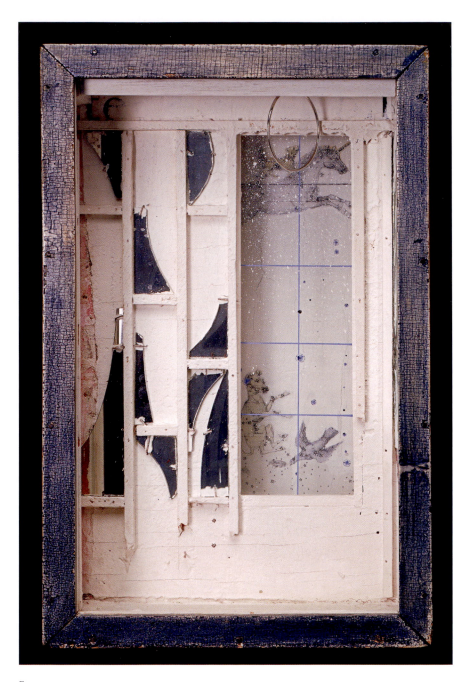

FIGURE 5.3.
Joseph Cornell, *Observatory Colomba Carrousel*, 1950. Box construction, 18 × 11½ × 5¾ in. The Robert Lehrman Art Trust, Courtesy of Aimee & Robert Lehrman, Washington, DC. Mark Gulezian/QuickSilver Photographers.

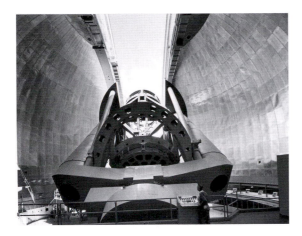

FIGURE 5.4.
The Hale Telescope,
Mount Palomar, c. 1948.
Photo: The Hale Observatories, Courtesy American
Institute of Physics, Emilio
Segrè Visual Archives.

typeface word, "yours." Perhaps playing on the title of astronomer James S. Pickering's book *The Stars Are Yours*, published in 1948, Cornell emphasized that the observatory window frames a cosmos that belongs to all.[17] But the words on the back of the box do not. Instead, they are a hermetic, virtually unreadable text, more akin to an antiquated scientific treatise than a modern artwork.

From this point on, Cornell frequently papered the backs of his astronomical boxes with pages from this same volume, creating mysterious documents that, like the Latin texts of early astronomers or the mathematical theories of modern astrophysicists, are meaningful only to a handful of like-minded scholars. In so doing, he visualized the complexity of scientific scholarship, even of human knowledge itself, pairing this conceptual density with the simple, accessible beauty of the metaphoric stars expressed so elegantly inside the box. Moreover, by alluding to the past with text material, he also underscored aspects of time he had already explored in *The Crystal Cage [portrait of Berenice]*. There, he had shown the astronomer Berenice gazing into her own past and future. Here, with the antiquated text backing the box, he again gave visual and verbal form to the fact that starlight is old light.

Cornell's new observatory boxes, shown to acclaim at the Egan Gallery, came in a creative rush that was sparked by the carrousel fire. However, his construction of a series of observatories in 1950 and his emphasis on celestial mapping were also perfectly in synch with popular responses to astronomy at this time. With the long-awaited dedication in June 1948 of the Hale Telescope on Mount Palomar (fig. 5.4), named in honor of astronomer George Ellery Hale, journalists pondered the technological and cosmological significance of the instrument. The telescope was hailed as having "the power of a million eyes" that would enable hundreds of thousands of new galaxies to burst into view.[18] Articles that pictured the new "Cyclops eye" described not only its equipment and the improved maps that would be made of the cosmos, but also

its broader cultural implications. As Kaempffert wrote in the *New York Times*, "The great instrument on Palomar Mountain was built for the same reason that we build great cathedrals, compose great symphonies, paint great pictures that testify to the awe with which we beheld a distant mountain-range in a rare moment."[19]

As a dedicated backyard stargazer, Cornell understood the feeling of awe before the vastness of the night sky. But his artistic purpose went further. In addition to evoking a sense of timeless wonder, he wanted his visions of the cosmos to offer a healing alternative to the recent terrors of the sky experienced during the war. Here, too, he shared sentiments that were part of a broader cultural fabric. Speaking at the dedication of the Hale Telescope, Raymond B. Fosdick, president of the Rockefeller Foundation, hoped that the telescope could furnish society with "some measure of healing perspective." With words that matched the mission of Cornell's *Celestial Theater*, Fosdick observed: "Adrift in a cosmos whose shores he cannot even imagine, man spends his energies in fighting with his fellow man over issues which a single look through this telescope would show to be utterly inconsequential."[20] To offer his viewers a similar healing look through a telescope, Cornell created observatory boxes that drew on the metaphoric parallel between a child's carrousel and the stars that revolve above us.

Not all of Cornell's observatory boxes in the Night Songs exhibition contain personifications of constellations culled from earlier star atlases. Some, like *Observatory Corona Borealis Casement*, encase a naturalistic view of the heavens, with spattered stars on a dark blue expanse (fig. 5.5).[21] Cornell retained the window format, underscored by the punning "casement" of the title, although he strengthened the connection with modern scientific observation by adding a rounded shape above the window that echoes the profile of a modern observatory dome.[22] Again he employed a grid, with wire mesh superimposed over a raised wooden pattern on the inner back of the box, but now, rather than signifying a measuring device that continues the lines of the atlas, the grid appears architectural, part of the wall beneath the rounded dome through which we see the night sky. Here Cornell seems to have considered what a modern observatory looks like from inside, as well as the stars it reveals, perhaps inspired by newspaper accounts he saved that paired photographs of the Palomar telescope's grid framework and mesh structures with views of the stars above (fig. 5.6). He may have further devised the ladder-shaped grid to echo popular descriptions of the new telescope as a "ladder of light," where, as one writer predicted in the *Times*, "climbing to the uppermost 'rung' of his new 'Jacob's Ladder' to the stars, man will be able to solve many a new cosmic mystery now beyond his reach."[23]

Through Cornell's window in the sky sparkle shooting stars, meteors, and distant galaxies—all suggested with spots and spatters of thick, white paint on a blue ground. The resemblance to a Jackson Pollock drip painting is

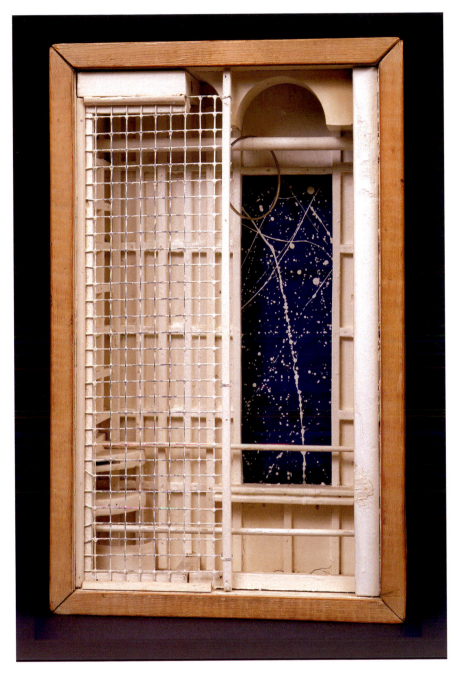

FIGURE 5.5.
Joseph Cornell, *Observatory Corona Borealis Casement*, 1950. Box construction,
18⅛ × 11³⁄₁₆ × 5½ in. Private collection, Chicago. Photo: Michael Tropea, Chicago.

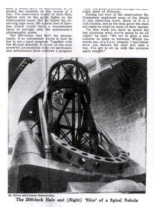

The 200-Inch Hale and (Right) 'Slice' of a Spiral Nebula

Figure 5.6.
"The 200-inch Hale and (Right) 'Slice' of a Spiral Nebula," unidentified clipping. Courtesy of the Joseph Cornell papers, 1804–1986, Archives of American Art, Smithsonian Institution.

striking, and although scholars have frequently drawn comparisons, there is more than stylistic similarity at work. Beginning in the mid-1940s, the night sky had featured prominently in the postwar avant-garde, from Joan Miró's *Constellations*, a series of twenty-two paintings shown at Pierre Matisse's New York gallery in the summer of 1945, to Ruffino Tamayo's *Heavenly Bodies* and Janet Sobel's proto-Pollock drip painting, *Milky Way* of 1946, Richard Lippold's *New Moonlight* of 1947–48, László Moholy-Nagy's dripped *Space Construction* on the cover of *Art News* in 1947, and, above all, Pollock's cosmic canvases of 1947, including *Shooting Star, Comet, Reflection of the Big Dipper*, and *Galaxy* (fig. 5.7).[24]

Cornell's friend, critic Parker Tyler, saw these paintings by Pollock and the larger drip paintings that followed as evocations of cosmic space and forces, writing in May 1950 that Pollock's paintings are to be observed "in exactly the way that we look at the heavens with their invisible labyrinths of movement provided in cosmic time by the revolutions of the stars and the infinity of universes." Tyler described Pollock's paint flying through space "like the elongating bodies of comets," rhetorically concluding, "What are his dense and spangled works but the viscera of an endless non-being of the universe?"[25] Whether Pollock intended his canvases to be understood in this literal way is doubtful, but, as Tyler demonstrates, they were.

By the early 1950s Cornell seems to have been intrigued enough by the spatial implications of Pollock's drip paintings to try his hand, at least a little, at the new style. But Cornell's cosmic references were grounded in Earth-bound observation, and the drip technique was simply a different way to illustrate the celestial bodies that had preoccupied him from the start. Rather than positioning Cornell as a would-be Abstract Expressionist, works like *Observatory Corona Borealis Casement* connect him to a broader current in the avant-garde at this time: a growing general interest in celestial themes. At last, the

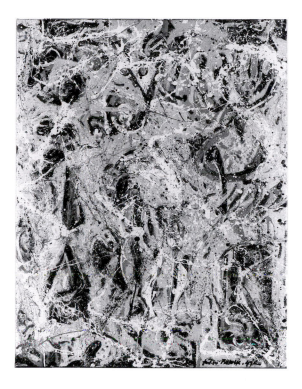

FIGURE 5.7.
Jackson Pollock, *Galaxy*,
1947. Oil, aluminum paint,
and small gravel on can-
vas, 43½ × 34 in. Joslyn
Art Museum, Omaha,
Nebraska, gift of Peggy
Guggenheim. © 2007 The
Pollock-Krasner Founda-
tion / Artists Rights Soci-
ety (ARS), New York.

art world seemed to be catching up to Cornell, who had long been fascinated by such subjects.

Like Cornell, his contemporaries faced the challenge of creating art in a postwar, atomic era. Boris Margo, whose painting *Stellar Gyrations* graced the cover of the *Magazine of Art* in 1947, wrote in an accompanying article, "Today the artist creates his own symbols, his own mythology. But to do so he needs new technique, new form, new content."[26] Among those things Margo believed needed to be expressed were "nature's spectacles, the vast happenings in the sky, the stresses within the soul." Pollock closely echoed these thoughts in notes he jotted in 1950: "Technique is the result of a need. New needs de-mand new technics [sic]," adding "energy and motion made visible—memories arrested in space." Later Pollock refined these thoughts in his often-repeated statement, "It seems to me that the modern painter cannot express this age, the airplane, the atom bomb, the radio, in the old forms of the Renaissance or of any other past culture. Each age finds its own technique."[27]

Clearly Cornell was not alone in his attempts to make cosmic energy and motion visible, to arrest memories, or to combat terrors rising with the dawn of the atomic age: even the inarticulate Pollock expressed the same fears and desires. Cornell's assemblage technique, though, had been in place since the 1930s, and he simply appropriated the abstract drip style to make his

observatory skies more realistic—more like the remarkable photographs of the starry skies being taken on Mount Palomar. Nevertheless, his incorporation of bits of drip painting and his overall fascination with cosmic themes suddenly brought his work more in line with avant-garde currents than it had been since the Surrealist heyday of the mid-1930s.

NIGHT VOYAGE

Cornell and his brother Robert spent the month of September 1951 at their sister Betty's chicken farm in Westhampton, New York. It was a time of renewal and inspiration. By September 5 Cornell had planned several "Hotel" boxes based on astronomical themes, including *Hotel Observatoire* and *Hotel de l'Univers*. A week later he reminded himself in a note to "consider for immediate—following line of boxes for Egan Gallery—making up a half dozen or so in vein of completely abstract, or semi to fill definite need, such as HIGH WIRE ACT, COLOMBIER, OBSERVATORY, etc."[28] Above all, he immersed himself in the natural world, watching the stars in the early hours, enjoying "the sense of 'observatory' in the evening (night) air—the expanse of the heavens in these parts." After an especially beautiful night, he wrote: "clear skies outside—walked outside & appreciated anew the beauty and magic of this experience, as on the first nights here—the expansiveness of the heavens, the song of nature throughout the night, the breeze, the fragrances of the grasses,—like a great breathing; deep, harmonious, elemental, cosmic."[29] He wrote a note about lying in bed and gazing at the stars through his window while listening to Beethoven's "Serioso" quartet, and, when it came time to leave, he typed one last diary entry about his little bedroom: "But what an 'observatory', what an alloyed joy, in its possession and presentation of an ideal workshop (writing, typing, research, reading, etc.)."[30] Years later he still remembered the beauty of the night skies that summer, and he continued to record the feelings of ineffable happiness he experienced when looking at the stars.

The next year and a half was an especially productive period, as Cornell explored themes and variations on the boxes he had introduced in the Night Songs exhibition. The results were displayed again at the Egan Gallery, in Night Voyage by Joseph Cornell. The exhibition announcement, coyly presented as a ticket, "valid February 10–March 10, 1953" (fig. 5.8), breathlessly introduced some of the works: "*Observatories Night Windows Grand Hotel du Nord Carousels Portraits Taglioni Penny Arcade Figureheads Argus Parmigianino Andromeda Camelopardus.*"[31] The "voyage" went backwards in time and forward in space, as Cornell named works with historical and astronomical themes, but the emphasis was clearly on the cosmos, with the presentation of new genres, like night windows and hotels, and obscure constellations, like

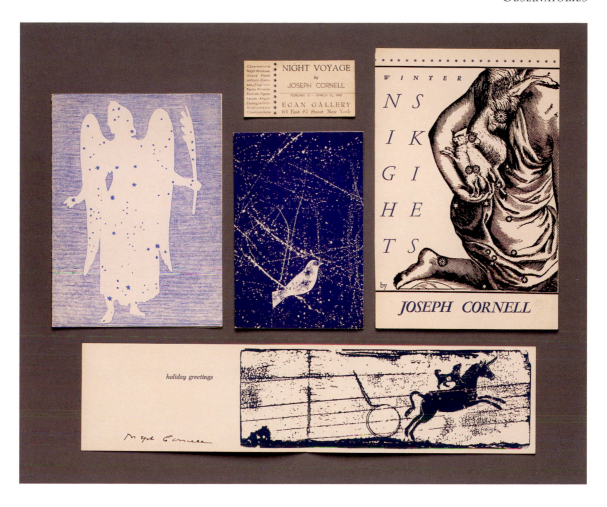

Argus and Camelopardus. Critical response was again positive, if vague. Preston wrote in the *Times* about Cornell's "little altar-pieces consecrated to the deities of nostalgia and escape," while in *Art Digest*, Sidney Geist noted an aspect of longing in the "nostalgic poetry" of the boxes.[32]

Although there is no record of exactly which works were included in the exhibition, it is likely that among those alluded to on the gallery announcement was *Carrousel*, dated 1952 (fig. 5.9).[33] With elements of an observatory, a night window, and a carrousel, this box combines individual aspects of other works: the wire grid and glimpsed sky of *Central Park Carrousel, in Memorium*, the Burritt atlas constellation map and sliding brass ring used in *Observatory Colomba Carrousel*, and the star-filled window and observatory architecture of *Observatory Corona Borealis Casement*. The observatory association is now even plainer, with the wooden arcs in the upper corners creating a negative space whose shape, complete with the narrow rectangle

133

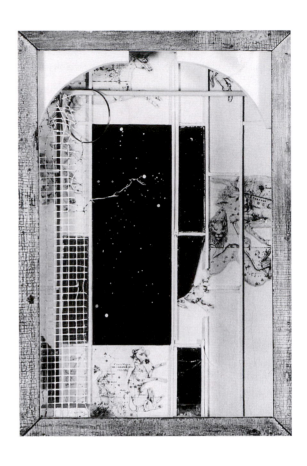

FIGURE 5.9.
Joseph Cornell, *Carrousel*,
1952. Box construction,
19 × 13 × 6 in. Location
unknown.

on top, clearly echoes the profile of an observatory dome. And, through the
window three diagonal stars, reminiscent of the belt of Orion, can be glimpsed
above a wire branch, just as Cornell viewed the constellation above the maple
tree in his yard (fig. 5.10).[34] The star-filled sky framed by constellation fig-
ures also visualized the sky survey undertaken as a joint effort by the Na-
tional Geographic Society and the Palomar Observatory. An article Cornell
clipped emphasized the astronomical number of stars to be charted: "the num-
ber of stars in the Milky Way galaxy, to which the Sun belongs, as between
200,000,000,000 and 300,000,000,000—'just about as many as there are dol-
lars in the national debt'" according to the astronomer in charge of the project,
who added that "the final figure on how many stars, if it could be computed,
would be so large as to be meaningless." In the margin of this article, Cornell
scrawled a note about a constellation he observed at Westhampton.[35]

In his carrousel boxes, Cornell moved the viewer back and forth in time
and space by associating ancient constellations he saw at night with the distant
sky objects being studied and mapped by modern astronomers on Mount Palo-
mar. Questions of time and space were even more deeply probed in another

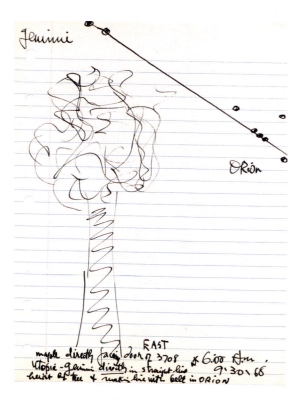

FIGURE 5.10.
Joseph Cornell, diary
entry, October 16, 1970.
Courtesy of the Joseph
Cornell papers, 1804–1986,
Archives of American Art,
Smithsonian Institution.

assemblage Cornell apparently worked on around this time, *Les Constella-tions, Voisines du Pôle* (fig. 5.11). With a constellation chart taken from Flam-marion's *Les Etoiles* featuring a striding Cepheus, curling Hydra, staff-in-hand and Phrygian-capped harvest keeper Custos Messium, and giraffe Camelop-ardus revolving around Ursa Minor (fig. 5.12), this box was probably the one he referred to in his diary in October 1951 as "'Little Bear' yellow box," but which presumably evolved into the Camelopardus box named in the exhibi-tion announcement.[36]

Like other observatory boxes of this period, in *Les Constellations, Voisines du Pôle* he positioned the white wire grid on the side, curving one strand at the top to suggest the arch of an observatory dome. Befitting an observatory, the inner side walls of the box are covered with mirrors, while the inner back is rubbed with a silvery-gray paint and spotted with darker flecks. Although a penciled note on the inside top of the lid indicates that Cornell may have continued working on the assemblage as late as 1960, in spirit and design—especially in the use of a white interior with white wire mesh—it seems likely that he began it nearly a decade earlier.

In this box, Cornell overlaid principles of physics onto the observatory theme. As he had already done in his film *The Children's Party*, he alluded to

135

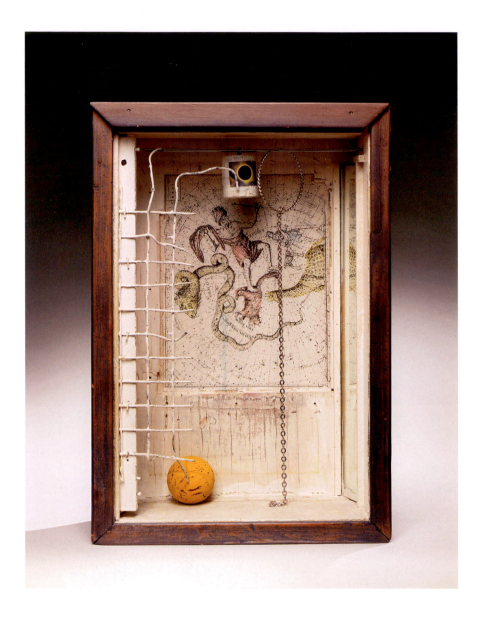

Newton's law of universal gravitation, now with gravity represented by the chain that "holds" the ring to Earth, while the rod on which the ring slides indicates the straight line of motion it would take if gravity did not pull it into a circular orbit around another heavenly body, like the cork-ball Sun. By appropriating Flammarion's *Voisines du Pôle* illustration, Cornell included an additional image of circularity, with the constellations making their slow, stately circuit of space, as determined by this same principle of universal gravitation. At the same time, the chain and circles and striding Cepheus also resonated

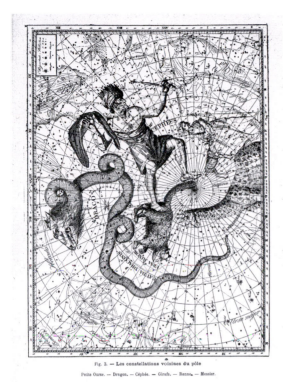

Fig. 3. — Les constellations voisines du pôle

Petite Ourse. — Dragon. — Céphée. — Girafe. — Renne. — Messier.

on a poetic level, mirroring lines from Arthur Rimbaud's "Illuminations" that Cornell copied on a scrap of paper for one of his *Celestial Theater* files: "I have hung ropes from bell-tower to bell-tower; garlands from window to window; golden chains from star to star—and I dance."[37]

New research also made its way into the box. The glowing constellations, solar eclipse on a hanging cylinder, and yellow ball beneath a silvery cloud all relate to recent findings on a well-known astronomical phenomenon: zodiacal light. Cornell was especially interested in this phenomenon, the faint glow that passes through the constellations of the zodiac in the morning and evening sky.[38] Over the years he had gathered nineteenth-century illustrations and explanations of the phenomenon in his "astronomy" clipping folder, and he even filled a small paper bag with pages torn from books and magazines describing it (fig. 5.13). His long-standing fascination was suddenly a topic of current concern when researchers at the Harvard Observatory in 1950 proposed that zodiacal light was caused by reflections from dust and gas of the two galaxies of stars nearest our own, the "Magellanic Clouds." As explained in the *Monitor*, dust particles sweeping off comets are vaporized by sunlight, and "spiraling slowly toward the Sun, this dust circles about in the earth's path and may cause the faint glow of the Zodiacal Light. It also may contribute to

OPPOSITE PAGE:
FIGURE 5.11.
Joseph Cornell, *Les Constellations Voisines du Pôle*, c. 1951–53. Box construction, 18 × 12 × 5 in. Purchase 1999 The Alberto Burri Memorial Fund established by Stanley J. Seeger. 99.37. The Newark Museum, Newark, New Jersey, U.S.A. The Newark Museum / Art Resource, NY.

FIGURE 5.12.
Les Constellations voisines du pôle, in Camille Flammarion, *Les Etoiles* (Paris: C. Marpon et E. Flammarion, 1882).

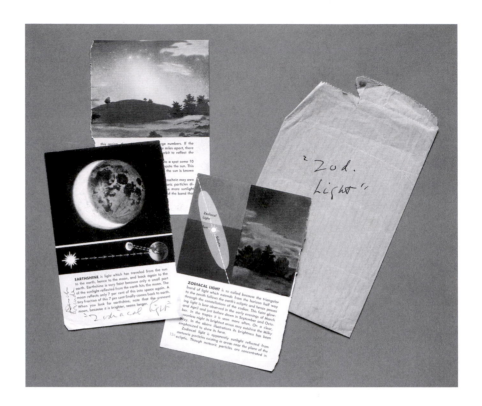

FIGURE 5.13.
Printed materials explaining zodiacal light, Joseph Cornell Study Center, Smithsonian American Art Museum. Mark Gulezian/QuickSilver Photographers.

the brightness of the corona—that fiery mop seen about the Sun's darkened disk when obscured by the Moon in a total eclipse."[39] With its glowing constellations, dusty cloud below, and solar eclipse above, Cornell's *Les Constellations, Voisines du Pôle* parallels this description of the zodiacal light effects of cosmic dust to an uncanny degree. However, the inclusion of a solar eclipse in this box points to yet another layer of meaning.

On November 8, 1951, Cornell typed a rambling diary entry. In addition to recording thoughts about a story by Isak Dinesen, exhibitions of work by Max Ernst and Franz Kline, and a snack of hot apple pie and vanilla sauce in the Fifty-ninth Street automat, he noted a visit to de Kooning, where they discussed, among other things, "Einstein, time, space, etc."[40] Earlier that year another diary entry chronicled a "late night 'quickening' going over Scientific Americans with article on Einstein & Aristotle—stimulus to follow up series for same PHYSICS 1951, philosophical toys, etc. etc."[41] Given Cornell's fascination with both ancient and modern astronomy and cosmology, his interest in Einstein is not unexpected. By mid-century, most Americans had some passing acquaintance with Einstein's theory of general relativity. In particular, they would have known of the importance of a solar eclipse for initially proving it in 1919, when astronomers recorded Einstein's predicted curvature of starlight as it neared the Sun.[42]

Eclipse of Sun to Test Einstein Theory

By Robert C. Cowen
Natural Science Writer of
The Christian Science Monitor

Washington

On Feb. 25 the moon will blot out the sun over Africa and provide a test for the Einstein theory.

According to this theory—the theory of relativity—light beams should be bent when they pass near a huge mass like the sun. This should show up as a displacement of the star field directly behind the sun as seen from the ground. If such a displacement can be found, it will be another peg of experimental proof for the theory.

No one in the western hemisphere will be able to see the eclipse. Its path of totality will sweep from the equatorial mid-Atlantic in a northeasterly direction across Africa to the heart of southern Siberia.

Ordinarily the sun obliterates the stars behind by its own brilliance. But, during an eclipse, astronomers have a few brief moments when they can study these stars. That is one of the reasons why experts from the United States Air Force, the Naval Research Laboratories, the National Geographic Society, and the Universities of Colorado and Denver are lugging equipment half way around the world to follow the sun into darkness from French Equatorial Africa to the Persian Gulf.

Khartoum in Path

By a Staff Artist

The shift in starlight revealed by eclipse observations was one of the basic confirmations of Einstein's general theory of relativity, and scientists leapt at the possibility to retest and refine it when a solar eclipse took place on February 25, 1952. Although New Yorkers had to be content with watching a virtual eclipse on the dome of the Hayden Planetarium, they could follow press coverage that included news and photographs of a National Geographic Society expedition to Khartoum, and even see a fanciful drawing of Einstein on a curved ray of light in the *Monitor* (fig. 5.14). Just three months after discussing Einstein with de Kooning, Cornell could be reminded once again of the importance of ongoing eclipse observation in confirming relativity right or wrong.[43] His inclusion of a solar eclipse in an observatory box would have easily resonated with viewers as a reference to Einstein, and the curved form of the hanging ring and the angle of the chain as it rests on the floor of the box could likewise have prompted thoughts about the interaction of light with gravity. While his working method precluded setting out with the conscious purpose of bringing together ancient constellations with modern concepts of time and space, linked associations must have emerged as he responded to the "sparkings" between the objects that found their way into the box.

FIGURE 5.14.
"Eclipse to Test Einstein Theory," *Christian Science Monitor*, February 13, 1952. Photo, © 1952 The *Christian Science Monitor*. All rights reserved.

139

Still, Cornell took pains to combine the old and the new, using an antiquated star map as a backdrop for allusions to modern physics. This combination of romantic nostalgia for a time when stars could be imagined as animals with a new world where space is curved and time is relative was not Cornell's alone. In fact, as is so often the case with Cornell's astronomical allusions, it mirrored sentiments expressed in other public outlets. For instance, a few years earlier a writer in the *Christian Science Monitor* pondered the shared sense of wonder that underlay old metaphors and new science:

> We don't call them shooting stars any more. We don't wrap them in the overrich velvet of language as "dripping jewels." We measure their light and their velocity. We wrap them in a space-time continuum. We study them as "clues." Yet out of wonder they come and into wonder they go. The clues burn themselves out. New mysteries wheel after old mysteries. Star dust is still in our eyes.[44]

Regardless of his interest in Einstein, "star dust" was still very much in Cornell's eyes as he conceived the Night Voyage exhibition, reflected not only in the observatories, but also in a series of hotel boxes he mentioned in his diary notes in the early 1950s. Two of these seem to have been shown at the Egan Gallery, as indicated on the announcement: "Grand Hôtel du Nord" and "Andromeda." While it is unclear which work was shown under the title "Grand Hôtel du Nord," the "Andromeda" box was most likely one now known as *Untitled (Andromeda; Grand Hôtel de l'Observatoire)* (fig. 5.15). He began working on such boxes as early as 1947—a note written on April 16 of that year presented the equation "Andromeda + Auriga = which evoked former preoccupation of working with mirrors—multiple reflections, rt angles, etc.,"—and at least some of them were still very much in progress less than a month before the exhibition opened, as indicated in a note from January 15, 1953, that recorded taking "Night Voyage stats" to the photostat maker.[45] A related diary entry described riding a train into the city: "on way in the marking up of the Flammarion book on ASTRONOMY for NIGHT VOYAGE exhibition—that sudden loosening up of emotion that comes with the expansive vistas & bird's-eye view in motion on elevated about life in general."[46]

Among the many photostat copies Cornell had made over the years from Flammarion's *Les Etoiles* was the illustration of Andromeda, taken, in turn, from Hevelius's star atlas of 1690 (fig. 5.16). Despite (or perhaps because of) the fact that Hevelius's Andromeda is a somewhat androgynous figure, seen "internally," as if from Earth rather than from outer space, Cornell was quite taken with this particular personification of the constellation. He noted its erotic charge by associating it with a "girlie" picture of the actress Jackie Lane, saving a bare-backed photograph of her, together with a star chart published in the *Monitor* in 1956 on which he scrawled "Jackie Andromeda" in the margin (fig. 5.17).[47] But his rendition of the constellation in his observatory box was

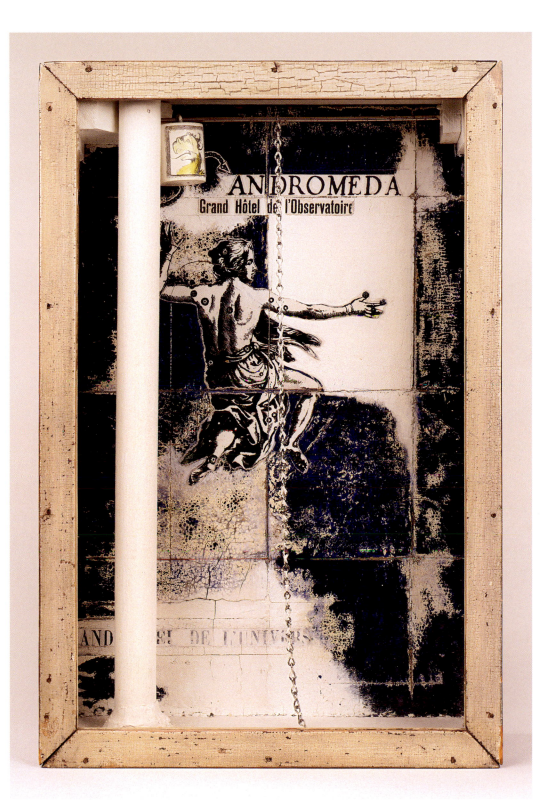

Figure 5.16.
*L'Andromède de l'atlas
d'Hévélius (1690)* in
Camille Flammarion, *Les
Etoiles* (Paris: C. Marpon
et E. Flammarion, 1882).

more coolly celestial. Using what appears to be enamel paint on masonite, Cornell achieved a mottled effect above and below the figure, suggesting the filmy appearance of a nebula. After mounting the Andromeda figure to the backing, he scored a rectangular grid and then repainted the incised lines to match the blue or white backgrounds. Pasted collage material positions Andromeda between the "Grand Hôtel de l'Observatoire" and "Grand Hôtel de l'Univers." Sliding on the rod at the top are a cylinder with the head of a griffon, an allusion to the mythological sea monster who threatened Andromeda before her rescue by Perseus, and a chain, a double signifier for chains that held Andromeda captive as well as that force of universal gravitation that still keeps her in place.[48]

The background grid for this and other Andromeda boxes is much larger than the wire screen that Cornell used in the carrousels to extend the lines of the collaged star charts. He may have expanded the grid to give visual form to new ideas about the size and age of the universe that were in the air just days before he took his copy of *Les Etoiles* to the photostat maker. On the last day of 1952, the *Times* reported that astronomers were using the new telescope on

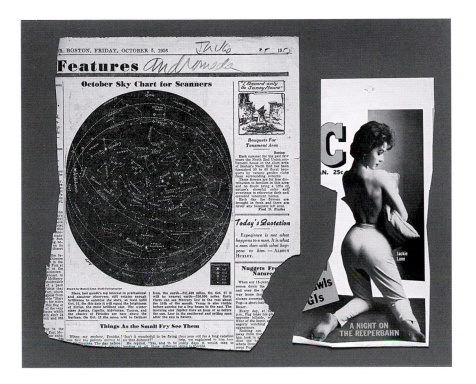

Figure 5.17.
"Jackie Andromeda"
notation and Jackie Lane,
Joseph Cornell Study
Center, Smithsonian
American Art Museum.
Mark Gulezian/
Quicksilver Photographers.

Mount Palomar to focus on the Andromeda galaxy (the terms "nebula" and "galaxy" were still being used interchangeably at this time). Observing that the Cepheid variable stars were brighter than had been supposed, they realized that the "yardstick" that had been used to measure the universe when Hubble began studying color-shifting of distant nebulae in the late 1920s needed to be recalibrated. The result, as announced in the *Times*: the Andromeda galaxy was much more distant than previously thought, estimated by Hubble to be approximately 1.5 million light years away. Moreover, astronomers calculated, to get to its present size, the entire universe began expanding twice as far in the past, about three or even four thousand million years ago.[49] Thus, to look at Andromeda in the night sky was to look far back in time. As physicist George Gamow put it in *Scientific American* in 1954, "the present-day photograph of the great Andromeda Nebula shows that group of stars as it looked about two million years ago, for it has taken this time for its light to reach us."[50] The scale for measuring astronomical time and space was radically enlarged; so was the grid in the Andromeda box.

In this instance, as in all of his other Andromeda boxes incorporating Hevelius's engraving of the constellation, Cornell carefully positioned the figure so she appears to be sitting on the grid line that rests just below her hips. She seems to be on a high wire, as if waiting to grab the chain and spin in space, like iron-jawed Frances Hanes did at Coney Island's Luna Park. Seated on a

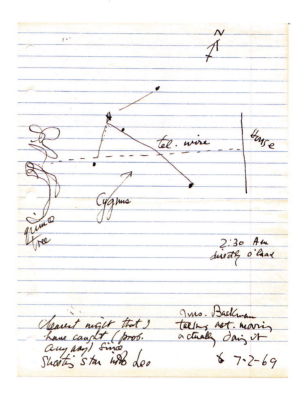

FIGURE 5.18.
Joseph Cornell, diary
notation, July 2, 1969, 2:30
a.m. "Allegory of Faith"
file, Courtesy of the Joseph
Cornell papers, 1804–1986,
Archives of American Art,
Smithsonian Institution.

thin line through space, like the stars that seemed "perched" on the telephone wire strung across his backyard (fig. 5.18), she imparts the idea of balance—balance that could be understood in the context of human, tightrope-walking balance, but also in the much larger sense of Newtonian cosmic balance between the forces of gravity and acceleration. Indeed, the implications underlying Andromeda's precarious celestial perch may be even more complex.

Earlier in 1952 a long article by Cambridge University astronomer Fred Hoyle that Cornell saved from the Sunday *New York Times* magazine presented a mind-boggling new theory about the universe (fig. 5.19). "Some scientists," Hoyle wrote, "hold that the universe as we know it now 'began' a billion or so years ago, when a single mass, in which all matter was concentrated, began to blow up, like an atomic bomb." Instead, he and his fellow "New Cosmologists" proposed a "balanced universe" with the expanding universe and the creation of matter perfectly balanced, with no beginning and no end in time, as a circular, self-renewing chain reaction.[51] Hoyle's theory gained popular currency through a series of BBC broadcasts produced in 1950, and by 1952 it was widely accepted as a possible alternative to the expanding soap bubble universe proposed by Lemaître back in the 1920s. In the *Times*, Hoyle described his theory in detail, noting that it would be proved or disproved on the basis of research currently underway at Mount Palomar. To relate Hoyle's

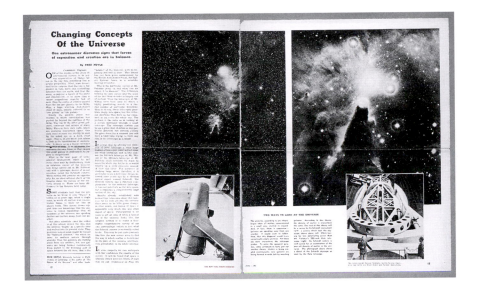

theoretical analysis to the new observatory, photographs accompanied the article, including images of two telescopes and their views of the sky, as well as a photograph of the observatory dome—captioned "Palomar's window on the sky." There was also a spiral nebula, photographed using the 200-inch telescope. The nebula in question was the Andromeda nebula.

In keeping with the observatory theme, in *Untitled (Andromeda; Grand Hôtel de l'Observatoire)* Cornell included a rectangle in the upper right of the box's inner back to suggest a window. This one, however, opens onto a white space of pristine, ordered perfection, quite unlike the dark, ragged edges of the known universe observed from Mount Palomar. Andromeda gestures to the space that has yet to be filled, as the constantly renewing matter that makes up the universe continues its eternal expansion. The hanging cylinder, the mounted dowels, even the repeated links of the chain all suggest parallels to the circularity implied by Hoyle's theory of an infinitely balanced universe. Whereas in *The Children's Party* Cornell chose film footage of tightrope walkers and aerialists as metaphors for laws of Newtonian physics, now his "high wire act" was relocated to the upper reaches of space and the outer limits of time.

Condensing matter and expanding space lay at the heart of Hoyle's theory. They were also important conceptual themes for Cornell. In Night Sky boxes such as the one featuring Andromeda, he used formal devices to balance the forces of compression and expansion: the box format creates visual pressure from the outer sides, while within, space seems to expand to the infinite stretches of the universe. Perhaps the parallels were just coincidental, resulting from a shared sense of cosmic balance in an expanding universe. Nevertheless,

FIGURE 5.19.
Fred Hoyle, "Changing Concepts of the Universe," *New York Times*, June 1, 1952. Joseph Cornell Study Center, Smithsonian American Art Museum. Mark Gulezian/ QuickSilver Photographers.

145

Cornell was interested enough in Hoyle's theory of celestial balance to keep not only a copy of the Sunday *Times* article in his papers, but also reviews of several of Hoyle's books, including a review of *The Nature of the Universe*, published in 1952. This one, which the artist marked with a large black check, neatly summarized Hoyle's theory of continuous creation.[52]

Night Voyage at the Egan Gallery also included austere boxes fronted with grids of windows. Cornell described one as an "'Observatory' panel-window with shattered glass looking out on night skies"; another as "Façade of window-panes (individual & real as against painted type)"; and still another as "Bird Cage White, vista of sky thru real window."[53] In retrospect, these window façade boxes seem to predict minimalist abstract grids made by artists a good decade later, but for Cornell the operant factor was the relationship between an observatory and a window. To look beyond a window into the night sky, whether from a bedroom, a birdcage, or the observatory on Mount Palomar, was an act of exploration worthy of contemplation and commemoration. And yet, Cornell was all too aware that those night skies had been the source of recent atomic terrors, that scientific exploration could lead to inconceivable horror, and that, as the author of an undated article he saved for his files put it, "philosophy can explode."[54]

He considered distributing a written parallel to the visual message of his boxes at the Night Voyage exhibition and went so far as to have printed on small pieces of fine paper with matching envelopes a quotation from a sermon by John Donne: "if you can hear a good Organ at Church, and have the musique of a domestique peace at home, peace in the walls, peace in thy bosome, never hearken after the musique of sphears, never hunt after knowledge of higher secrets, than appertaine to thee."[55] In the end he decided against making the quotation part of the exhibition—perhaps the idea of never hearkening after the music of the spheres ultimately seemed contradictory to his aims—but the plea for peace and the implicit warning about where a search for "knowledge of higher secrets" could lead were clearly important to him.

Winter Night Skies

From December 12, 1955, through January 15, 1956, Cornell's third exhibition centering on astronomical themes was held, this time at Eleanor Ward's newly opened Stable Gallery. Winter Night Skies, as it was called, featured variations on themes already announced in the previous two exhibitions at the Egan Gallery. The brochure, decorated with a copy of Hevelius's version of the constellation Auriga taken from Flammarion's *Les Etoiles*, introduced some of the works: three versions of boxes featuring Auriga, three versions of Andromeda, and one with Cameleopardalis (an alternate spelling for the constellation Camelopardus). A checklist Cornell submitted to the gallery also

named *Hotel de l'Etoile* and a second Cameleopardalis box.[56] In notes made during the months leading up to the exhibition, Cornell charted his emotional states of mind: "beautiful sense of grace experienced working on Andromeda," "gratitude to counteract let-down sense of futility feeling from 'Camelopard' chart Box lifted into something satisfying + beautiful from dusty cellar frustration," "loosening up of working in larger boxes stemming from unfoldment with larger 'Auriga' box—a beautiful lift coming early morning in the warmth of the cellar atmosphere."[57]

This time he did frame the exhibition with a quotation in the announcement, taken, with minor changes, from Garrett P. Serviss's *Astronomy with an Opera Glass*. The passage Cornell chose describes the constellation Auriga as the figure of a man carrying a goat and her two kids in his arms, noting that Capella, the star representing the goat, ordinarily is the first bright star seen through the breaking clouds of a storm, thus earning it the reputation as the sailor's friend. All this was common star lore. But Serviss added an unusual note, claiming that Auriga foreshadowed the Christian Good Shepherd who would rescue the sinful world.[58] For Cornell, who studiously avoided openly suggesting any religious dimensions to his works, it was a strange introduction to the exhibition, chosen no doubt because the message of redemption echoed the healing goals of the *Celestial Theater*. The glowing reviews of Winter Night Skies skirted this aspect of Cornell's vision. In the *New York Times*, Preston noted that "little windows in his bare, cell-like boxes open on to cloudless climes and starry skies and beckon the spectator to lose himself in the firmament."[59] Laverne George wrote in *Arts Magazine* about the "air of nostalgia" in Cornell's "Greek mythology, strips of lettering which spell out the names of the characters and small French hotels, stellar nebulae scattered across blue paper, sections of ancient maps," detecting in the boxes "a private little world of erudite puns and witty allusions."[60]

The most insightful comments about Winter Night Skies came two years later in *Art News*, when Howard Griffin wrote a feature article that offered thoughts, in retrospect, about the exhibition, together with perceptions based on a recent interview with the artist.[61] Although Griffin was the only critic to mention the quotation from *Astronomy with an Opera Glass* that prefaced the exhibition, he merely noted that Serviss described Auriga as a figure of a man carrying a goat and two kids in his arms. Rather than engage the issue of redemption, Griffin tried to articulate the sense of celestial magnitude conveyed in the boxes. Among the works he discussed was *Hôtel du Nord* (fig. 5.20), one of the Auriga boxes included in Winter Night Skies. In it, Cornell positioned a figure from Hevelius's atlas in front of a white void, prompting Griffen to describe Auriga, "from whose fingertips a widely-scattered stellar world exploded. Who was he? Toward what did he point? If one looked closely, one saw that the paper shape had been affixed to the wood, the arm gesturing toward a deeper and less penetrable space, like window opening on window."[62]

147

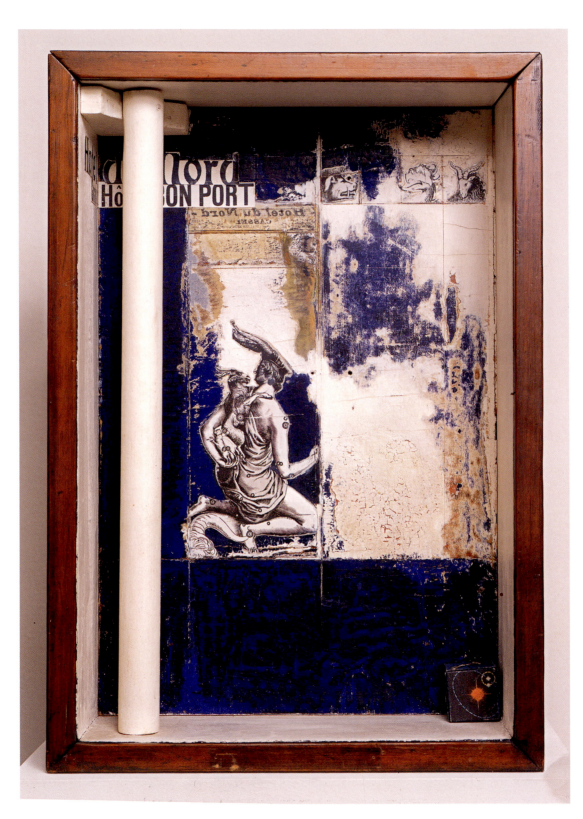

In the upper left corner of *Hôtel du Nord*, Cornell included collage material that named the "Hôtel du Nord" and "Hôtel Bon Port" in large letters. With smaller text he repeated the words "Hôtel du Nord," although in reverse, using the device, found frequently on the backs of astronomy boxes, of changing the orientation of text to suggest rotation. He continued this theme of rotation with the inclusion of a small cube at the bottom of the box, covered with a tiny star chart showing double stars orbiting around a larger one, as a modern parallel to traditionally anthropomorphized constellations. The diagram (fig. 5.21), one of numerous diagrams of stars, eclipses, and rainbows Cornell clipped from his many copies of Zim and Baker's *Stars*, illustrated a triple star system, a large star accompanied by two smaller ones, recalling the sailor's friend, Capella the goat, along with her two kids. In this way, he combined old and new ways of visualizing the stars, underscoring their reassuring constancy in the face of changing modes of mapping and understanding them. It was a practice he continued in a collection of related works—later referred to in a note as "unfinished miniatures"—little boxes each no more than a few inches wide, decorated with or containing star charts and related materials (fig. 5.22).[63]

Thus the observatory theme had evolved from the actual scientific instrument on Mount Palomar, to consideration of the findings made there about the infinite universe, and to their scientific, existential, and spiritual significance. Cornell was not unique in considering the link between modern scientific study and larger cosmological questions. A short poem by Leslie Nelson Jennings entitled "Telescope," published in the *Christian Science Monitor* in 1948, demonstrates how deeply embedded these ideas were in contemporary American thought:

Ever since Galileo charted one
Small corner of the universe, and set
Its boundaries beyond our minor Sun
We have been searching farther, probing yet
Deeper into that mystery where space
May hold expanding firmaments, curve back
Upon its own circumference to trace
A vaster circle than our zodiac.

Now to a larger window in the sky
We turn that mirror on Mount Palomar,
Hoping at last to measure what no eye
Ever has found, advancing star by star
Through island constellations without end
Toward something faith alone can apprehend.[64]

Included in Winter Night Skies were several works that required viewers to think in increasingly complex ways about how Cornell's vision of the cosmos

OPPOSITE PAGE:
FIGURE 5.20.
Joseph Cornell, *Hôtel du Nord*, c. 1953. Box construction, wood, glass, collaged printed paper and painted wood, 19¼ × 13¼ × 5½ in. Whitney Museum of American Art, New York. Purchase 57.6.

149

Pair of Double Stars: Castor

DOUBLE STARS Over a third of all known stars are double, or "binary." The components of a few can be seen with the unaided eye; thousands can be "separated" with a telescope; thousands more are detected by the spectroscope. Some stars have three or more components; Castor has six—three doubles. The main, mutually revolving pair will be closest together in 1968—about 55 times the distance of the earth from the sun.

Mizar, at the curve of the Big Dipper's handle, has a faint companion. Mizar itself is a telescopic double and the brightest component is a spectroscopic double star. When the two stars are in line, the spectra coincide. When, as they revolve, one approaches us as the other moves away, the spectrum lines are doubled. Capella and Spica are also spectral double stars.

As double stars revolve, one may eclipse the other, causing reduced brightness. Best-known of eclipsing double stars is Algol, in Perseus. It waxes and wanes at intervals of about three days. The eclipsing stars are 13 million miles apart. Their combined magnitude varies from 2.3 to 3.4.

Triple Star System

VARIABLE STARS are those that fluctuate in brightness. Most dramatic are the exploding stars, or novae. These dense, white stars rapidly grow in brilliance, up to 100,000 times or more, then fade away. Other variables change less drastically regularly or irregularly. Some red giants and supergiants vary from 4 to 10 magnitudes over a few months to two years. Mira, in Cetus the Whale, is a famous long-period variable that shows extreme changes of brightness.

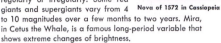

Nova of 1572 in Cassiopeia

The variables known as classical Cepheids vary in brightness over periods of one day to several weeks. The distance of any of these Cepheids can be readily estimated because of the definite relationship between its variation period and its absolute magnitude. By measuring the period, the absolute magnitude can be determined, and by comparing the absolute magnitude with the apparent magnitude, the distance can be estimated. These Cepheids are important in the calculation of distances of star clusters and galaxies (pp. 40-43). In recent years, new information about classical Cepheids has indicated that previous estimates of the distances of galaxies beyond our own galaxy should be at least doubled.

Eclipsing Binary, Algol, with Magnitude Changes

A Rainbow Is a Spectrum

forms from light reflected twice within drops. Light may be reflected more than twice, so occasionally up to five bows are seen.

Another type of bow — red, or red and green — may appear with primary and secondary bows.

How a Raindrop Refracts Sunlight

Total Eclipse of the Moon

LUNAR ECLIPSE The earth's shadow is some 900,000 miles long. When the moon enters into it and is eclipsed, the eclipse lasts as long as several hours and may be total for as much as 1 hour and 40 minutes. In any year there may be no eclipses of the moon or as many as two and rarely three. Though there are fewer eclipses of the moon than of the sun, they last longer and can be seen by more people over a wider area. Because some of the sunlight striking the earth is diffused and scattered by our atmosphere, the earth's shadow is not completely dark. Enough of this light reaches the moon to give it a faint coppery glow even when it is totally eclipsed. An eclipse of the moon occurs only at the time of full moon. Because of angles of the moon's orbit, it may miss the

154

TOTAL LUNAR ECLIPSES

Date	Time of Midpoint of Eclipse (EST)	Duration of Eclipse	Duration of Totality
Dec. 30, 1963	6:10 p.m.	3 h. 35 m.	1 h. 25 m.
June 24, 1964	8:05 p.m.	3 h. 40 m.	1 h. 40 m.
Dec. 18, 1964	9:35 p.m.	3 h. 30 m.	1 h. 5 m.
Apr. 24, 1967	7:05 a.m.	3 h. 35 m.	1 h. 20 m.
Oct. 18, 1967	5:15 a.m.	3 h. 25 m.	0 h. 55 m.
Apr. 12, 1968	11:50 p.m.	3 h. 25 m.	0 h. 55 m.
Oct. 6, 1968	6:40 a.m.	3 h. 30 m.	1 h. 0 m.

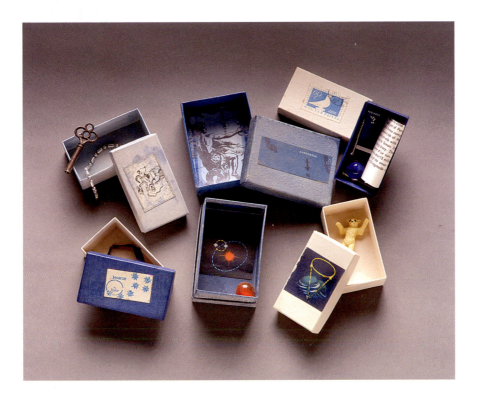

was also directed "toward something faith alone can apprehend." Among these were stark constructions like *Hôtel de l'Etoile*, a white box simply containing the underlined words of the title above a narrow vertical window revealing a few dots of paint on a dark blue sky, and *Untitled (Window Façade)*, with a grid of small glass windows, five of which are fractured (fig. 5.23). While perhaps punning on works by Duchamp, like the *Large Glass* and the closed French window entitled *Fresh Widow*, Cornell also elaborated upon the observatory theme. In his window façade box, using repeated panes of glass reminiscent of film frames, he alluded to "shooting stars" with selectively shattered panes. He was clearly aware of the incongruity, later writing in a diary entry on September 6, 1958, about "cracked panes or windows with stars,"[65] but the astronomical allusion was lost on critics like Griffin, who saw only that the "bullet holes into eternity had a neat and desperate quality."[66]

An apparent existential counterpart to the Auriga boxes, this bleak window box seemed to offer no refuge in an imaginary celestial hotel, no good shepherd to redeem the world. In place of the richness of the *Celestial Theater*, with its cast of age-old actors on a cosmic stage, what struck Griffin was only a "desperate" emptiness, punctuated by bullet holes. However, despite Cornell's admiration for the works of Sartre and Camus, about whom he saved many articles for his "Literature" clipping file, Cornell was no existentialist. In his

Opposite page:
Figure 5.21.
Clockwise from upper left: "Star Types," "Lunar Eclipse," and "Sunlight and Rainbows" in Herbert S. Zim and Robert H. Baker, Stars, *A Guide to the Constellations, Sun, Moon, Planets, and Other Features of the Heavens* (New York: Golden Press, 1956).

Figure 5.22.
Joseph Cornell, small boxes with astronomical charts and objects. Joseph Cornell Study Center, Smithsonian American Art Museum. Mark Gulezian/QuickSilver Photographers.

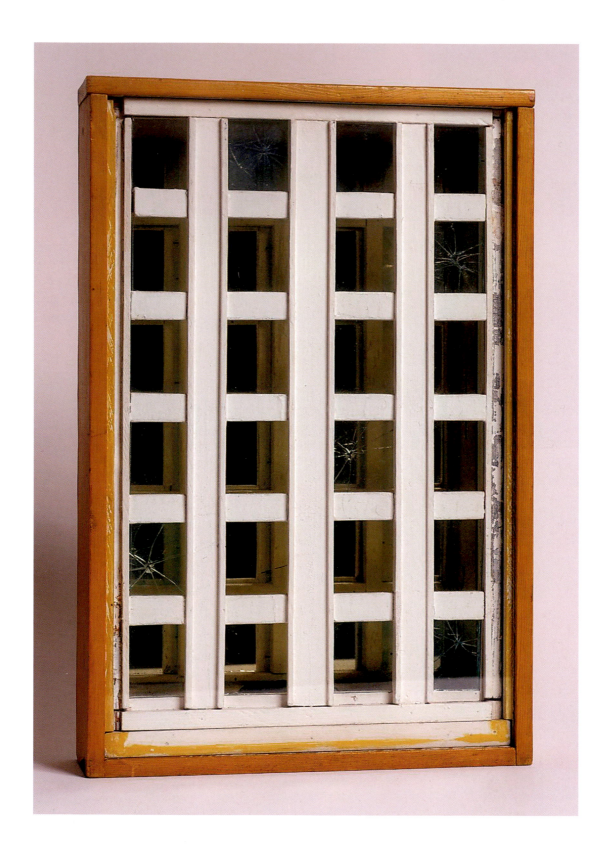

universe there was deep meaning that extended beyond the facts gathered by astronomers past and present—metaphysical meaning, whereby the physical aspects of the material world were symbols for something much greater, spiritual meaning that Cornell's beloved Mallarmé captured in his poem "Les Fenêtres," when the narrator observes his reflection in a pane of glass and, "In the chaste morning of the Infinite, / I look at myself and see myself as an angel."[67]

OPPOSITE PAGE:
FIGURE 5.23.
Joseph Cornell, Untitled
(Window Façade), c. 1953.
Box construction, 18⅝ ×
12⅜ × 3½ in. The Menil
Collection, Houston.
Photo: Hickey-Robertson,
Houston.

CELESTIAL HEALING

On January 28, 1953, Cornell noted in his diary: "midnight—kitchen just dipping into Gaposchkin bk on the stars." His next entry followed up: "Cecilia Payne-Gaposchkin bk 'Stars in the Making' in G.C. Station bookshop supplement NIGHT VOYAGE research—enriching the Auriga + kid goats feeling— Some Bayer plates in her work worked out in new box same morning or yester one before photostats at A + F with new crop constellations. * [a rich evening voyage]."[68] The book in question was an account of the evolution of the universe, written for the layman by noted Harvard astronomer Cecilia Payne-Gaposchkin. In her book, billed in an ad in Cornell's files as "a celestial Cook's Tour conducted by one of the world's great astronomers," Payne-Gaposchkin developed an extended metaphor of the cosmos as theater, with chapters titled "The Players," "The Scene," and "The Drama." As she wrote in the introduction,

> The drama of cosmic evolution is played out upon a stage that stretches beyond the limits of our vision, at a pace so slow that the span of human history has witnessed no action. None the less, evidences of the drama are spread before us. We are like people who stand outside a movie theater, and try to reconstruct the story from a display of single "shots." . . . Each "still" represents the interplay of a group of actors. We witness individuals in moments of crisis, and individuals that radiate tranquility. Intimate scenes pass before us, groupings that reveal crucial moments of the drama. Stupendous mob scenes reveal the tendencies of stellar communities. The task of astronomy is to analyze the interplay of forces that has produced each situation, and to weave the situations into a coherent drama.[69]

Payne-Gaposchkin's celestial theater was designed to explain the complex workings of the modern universe, according to the latest astronomical discoveries, and, given the elevated nature of her material, it is not surprising that she chose a theater analogy to bring it down to Earth. Cornell bought the book at Grand Central terminal, passing under its ceiling twinkling with constellations. He dipped into it in his kitchen at midnight, as the winter stars made their way across the sky. Like Payne-Gaposchkin, he, too, envisioned a celestial

153

theater, but unlike her scientific account of the facts and figures of the stars, his long-term engagement with the cosmos was designed to touch the souls, as well as the minds, of his audience. Cornell's mission was redemptive, and he devoted his energies to creating a comforting vision of the cosmos to replace wartime terrors. His cosmic theater ranged from metaphors of the circus and playground, to ancient heroes found in night skies, to visualizations of scientific discoveries, each of which might act as a force for healing in a troubled world.

On some level at least, his message got across, and his work was increasingly well-received. In 1957 he won a $250 prize from the Art Institute of Chicago for his carrousel-observatory construction, *Pavilion*, and in 1959 the *New York Times* announced: "Two $1500 painting prizes, the Ada S. Garrett Prize and the Flora Mayer Witkowsky Prize, went respectively to Joseph Cornell, for a surrealist collage called 'Orion' and to Hans Hofmann for an abstract oil, 'The Pond.'"[70] Although Cornell never exhibited his *Celestial Theater* dossier, with its carefully mounted clippings and collection of "varia" about the stars, throughout the 1950s the concepts he explored in it made their way into his observatory boxes, where ancient constellations paired with modern discoveries to take his stargazers on a comforting journey through time and space.

Cornell's observatories clearly fit into the public context of postwar science and art. They also fit into the private context of his deeply held Christian Science beliefs. The healing mission of the *Celestial Theater*, with its concept of art as antidote, was an obvious expression of his faith in the enigmatic power of the cosmos. But there were also apparent contradictions between rational experimental science and spiritual Christian Science that he attempted to reconcile in his Night Sky boxes. To Christian Scientists, matter is only an illusion. Truth rests in the infinite, divine Mind of God. As Mary Baker Eddy wrote, "Matter disappears under the microscope of Spirit."[71] Or, as Cornell quoted Mrs. Eddy in his diary notes, "Spirit + matter no more commingle than light + darkness. When one appears, the other disappears."[72] Given the acceptance of the insignificance of the material world that is at the core of Christian Science, how would a practitioner like Cornell approach the exciting new discoveries about the universe and the cosmological questions that they raised?

For a Christian Scientist, in the words of Eddy, "astronomical order imitates the action of divine Principle; and the universe the reflection of God."[73] The detailed coverage of modern astronomical discoveries in the *Monitor* can be understood as a continuation of this metaphysical sense of knowledge, in which understanding the order of the universe is tantamount to understanding "divine Principle," or God. For example, Hoyle's concept of an infinitely expanding universe offered a parallel to the Christian Science belief in an infinite unfolding of God in the cosmos, a point made in 1950 in an article written by none other than the editor of the *Christian Science Monitor*, who summarized: "Briefly, Mr. Hoyle says the universe is being continuously

created, and is infinite. Mary Baker Eddy, three-quarters of a century ago, wrote 'Creation is ever appearing, and must continue to appear from the nature of its inexhaustible source.' This is precisely what Mr. Hoyle says happens in the creation of the universe."[74] In articles like this one, as well as in hymns and in Eddy's texts, the material things of the natural world—especially astronomical phenomena—function as vehicles for spiritual concerns. Even when this meaning is not directly spelled out, the message is implicit. This is evident in the many poems published in the *Christian Science Monitor*—a number of which found their way into Cornell's papers—that praise the beauty of the stars, the constellations, the Moon, and the infinite night sky as thinly veiled metaphors for the divine Mind of God.[75]

Cornell was an artist who cared deeply about the cosmos, from historical, scientific, and spiritual standpoints. Living during an unparalleled age of astrophysical discovery he, like many of his contemporaries, sought ways to envision such nearly unimaginable concepts as an expanding universe, the curvature of space, and the relativity of time. As a Christian Scientist, he was schooled to think in metaphoric terms, and in his art he layered physical science and Christian Science to produce his multidimensional views of the cosmos. His approach was indicative of a general concern among Christian Scientists with reconciling new scientific research and Christian Science metaphysics. An editorial published in the *Monitor* contained these words, which he circled: "Life isn't all bombs and nuclear energy and home laundries and tanks. There is still faintly discernible a spiritual side, a side in which things like birds and books and people have some part. There are still men and women who believe that the spiritual and aesthetic side of life is more important than the material and militaristic side."[76]

For his *Celestial Theater* clippings, he saved a *Monitor* editorial from 1948 entitled "A Window to the Stars." In it, the author placed his remarks within the context of the dedication of the new telescope on Mount Palomar: "We have gone a long way since Galileo. Yet once again, as in his day, men stand solemnly and a little aghast before the staggering vision of the universe around them." Humans can, the author went on to assure his readers, find inspiration in the superb achievements of men who have dedicated themselves to the advancement of human knowledge. They can thrill to the discoveries that will be made on Mount Palomar. But if they combine this knowledge with the "purity of heart which accepts the kingdom of God 'as a little child,' they will find a new heaven within and a new earth without and reality will break increasingly through appearance."[77] Perhaps Cornell kept this editorial because it reflected his own approach to science and faith. While thrilled by the new discoveries that were reshaping modern understanding of the universe, he also believed that, in the end, the planets and the stars were reflections of something far greater, "symbols of an order divinely created," as another article he saved for his *Celestial Theater* clippings put it.[78] The better one understood and

155

BIBLE HOUSE, COOPER INSTITUTE, AND CLINTON HALL.

appreciated the stars and the forces governing them, the closer one could be to understanding the Truth that signifies the Christian Scientist's God.

From this viewpoint, Cornell's observatories and other constellation boxes offered glimpses not only into the night sky, or even into the complexities of modern physics, but also into the infinite universe and the forces that govern it, as the ultimate reflection of divine Truth. Already in his *Children's Party* film trilogy there were inklings of the spiritual. *The Midnight Party* includes a quick view of birds in flight seen from below with a large hand entering from the upper right; in both *The Midnight Party* and *The Children's Party*, the acrobat dangles from the rope in her mouth in a pose of prayer; in *The Midnight Party*, after the brief shot of a washerwoman, a rapid intertitle reads, "He shall transform the households of drudgery into homes of ease and happiness; He shall work unceasingly night and day; And yet his origin shall remain shrouded in mystery," before dissolving to a cloud-filled sky. As the opening frame of *The Children's Party* demonstrates, the upside-down and backwards "The End" is just the beginning.

The importance of the spirit also underlay Cornell's conception of the observatory boxes. The observatory—whether housing a telescope, opening a window onto heaven, or offering imaginary refuge in the form of a celestial hotel—was a key motif for Cornell, linking natural science and Christian Science. While his observatory boxes were by no means intended to preach, the message was there for anyone who wished to find it: modern science is not just capable of producing horrific creations like the atom bomb, but it also enables us to see into the deep reaches of space, and, for those so inclined, even into the Mind of God. He reminds us that parables can be found in the stars, where Auriga presages the Christian good shepherd and Andromeda's sacrifice, rescue, and placement in

the sky is a story of redemption and eternal life. Even the stark window façade boxes have religious parallels. Cornell wrote a draft of a letter to de Kooning in the fall of 1951, describing his consideration during the past summer of "the façade of windows on the Bible House at Astor Place, which is part of a new 'exploration'."[79] The building, with its six-floor façade pierced by rectangular windows, was the home of the American Bible Society until 1936, when it moved to the heart of the gallery district, at the corner of Park Avenue and 57th Street (fig. 5.24). Far from reflecting the "desperate" quality that critic Griffin sensed, Cornell's window façade boxes began as a nostalgic exploration—an homage to the old center for the dissemination of sacred literature that was slated for de-molition.[80] In 1953 Cornell jotted in his diary, "CS Lecture 'spirit must always be taught by symbols'."[81] Perhaps this was why he always refused to discuss what his works meant, insisting that meaning should come from the viewer's personal response to them. To openly explain the Night Sky boxes would deny the viewer the opportunity to be taught by symbols. But for those who did probe both the physics and the metaphysics of these works, Cornell's celestial boxes could hold at bay the terrors that lay at the heart of the atomic age.

THE SCIENCE OF THE STARS

DURING THE 1930S COSMOLOGICAL QUESTIONS about the size and shape, creation, and age of the universe preoccupied scientists and filtered down to the general public. The expanding "soap bubble" universe, the implications of Einstein's theories about space and time, and the discovery of cosmic rays were explored by an international group of scholars whose goal was greater understanding of the cosmos, regardless of national ties. After World War II, however, such questions were cast very differently. In 1949 both the *Times* and the *Monitor* reported that Soviet astronomers had pledged to fight the so-called reactionary-idealistic theories of bourgeois cosmologists that support "clericalism." At a meeting in Leningrad, newspapers explained, Soviet scientists proposed to conduct "a complete discussion of the problem of the origin of the solar system in view of sharply differing existing viewpoints." In particular, stated the American press, Soviet astronomers resolved to prove the impossibility of metaphysical explanations for the origins and evolution of the universe.[1]

Scientists in the West reacted strongly to the Soviet insistence on materialism. Writing in 1951 in his book *The Nature of the Universe*, Hoyle warned: "Secrecy, nationalism, the Marxist ideology, these are some of the things that are threatening to choke the life out of science."[2] The *Monitor* took special issue with the Soviet stance, responding that "no rational person can deny that the free and untrammeled pursuit of the sciences has at least reintroduced into the closed world of the senses the possibility of a universe of pure thought."[3] Another *Monitor* article—this one Cornell saved for his files—paraphrased a lecture entitled "The Service of Science in an Age of Confusion," by the dean of Yale's Graduate School, who stated that science can never support materialism, for its goal is to clarify man's picture of himself and the universe, which is "essentially a spiritual idea."[4]

Within this cold war context, the contributions of the great free-thinkers of the history of astronomy took on special importance. Throughout the 1950s,

CHAPTER VI

books chronicling the conceptual revolutions that shaped modern astronomy appeared, along with reviews that positioned these studies against the perceived dogma of Marxism. New publications about Galileo, articles about Descartes and Copernicus, even a presentation at the Hayden Planetarium entitled "4000 Years of Astronomy," reminded Americans in 1955 of the contributions of past astronomers. A poem published in the *Christian Science Monitor* in 1958 shows how thoroughly the association between astronomers and freedom had permeated popular culture. "In Orbit," by Pearl Strachan Hurd, concludes:

> And I wondered how far
> Ptolemy ranged now
> Or Copernicus; how soon
> Our atlases would accommodate
> Rivers and alps of the Moon.
> Always the free mind went racing
> Forward, no going back;
> The free mind—ahead of the pack.[5]

CABINETS FOR ASTRONOMERS

Judging by the frequent references to the great men (and occasionally women) of astronomy in Cornell's written notes, clipping files, and artworks, it is clear that he was fascinated by those scientists, past and present, whose discoveries defined the known universe. In a diary note recorded in 1960, he jotted, "new age of science (so called)—gratitude for this heritage, this link in an unbroken chain."[6] His interest in the history of astronomers was apparent as early as his 1936 *Soap Bubble Set*, and he did not need the cold war emphasis on the freedom of thought to stimulate it. However, he clearly registered the new public absorption in astronomy, and, as was the case with his observatories, he embarked on a series of works that intersected neatly with current concerns. In his earlier works he developed elaborate personal codes for astronomical principles, with leaning towers or trapeze artists illustrating such concepts as center of gravity and velocity. Few people understood the allusions, and in his notes his frustration with critics and viewers is apparent. Perhaps to counter Miller's charges of "chi-chi infantilism" and other critics' insinuations that his works were childish, in the early 1950s he began producing astronomy boxes that were much more direct in their homage to the great minds of the past, merging his own interests with the growing public awareness of historical astronomers.

Among the earliest was a soap bubble set made around 1950 (fig. 6.1). Subtitled *Système de Copernic*, the inner back of the box was papered with a large chart printed in Paris in 1761, one of a series that Cornell owned of beautifully engraved, hand-colored French charts explaining the achievements of

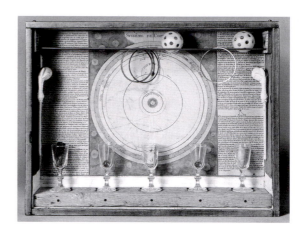

FIGURE 6.1.
Joseph Cornell, *Untitled (Soap Bubble Set: Système de Copernic)*, c. 1950. Box construction, 14¼ × 18½ × 3¾ in. Yokohama Museum of Art, Yokohama, Japan.

astronomers and various astronomy principles. No doubt he enjoyed the charts' whimsical smiling suns and moons, ornate typefaces, and elaborate frames. In this particular case, he also could have appreciated the visual similarity between this chart of the cosmos and a soap bubble, as well as the detailed description of Copernicus's system in which the Sun is orbited by planets that are, in turn, bordered by a thin layer of firmament filled with neatly placed stars.

Copernicus published his radical cosmology, *De revolutionibus orbium coelestium* [On the Revolution of the Heavenly Spheres], in Nuremberg in 1543, positioning the Sun near the center of the universe. Like his predecessor Ptolemy, he believed that planetary motion was circular, with planets moving in small circles, or epicycles, while following the path of a larger circle.[7] In the "Système de Copernic" soap bubble set, this Copernican circularity is underscored by the circles on the chart. It is also expressed at the top of the box, as the brass circular rings hanging from two rods suggest epicyclical paths for the two spherical balls—planets or moons—that rest on the rods when the box is level. As in the slightly earlier soap bubble sets shown at the Copley Galleries, cordial glasses nestled on the inner base of the box contain blue marbles, driftwood, and a spiral shell to suggest planets and nebulae drifting through space, setting an overall mood that is both scientific and nostalgic.

In some respects, it is odd that Cornell chose a French chart, rather than an American one, to honor Copernicus in the early 1950s, since the Polish astronomer had gained a place of increasing importance in American culture. During the war the four hundredth anniversary of the death of Copernicus was celebrated at Carnegie Hall, where he was hailed as a symbol of freedom. In a message read at the ceremony by Harlow Shapley from President Roosevelt, the president remarked: "we are waging mortal war in defense of that democratic way of living which enabled such geniuses as Copernicus and Benjamin Franklin to mature and serve."[8] After the war American journalists hailed the Polish nation's recovery of the region where Copernicus's home was

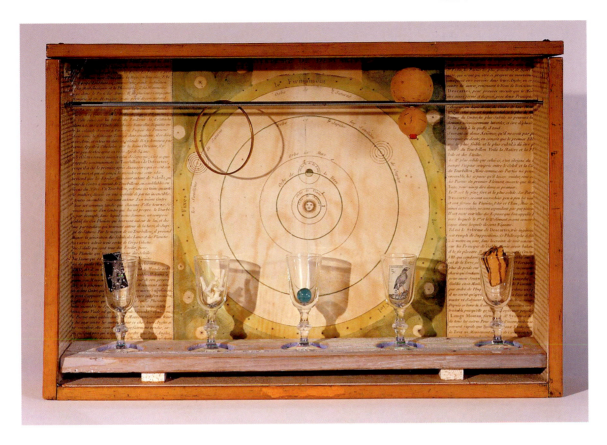

located and the rebuilding of Copernicus's much-damaged observation tower as important signs of postwar recuperation.[9] But the Francophile in Cornell won out, and in his box Copernicus's contributions were presented, via an old French chart, with appropriate *savoir faire*.

Another box of this type, *Soap Bubble Set (Système de Descartes)* (fig. 6.2), made around 1952, follows a similar format, with a chart dedicated to Descartes covering the back of the box and cordial glasses filling the lower front.[10] While Descartes is best known for his philosophical and mathematical contributions, his first major treatise, *Le Monde, ou Traité de la Lumière*, written in 1634, concerned optics and astronomy. In it, Descartes accepted the Copernican position, including the epicyclical explanation of planetary motion, but after news of Galileo's house arrest he decided not to publish it. Instead, he wrote a treatise on science that contained sections on optics and geometry under the title *Discours de la méthode*, published in Leiden in 1637.

At first glance, the "Système de Descartes" chart (fig. 6.3) looks nearly identical to the one used in "Système de Copernic," but upon closer inspection, there are important differences. Most apparent is the layer of firmament, now described as "Le Ciel des Etoiles Fixes." Beyond it are stars with yellow

FIGURE 6.2.
Joseph Cornell, Untitled *(Système de Descartes)*, c. 1952. Box construction, 12 × 21½ × 4 in. The Menil Collection, Houston. Photographer: Hickey-Robertson, Houston.

161

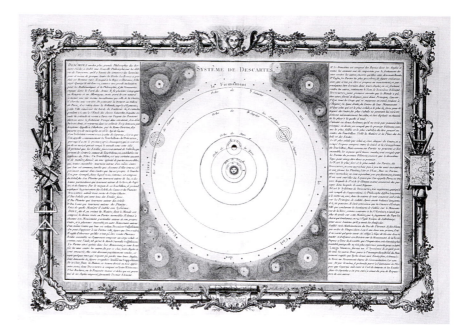

FIGURE 6.3.
[François Nicolas]
Martinet, *Système de
Descartes*, 1761. Joseph
Cornell Study Center,
Smithsonian American
Art Museum. Mark
Gulezian/QuickSilver
Photographers.

and blue rings around them, linked to their neighbors by swirling, figure-eight patterns of lines that seem to presage the turbulent sky of Van Gogh's *Starry Night*. As the text explains, the chart illustrates Descartes' theory of *tourbillons*, the celestial vortices described in his *Principia Philosophiae*, published in 1644. Here, he postulated that space was not an empty void but was entirely filled with matter in the form of ether. Descartes surmised that when a solid body like a planet moves through the ether, ether is forced away from the front of the object and then flows around it in a circular motion; thus the universe must consist of eddies and whirlpools. Perpetually in motion, the ether in turn would cause motion in the bodies situated in it, with pressure from ether holding the planets in their orbits around the Sun. In Descartes' system, these vortices were also the cause of gravity: a ball thrown into the air falls to Earth because some matter prevents it from continuing to follow a straight line. Although Newton made short work of Descartes' theory of vortices in his explanation of the laws of motion, the idea of a universe dependent on the operation of systems in motion was an important one.[11]

In fact, it was an idea that was revived in the 1950s, as research conducted on Mount Palomar yielded new understanding about the size and state of the cosmos. As summarized in "Turbulence in Space," a 1952 article in *Scientific American* by George Gamow, astronomers were now studying the role of turbulence on the surface of the Sun, in the clouds of dust and gas in the Orion Nebula, and in the motions of galaxies throughout the entire universe. As Gamow put it, "From the grand point of view we can consider the universe to be filled with a gas the molecules of which are represented by individual

galaxies. Must we conclude that this 'gas' is also in a condition of turbulence?" The answer, he concluded, was yes: "We should accept turbulence among the large-scale masses of the universe as the natural condition in the same way as, at the microscopic level, we accept as natural the irregular thermal motion of molecules."[12]

Cornell had already imagined the universe as a whirlpool with his placement of Niagara Falls on the cover of *View* magazine, but now he took this idea further, visualizing Descartes' system in his assemblage. While, as in the Copernicus box, a metal ring echoes the circular planetary orbits of the chart, two fused cork balls cleverly demonstrate epicyclical motion, since as the large ball rolls across the box on the metal rod, the smaller ball circles the larger one, mimicking the figure-eight shape of the *tourbillon* vortices that link pairs of stars on the chart. Cornell also added a second chart: a fragment of a constellation map nestled in the cordial glass at the far left. The constellation was an unusual one seen only in the Southern Hemisphere: Pyxis Navis, the Mariner's Compass. Designated as a constellation by Nicolas de Lacaille in 1752, it was pictured by Bode in 1801 as a compass in a box.

Cornell's inclusion of the compass box constellation in his own box offers yet another layer of meaning to this work, reminding the careful viewer that the stars not only have fascinated natural philosophers but also have been practical navigational tools. He included actual compasses in other box constructions, suggesting further links among Descartes' celestial whirlpools, the turbulent travel of galaxies through space studied by modern astronomers, and the theme of finding one's way by the stars. Perhaps Cornell also wished the astute observer to consider the act of finding one's way in relation to Descartes' most famous dictum "cogito, ergo sum," a statement equating thinking and being with significant parallels to the Christian Science belief in God as Mind.[13] It seems more than coincidental that the glass containing the compass constellation is placed in front of text explaining Descartes' three suppositions about God's creation of the material universe. Moreover, by associating the mathematician Descartes with the concept of divine creation, Cornell implicitly— and perhaps unwittingly—echoed the press's positioning of Descartes as an anti-Marxist figure.[14]

Not all of Cornell's odes to astronomers took the form of large cases with celestial maps covering their inner backs. Some hardly seem like "art" at all. For instance, among Cornell's small cardboard boxes papered with astronomy-themed material is a small cardboard box simply covered with a page removed from a book, painted with blue watercolor wash, and tied with a piece of string (fig. 6.4). A more humble tribute to Newton can hardly be imagined, and yet that is the purpose of this construction. To wrap the box, Cornell took a page lauding Newton's achievements from *Les Trois Regnes*, a book-length didactic poem by Jacques Delille published in Paris in 1806.[15] Delille invites the reader to mount Newton's chariot to visit the eternal celestial spheres, where we

Viens; et, sans m' effrayer du sort de Phaéton,
Que je monte avec toi sur le char de Newton !
Guide-moi, montre-moi les sphères éternelles,
Leurs chemins journaliers, leurs marches annuelles;
La gloire d'expliquer leurs cours mystérieux
Seule n'y conduit pas tes regards curieux;
Tu n'y vas point chercher les combats des systèmes,
Les nuages du doute et la nuit des problêmes,
Mais la grandeur du monde et du Dieu qui l'a fait,
Mais des sociétés le modèle parfait,
Où, dans les ...

... chaque sujet conspire;
Où la comète ... objet de nos terreurs,
S'égare ... re et revient sans erreurs.
... beau dans sa source première;
... oleils, d'où l'ange de lumière
... gard de pitié,
... itié,
... rofonde
... aster est un point, et chaque point un monde
... blimes ... ts ne sont pas faits pour moi,
... le monde en recula d'effroi.

see the grandeur of the world and of God who has made it. This is a world of order, the author writes, where comets return with regularity. Delille describes the cosmos as a vast ocean: "Je ne te suivrai pas dans cette mer profonde / Où chaque aster est un point, et chaque point un monde" [I will not follow you into this deep sea / Where each star is a point, and each point a world].[16] If Cornell read ahead for the next two pages in his copy of the book, he would also have encountered Delille's praise of Newton's study of light, including a florid passage about the natural philosopher's examination of the prismatic effects seen in soap bubbles.[17]

Choosing a passage that highlighted Newton's achievements in astronomy, Cornell painted a celestial blue background for Delille's description of the cosmos. He also tied the box shut, perhaps alluding to lines directly preceding Delille's mention of soap bubbles that describe scientists prior to Newton as puzzled by the mysteries and secrets of the world. Like Duchamp's *With Hidden Noise*, a ball of string screwed between two metal plates with a mysterious object inside that makes noise when the artwork is shaken, Cornell's little Newton box also seems to contain secrets. By tempting the viewer to untie the box and look inside, Cornell asks us to assume Newton's role as an investigator of the unknown, to reveal the hidden mysteries of this miniature world.[18] In so doing, the artist presented an esoteric version of a popular 1950s' notion: that scientific research could unlock the secrets of the universe.

FROM ARCHIMEDES TO ATOM SMASHING: CELESTIAL SAND BOXES

Other unconventional boxes take us further back in the history of cosmology: works Cornell called "sand boxes," shallow glass-fronted boxes meant to be manipulated by the viewer or to rest horizontally on their backs.[19] While Cornell's sweet-toothed inspiration seems to have come from a shallow pastry box with a cellophane window revealing cream horns in motion when slightly shaken, their identifying feature is colored sand—often solar yellow and lunar blue—that moves to reveal or conceal small, free-moving or fixed objects when the viewer gently shakes the box.[20] Often there are incised or raised patterns of concentric circles or radiating lines on the inner back of the box. Although Cornell produced works containing sand throughout his career, beginning in the mid-1940s a distinct category of celestial sand boxes emerged as works that may have been intended, at least in part, as tributes to the self-proclaimed "Sand Reckoner," the greatest mathematician, inventor, and physicist of antiquity: Archimedes.

Among Archimedes' many treatises is an arithmetical curiosity entitled *The Sand-Reckoner*. In it, he proposed a method for counting all of the grains of sand that could fit into the universe. Building on the hypothesis that Earth revolves around the Sun, voiced by the first and most eminent of the Alexandrian astronomers, Aristarchus of Samos, in *The Sand-Reckoner* Archimedes devised a way to compute the size of the known universe. Assuming that the ratio of the size of Earth to the size of the universe is comparable to that of the orbit of Earth compared to the sphere of stars, and thus that the universe could indeed be measured, Archimedes developed a remarkable terminology for expressing extremely large numbers, up to what in modern notation is written as 8×10^{63}. In so doing, he estimated an immense universe, on a magnitude far beyond that imagined by any of his predecessors. Theorizing that this number would be large enough to count the grains of sand that could fit into the universe, Archimedes was the first person to think on the nearly unimaginable large scale of modern astronomy.[21]

Back in 1943 Cornell had included Archimedes among the luminaries of astronomy in the word tower for *The Crystal Cage [portrait of Berenice]* in *View* magazine. Now, it seems, he wanted to extend that honor, by encapsulating Archimedes' contribution to the science of astronomy in individual works. While not all of the sand boxes imply this relationship to Archimedes, a few do. Consider, for instance, an undated yellow sand box, probably created in the early 1950s (fig. 6.5). In this assemblage, he nailed an illustration of the Sun orbited by planets to the center of the box, perhaps acknowledging Archimedes' acceptance of his predecessor Aristarchus's heliocentric universe. Incised concentric lines radiating out from the Sun suggest the spheres of fixed stars that both early scientists described in the heavens. The model of the solar

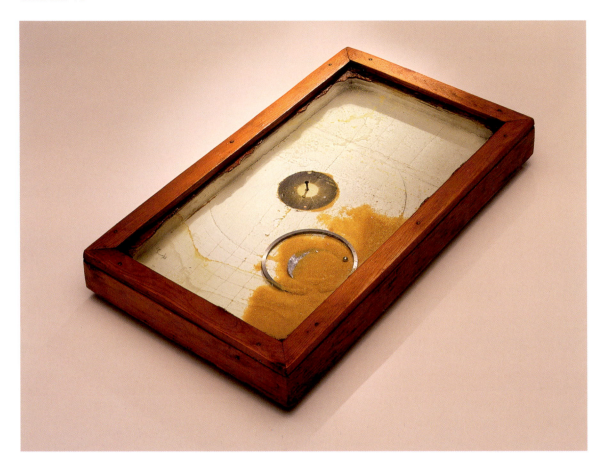

FIGURE 6.5.
Joseph Cornell, *Untitled [Yellow Sand Tray, Sun and Planet Images]*. Box construction, 1⅝ × 14⅞ × 8⅝ in. Collection Walker Art Center, Minneapolis. Gift of The Joseph and Robert Cornell Memorial Foundation, 1993.

system is repeated with a free-moving metal ring, inside of which are a flat disk (the Sun?), six tiny silver balls (the planets known to Archimedes?), and one brass one (the Moon?). Yellow sand moves throughout this kinetic cosmos when the box is shaken, immediately recalling Archimedes' ingenious system for counting the grains of sand in the universe. If Cornell intended this association with Archimedes, it would have been a gesture very much in keeping with the times. Such associations between the classical world and the modern reaches of distant space also made their way into popular advertising, for instance in a *Scientific American* ad for the Univac computer that placed the shiny machines of modern technology and an ancient bust of Jupiter amidst countless specks of planets and stars.[22]

Other sand boxes relate to Archimedes in additional ways. One with blue sand, starfish, small shells, a tiny cork, metal balls, a coin, and a metal wire in the shape of a spiral presents a similar view of the universe (fig. 6.6). With objects representing celestial bodies and with rich blue sand for the sky, the spiral takes on multiple meanings. It recalls the spiral nebulae that had fascinated

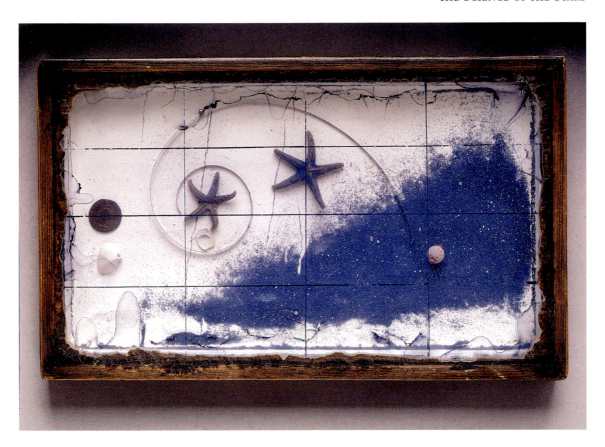

Cornell since the early days of *Nebula, the Powdered Sugar Princess*, but it also alludes to Archimedes, whose treatise *On Spirals* was written in 225 B.C. A particular type of spiral, typified by its regular development from the center, is even called "Archimedes' Spiral," seen, for instance, in an illustration of the philosopher having traced it in wet sand (fig. 6.7).

Cornell's spiral in the blue sand box, however, is too unfurled to qualify as an Archimedian type. Perhaps over time it has lost its tension, or, perhaps the artist wished to use the spiral to allude in a general sense to Archimedes, while also cross-referencing another spiral form, the logarithmic spiral. First studied by Descartes, this is a spiral for which the radius grows exponentially with the angle, resulting in a spiral that seems less tightly "wound" than the Archimedian type. Also known as the Bernoulli and the Fibonacci spiral, this shape can be found in nautilus shells and even in the spiral motion of growing plants, facts that Cornell knew from his readings about mathematics and recorded by clipping illustrations of nautilus shells and cornstalks from children's math texts.[23] Dating back to *Nebula, the Powdered Sugar Princess*, he recognized the importance of the spiral form in understanding the shape of galaxies, and he probably read Payne-Gaposchkin's 1953 article in *Scientific American*, "Why

FIGURE 6.6. Joseph Cornell, *Untitled [Blue Sand Box with Starfish]*, c. 1952. Box construction, 1¼ × 15½ × 9½ in. The Robert Lehrman Art Trust, Courtesy of Aimee & Robert Lehrman, Washington, DC. Mark Gulezian/QuickSilver Photographers.

167

FIGURE 6.7.
Frontispiece, Sir Thomas
Heath, *Archimedes*
(London: Society for
Promoting Christian
Knowledge), 1920.

Do Galaxies Have a Spiral Form?" which opened, "Wherever we look in nature we can see spiral forms: the uncurling fern, the snail, the nautilus shell, the hurricane, the stirred cup of coffee, the water that swirls out of a washbowl. Perhaps we should not be surprised to see spirals in the great star systems whirling in space."[24] At the same time, he drew biblical parallels, writing in a diary note in 1950, "spiral & ball serpent & apple."[25]

Considering all of the conceptual resonance inherent in the simple spiral, Cornell may even have wished to cross-reference the fact that the spirals that had fascinated Archimedes long ago not only shaped galaxies but also traced the motion of subatomic particles. While research on quantum mechanics occupied physicists throughout the first half of the twentieth century, during the 1940s increased attention was paid to understanding the composition of the atom. By studying cosmic rays, it became clear that one of their chief constituents was a particle called a meson—a neutral particle much larger than an electron and lighter than a proton that exists only briefly as matter before converting to energy. Led by Robert Oppenheimer, physicists theorized that the meson held the key to understanding the forces that hold the nuclei of atoms together and, consequently, the basic forces of the universe as a whole. As reported in the *New York Times* in 1947 in terms that could have struck

Cornell as an allegory of Christian Science, "The extremely short 'material' existence of the neutral meson, during which it pulsates and dies, to reappear again as energy, may thus be said to represent the basic 'pulse beat' of the material universe."[26]

Beginning in late 1946, the paths of mesons could actually be seen in photographs made using Berkeley's giant cyclotron, and in 1948 the Atomic Energy Commission approved a plan for the construction of a 2,200-ton proton synchrotron to be built at the Brookhaven National Laboratory. It accelerated protons to previously impossible energies, comparable to those of the cosmic rays showering Earth's outer atmosphere. Technically called the Brookhaven "cosmotron," the machine soon became known in the American popular imagination as the world's largest "atom smasher." Dedicated in December 1952, it was hailed as "the newest tool for learning what holds the hearts of atoms together, where the energy of stars comes from, what are the basic atomic facts of life of the universe."[27] It was also heralded as an antidote to cold war fears of atomic mass destruction, as a machine "so powerful it can pick up the pieces after an atomic bomb explosion and put them back together again."[28]

Perhaps it was a combination of both of these possibilities—expanded knowledge of the universe and redemption from atomic cataclysm—that led Cornell to clip several pages from an unidentified source illustrating the behavior of subatomic particles with photographs made in the Brookhaven Laboratory. One photograph in particular caught his attention, taken using a "bubble chamber" filled with super-heated pentane gas in which meson particles, leaving logarithmic spiral tracks, collided to form "stars" (fig. 6.8). "Sand box !" he penciled in the margin, adding, "develop graffiti without plate also."[29] Whether this particular illustration led to the inclusion of the metal spiral in the blue sand box is unknown; however, it is clear that in his sand boxes Cornell recognized potential cross-indexes not only to ancient mathematics, but also to the indexical signs of modern high energy physics. Moreover, his presentation of such lofty thoughts in a format that suggested a child's sand box also fit the spirit of the times. In the press, the language of play was applied to describe atom-smashing experiments, with the movements of atoms likened to the paths of billiard balls or baseballs trailing in the hard mud of a ball park, and the operation of the universe compared to a cosmic chess game.[30] That a little coil of metal or a ball bearing or a miniature star fish could take the viewer on a conceptual journey from Archimedes to atom smashing would have struck Cornell as yet another example of how well-invested simple details could yield a wealth of, to use his term, "compounded interest."

Cornell's sand boxes simultaneously present macrocosmic and microcosmic worlds: the huge expanse of the starry firmament and minute subatomic particles. A decade earlier, in his scenarios for *Nebula, the Powdered Sugar Princess* and in his soap bubble sets with amoebas and shells, he had explored the notion of merging microscope and telescope. By midcentury, many of his

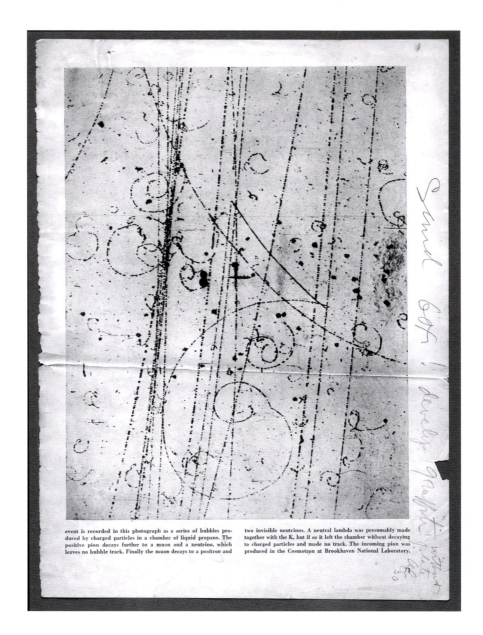

event is recorded in this photograph as a series of bubbles produced by charged particles in a chamber of liquid propane. The positive pion decays further to a muon and a neutrino, which leaves no bubble track. Finally the muon decays to a positron and two invisible neutrinos. A neutral lambda was presumably made together with the K, but if so it left the chamber without decaying to charged particles and made no track. The incoming pion was produced in the Cosmotron at Brookhaven National Laboratory.

contemporaries shared this vision. Science writer Herbert Nichols grappled with the incomprehensible complexity of the universe in a *Christian Science Monitor* article entitled "Length—Breadth—Space—Time":

> The natural scientist as an observer stands midway between a universe that is, at the same time, infinitesimal and infinite. He is perplexed by planets and stars that spin in gravitational fields while things tiny—electrons and their ilk—seem affected by a force entirely different, electromagnetism. Few

men of research today put their faith in a smoothly functioning mechanical universe. There is too large a field still unknown in the unseen realm of the atom and in the fathomless depths of intergalactic space—perhaps forever unknowable through human perception.[31]

With unpredictable shifting sand now revealing, now obscuring, Cornell found a perfect way to visualize this sense of the unknowable, on both astronomic and subatomic scales. Carefully raised lines on the inner bottoms of the boxes create linear patterns in the sand, sometimes concentric rings, most often found in the yellow sand boxes, sometimes straight lines radiating from the center, seen primarily in blue and black sand boxes (fig. 6.9). While both types of linear patterns could allude to the movements of bodies through outer space, they also had parallels in the tracks of subatomic mesons orbiting the nucleus of an atom. Diagrams and photographs published in *Scientific American* in the 1950s illustrated their concentric orbits, as well as the "meson star" patterns they formed when "smashed" (fig. 6.10).[32] The resemblance to Cornell's sand boxes is striking, and given the general interest in atomic research in the 1940s and 1950s, it is conceivable that he intended his boxes to illustrate the movements of the planets and the actions of atoms, with their lines of force, broken orbits, and explosion patterns shown with raised lines, ball bearings, metal rings, and even little starfish.

Using sand was also a way to illustrate the concept of transformation of matter from a solid to a liquid state and back again. Perhaps an article in the *Monitor* published in 1942 entitled "Did You Ever Wonder How Ordinary Sand Can Be Made to Act as a Fluid?" caught his eye. In it, the author quoted

OPPOSITE PAGE:
FIGURE 6.8.
Photograph of subatomic particles at Brookhaven National Laboratory. Unidentified clipping, c. 1952–53. Joseph Cornell Study Center, Smithsonian American Art Museum. Mark Gulezian/ QuickSilver Photographers.

FIGURE 6.9.
Joseph Cornell, *Untitled [Blue Sand Box]*, early 1950s. Stained wood box with glass top, French text (on bottom), crystals or sand, metallic bead, and metal ring, $9^{3}/_{8} \times 15^{1}/_{16} \times 1^{7}/_{8}$ in. Lindy and Edwin Bergman Joseph Cornell Collection, 1982.1860, The Art Institute of Chicago. Photography © The Art Institute of Chicago.

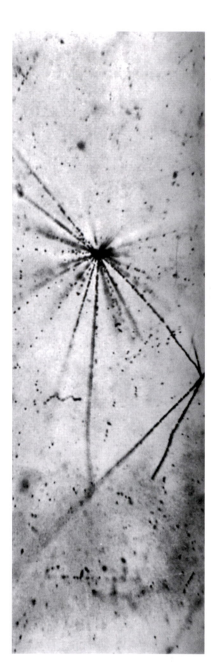

FIGURE 6.10.
Meson Star, in Sergio DeBenedetti, "Mesonic Atoms," *Scientific American* 195 (October 1956).

an unnamed seventeenth-century English natural philosopher's explanation of the difference between a solid and a liquid form as owing to the greater movement of atoms in a liquid state:

> Let us suppose a dish of sand set upon some body that is very much agitated. . . . By this means the sand in the dish, which before lay like a dull and unactive [*sic*] body, becomes a perfect fluid; and ye can no sooner make a hole in it with your finger, but it is immediately filled up again, and the upper surface of it leveled. Nor can ye bury a light body, as a piece of cork, under it, but it presently emerges or swims, as it 'twere, on top; nor can ye lay a heavier [body] on top of it, as a piece of lead, but it is immediately buried in sand, and (as 'twere) sinks to the bottom.[33]

Each time they are gently shaken, Cornell's sand boxes reenact this demonstration, as solid sand becomes fluid and cork pieces and metal balls or disks embark on their unpredictable journeys through a model cosmos.

Although Cornell began making sand boxes earlier—he wrote to an acquaintance late in 1946 asking him to show a few of his new sand boxes to Einstein for comment—he did not exhibit them publicly until 1955, when he included several in an exhibition at the Stable Gallery.[34] Their parallels in ancient and modern science were understandably missed by viewers, although critic Frank O'Hara noted that "the effect of their beauty was so singular as to defy description; they are moving, too, as evidences of so pure and uncompromising a spirit in our midst." Regarding Cornell's

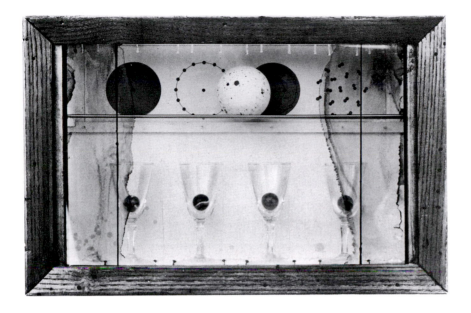

FIGURE 6.11.
Joseph Cornell, *The Birth of the Nuclear Atom*, c. 1957. Box construction, 9¾ × 15 × 3¾ in. Location unknown.

works as a whole at the Stable Gallery, O'Hara praised their "look of Platonic purity and wisdom," without understanding their scientific allusions.[35] Perhaps frustrated that such cleverly cross-indexed, intellectual works only elicited vague aesthetic responses like O'Hara's, Cornell produced at least one related work whose source in atomic physics could not be missed: *Birth of the Nuclear Atom* (fig. 6.11).

As the atomic age arrived in full force in the 1950s, parallels between the astronomic and subatomic "universes" were drawn by science writers in the popular press, as they explained to lay readers how protons and electrons "orbited" around a central nucleus. In 1956 one article in particular drew Cornell's attention: "The Birth of the Nuclear Atom," published in *Scientific American*.[36] He not only saved a copy of it for his files, he clipped one of the illustrations and mounted it on the inner back of his *Birth of the Nuclear Atom*. Using the format familiar from soap bubble sets, with a rolling cork ball and cordial glasses with small marbles in them, he extended the domain of the soap bubble set to include the most basic building blocks of matter, as illustrated in a chart chronicling four early conceptions of the structure of the atom, culminating in Ernest Rutherford's 1911 explanation of the atomic nucleus. The article also examined Danish physicist Niels Bohr's further refinements of Rutherford's findings, dubbing Bohr "the Newton of atomic astronomy."[37]

While the round forms of the atoms in the chart no doubt appealed to Cornell as shapes that could suggest bubbles, he was also aware of the use of soap bubbles to explain the size of atoms. He collected multiple copies of a special reprint of "The Atom, a Primer for Laymen,'" published in *Life* magazine in 1949, with a picture of a soap bubble and pipe illustrating atomic scale

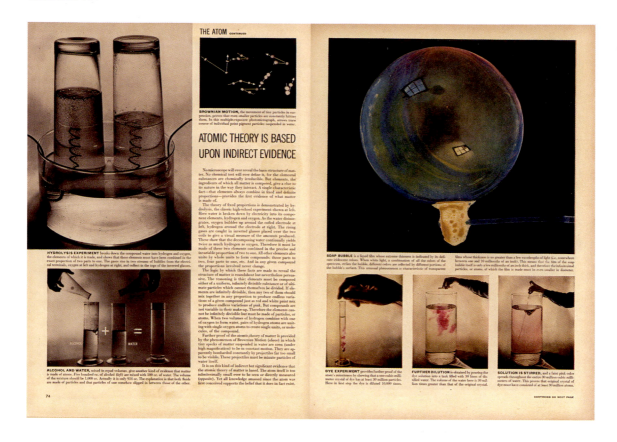

FIGURE 6.12.
"Atomic Theory Is Based upon Indirect Evidence," in "The Atom, a Primer for Laymen," *Life*, May 16, 1949, 6–7.

(fig. 6.12). Given his goal of using his art to counter fears of the atom bomb, works such as the *Birth of the Nuclear Atom* and the sand boxes with their meson spirals and stars lauded the atom as a remarkable wonder of nature. They put into human terms and scale the new worlds being unveiled by scientists. For the general public, these new worlds were often daunting; as the author of a 1951 article Cornell clipped from *Collier's* put it, "The very vocabularies in current use in the science sections of our magazines and newspapers—the 'artillery of physics': bombardments of cosmic rays, gravitational shifts, fields of force; the affinities and hostilities of protons, neutrons, electrons, antibodies, enzymes—present us daily with intimations of an astounding environment of unseen powerful forces surrounding us on every side."[38] In Cornell's works, however, these forces were tamed, held in check behind glass and couched in the seemingly playful language of philosophical toys.

SPUTNIK IN CASSIOPEIA

In 1952 the International Council of Scientific Unions declared July 1, 1957, through December 31, 1958, as the "International Geophysical Year" because

cycles of solar activity would reach a high point during that time. In 1954 the council called for artificial satellites to be launched during the International Geophysical Year to map Earth and study the cosmos. The Space Race was on. A year later the United States government chose the Naval Research Laboratory Vanguard program to develop an Earth-orbiting satellite. With the first two navy Vanguard launch attempts spectacular failures, on October 4, 1957, the Soviet Union shocked the world by successfully launching *Sputnik I*, the world's first artificial satellite. Orbiting at a height of 500 miles above Earth, traveling at 18,000 miles per hour, it circled the globe every 96 minutes. Spotting that "busy little stranger from the U.S.S.R." from front yards became "America's new pajama game," as the *Monitor* put it, and the sound of its incessant beeping broadcast on radio and television became a fascinating, frightening symbol of the possibility of Soviet domination of the universe.[39]

Cornell had been intrigued by the history of astronomy from early in his career, and many of his finest works drew upon a vision of the cosmos that combined scientific facts with mythological and spiritual understanding of the cosmos. During the 1950s, however, his emphasis shifted markedly, as he produced works that were much more overtly about science, in keeping with the mood of the times. Even before the declaration of the International Geophysical Year, he had been moving in this direction with soap bubble sets that increasingly resembled three-dimensional diagrams of astronomical charts. With cork balls hanging on strings seeming to hover weightlessly in space and rolling marbles on glass shelves suggesting celestial bodies in motion, he anticipated the fascination for orbiting space objects that *Sputnik* unleashed, while at the same time alluding to the traditional maps and charts of astronomers of the past.

With the advent of the Space Race, his interests became more specific, as he diligently collected materials explaining and celebrating actual astronomical achievements. These, in turn, supported a series of boxes that he referred to in general terms as "Space Object Boxes," works that drew directly on modern findings and events, as well as the craze for backyard astronomy.[40] Indeed, his space object boxes not only fit into the avant-garde interest in assemblage shared by up-and-coming artists such as Robert Rauschenberg,[41] they also suited the category of "artist's conception" of outer space, typified by the pseudo-realistic outer-space paintings of Chesley Bonestell that illustrated many of the books and magazines that Cornell read, including a *Sputnik*-inspired article in the *New York Times* about space travel that he saved for his files.[42]

Toward the end of the 1950s, Cornell produced a box titled *Cassiopeia #1* (fig. 6.13).[43] This soap bubble set contains a fragment of a clay pipe, two metal rods supporting a rolling white cork ball, and a piece of driftwood nailed to the top. On a rough inner back he pasted three diagrams: at the left, the constellation of Orion, the hunter (mounted upside down); at the right, Taurus, the bull; in the center, a glowing orb labeled "Tycho's Nova," surrounded by stars. Additional collage elements cover the back of the box: two pages, one turned

175

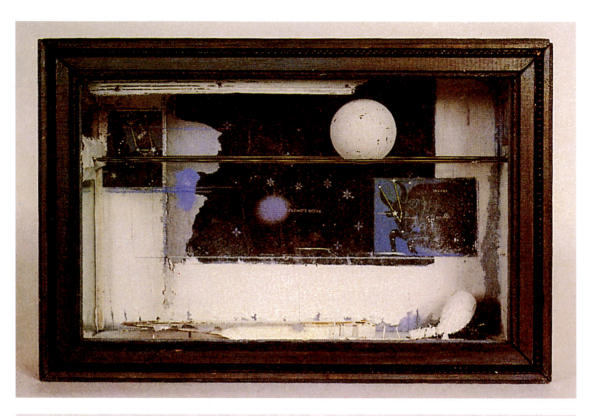

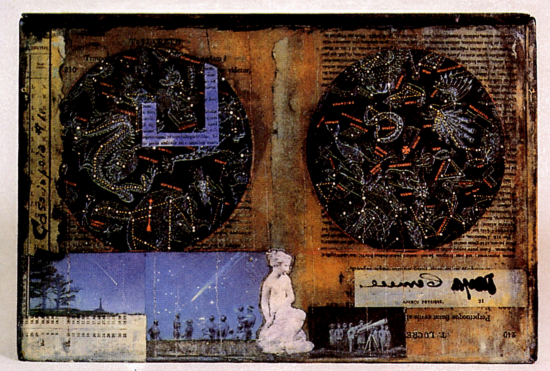

upside down, from a Latin text by the Roman philosopher Lucretius; two round charts with white constellations picked out on black; two illustrations of the starry night sky in the lower left corner, one showing people watching Halley's comet in 1910; an illustration of a group of people behind a telescope in the lower right corner; a picture of a statue in the lower center; the title of the work at the far left; and the artist's signature, in reverse, at the lower right. As was the case in Cornell's night sky observatories, this work combined references to past and present, with possible suggestions for the future.

The location of the constellations on the front of the box immediately alerts the astute viewer that there is more than meets the eye at work. Cornell seems to have positioned the charts, clipped from Zim and Baker's *Stars*, in the interest of allegory rather than accuracy. To be sure, he turned Orion upside down to approximate better the actual position of its stars, but he made no similar adjustment for Taurus. And Tycho's Nova, which shone in Cassiopeia, should be located far above Orion and Taurus. Rather than replicating the actual appearance of the sky, Cornell posed the hunter and bull on either side of Tycho's star, which, in turn, is outshone by the bright white sphere rolling on the metal rods, passing the familiar constellations as *Sputnik* was doing each night in the sky.

On a public level, the box mirrors the excitement and concerns of the *Sputnik* launch. *Sputnik* blinked across the October sky on a nightly basis, a newcomer among the familiar constellations and the light of the Moon. Observers in the Northeast were advised how to find the satellite and its rocket using binoculars.[44] Facing the northwest horizon shortly before dawn, they were instructed to locate the satellite just to the left of Cassiopeia (where Tycho's Nova had blazed in 1572). After passing Orion and Taurus, it disappeared from view at the southern horizon. In devising his Cassiopeia box, surely Cornell considered the appearance of this new astronomical phenomenon, suggesting the presence of a modern, man-made Moon amid the age-old constellations. On the back of the box, he continued the theme, showing stargazers watching a bright body streak across the sky at the lower left and using a telescope at the lower right.[45] Moreover, he positioned the two round star charts to approximate the effect of looking through binoculars, with Cassiopeia highlighted with a blue, partial frame. Below her in the center back of the box he pasted a picture of a porcelain statue of a seated naked pubescent child: Cassiopeia herself, presiding over the heavens.[46]

If his box was, at least in part, inspired by the launching of *Sputnik*, Cornell was not alone in translating the event into a cultural product. Even before *Sputnik*, satellites had inspired artistic responses and retail booms. Tin Pan Alley had been grinding out songs about satellites since the announcement of the International Geophysical Year, including "Satellite Baby," "Satellite for Two," and "Satellite Excursion with the Boogie Beat." Home planetariums were new "philosophical toys," such as the Sky Zoo that projected thirty-five

OPPOSITE PAGE:
FIGURE 6.13.
Joseph Cornell, *Cassiopeia #1*, c. 1957–58. Box construction, recto and verso, 9⅞ × 14⅞ × 3¾ in. Location unknown.

constellation figures onto any ceiling, designed by Armand Spitz in 1955. After the Soviet artifical moon was put into space, additional songs appeared on the scene, such as "New Moon over Moscow," as reported and satirized in a *Monitor* article and cartoon.[47] The popular television show *Playhouse 90* planned to incorporate the Soviet space satellite in its comedy drama "The Jet Propelled Couch" on November 14, 1957.[48] Other cultural shifts were also forthcoming: in Allentown, Pennsylvania, Santa Claus was slated to arrive at the town fairgrounds aboard a motorized satellite, and Macy's New York department store rushed to open a new toy section featuring Earth satellite balloons, geophysical computers, and satellite battle stations. In the first week of *Sputnik's* launch, sales of binoculars, telescopes, and science fiction skyrocketed.

But for the most part, the picture was not rosy. On the political front, near-hysteria reigned in the United States. With headlines such as "World Seen Reaching a Balance of Terror" and "'Big Brother' in the Sky?" cold war tensions heated. The *New York Times* raised fears of push-button nuclear war, reporting, "There is ample reason, unfortunately, to accept Mr. Khrushchev's boast that the launching of *Sputnik* proved that the Soviet Union has already developed the intercontinental ballistic missile."[49] With an artist's rendering of Earth seen from the satellite's viewpoint, the *Christian Science Monitor* suggested that "Texas and Northern Mexico May Look Something Like This to the *Sputnik*" (fig. 6.14), while other articles in the same newspaper warned that "Big Brother" *Sputnik* might be mapping Earth.[50] Indeed, the *Christian Science Monitor* presented the U.S. position in the bluntest of terms:

> Military—and diplomatic—logic today is posing one desperately essential task for the United States. That is, to catch up, at whatever the cost, with the Soviet Union in missile development. President Eisenhower has made no "Operation Candor" address to the nation thus far. But all the available evidence indicates that the United States is definitely, and perhaps dangerously, behind the Soviet Union in the missile race.[51]

The Soviet use of an intercontinental ballistic missile to launch the satellite was far more threatening than the orbiting body itself. In a widely quoted interview with James Reston of the *New York Times*, Khrushchev stressed that Soviet possession of the ICBM made piloted bombers obsolete, claiming, "You might as well throw them on the fire. You cannot send human flesh and blood to fight things like that," adding ominously, "we have other things up our sleeves."[52] Despite attempts at levity—the *Monitor* reported that a radio amateur in Gloucester, Massachussetts, found that by twisting the dial of his receiver he could change the pitch of *Sputnik's* beep to play "Yankee Doodle Dandy"—the general mood was serious, and summaries of European press reports accused the United States of taking a complacent view toward Soviet space research, a complacency that could, at its most extreme, lead to atomic war.[53]

The Great Space Adventure Begins

By Robert C. Cowen
*Natural Science Editor of
The Christian Science Monitor*

[Body text of the newspaper clipping is largely illegible]

Texas and Northern Mexico May Look Something Like This to the Sputnik

On the front of his Cassiopeia box, Cornell placed ancient combatants in the sky: Orion, the greatest hunter among men, whose pride got the best of him, and Taurus, Zeus disguised as the bull that kidnapped Europa. Could Cornell have embedded a political message in his celestial sky? It is tempting to see a modern geopolitical parallel in the face-off of the two celestial superpowers, with rolling sphere *Sputnik* now in one corner, now in the other. In his notes and diary entries, Cornell appears to be the most apolitical of commentators; there is hardly even the slightest mention of current events. But he had another way of taking notes on the world around him: his extensive clipping files. There, he kept track of the contemporary scene, and there his political views emerge. Clearly, he was a pacifist, and, as we have seen, his fear of the atomic bomb led him to clip numerous articles related to it. He believed strongly in the importance of scientific research, but he shared the concern of many of his contemporaries that fearful powers could be unleashed. He mourned the innocent victims of war, especially children, and, as early as the late 1950s, presciently began gathering materials about the situation in Indochina that would escalate into the Vietnam War. Even the advertisements he placed in his files reflect this political dimension: for instance, he kept an ad for the Monsanto Corporation that showed a missile falling to Earth, with the caption "Monsanto research helps bring answers from space to guard your free world."[54] It seems likely that in his Cassiopeia box, he presented his own complex reactions to the latest turn in the race for space.[55]

As was also the case in some press reportage, on one hand Cornell seems to have applauded the technological achievement of putting a man-made Moon into outer space, capturing the wonder that backyard viewers must have felt as they watched the speck of light zoom through the heavens with their binoculars. On the other hand, he seems to have examined the political

FIGURE 6.14.
Texas and Northern Mexico May Look Something Like This to the Sputnik, in "The Great Space Adventure Begins," *Christian Science Monitor,* October 12, 1957. Photo: United States Navy.

179

implications, not only on the front of *Cassiopeia #1*, with his opposition of Orion and Taurus, but also on the back of the box, where he colored the names of the constellations seen through the "binoculars" in red. In this cold war climate, red stood for the Soviet Union, which now, it was feared, stood on the brink of controlling the heavens. Other boxes that Cornell made around this time had backs papered with pages from an old text with the heading "Philosophie Politique."[56] In *Cassiopeia #1*, it seems he updated that philosophical interest in politics to include modern cold war concerns.

While it may seem strange to think of Cornell making a political statement in boxes like these, it should be recalled that in the 1950s he had already begun to express his religious beliefs more openly in his art. Political issues were also making their way into his work, and it is conceivable that he, like many of his countrymen, saw the Soviets' *Sputnik* success as a threat to both science and religion. Early in his career, Cornell had mastered the Surrealist technique of juxtaposing incongruous objects to make a creative statement about the cosmos. Now, it seems, he had expanded that technique also to include incongruous ideas, so that *Cassiopeia #1* could simultaneously allude to an ancient visualization of a constellation, Tycho's nova of 1572, and the modern race for the domination of space.

Cornell may have had these ideas in mind when he papered the back of *Cassiopeia #1* with two pages of Latin text. Using an excerpt from Lucretius's *De Rerum Natura* [On the Nature of Things], he may have intended to do more than just draw a parallel between the past and the present. In *De Rerum Natura*, Lucretius set forth the notion that the workings of the world are the result of the free motion of atoms through space, and not dependent on the will of the gods. His materialist views were revived in the seventeenth century, and his theory of atoms in constant movement sounds surprisingly modern, especially in light of Werner Heisenberg's principle of indeterminacy formulated in 1927.[57] Cornell's interest in Lucretius corresponded with his fascination with subatomic physics. However, what may have also struck him was the difference between Lucretius's explanation of the free will of atoms and Soviet restrictions on science and religion. Later Cornell jotted the words of another ancient philosopher in his diary: "for the Sun + stars are born not, neither do they decay, but are eternal + divine. Aristotle, 384–322 B.C."[58]

There were personal meanings embedded in the Cassiopeia box, too. Cornell pasted his signature at the lower right, writing on thin paper with fluid ink that soaked through to enable his name to be seen in reverse, deliberately invoking the famous mirror writing of another artist who, while fascinated by science, also maintained his religious beliefs: Leonardo da Vinci. Cornell identified with Leonardo, referring to him in his notes and citing his mirror writing, perhaps inspired by the previous example of Duchamp, as well as by contemporary advertisements that reflected his own interest in the history of great minds (fig. 6.15).[59] Beginning in the autumn of 1960, he also found a new

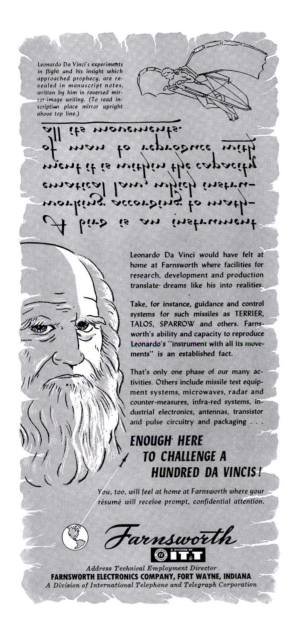

way to relate to the constellation Cassiopeia. While the star pattern had long been a favorite fixture in his backyard stargazing, like the ancients, he also assigned it human form by nicknaming a teenaged schoolgirl "Cassiopeia" in his diary notes.[60] She worked at the lunch counter in one of Flushing's five-and-dimes—Woolworth's or Fisher Beer's—and for a time she became his earthly incarnation of the stars.

Writing unsent notes and letters to her, he chronicled his "adorable but poignant preoc. with the new 'star.'"[61] Caught up in an infatuation bordering

FIGURE 6.15.
"Enough Here to Challenge a Hundred da Vincis!" *Scientific American* 195 (September 1956). Courtesy of ITT Corporation.

on obsession, he left her self-described "secret pal tokens" and noted sightings like "Cass. spotted coming from Nedick from Main + Roosevelt 11:45—" and "Cass. actually seen + was waited on by her (Fr. cruller + lt. cof.)."[62] He compiled material related to her into a source material file containing star charts of the constellation, notes about spotting both the stars in the sky and her human incarnation ("the constellated figure herself"), and other related clippings.[63] He made boxes for her, including at least one of the Cassiopeia boxes he produced in the late 1950s or early 1960s, referred to in his notes as "PLANETARIUM for Cassiopeia, 'night into day,'" and the Cassiopeia object box discussed earlier was clearly inspired by her (see fig. 4.12).[64] He imagined giving her a box, writing "Cassiopeia forlorn midday to work as the 1st day back to school—at noon—myself in a forlorn state—she walked right past little dreaming of the box at home waiting so eagerly to be presented to her but it's hopeless I'm afraid." Perhaps realizing he was on safer emotional ground indulging in celestial fantasy, he continued his note, "and last night high in the sky sinking with her friend the Little Bear during its slow dance for her."[65] Regardless of the impossibility of a real relationship, she was an important muse for him. "Constellation as consolation," he titled one note, while in another he observed, "Cassiopeia <u>found</u>, and self too in the finding."[66]

His Cassiopeia notes and source materials rarely reveal anything specific about his boxes. The only note that directly refers to *Cassiopeia #1* simply reads "#1 Box double circles constell. back darkened CASS constell. + pipe etc. in box."[67] However, the clippings he included in the file do shed at least oblique light on the thinking that lay behind the box. In addition to familiar star charts and notes to or about the object of his crush, he added newspaper articles about current affairs, such as "Tension on the Party Line," from the *Monitor* on August 31, 1960, as well as "Fission and Fusion in the Arab World" and a political cartoon about Communist Cuba, both appearing in the *New York Herald Tribune* in 1962.[68] Perhaps to counter the menace of Communism highlighted in these articles he included several illustrations of the nativity, one captioned "The Coming of Christ," another "Madonna of the Magnificat," along with other materials relating to Christmas.[69]

Despite its complicated personal meaning, on a public level, the more overt Space Race message of *Cassiopeia #1* fit perfectly into its contemporary context, as tensions between the United States and the Soviet Union reached a fever pitch. Other boxes also seem related to the mood of the times, including a soap bubble set featuring a large reproduction of a drawing of the Moon on the inner back that he sold to Chicago collectors Edwin and Lindy Bergman in October 1959 (fig. 6.16). Cornell had worked on soap bubble sets intermittently throughout the 1950s, although for the most part these took the form of boxes devoted to astronomers of the past, like his Copernicus and Descartes boxes. Toward the late 1950s, however, he renewed his interest in the Moon, making notes in his diaries about Moon charts and Moon boxes. By 1959 his

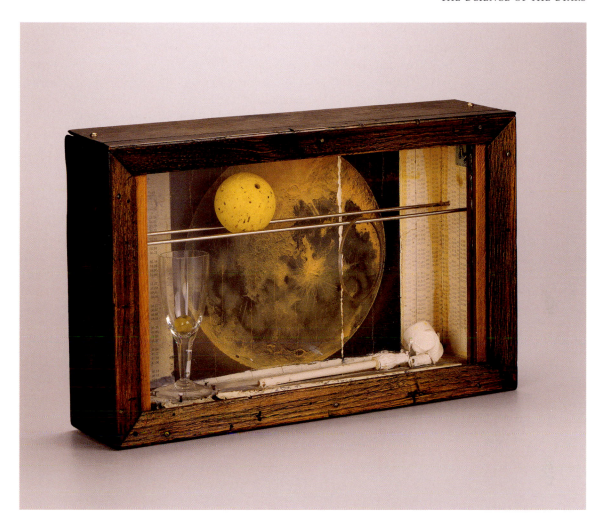

revived lunar fascination intersected neatly with yet another Soviet techno-
logical triumph.

While the launching of *Sputnik* in 1957 sent shockwaves throughout the
world, the specter of Soviet domination of the heavens loomed even larger
when the Russians landed an unmanned spacecraft on the Moon on September
14, 1959. It was clear that the United States was falling even further behind in
the Space Race. The Moon became a symbol of the situation, and, like many
Americans, Cornell began to consider it in a new light. He saved the front
page of the *New York Times* that announced the Soviet landing, along with a
large map of the Moon. While the message of the main headline and close-up
photograph of the Moon was straightforward—Soviet technology had yielded
pinpoint accuracy—the smaller headlines carried more subtle cold war warn-
ings: "Flags in Vehicle" suggested national claims on the Moon, and "Sphere

Rams Surface at 7,500 M.P.H.—Moscow Jubilant" sounded a menacing note of Russians rejoicing over a violent collision. The *Times* reported: "The Soviet press and proclamations issued both at home and for abroad were quick to restate the claim of superiority for Soviet science and by extension the superiority of the Communist system that has supported it."[70] Additional articles in that day's paper expanded on the story, and Cornell saved these, too, as well as others that appeared in the days to come.[71] With the Moon-shot concluding literally on the eve of the arrival in Washington of Khrushchev for talks with President Eisenhower, and with the United States having failed in its own attempts to land an object on the Moon the preceding year, it was feared that the Soviet leader would offer the event as proof of Soviet determination to surpass the United States in all fields of technology. Cornell saved a *Times* editorial, "What Mr. Khrushchev Won't See," published as the rocket made its way to the Moon on September 10, 1959, circling the opening paragraph that praised the values of freedom and democracy rejected by Communists.[72]

Just weeks after the Soviet unmanned landing on the Moon, Cornell, who was always reluctant to sell his work, let the soap bubble set enter the Bergmans' collection in Chicago, and although he may have begun it earlier, it is significant that he considered this box ready for sale at this particular time.[73] Reviving the format of his S*oap Bubble Set* of 1936, Cornell included a large Moon on the inner back of the box, as well as a clay pipe and a cordial glass. Again affixing his signature in reverse, *à la* Leonardo, Cornell covered the outer back of the box with two pages of a Latin text, *Commentarius Literalis*, a biblical commentary on the fifteenth chapter of the Book of Judges. In this chapter, Samson takes on the Philistines, a story that may have suggested parallels to the then current U.S./U.S.S.R. face-off.[74] At the very least, choosing to paper the back of the box with a text about the Bible underscored the importance of spiritual understanding of the wonders of the heavens, especially in an age of space exploration that could conceivably lead to such wonders as manned spacecraft and Moon landings.

On either side of the Moon and on the inner sides of the box, Cornell pasted long columns of numbers, probably taken from records of star sightings of the sort first kept by Tycho and published by Kepler—he kept printed examples of such star notations in a variety of languages for use in boxes like this one. At the same time, the columns of numbers could allude to the recent work of modern rocket scientists, whose complex mathematical computer calculations had resulted in a man-made satellite landing on the Moon. Many of Cornell's books about astronomy had speculated on such a landing, including *The Golden Book of Astronomy*, of which he owned multiple copies. He was fascinated enough by the thought of men on the Moon that he saved an advertisement from the October 1959 issue of *Scientific American* illustrating a new material for shoe soles that could result in footwear that feels as "lively as a walk on the Moon," while also being "tougher than a bride's first piecrust" (fig. 6.17).[75]

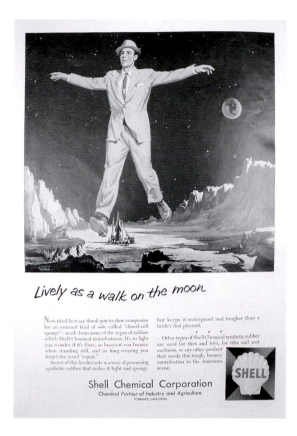

FIGURE 6.17.
"Lively as a Walk on the
Moon," *Scientific
American* 201
(October 1959).

SMILING SUN BOXES AND SOLAR SETS

While the technological and political dimensions of the *Sputnik* and the satellites that followed preoccupied Americans, other heavenly bodies were also of interest to Cornell during the 1950s. Around 1955 he turned his attention to the Sun, producing a series of solar boxes that combined scientific and spiritual concerns. For the most part, these works feature kitschy smiling Suns, metal disks taken from lids of Il Sole antipasto cans and affixed to the inner backs of boxes. Some of these boxes are similar to Cornell's earlier cabinets for astronomers backed with eighteenth-century charts, others fit into the category of hotel boxes, and still others are soap bubble sets. All relate the cosmos to the broader public and private concerns that informed his astronomy work as a whole.

For instance, in a box construction, *Untitled (Phases de la lune)* (fig. 6.18), Cornell attached the Il Sole lid above a Sun-topped chart of the phases of the Moon and technical diagrams of parallax angles, printed on an eighteenth-century chart belonging to the same set as those used in the Copernicus and Descartes boxes. On the inside top of the box he glued two pages of Latin text,

185

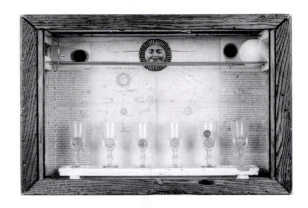

taken from a copy of Bacon's *De Augmentis Scientiarum*, a text in which the author established an ordered system of science, rising from natural history, to physics, and finally to metaphysics, which Cornell echoed with his presentation of scientific charts topped by the anthropomorphic Sun. He also included two modern charts taken from Zim and Baker's *Stars*, illustrating the effects of the gravitational pull of the Moon and Sun that cause spring tides, on the left, and neap tides, on the right. In so doing, he may have had in mind findings published in *Scientific American* in 1954, which, while noting that Bacon had been one of the first to study the relation of ocean tides to the Moon, updated his theories by explaining that the Sun and the Moon also caused tides in the atmosphere above Earth.[76]

While the *Phases of the Moon* box is linked to an earlier natural philosopher, several of the Sun boxes were intended as spiritual memorials to a particular modern individual: the actress Judy Tyler. Known first for her role as Princess Summer-Fall-Winter-Spring on the *Howdy Doody* television show, she went on to star in the Rogers and Hammerstein musical *Pipe Dream*, based on John Steinbeck's novel *Sweet Thursday*. Tyler's life came to an abrupt end when she was killed in an automobile accident on July 4, 1957. After her death, Cornell compiled a clipping file of photographs and obituaries, corresponded with her parents, and began a series of Sun boxes in her memory, including *Suzy's Room (In Mem. Judy Tyler)* (fig. 6.19) as well as several other *Suzy's Pipe Dream* boxes produced between 1957 and 1960. The titles referred to Tyler's *Pipe Dream* role: the down-and-out runaway, Suzy, who lands on Cannery Row and lives in an abandoned boiler pipe. In a twist that Cornell must have appreciated, the musical concludes with the marine biologist, "Doc," admitting his love for Suzy, as his friends mistakenly present him with a telescope, instead of a microscope, so he can complete his research. Cornell owned a recording of the musical's songs, which he played while he worked, and the "pipe dream" theme neatly cross-indexed his earlier soap bubble sets, his interest in dreams, and his admiration for the musical and the actress who starred in it.[77]

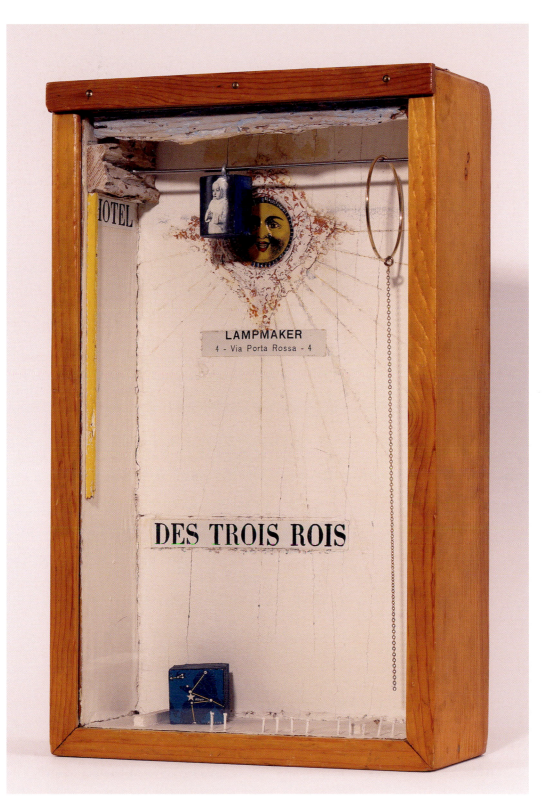

In his notes, he toyed with various ideas for commemorating Tyler in his boxes. He thought about using a block with the letter "J" for Judy, and he sought other ways to memorialize her through his art, writing in a note: "Judy Tyler * SUN from doldrums marveling at this getting into motion 'bringing to life.'"[78] For *Suzy's Room (In Mem. Judy Tyler)*, he returned to the smiling Sun that had first appeared in the historical astronomer boxes, affixing an Il Sole lid in a thick layer of plaster on the inner back of the box. He added a photostat with the word "Lampmaker" below it, as well as the word "Hotel" on the inner left side and "Des Trois Rois" on the inner back. At the bottom of the box he included a cube covered with a chart of the constellation Aquila, the Eagle, taken from Zim and Baker's *Stars*. Sliding on a metal rod at the top of the box are a ring with a chain hanging from it and a cylinder with a photostat of a French postage stamp featuring another Suzy: a late-fifteenth-century painting by Jean Hey, the Master of Moulins, entitled *Suzanne de Bourbon in Prayer*.

Cornell found important personal and spiritual parallels in the Sun, with its related concepts of light and illumination, and it was no doubt this solar significance that he wished to impart to the departed Tyler. He scrawled one note about the "reassuring symbolism of light with its real significance, healing light."[79] On a scrap of paper he jotted, "'the brightness of thy rising,' Isa. 60 Bible for Sun boxes."[80] He reminded himself of "metaphor of Sunshine heaven runs over" and of "'light' in symbolic sense."[81] Another note contains a quotation from Psalm 119: "Thy word is a lamp unto my feet, and a light unto my path."[82] He marked a passage from the *Christian Science Monitor* with the words, "Just as the Sun is always shining, though it may be temporarily hidden by clouds, so God is constantly at hand, pouring forth infinite blessings."[83] In another note he quoted the following line from *Science and Health with Key to the Scriptures*: "The Sun, giving light and heat to the earth, is a figure of divine Life and Love, enlightening and sustaining the universe," also citing the apostle John's words, "God is Light and in him is no darkness at all," adding, "new SUN BOX—lamp maker."[84] Perhaps this time the eagle constellation alluded to Saint John, whose symbol is the eagle, while the "Hotel des Trois Rois" referred to the three Magi, whose stargazing Cornell had already drawn attention to in the *View* magazine word tower and which also played a part in the *Celestial Theater*. The result was a work that offered a Broadway star a place in among the real stars, commemorating her life and offering her spiritual succor.

But not all of Cornell's solar boxes are "smiling Sun boxes," as he called them. Beginning in the mid-1950s, he began making what he referred to as "solar sets," soap bubble sets and other solar boxes that presented the Sun in more scientific ways, in keeping with the growing importance of astronomical science during the Space Race years. In particular, he emphasized the place of the Sun in the cosmos and its special physical properties. *Untitled (Solar*

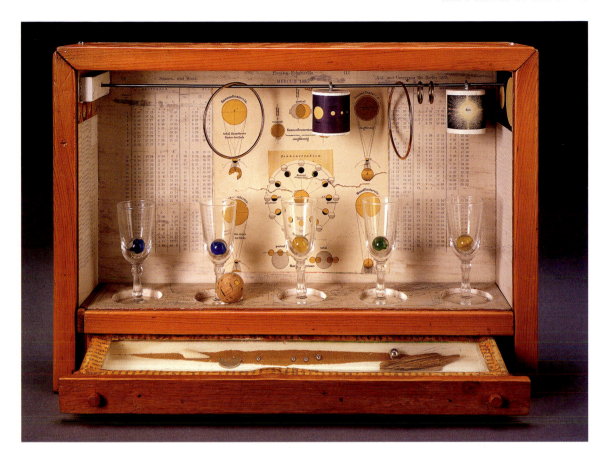

Set), made around 1956–58 (fig. 6.20), includes a variety of charts showing the phases of the Moon and types of eclipses, bracketed on either side by long lists of numbers charting the phases of the Moon. Cordial glasses containing colored marbles suggest planets revolving in space around the Sun, as well as the colors of the spectrum that solar light comprises when reflected through a prism. On a rod near the top of the box, four metal rings and two cylinders with charts of the planets and the Sun can slide from side to side. At the bottom is a drawer that opens to reveal a yellow sand tray, edged with Latin text and containing five ball bearings, a small piece of driftwood, a spiral shell, and a coin with an owl.[85] Packed with visual stimuli, this solar set privileges scientific information, with charts, numbers, and models filling the empty space found in spiritual Sun boxes such as *Suzy's Room*.

Perhaps Cornell was aware that the International Geophysical Year's first major research project focused on the Sun, with rockets and balloons launched to study solar flares and sunspots.[86] In the later 1950s or early 1960s he made at least one work devoted to the topic of sunspots, a tiny cardboard box with an illustration pasted on the lid clipped from *The Golden Book of Astronomy*

FIGURE 6.20.
Joseph Cornell, *Untitled (Solar Set)*, c. 1956–58. Box construction, $11\frac{1}{2} \times 16\frac{1}{4} \times 3\frac{5}{8}$ in. The Robert Lehrman Art Trust, Courtesy of Aimee & Robert Lehrman, Washington, DC. Mark Gulezian/QuickSilver Photographers.

comparing a sunspot, with its central umbra and surrounding penumbra, with the relative size of Earth.[87] Solar research during the 1950s had concentrated on the behavior of the clouds of hydrogen gas on the surface of the Sun, using new devices such as the coronoscope that made it possible to observe and photograph the Sun's corona at all hours of the day or night, enabling scientists, as one journalist put it, to watch the Sun "blow a fuse."[88]

In particular, scientists grappled with the question of solar magnetism. In 1908 George Ellery Hale, working on Mount Wilson, discovered that the lines in the spectrums of light from sunspots were split in a way that indicated strong magnetic fields; however, whether the Sun had a permanent magnetic field was still a matter of conjecture by the 1950s. Research carried out with high-altitude balloons convinced some scientists that there was no permanent solar magnetism, but in 1958 new findings suggested otherwise, as scientists applied magnetohydrodynamics, the science of gaseous motion in magnetic fields, to the Sun.[89] By 1961 data obtained by the *Explorer X* satellite provided direct evidence that solar winds blow the Sun's magnetic field even past Earth.[90] Cornell must have absorbed at least some of these findings, prompting a box entitled *The Magnetism of the Sun*, probably made in the early 1960s. A soap bubble set, this box includes the familiar rolling cork ball, clay pipe, and driftwood, with their dual identities as real and metaphorical objects. On the inner back of the box, however, he pasted a chart illustrating the behavior of the Sun's magnetic field, grounding the soap bubble set's "flights of fancy" in the facts of hard science.[91]

CELESTIAL NAVIGATION

During the 1950s and early 1960s, Cornell increasingly turned his attention to the world of popular science, and he produced boxes that summarized and commented on topics of interest to the general public. To keep abreast of current developments, he drew heavily on the *Times* and the *Monitor*, as well as articles in *Scientific American*, *National Geographic*, and *The Sky Reporter*, the newsletter of the Hayden Planetarium, to which he subscribed. In addition to satellites and solar research, exploration of the distant cosmos and the tiny atom, he focused on navigation, combining his long-standing fascination for maps and geography with recent advances in mapping the distant reaches of space.[92]

The theme of celestial navigation fascinated Cornell, and in the 1950s he produced several boxes devoted to it. He was certainly not alone in his interest. Since its opening in 1935, each year the Hayden Planetarium staff had offered New Yorkers popular courses on celestial navigation. Perhaps he had read the article "Celestial Navigation" in 1936, in the inaugural issue of *The Sky, Magazine of Cosmic News*, published by the Hayden Planetarium. That

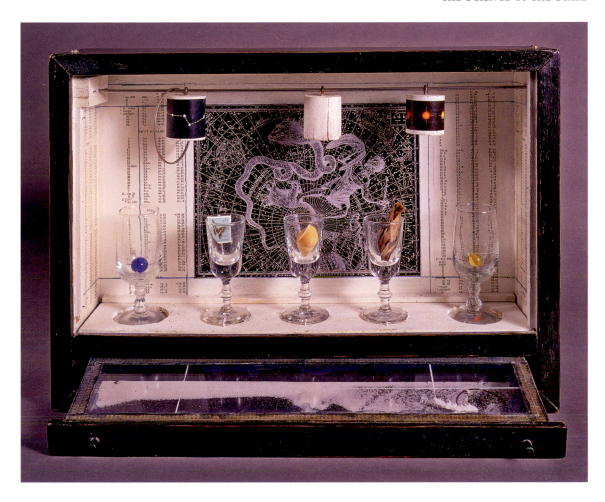

article pointed out that, due to the advent of commercial airplane flights and the construction of new planetariums, "more people are now interested in this subject than ever before."[93] Even if he missed that one, magazines such as *The Sky*, *Sky Reporter*, and *Scientific American* frequently featured articles about the topic. Given Cornell's years of stargazing, he would have found such items especially appealing, and, as the *Sputnik* era brought people to their yards in droves, he joined their ranks to imagine navigating the cosmos.

Although Cornell had been intrigued by personifications of constellations from the outset of his career, in the 1950s he also began to refer to scientific methods of charting the cosmos in his work. For example, in *Celestial Navigation* (fig. 6.21), he combined old and new ways of navigating by the stars. He positioned a negative photostat of Flammarion's *Les Constellations Voisines du Pôle* as if seen through a window, and he surrounded it with columns of numbers noting star positions, referring not only to the importance of record-keeping in the history of astronomy, but also to cutting-edge

FIGURE 6.21.
Joseph Cornell, *Celestial Navigation*, c. 1956–59. Box construction, 12¼ × 17¼ × 4 in. Collection of Mark Kelman, New York.

191

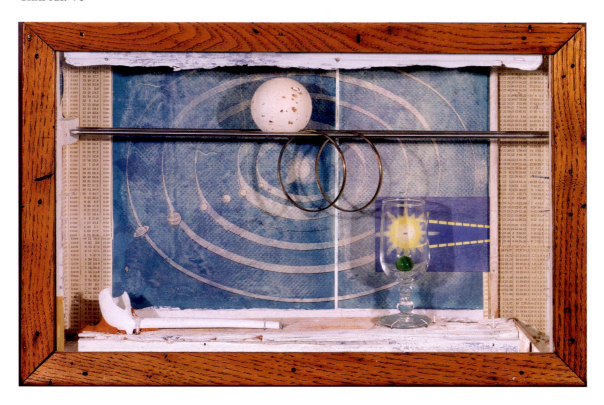

developments in numerical technology. Like many New Yorkers, Cornell may have visited Computers in Astronomy, the fall 1958 exhibit at the Hayden Planetarium, which included a section on the use of computers in celestial navigation, as well as one illustrating computer calculations to determine past and future locations of stars.[94] In his *Celestial Navigation* box, he underscored the difference between ancient anthropomorphizing of the stars and modern systems of mapping by incorporating two charts clipped from Zim and Baker's *Stars* on hanging cylinders: one illustrates the color of stars, a factor in star classification, while the other shows the Big Dipper as it will appear in the year A.D. 100,000. Under the main compartment of the box is a drawer that opens to reveal a sand box. With small spiral shells, ball bearings, and white sand on a dark background beneath glass tops marked with a white grid, he evoked the idea of measuring the shifting positions of bodies in constantly moving astronomical and subatomic universes.

While Cornell was certainly aware of the innovations in navigation and mapping that had enabled early explorers to chart Earth, commemorated in the mid-1950s in boxes such as *Suite de la Longitude*, he also turned his attention to exciting new tools for mapping the cosmos. In *Radar Astronomy* (fig. 6.22), a soap bubble set produced probably in the early 1960s, he celebrated the use of radar for gathering information about the solar system. Radar was

developed in the 1930s, and its technology evolved rapidly during World War II when it was used for detecting airplanes and ships. After the war, radar research expanded on two fronts: to devise necessary weapons for strategic defense during the cold war and to develop new tools for scientific research. While radar became an integral part of American defense systems in the 1940s and 1950s, it also led to important findings in astronomy. In 1946 radar beams were reflected off the Moon and back to Earth. In 1958 radar contact was established with Venus, revealing that the surface of Venus is as pock-marked as the Moon.[95] Beginning in September 1958, research teams at Stanford attempted to make radar contact with the Sun.[96] In his *Radar Astronomy* box, Cornell seems to have summarized this knowledge. He affixed a diagram of the Sun, taken from a larger illustration of a lunar eclipse in Zim and Baker's *Stars* (see fig. 5.21). He removed the part of the diagram that included Earth and the Moon, thereby permitting yellow dotted lines to suggest radar beams instead of the path of the Sun's light. Moreover, on the blue painted chart of the Sun and planets backing *Radar Astronomy*, concentric circles radiate from the central celestial body, past a pitted cork ball Moon or Venus, reminding the viewer of recent radar research.

In addition to its scientific aspects, *Radar Astronomy* may also have a spiritual dimension. In the early 1960s Cornell read a book by Louis Batten entitled *Radar Observes the Weather, New Understanding of Cloud Physics*, published in 1962.[97] In his copy, he wrote "Angel Echoes" on the title page, a reference to chapter 9, "Radar Sees the Earth and Angels," which he marked with a scrap of paper. In this chapter, Battan described a phenomenon known as "angel echoes," a term used for unexplained echoes from regions in the sky that are absolutely clear, although Battan noted that birds could be the cause of these signals. Cornell was fascinated by bird navigation, saving multiple copies of "Celestial Navigation by Birds" from *Scientific American*, as well as a *Natural History* article entitled "Migration of Angels," with intriguing links between birds and angels.[98] Later in the chapter, Battan discussed and illustrated a type of echo called a "ring angel," in which rings develop from small circles, expanding in intervals like the pattern made when a stone is thrown into a calm lake. Cornell must have been intrigued by the idea of angels being detected by radar, and the concentric circles tracing the orbits of planets in his *Radar Astronomy* box may have also been intended as allusions both to scientific radar signals and to spiritual "ring angels."

The history of mapping, the science of astronomy, and the quest for spiritual enlightenment converge in another soap bubble set probably made around the late 1950s (fig. 6.23). In this work, the clay pipe blows a variety of seemingly innocuous "bubbles": a scientific chart, a map, a white cork ball, and a metal ring. These bubbles, however, take the viewer on a remarkable scientific and spiritual journey through time and space. Emerging from the bowl of the pipe is a red sphere, backed by a barely glimpsed white one, surrounded by a dotted line and framed by a white graph. It is an illustration, "Eclipsing Binary, Algol, with Magnitude Changes," clipped from Zim and Baker's *Stars*

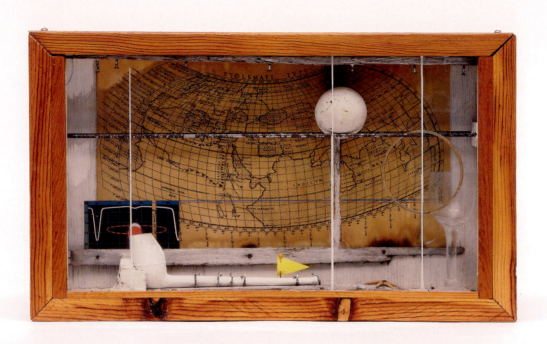

FIGURE 6.23.
Joseph Cornell, *Soap Bubble Variant,* c. 1959–60. Box construction, recto and verso, 9⅝ × 16 × 3⅞ in. Photograph courtesy of PaceWildenstein, New York.

(see fig. 5.21). Located in the constellation Perseus, the "winking demon" double, or binary, star Algol revolves in such a way that it eclipses itself, causing fluctuations in brightness, depending on which component is observed from Earth. Cornell was fascinated by this phenomenon, and he used this diagram in several boxes and collages in the 1960s.[99] On one hand, he could not have missed the resemblance to the ringed planet Saturn that had appeared in his first soap bubble set in 1936; on the other, he may have been intrigued by the relationship between a binary star, blinking in the night sky, and the binary numerical systems used by computers to make complex mathematical calculations about the size and age of the universe. And he may have considered parallels between the cork ball rolling through the box and the moons to be seen in the night sky, not only the lunar orb, but also new manned satellites making their way through space, such as the one that carried two Soviet "astro-heroes" back to "Red Earth," in 1962, when "the celestial carousel wound down at last and off stepped the Soviet astro-twins," as reported in an article Cornell saved and circled from the *New York Herald Tribune.*[100]

On the inner back of the box, he affixed a different kind of diagram: a Ptolemic map of Earth. Around A.D. 150 the Greek astronomer produced data for creating a world map; however, none of his maps have survived. In the fifteenth century, scholars recreated Ptolemy's map, using directions in his

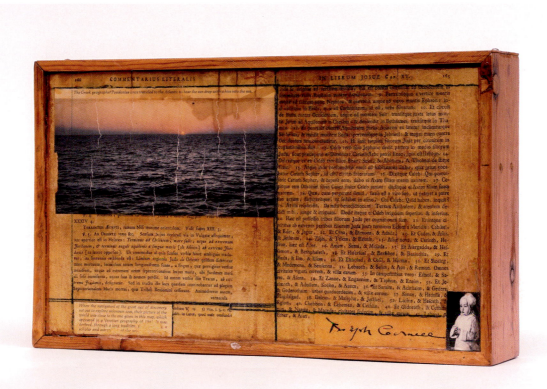

Geographia that explain how to project a sphere onto a flat surface with a system of latitudinal and longitudinal gridlines. Beneath the map and the diagram of Algol is a piece of driftwood, suggesting that both celestial bodies are drifting through an ever-expanding soap bubble universe, accompanied by a tiny starfish attached to the inner bottom of the box and the cork ball Moon that rolls from side to side on metal rods.

Cornell continued his exploration of science and spirit on the outer back of the box, covering it with texts and pictures. In the upper left quadrant, he pasted a photograph of the surface of the ocean and a setting Sun, topped by the following text: "The Greek geographer Posidonius once traveled to the Atlantic to hear the Sun drop with a hiss into the sea." At the bottom of the lower left quadrant, he glued a text that reads, "When the navigators of the great age of discovery set out to explore unknown seas, their picture of the world was close to the one given in this map, which appeared in a Venetian geography of 1561. It was derived through a long tradition, [from Ptolemy], a scholar and astronomer of the sec[ond century]." A Stoic astronomer and mathematician, Posidonius attempted to estimate the size of the Sun and the Moon, while Ptolemy's astronomical treatise, the *Almagest*, proposed a geocentric model of the universe and included a star catalogue of forty-eight constellations.

195

If these were the only collage elements on the back of the box, they might be seen as references to classical learning and the history of astronomy. However, covering the entire back of the box are two pages from the Latin *Commentarius Literalis* that Cornell also used in another soap bubble set (see fig. 6.16). In that box, he had perhaps included the commentary on the book of Judges as an allusion to cold war tensions. For the back of this box, he chose pages explaining passages from the book of Joshua, which includes the biblical account in which Joshua's prayer for God to halt the Sun and the Moon—that is, to stop time—is answered. The theme of prayer is emphasized with a postage-stamp-sized photostat in the lower right corner of the Master of Moulin's fifteenth-century painting of Suzanne de Bourbon. Beside the praying child is Cornell's signature, with a final flourish that physically links the artist's identity with the devout worshipper, whose ultimate destiny is to escape the physical bounds of time and space, of geography and eclipsing stars, to enter the infinite metaphysical universe of the spirit.

CUSTODIANS OF THE NIGHT

On August 5, 1962, the movie-going public was shocked to learn of the death of Marilyn Monroe. Her suicide caused "a wave of sorrow to be felt by millions," in the words of the minister who conducted her funeral service.[101] Among those millions was Cornell, who saved an article detailing her last rites, along with others that chronicled facts of her life and death, in a clipping dossier he had been compiling since the mid-1950s. Within days of her death he considered a work to honor her, noting on August 8, "demolition from the Hotel Fontaine—for Marilyn Monroe 'In Memorium'," and on the 11th, "Extraordinary 'working out' of so called 'M.M. box. . . .'"[102] A week to the day after her funeral, thoughts for a memorial box jelled in a series of diary notes. In one he wrote, "image of 'the Custodian' add ASTRON. Chart. Marilyn." A few days later he titled a diary page "A childhood for Marilyn" and abbreviated lines from a poem by Lorca: "to beg C. the Lord / to give bk the soul I had / of old, when I was a child," adding "but she never had any childhd except one so hideous as to shatter any nostalgia of one's own 'soul' of childhd." He saved an article from the *New York Daily News* about the one person she loved as a child, a woman who, the movie star had observed in an interview, "didn't believe in sickness, or disease or death. . . . She believed the mind could achieve anything."[103] "Christian Science practitioner," Cornell wrote beside it.

Most significant to him, though, was a moment's glimpse on August 15 of a young boy going through a subway turnstile. It struck him as a kind of "blessed symbolism" of passing through the gates of heaven, as well as an image of the innocent childhood that had been denied to the movie star. Over a

month after her death, he still pondered the meaning of that split-second view of a stranger, writing:

> That gangling in khaki shorts and blue shirt pushing through the stiles with mother + younger sister in the morning rush . . . another "Wednesday" with its peculiar poignancy at the passing of a "stranger" another "sign", "encounter", precious though poignant—clear + fresh + pale washed out blue of blouse—a look of unspoiled youth, a kind of wandering wondering, then "suddenly" . . . in a flash . . . this "youth in blue" . . . CUSTOS MESSIUM— the Custodian—the wandering night companion of the "Little Bear" and Camel-leopard. He is a forgotten constellation "cannot be seen with the naked eye" and yet for those with "eyes to see."

To visualize the experience of going down into the subway and then emerging into the light—"this Eurydice experience" as he called it in the same note—he turned to the constellations to create a memorial for Monroe.[104]

Unlike Pop artist Andy Warhol, who focused on the garish and destructive aspects of Monroe's fame, Cornell associated her with falling stars, jotting a note two weeks after her death, "Perseid shower 8/18/62 M.M.," referring to the meteor showers in Perseus that occur each August.[105] But it was the constellation Custos Messium that preoccupied him as he tried to put into concrete form the vision at the subway turnstile (fig. 6.24). Having spied a child in blue passing through a subway gate, he translated that actual moment into an incarnation of the constellation Custos Messium: the perfect celestial protector for the actress as she passed from this life to the next. In the end he created three "Custodian" boxes by using portions of the chart of "Les voisines du pôle" from Flammarion's *Les Etoiles*, including *Custodian II (Silent Dedication to MM)* (fig. 6.25).[106] With white wire mesh, a metal chain and ring hanging from a rod at the top, a rolling red ball, driftwood, and a constellation chart mounted to the inner back with its grid lines continuing across the inner back of the box, Cornell envisioned a miniature cosmos for the film star.

The constellation Custos Messium, the Custodian, was devised by Lalande in 1775 to honor the famed astronomer Charles Messier as the custodian of the night skies. Located in northern Cassiopeia, between Cepheus, the Ethiopian king, and Camelopardalis, the Giraffe, the constellation was personified as a young boy guarding the harvest. Although discredited in the 1920s, it was included in Bode's *Uranographia* as a bare-legged boy carrying a staff. Cornell knew it from two sources: the Bode illustration in Flammarion's *Les Etoiles* and a description that he copied word-for-word from Richard Hinckley Allen's *Star Names: Their Lore and Meaning*.[107] Allen surmised circuitously that because Cepheus and Cassiopeia were rulers of an agricultural kingdom and because the giraffe Camelopardalis grazed on grain, a guardian was needed to protect the crops. Cornell went one step further, assigning the custodian the additional task of guarding Monroe's spirit.

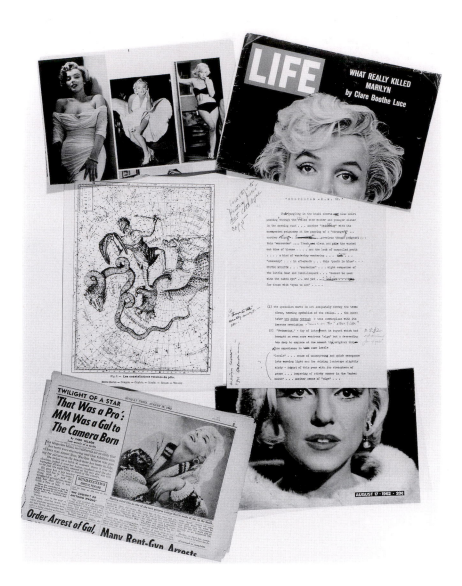

FIGURE 6.24.
Joseph Cornell, source
materials and notes from
Marilyn Monroe file.
Joseph Cornell Study
Center, Smithsonian
American Art Museum.

OPPOSITE page:
FIGURE 6.25.
Joseph Cornell, *Untitled*
(*Custodian II, Silent Dedi-
cation to MM*), 1962–63.
Box construction,
18 × 12¼ × 5 in. Private
collection. Photo: Edward
Owen / Art Resource, NY.

Revising a box probably begun in the early 1950s, on the inner back Cor-
nell affixed a photostat of the constellation, with its name at the boy's feet. He
angled Cameloparadalis and Ursa Minor onto the inner left side of the box, but
above Custos Messium he truncated the body of Cepheus, leaving only the
king's comparatively huge legs and the suggestion of his hidden private parts
in the shadow of his skirt. Perhaps he removed the upper body of Cepheus
because it distracted attention from the smaller figure of Custos Messium;
however, the remaining huge legs and shadowed crotch add an ominous note
of threat, justifying the need for the cosmic custodian to guard the fragile star
from celestial sexual predators.[108] Hanging from a rod at the top of the box is

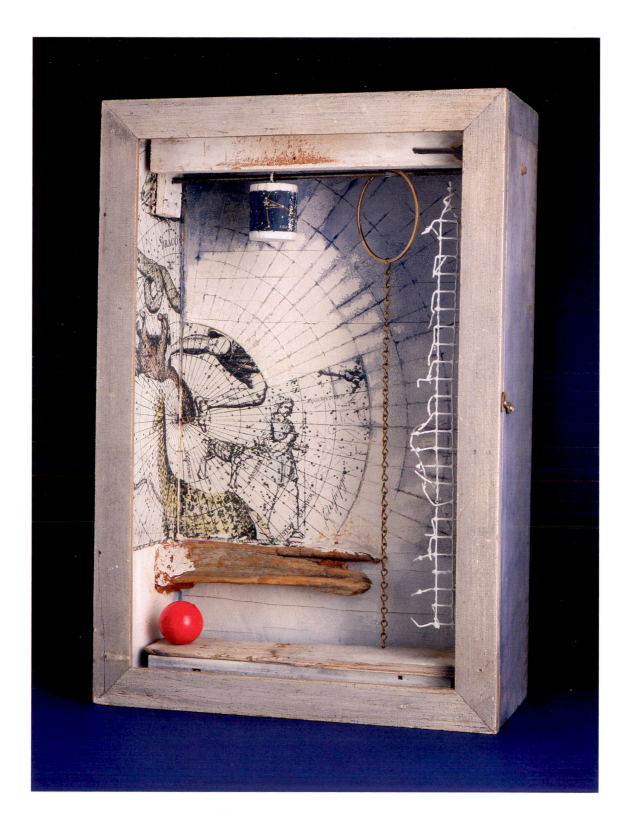

a wooden cylinder on which a chart of the constellation Aquila, the Eagle, is pasted. Prominently labeled in the center of the chart is the large star Altair, one of the brightest in the night sky, perhaps now playing a dual role as a stand-in for the deceased movie star who is nowhere else to be found in the box.

Given his ongoing interest in the rich metaphors of astronomy, Cornell's use of a constellation as a guardian for Monroe is not unexpected. What is surprising is that the association of the actress with outer space was also inadvertently made in the popular press, with stories about both topics frequently appearing side-by-side. For instance, in Cornell's M.M. dossier he kept an issue of *Life* magazine whose cover featured a portrait of a space program test pilot, with the headline "Marilyn Monroe Pours Her Heart Out" placed beside him.[109] Cornell saved the cover of the August 10, 1962, issue of *Time* magazine, caricaturing "Space Planner D. Brainerd Holmes" as a satellite orbiting the Moon, and penned a note on the cover to "see p. 45," an article about Monroe.[110] To his dossier he added a page from the *Christian Science Monitor*, with side-by-side articles about the use of television technology to explore the Moon and the suicide of the actress.[111] And, he filed away the front page of the *New York Herald Tribune*, with a story about the Russian space program above one entitled "Marilyn Monroe: 'Probable Suicide.'" While none of these magazines and newspapers implied a direct relationship between outer space and the movie star—they were simply the hottest stories of the day—the ever-vigilant Cornell no doubt appreciated, and even drew upon, the connection. If so, he was not alone. As Hauptman has pointed out, Cornell was also inspired by an October 1962 article in *Show* magazine written by Clifford Odets, in which the author used the astronomy term "dark companion"—an unseen star whose gravitational pull determines the erratic path of a visible one—to explain the effect of Monroe's "Dickensian pattern of early foster homes, of rejection and parental deprivation."[112]

In his notes, Cornell alluded to other works he dedicated to the movie star, suggesting further conceptual connections to science. In December 1962 he jotted a note about a work: "'Object of Contemplation' [Pictures for a golden child]," adding in the margin, "for M.M. piece gradually make it as such." Below that note he cited page numbers for "a passage of 'profound depths'" in physicist Max Planck's book, *The New Science*.[113] In another note he copied the famous quotation attributed to Newton about being like a child playing on the seashore with pebbles and shells, while the vast ocean of truth lay undiscovered before him. Below Newton's words he added "Sat. aft. 'at home' working—'Owl Nebula,' 'Soap Bubble Set,' 'Contemplation Piece.'" Another note refers to "An homage—apotheosis- 'for M.M.'—(autumnal 92) [Shooting Star ident.] COLLAGE a kind of pendant to 'the nearest star'—a benediction—."[114] Clearly Cornell remained fixed in his desire to memorialize Marilyn Monroe by means of the language of the stars.

The Age of *Sputnik* was a complicated era of scientific achievement and political tension. It was also a period of spiritual vulnerability, as Americans feared Communism's threat to religious belief systems. Cornell wove all of these ideas into his clipping files, diaries, and boxes, producing complex, science-based works that address spiritual concerns, while also alluding to the rich history of astronomy.[115] He continued this approach, with even greater emphasis on spirituality, as he entered the final decade of his life. During his twilight years, he produced a remarkable body of collages, enlarging ideas about the cosmos that he had explored throughout his long career.

THE TWILIGHT ZONE

As Cornell's reputation grew, important exhibitions featured his art. Displaying his work along with Duchamp and Kurt Schwitters, Cornell was given an individual room in the *Art of Assemblage* exhibition organized by William Seitz at the Museum of Modern Art in 1961.[1] Early in 1966, a few months after the death of his mother, Cornell's first retrospective opened at the Pasadena Art Museum, following Duchamp's 1963 retrospective at that museum. Also in 1966, Cornell was nominated to represent the United States at the Venice Biennale, although those plans fell through. His national importance as an artist was confirmed by a major retrospective exhibition of his work in New York, organized by Diane Waldman at the Guggenheim Museum and on view between May 4 and June 25, 1967.

The Guggenheim retrospective included seventy-eight box constructions that spanned the artist's career, as well as ten recent two-dimensional collages. Critics generally praised the astronomy boxes, although, like earlier critics, they did so in vague cosmological terms, evoking Symbolist mysticism. For instance, Harold Rosenberg wrote in the *New Yorker*:

> He responds like Valéry to the infinity of the night, and shares with Mallarmé the idea of art as a cosmic game of chance. . . . Sand, firmaments, and figures of the zodiac recur in the boxes done in the fifties, in which strips of sky starred by flecks of white paint replace the portraits of the Medici boxes. It is almost as if these works were responses to Baudelaire's lines in "The Voyage":
>
> > *Show us those caskets made of your rich memories,*
> > *Those marvelous jewels made of stars and ether.*[2]

CHAPTER VII

By 1967, critics positioned Cornell as an important influence on the younger generation of post–Abstract Expressionist artists. Nearly every response to the Guggenheim exhibition discussed Cornell's work in relation to that of Rauschenberg, whose "combines" helped establish assemblage as a legitimate avant-garde creative practice in the mid-1950s. Some, like John Ashbery, cited a direct cause and effect: "Certainly Rauschenberg . . . looked long and deeply at Cornell's work before his show (also at the Egan Gallery) in 1954."[3] Other critics voiced parallels to Pop Art, although they took pains to distance Cornell's dependence on nostalgia from Warhol's and Lichtenstein's hip examination of contemporary consumer culture. Ashbery even related some of Cornell's more austere boxes to Minimalism, although he argued that it was a metaphysical similarity rather than physical resemblance that linked Cornell to artists like Sol Lewitt, Robert Morris, and Donald Judd.[4] Hilton Kramer went so far as to dub Cornell "something like the leader of a school."[5]

Cornell was interested in the younger generation, although his "leadership" took the form of following their work and setting an example through his own. He saved newspaper illustrations of art by Rauschenberg, Warhol, and Judd, as well as pictures of Eva Hesse's *Accretion,50 Times*, Robert Smithson's *Spiral Jetty*, George Rickey's *Space Churn with Octagon*, and an Op Art painting by Bridget Riley, *Blaze IV*.[6] He welcomed young artists, including Warhol, James Rosenquist, and Yoko Ono (with her husband, John Lennon), to his home with varying degrees of warmth.[7] At the same time, he resented what he saw as the facile nature and easy fame of Pop Art, writing in a diary entry that the rich source material of contemporary life was "so poorly worked by current pop artists—in particular Andy Warhol—current cover of TIME." He added at the bottom of the note, "'Penny Arcade' preceded the tidal wave of pop art."[8]

In 1967 Cornell's national celebrity was assured with the publication of an eleven-page picture spread and essay in *Life* magazine (frontispiece). Of all of the critical retrospective analyses of Cornell's work, this article offered the most serious consideration of Cornell's approach to astronomy. Entitled "Imagined Universe Stored in Boxes," the article opened with an illustration of *Sunbox* and a caption that raised perceptive questions about the work:

> This box is only 10 inches high, 15 inches wide and 3 inches deep. Yet viewers find it large enough to set them speculating about the universe. . . . It is put together with the precision and balance of an algebraic equation and yet it is deliberately enigmatic. Do the nestled marbles represent established concepts of the universe? Do the dangling rings represent a universe gone askew? Or is man's whole notion of the universe just a pipe dream?[9]

In "Enigmatic Bachelor of Utopia Parkway," the essay that followed the captioned pictures, David Bourdon described interviewing Cornell at his home: "Perhaps the main thing I learned from my visit was how painstaking

Cornell is, precisely calculating his efforts so that his boxes, compressing infinite quantities of time and space, become microcosms in which a moment has been captured for what seems an eternity."[10] While Bourdon praised Cornell's boxes and the dense meaning packed into them, he presented their maker as a benign kook. On the final page of the article, under the subtitle "Wringing of hands over a misplaced pipe," Bourdon concluded by describing the artist as on the verge of tears because he was not pleased with the soap bubble set he was reworking.[11]

The *Life* magazine article demonstrated how well Cornell's work could fit into broader space age interests of the 1960s. In a national magazine with a huge popular readership, the hook used to grab the reader's attention was astronomy, with references to the universe in the title and the first illustration. Bourdon described the artist in scientific terms, as someone who makes precise calculations about time and space. Even the artistic qualities Bourdon underlined—Cornell's irrational "Proustian digressions that meander back and forth in time," where "actual things seem suddenly remote and unfamiliar, while stray wisps of a dim past become real and immediate"—allude vaguely to Einstein.[12] Nevertheless, Bourdon separated the artist from the world of science by implicitly questioning Cornell's gender identity, as the "enigmatic bachelor" wrings his hands and seems ready to cry at the end of the interview. Bourdon's composite picture is confusing: on one hand, Cornell is a master of rational measurement; on the other, he is debilitated by his emotional instability and questionable marital status. No wonder Cornell detested the article.

Despite the implicitly homophobic line Bourdon drew between science and art, he zeroed in on important aspects of Cornell's art, especially his dependence on metaphors of science, astronomy, and time. Indeed, these were themes that surfaced repeatedly in Cornell's diary notes, which, as the decade wore on, increasingly combined scientific knowledge with his dreams of romance and visions of departed loved ones. He carefully recorded the stars and constellations he observed in the sky, noting the time of observation and their position in relation to markers like the quince tree in his yard. At the same time, science entered his dream world with the vivid "astronomer dream" he had in 1961, in which he envisioned an astronomer holding a quadrant at the side of his head.[13] Like a scientist reviewing his data, he went over his clipping files, culling and organizing decades of factual material. At the same time, he sought ways to express what seemed inexpressible, writing in one note, "And now: —in the early hours again—'helplessness' in the attempt to put down (capture) the ineffable."[14]

Television occupied an increasingly large portion of his time, especially after the deaths of his brother and mother. Here, too, his choices indicate his dual fascination for the rational and the irrational. He took notes on mathematics from classes that he watched on "Sunrise Semester." But he also watched *The Twilight Zone*, where each week television viewers traveled "through another

dimension, a dimension not only of sight and sound but of mind. A journey into a wondrous land of imagination." *The Twilight Zone* blended modern science with space age fantasy: tiny spacemen harassing a woman turn out to be American explorers on a planet inhabited by a giant; an airplane return- ing to New York in 1961 mysteriously breaks the time barrier to find itself in the Age of the Dinosaurs and then above the grounds of the 1939 New York World's Fair; a young William Shatner looks out the window of an air- plane and sees a hairy gremlin tinkering with the engine. Episodes like these capitalized on popular fantasies of travel through time and space that had long interested Cornell.

As Cornell's art progressed during the 1960s, it moved in two general di- rections. Despite the critical acclaim that he received for his boxes, he did not develop new subjects for them after the late 1950s. Instead, he repeated and refined earlier formats, revising soap bubble sets and observatories begun in the 1950s and making new variants on space object and celestial navigation boxes. While he continued to produce astronomy-themed boxes along already- established lines through the mid-1960s, beginning in 1953 he also embarked on a new body of work: two-dimensional collages that marked a bold departure from his three-decade-long engagement with the assemblage box.[15] In place of the literally confining boxes he had used throughout the 1940s and 1950s, the flat format liberated him to think in more expansive terms. His collages offered him the freedom to experiment with new scientific, fantastic, and even erotic ways to envision the cosmos.[16]

RAINBOWS FOR FALLEN STARS

While Cornell was intrigued by the idea of individuals memorialized as con- stellations, he realized that other astronomical phenomena, including rain- bows, also could commemorate the departed. As he began working seriously in collage in the 1960s, he dedicated a work to another deceased actress: Jeanne Eagels, a theater and film star who died in 1929. In 1963, a little over a year after the death of Monroe, Cornell watched a late-night movie on television: the 1957 film *Jeanne Eagels*, starring Kim Novak. He saved a page from the *TV Guide* listing the program, marking it with an elongated figure eight in the margin and penning the word "collage" at the top of the page. The film sparked Cornell's memories of having seen Eagels perform in the play *Rain* on Broad- way in the 1920s, and it led to a collage in honor of the actress: *How to Make a Rainbow (for Jeanne Eagels)* (fig. 7.1).

For a variety of reasons, Cornell empathized with Eagels. Although he did not create an overt "custodial" work by including the constellation Custos Messium, he did seek to protect her by fashioning, as he put it in a diary note, "a Secret Childhood for Jeanne E——."[17] He was especially struck by how much

Figure 7.1.
Joseph Cornell, *How to Make a Rainbow (for Jeanne Eagels)*, 1963. Collage, 11⅜ × 8⅜ in. Photograph courtesy of PaceWildenstein, New York.

her life paralleled his own, or at least by how the Kim Novak movie seemed "so astonishingly autobiographical." It brought back memories of New York in the 1920s, of newspaper "column chit-chat about Jeanne Eagels working the slot machines in little joints adjacent to her theater."[18] Like Marilyn Monroe, Eagels died young, with a history of drug and alcohol problems. Cornell went to the Flushing Public Library and read about her life, transcribing lines from George Oppenheimer's book *The Passionate Playgoer*: "'after 5 yrs. of imprisonment in the success of RAIN, the madness of the caged came upon poor Jeanne Eagels, + in a sense she died of that madness. Hers was the desperation + the death of the trapped.'" Cornell added in the margin, "J.E. what an illumination consolation this 'trapped' business—to further cut down stupid 'sensitivity' what an astonishingly new Rapport," and he repeated the phrase "'caged' 'desperation'" at the bottom of the page in a reference to his brother Robert.[19]

In particular, he was struck by a passage from Glenway Wescott's book *Images of Truth*. Writing about the novelist Katherine Anne Porter, Wescott observed, "Shapes and inanimate objects in her portrayal of the world are never geometrical or surrealistic or modernistic. Things are what they are; and what people do results directly from what *they* are." Cornell bristled at Wescott's dismissal of "geometrical or surrealistic or modernistic" qualities. He headed

a diary page "(J.E.)" and marveled at how easily the Jeanne Eagels rainbow collage had come about, "—spontaneously, this, if you please, despite its 'geometrical' + 'surrealistic' aspect." In addition to his comments on Wescott's book, he cited a biblical reference: Matthew 18:1–4 (a passage including the words "except ye be converted, and become as little children, ye shall not enter into the kingdom of heaven"). He asked himself, in another bit of marginalia, "is 'Rainbow' outcome of a truly childlike nature. One can only hope so!"[20]

Unlike Wescott, who could blithely proclaim that "things are what they are," Cornell wove a conceptual web of associations, uniting memory, reality, and geometry, as well as the visionary and revelatory aspects embedded in his "Jeanne Eagels exploration," as he called it. He looked for ways to legitimize geometry, writing in one note, "'the cone, the cylinder + the cube' Cézanne for Jean Eagels."[21] In other notes he marveled at the vivid memories of his youth that the film about Eagels had stimulated, and he compared his "so-called 'Jeanne Eagels' revelation" to the writings of Proust.[22] He observed the parallels between his rainbow collage and de Chirico's *Toys of the Prince*, the "finite and infinite," and "the golden child Jeanne."[23] He linked the rainbow theme of the Jeanne Eagels collage to the Christian Science interpretation of the biblical book of Revelation, citing Mrs. Eddy's description of the rainbow-clad angel as "Truth's prism and praise."[24] And he alluded to a recent dream or vision in which he believed he spotted Eagels in an elevator.[25]

Cornell also turned to the science of astronomy to honor the deceased Broadway star. He knew that a rainbow is a form of prism that divides sunlight into solar spectra, and, as seen in other boxes and items in his clipping files, he was well aware of the importance of spectral analysis in understanding the distance, composition, and evolution of stars. In a note in his Jeanne Eagels file, he mentioned the "Golden STARS spectrum," referring to charts in Zim and Baker's *Stars* that explained sunlight as a mixture of colors that can be seen when refracted through a prism or a raindrop (see fig. 5.21). He included the seven colors of the spectrum in the collage, while also reducing form to a cone, cylinder, and cube, *à la* Cézanne, positioned in vague space, *à la* de Chirico. In the foreground, he pasted charts illustrating the potential for infinite expansion of cubic numbers, taken from a children's book, Irving Adler's *The Giant Golden Book of Mathematics*.[26] In choosing these charts, he may have thought back to earlier scientists' spectral analysis of starlight, which identified the changing chemical structure of a star during the cooling process. However, he combined scientific knowledge with other metaphorical meanings of the Sun. Thus a rainbow could illustrate the spectra of visible starlight, while also functioning as a popular symbol of hope and a Christian Science image of Truth. On a more specific level, the collage could also be seen as an acknowledgment of Eagels's widely recognized finest hour, with its rainbow enabling her to take one last bow for her stage role in *Rain*.

SPACE ODYSSEYS

On February 26, 1965, Cornell's brother Robert died at the age of fifty-five. Despite the burden of care Robert's physical condition imposed on all of the members of his family, he was deeply loved. Cornell's diaries are full of notes about Robert's smile, his sense of humor, their shared interest in the birds and stars, and their Christian Science faith. Cornell's mother, with whom his relationship had become increasingly tense, had already left the house on Utopia Parkway in 1964 to be cared for by her daughter after a hip fracture, and with Robert's passing he found himself alone for virtually the first time. With his mother's death in October 1966, Cornell lost the last link to the immediate family circle that had determined his adult life until this point. He sought solace in his diaries and in his work, using both to assuage his loneliness. He enthusiastically followed new advances in the Space Race, clipping articles and making notes about satellites, orbiting space capsules, and humankind's triumphant first steps on the Moon. While these topics found their way into his art, he layered them with his own spiritual visions of celestial travel.

Cornell was interested in satellites, and in the early 1960s he produced two similar collages: *Observations of a Satellite I* and *Weather Satellites* (fig. 7.2). Both showed a hummingbird in a glass chamber, clipped from the cover of the January 1953 issue of *Scientific American*, and a shining icosahedron, a twenty-sided figure taken from *The Giant Golden Book of Mathematics*. Beneath a glass dome, the hummingbird tilts its beak toward the shining shape in the sky. Given the reference to satellites in the titles, it is likely that in both collages Cornell cross-indexed the advances in communication and weather satellite technology that marked the period between 1958 and the mid-1960s. In particular, he probably had in mind the first *TIROS* weather satellites that were launched from Cape Canaveral between 1960 and 1965. These pill-box-shaped satellites carried television cameras, initially transmitting murky pictures of cloud formations back to Earth. Their technology developed rapidly: *TIROS* 9, launched in 1965, produced a photo-mosaic of the entire Earth by blending 450 photographs shot over a twenty-four-hour period.[27]

After the dismal setbacks that plagued the Vanguard Projects of the 1950s, the successful launching of weather satellites was greeted with elation in the press. A writer in the *Christian Science Monitor* described the first *TIROS* satellite as "phenomenally successful," outlining future communications, navigations, reconnaissance, and early warning vehicles being designed by space planners, as well as "Project Ozma," the search for life on other worlds.[28] With NASA and the Pentagon launching satellites at a rate of two per month in the early 1960s—"scattering satellites into the sky like buckshot," as a writer in the *Monitor* put it—a new era in U.S. space technology had begun.[29] The humiliation of *Sputnik* was a thing of the past.

Weather satellites transmitted information to dish-shaped antennae, which in turn converted radio signals into photographs of clouds. In addition to publishing photographs of the satellites, newspapers and magazines printed photographs of the satellite dishes, dubbed "giant ears" (fig. 7.3). In one article that accompanied a photograph of an antenna, the author emphasized how rapidly the dish moved to pick up the whizzing satellite's signals, first gathering radio signals of pictures and then "listening" as the satellite "began chattering into the giant ear what it had learned about the way the earth absorbs and radiates the Sun's heat rays."[30] Cornell seems to have shared this anthropomorphic approach to technology in his collages. The hummingbird's spread wings and pointed beak form a shape oddly similar to the broad satellite dish with its pointed apparatus, and it is easy to imagine the bird "chattering" with the orb in the sky. Moreover, the highlights atop the glass container resemble the clouds in the dome of Earth's atmosphere that the *TIROS* satellites were photographing. In one of the collages, Cornell clipped the figure of the *infanta* from a reproduction of Diego Velasquez's seventeenth-century painting, *Las Meninas*, and positioned her below and in front of the hummingbird, where her square skirt and vertical bodice mimic the shape of the small buildings and towers that supported satellite dishes. Given Cornell's interest in celestial navigation by birds and his delight in whimsy, he no doubt enjoyed imagining birds planning their migration routes with the aid of weather satellite information.

Even more exciting than the launching of weather satellites were the manned space voyages of the 1960s, beginning on April 12, 1961, when Soviet cosmonaut Yuri Gagarin became the first human to orbit Earth from space. The U.S. program lagged behind, and it was not until February 20, 1962, that John Glenn orbited Earth. NASA's manned spaceflight program went into full swing with Project Gemini, whose first launch took place less than a month after the death of Cornell's brother. While earlier Project Mercury launches had succeeded in putting individuals in space on suborbital and orbital missions, the Gemini flights involved teams of astronauts accomplishing complicated tasks. In 1965 alone, five manned Gemini missions were completed, several of which involved complex capsule dockings and space walks. Like everyone within reach of a newspaper or television set during space flights, Cornell was fascinated by the achievements of the Gemini astronauts, American heroes whose courage and skills were applauded in newspapers, magazines, and on the nightly news. He saved articles about the missions, wrote astronauts' names in his notes, and made collages in which he reached beyond the facts of engineering technology so faithfully reported in the press to capture the wonder of journeying through the cosmos.[31]

Around 1966 Cornell produced a collage based directly on a specific Gemini mission (fig. 7.4), the dual launching and space rendezvous of *Gemini VI* and *VII* between December 4 and 18, 1965. Using one of the NASA photographs of

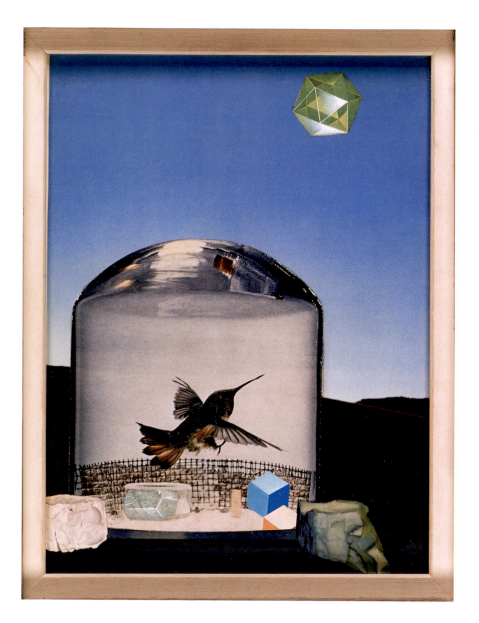

FIGURE 7.2.
Joseph Cornell, *Weather Satellites*, 1965.
Collage, 12 × 9 in.
Whitney Museum of American Art, New York; purchased with funds from The Lily Auchincloss Foundation, Richard Brown Baker, the John I. H. Baur Purchase Fund, the Felicia Meyer Marsh Purchase Fund, Mr. and Mrs. William A. Marsteller, and an anonymous donor, 82.23.

Gemini VII seen from *Gemini VI* that became iconic images of the mission, he added the incongruous element of a doll's head on the capsule's heat shield.[32] Perhaps initially inspired by the golden strands of trailing cables in the original photograph, he united them with the doll's blonde hair to create a strange fantasy of space travel. On the left he pasted a Chinese figure and other charts, while on the right he glued a portion of the same diagram of a solar eclipse he had used in his *Radar Astronomy* box, as well as a picture of blurred objects streaking through space.

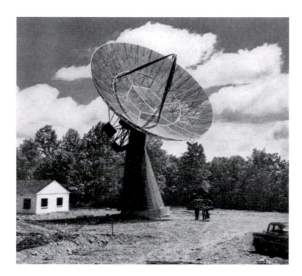

The launching of the *Gemini VI* and *VII* spacecraft were exciting triumphs for the U.S. space program. *Gemini VI* was originally scheduled for take-off in late October, with a rendezvous with an unmanned target vehicle. When the target launch failed, *Gemini VI* was technically renamed *Gemini VIa* and rescheduled for December, with a bold new plan: to rendezvous with another manned capsule already slated for launching, *Gemini VII*. *Gemini VII* went into space first, on December 4, 1965, with *Gemini VI* following on December 15. The two craft executed the first rendezvous in space, at one point coming within a foot of each other. Aboard *Gemini VII*, astronauts Frank Borman and James Lovell orbited Earth 206 times, setting a new record by remaining in space for nearly fourteen days. The success of the combined missions was an important signpost on the road to the Moon, demonstrating that vehicles could rendezvous in space and that humans could endure flights of long duration without harmful physical effects.

The newspapers were understandably full of details about the mission, including some that Cornell apparently turned to when making his collage. As reported in the *Times* on December 5, early in the flight of *Gemini VII*, Borman reported a "bogey"—pilot code for an unidentified aircraft—crossing in front of the spacecraft. A follow-up story on December 7 in the *Monitor* added that both Borman and Lovell reported seeing brightly lit particles pass by in what appeared to be a polar orbit, and that Borman told ground crews on Earth that something swung forward from the rear to hit the front of the capsule. According to the *Monitor's* staff correspondent, "Experts and laymen here at the Manned Spacecraft Center have been puzzling over these reports ever since they were received." Strange lights continued. On December 11, the *Times* reported that a large fireball that streaked across the sky the previous

FIGURE 7.3. "Sixty-foot Telescope of Harvard University," *Scientific American* 195 (October 1956): 64.

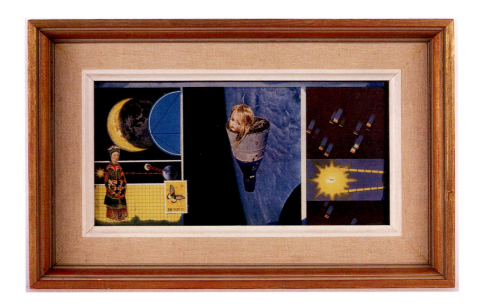

Figure 7.4.
Joseph Cornell, untitled,
c. 1966. Collage, 6¼ ×
12½ in. Photograph
courtesy of PaceWilden-
stein, New York.

night was probably a meteor, and that a shower of meteors was expected that day from the constellation Gemini. The next day, the *Times* shifted its focus to man-made light effects, explaining that *Gemini VII* had established the first space-to-ground contact by a laser beam.[33]

The realities of space exploration reported in the newspapers and the fantasies broadcast each week on *The Twilight Zone* were beginning to seem remarkably similar. In Cornell's collage, the doll's head at the back of the spacecraft, the streaks of light on the right, and the rays of light beaming to Earth on the left would have been readily recognizable at the time as allusions to the mysterious "bogey" and lit particles, as well as the meteors and laser beams reported in press accounts of the mission.[34] The positioning of a disembodied head on the exterior of the spacecraft would resonate with *The Twilight Zone* audience's fascination for gremlins on airplane wings and other creatures from outer space.

Other details in the collage also relate to stories published in the papers during the *Gemini VI* and *VII* mission. By far the most exciting event was the rendezvous of the two spacecraft, an accomplishment that boosted world opinion of the U.S. space program. In addition to praising its importance for future missions to the Moon, the American press placed the achievement firmly in the center of international cold war politics. In the *Times*, an article entitled "Castro Congratulations" summarized world opinion by quoting *Le Monde*: "For the first time since the first Soviet satellite was launched in 1957, the United States unambiguously has the edge over the Soviet Union." Emphasis was placed on the congratulations expressed by Communist countries, with

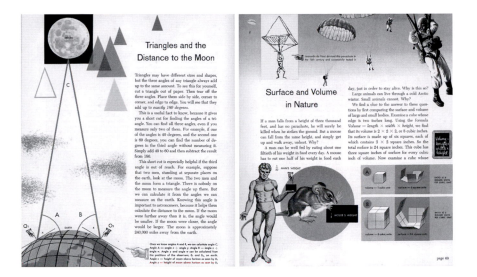

China conspicuous in its silence. Another article in the same issue of the *Times* focused directly on the Soviet Union and China and reported that although the Soviet Union gave unstinting praise to the United States for the Gemini rendezvous, "Chinese Reds ignore the feat."[35] On the left side of Cornell's collage, a Qing dynasty court lady stands on a special grid—the board used in the Chinese game of *weiqi* (better known in the West by its Japanese name, *go*). By including a Chinese figure from an earlier historical period and positioning it on a *weiqi* board with its "star point" dot, Cornell contrasted the isolationist Chinese with the forward progress of the United States, whose technological know-how was aimed at landing on the Moon.

Indeed, in the upper half of this panel, Cornell pasted a diagram of the Moon eclipsing the Sun and a bright blue half-circle eclipsing the Moon. Within the half-circle are three lines that form two congruent triangles. Cornell was very familiar with the use of triangles to calculate the distance to the Moon. Both Adler's *Mathematics, The Story of Numbers, Symbols, and Space* and *The Giant Golden Book of Mathematics* contained a page titled "Triangles and the Distance to the Moon," which Cornell knew well (fig. 7.5). Loose clippings from the page crop up in a variety of places in his papers. They also appear in his collages. One, for instance, features a doll against a sunset, with polygons, the Moon, and a drawing of a parachute designed by Leonardo, all clipped from *The Giant Golden Book of Mathematics* (fig. 7.6).[36] By demonstrating how triangles could measure the distance to the Moon in the Gemini capsule collage, he echoed the hope, voiced in many newspaper accounts, that the combined successes of *Gemini VI* and *VII* represented a huge advance for the U.S. program to land a man on the Moon.[37]

FIGURE 7.5. Joseph Cornell, *Triangles and the Distance to the Moon* and *Surface and Volume in Nature*, in Irving Adler, *The Giant Golden Book of Mathematics* (New York: Golden Press, 1960).

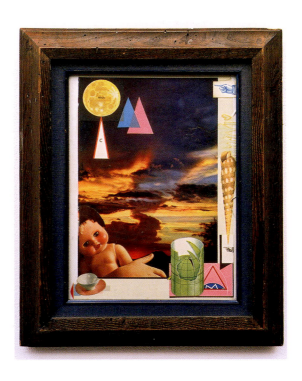

Although national pride was high in the United States after finally beat-ing the Soviet Union in one lap of the Space Race, on an international level attempts were made to put outer space exploration above quarrels between countries. This was especially true in the rarefied realm of postage stamp is-sues. As announced in the *Times* just days after the launch of *Gemini VII*, the Republic of Togo produced an unusual stamp honoring the epoch-making walks in space by Soviet cosmonaut Alexei Leonov, during the flight of *Vosk-hod II* in March 1965, and U.S. astronaut Edward White, during the flight of *Gemini IV* in July of that year.[38] The stamp pictured the men in their space-suits, along with rocket-tracking equipment. Given his fascination with outer space, it comes as no surprise that Cornell obtained several of these stamps and used them in collages.[39] And in 1971, when three Soviet cosmonauts died dur-ing their return to Earth, Cornell saved articles about the tragedy for his files and made a collage that he labeled on the back "6/30/71 // [Re-entry homage to the 3 Russ same day as news found dead . . .]."[40]

Cornell was not alone in turning to the space program for inspiration for works of art. Beginning in 1962, NASA began to commission works of art to chronicle the space program, in time amassing a collection that eventu-ally included cutting-edge works by Warhol, Rauschenberg, Annie Leibovitz, and Vija Celmins, as well as drawings and paintings by more traditional art-ists, such as Jamie Wyeth.[41] The impact of the space age could also be seen in

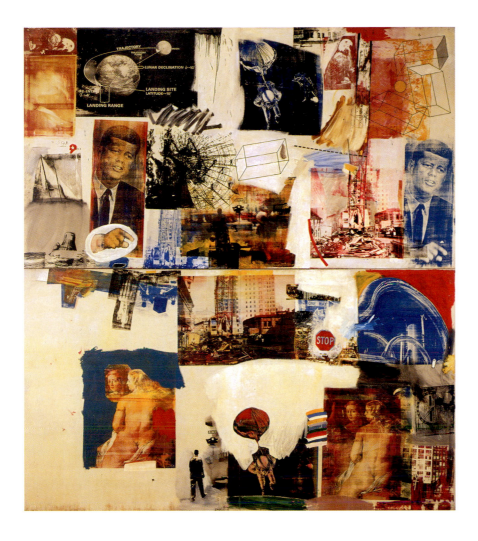

other avant-garde works. In 1964, for instance, Rauschenberg included photo-silkscreen images of an astronaut descending from a parachute, a space capsule bobbing in the sea, and a diagram of a lunar trajectory in *Skyway* (fig. 7.7), a large painting that hung on the façade of the U.S. pavilion at the 1964–65 New York World's Fair. Like Cornell, Rauschenberg combined references to the space program with other political and historical details, although he worked on a much larger scale and in a more assertive style. As Dorothy Kosinski has observed, in this painting Rauschenberg's repetition of elements engages notions of similarity and difference, asking the viewer to consider aspects of vision.[42] Cornell's work, however, functions on a different level, with didactic references to outer space functioning as conduits to visionary fantasies about space travel.

FIGURE 7.7. Robert Rauschenberg, *Skyway*, 1964. Oil and silkscreen on canvas, 216 × 192 in. Dallas Museum of Art, The Roberta Coke Camp Fund, The 500, Inc., Mr. and Mrs. Mark Shepherd Jr. and General Acquisitions Fund. Art © Robert Rauschenberg / Licensed by VAGA, NY.

Voyagers

In 1966, against the backdrop of that year's five successful Project Gemini launches, Cornell produced a collage entitled *Now, Voyager*. It included a photograph of a child riding a white horse with charts of the Sun and other celestial bodies in the background, along with postage stamps and other diagrams in the lower foreground (fig. 7.8). The theme of interplanetary flight is clear, with a progression moving from Earth-bound to celestial bodies. On the

lower right postage stamp, an elephant lifts its trunk toward a slightly higher butterfly stamp that leads to a still-higher bright yellow stamp at the left. Issued by the Republic of Togo, this yellow stamp commemorated the national airline, Air Togo, with flying machines reminiscent of Cornell's *View* magazine days: a hot-air balloon and a dirigible. From the flying machines we move further into outer space, to the Sun in the upper left corner. As if on a celestial carrousel, the child hovers in space, his bright buttons suggesting additional celestial bodies, and he seems poised, as if caught in the cross-hair mullions of a window through which he can be glimpsed. On the back of the collage, Cornell identified the horse as Pegasus by clipping a description of the constellation from Zim and Baker's *Stars* that describes its location between Cassiopeia and Andromeda. In the another version of the collage, now in the Art Institute of Chicago, he positioned the rider beneath the curved arc of the chart of the first four planets, as the horse appears ready to gallop past Mars to the far reaches of the cosmos.[43]

While Cornell's whimsical details suggest fantasies of childish delight, in his collage he also cross-indexed another scientific mission to explore outer space: the expedition of the unmanned spacecraft *Mariner IV*. On November 28, 1964, *Mariner IV* was launched from Cape Kennedy. The craft's 350-million-mile destination was Mars. On July 14, 1965, *Mariner IV* returned twenty-two television pictures of the surface of the planet before moving on to a huge orbit around the Sun. The nation was gripped with the excitement of seeing actual pictures of the planet's surface. Television programs focused on the spacecraft's findings and their implications. On the morning of July 12, *Lamp Unto My Feet* featured a dialogue between the *New York Times* science editor and church leaders discussing how theological views might be affected by present and future explorations of outer space, while that evening Charles Kuralt hosted *Mission to Mars: The Search for Life,* a preview of the July 14 encounter. On July 29 President Johnson conducted a news conference about *Mariner IV*, while that evening's episode of *The Munsters* was titled, "If a Martian Answers, Hang Up." The most detailed account of the mission, however, did not appear until the following year, in *Scientific American*. Cornell clipped and kept the article, entitled "The Voyage of Mariner IV."[44]

Cornell's title, *Now, Voyager,* was an appropriate choice. He appropriated it from Walt Whitman's two-line poem, "The Untold Want," written in 1871 and published in *Leaves of Grass*. On an undated diary note, he scrawled the full line, "'Now Voyager, sail thou forth to seek + find' W. Whitman."[45] A fitting directive for any explorer, it was especially suitable for the voyage of *Mariner IV*. As a writer in the *New York Times* put it, "Not since Galileo first trained his telescope on the Moon has there been such a prospect for a quantum leap in man's knowledge of a nearby world."[46] Echoing the actual path of the spacecraft, in both versions of *Now, Voyager* Cornell placed his celestial mariner within the vicinity of both Mars and the Sun, choosing appropriate

MARS circles our sky in just under two years as it revolves around the sun in some 687 days. It moves in an eccentric orbit; sometimes it is 35 million miles from us, sometimes 234 million miles. The positions best for observation occur every 15 or 17 years (August 1956 was last). On this reddish planet white polar caps, which may be snow on

Shrinkage of a Polar Cap (tilted toward earth) During a 3-Month Period

Mars with Its Two Satellites, Deimos and Phobos the surface with fog above it, enlarge in winter and shrink in summer. Then greenish-blue areas become more pronounced, in contrast to the large, reddish-brown areas, possibly due to iron rust. The atmosphere contains carbon dioxide and traces of water but no oxygen. Temperatures reach 50 degrees F. near the equator. The so-called canals are still objects of mystery. Great interest centers on the possibility of life on Mars. The planet's two moons are about 10 miles in diameter. The inner one revolves so fast that it rises and sets three times in a Martian day. [117]

FIGURE 7.9.
Mars, in Herbert S. Zim and Robert H. Baker, *Stars, A Guide to the Constellations, Sun, Moon, Planets, and Other Features of the Heavens* (New York: Golden Press), 1956.

diagrams from Zim and Baker's *Stars* to position the figure in space (fig. 7.9). The voyager has passed Deimos, the inner moon of Mars, on his way to the red planet.

In the collage, the Sun plays a prominent role, as, in fact, it did for *Mariner IV*, which was powered by solar energy panels and whose experiments included measuring low-energy protons that stream outward from the Sun as "solar wind."[47] Perhaps Cornell even made two similar versions of the collage to reflect details of the actual mission. Because of the uncertainties of such a difficult undertaking, NASA authorized two launchings of identical satellites, *Mariner III* and *Mariner IV*, to ensure a greater likelihood that at least one might make it to Mars. It was a wise plan. *Mariner III* failed when the launch vehicle's tip did not open to release the spacecraft. *Mariner IV*, however, was a remarkable achievement, bringing humankind closer than ever before to the far reaches of space.

While it seems quite likely that Cornell envisioned his Voyagers as public embodiments of the *Mariner IV* spacecraft, aspects of the collages also suggest private meanings embedded in them. In a diary note written in 1968, Cornell mentioned "R's horse toy collage," and, a few lines later, he related it to Robert Schumann's piano suite, *Kinderscenen*, specifically mentioning the piece, "Knight of the Rocking Horse."[48] While it is not entirely clear which collage Cornell may have had in mind—there are several late collages with schematic horses in them—in *Now, Voyager* he may have cross-indexed Whitman's poem, Schumann's piano suite, and interplanetary travel to construct a visionary portrait for his recently departed brother Robert, whose own immobility was sadly underscored by his lifelong fascination with moving toy trains, but whose death at last offered him the opportunity to voyage among the stars forever.

At the bottom of the stamp version of the collage, Cornell pasted a figure 8, clipped from a page in *The Giant Golden Book of Mathematics*, with the

heading, "Finite and Infinite." He also completed the blue circle begun by the cancellation mark on the Air Togo stamp, and he drew another undated blue circle to frank the butterfly one. Lacking a beginning or an end, each of these shapes symbolizes infinity. While reflecting Cornell's Christian Science belief in the endlessness of life after death, the emphasis on the infinite also resonated with current issues in astronomy. In the mid-1960s astronomers used the 200-inch telescope on Mount Palomar to study celestial objects so distant they seemed to lie close to the beginning of time: extremely remote quasars, a class of astronomical objects that emit enormous amounts of energy in light and radio waves. Cornell clipped an article summarizing the research from the *Times*, circling the title: "Is the Universe Eternal? A New Clue."[49] Typical of his process of cross-indexing, he worked scientific debates like this one into the framework of his Christian Science beliefs. In the margin of another article from the *Times*, he penned: "SPACE IS NOT OBSTACLE TO THE MIND' S+H."[50]

Robert's death inspired Cornell's use of the term "Eterniday," found heading a diary entry on March 19, 1965, when he sat in the Dixon cafeteria and wrote: "in Dixon now, Robert, + I think you may <u>very well</u> be here right now—cold light on the building across the St. Hotel Dixie why am I telling you when you can <u>see</u> it better than I can."[51] An undated scribble noted "'eternity' vs. time," while another note marked "astronaut file" recorded, "In Greek Psyche is the common name for the soul + the butterfly."[52] Cornell's use of geometric shapes to symbolize infinity fit neatly with his general interest in mathematics; however, it also corresponded to ways that Christian Scientists used the language of mathematics to popularize notions of infinite life. Take, for example, "Metric Geometrics," a poem that Cornell clipped from the *Monitor*:

> *Take this straight line—*
> *Bend it, curve it,*
> *It becomes infinity.*
> *Sweeping curves,*
> *bending circles,*
> *This is a lifetime.*
> *Who can say*
> *Where lifetime ends*
> *And joins forever?*
> *Perhaps when lines*
> *Come to never-ends.*
> *Full circling.*[53]

The "full circling" on Cornell's Voyager collage suggests planetary orbits, stamps marked "to go," constellations wheeling across the sky in their circular paths, and the Christian Scientist soul's "never-ends."

219

STAR-CROSSED LOVE

For Cornell, the 1950s had been a period of public exhibition of accessible works that touched on popular interest in scientific themes and that led to considerable fame for the artist. By contrast, the 1960s were years of personal erotic exploration. In 1964 he befriended performance artist Carolee Schneeman, whose seminude "Happening," *Meat Joy*, was performed at the Judson Memorial Church in that year, and he owned a set of nude photographs of her.[54] In 1964 he also met another young performance artist, twenty-four-year-old Yayoi Kusama, known for sculpted genitalia and other body art, as well as for her polka dot "infinity nets," designed to capture the endless time and absoluteness of space, and he embarked on a brief sexual relationship with her.[55]

In the same year he renewed his acquaintance with Joyce Hunter, a teen-aged waitress with whom he had become involved in early 1962, in what was probably Cornell's first real-life romance. He had given her love tokens and even a kiss before she dropped out of his life in October 1962.[56] From that point on, Joyce assumed mythic proportions in his imagination, and he devoted collages to her, using the nickname "Tina" in place of her real name and relating her to the constellation Cassiopeia.[57] He wrote unsent notes to her and placed them in his paperback copies of I. Bernard Cohen's *The Birth of a New Physics* and Arthur Koestler's biography of Kepler, *The Watershed*.[58] And, as in his memorials to Marilyn Monroe and Jeanne Eagels, he devised celestial metaphors for her.

Between 1962 and 1964 he produced a series of "Penny Arcade" collages in remembrance of their magical, if fleeting, moments together. Diary notes indicate that pivotal points in Cornell's perception of the budding romance occurred on Lincoln's birthday and Valentine's Day in 1962.[59] He honored these holidays in his collages by combining newly minted Lincoln pennies and pictures of Cupid. In *"Penny Arcade" series re Autumnal* (fig. 7.10), he placed them together with charts clipped from Zim and Baker's *Stars*. One in the center features the constellation Aquarius, the zodiac sign coinciding with Lincoln's birthday and Valentine's Day. The other chart, at the top of the collage, shows constellations in two yellow, eyeglasses-shaped ovals, reminiscent of the binocular view on the back of his earlier Cassiopeia box. Perhaps as a testament to the longevity of his affections, this chart illustrates the movement of the Pole Star over time: on the left is its location in 1952, on the right is its projected position in the year 14,000.[60]

As in many of the collages from the last decade of his life, in *"Penny Arcade" series re-Autumnal* he combined references to the stars with geometric diagrams, perhaps to allude to the spatial complexities of recent findings in astrophysics. On one hand, he offered a schematic cube at the lower right corner, an example of projective geometry used since the Renaissance to indicate

three-dimensional space on a two-dimensional surface; on the other, he introduced a more complex spatial system in the diagram to its left, a star-shaped system of triangles with the ever-shifting planes of spherical space, clipped from Adler's *The Giant Golden Book of Mathematics*. In the upper right he pasted a diagram of the dodecahedral skeleton of a tiny sea animal called a radiolarian, illustrated in the "Mathematics in Nature" section of both of Adler's books. In turn, it recalled the increasingly multisided Platonic solids Kepler assigned to the planets in his conception of the solar system. Adler illustrated

FIGURE 7.10.
Joseph Cornell, *"Penny Arcade" series, re Autumnal*, October 14, 15, 1964. Collage, 11½ × 8½ in. The Dicke Collection.

221

Kepler's theory in *The Giant Golden Book of Mathematics*, where the author also explained that in the Pythagorean system the dodecahedron was the symbol of the universe as a whole.[61]

In autumn of 1964 Hunter reappeared in Cornell's life. After he refused to give her money, she stole several box constructions from his unlocked garage. Alerted by a dealer that she was trying to fence them, he filed charges and she was arrested, although he subsequently posted bond and refused to testify in court, enabling her to go free. He sent her money and saw himself as her protector, but in the end neither his dollars nor his love could save her. She was murdered by an acquaintance on December 18, 1964. Cornell deeply mourned her death. He paid for her burial and even asked detectives to locate her three-year-old ill daughter, Sharon, although their efforts were unsuccessful.[62] He found solace in a Valentine's Day 1965 afternoon of "healing of grief about precious Joyce."[63]

Cornell embarked on a series of collages portraying Cassiopeia as an allegorical nude figure. Using a detail from a reproduction of Dosso Dossi's painting, *Circe and her Lovers*, he cast Circe, the daughter of the Sun turned enchantress, in the role of Cassiopeia. With her upraised arm, Dosso's Circe was an apt model for Cornell's Cassiopeia, who typically assumes this pose. Moreover, her companions could play parts as constellations: two dogs at the right could be embodiments of Canis Major and Minor; the birds in the upper corners could stand in for Noctua, the Owl, and Aquila, the Eagle. At Circe/Cassiopeia's feet lies an open book with a geometrical diagram. In some versions he used pictures of the Sun and Moon and polygons clipped from Adler's book about mathematics; in others he pasted the constellation Cassiopeia from Zim and Baker's *Stars*. On the back of one done in 1966 (fig. 7.11), he added an illustration of Tycho's Nova of 1572, clipped from Zim and Baker's explanation of variable stars (see fig. 5.21), and he affixed the caption for the illustration, "Nova of 1572 in Cassiopeia," below his name, allowing it to double as a caption for the star chart and for his own signature.[64] On one level, Joyce-Tina-Cassiopeia represented that impossibly bright star for Cornell, and for the rest of his life he celebrated their union in his notes and in his art.[65] On another level, the always-present constellation Cassiopeia represented a kind of mathematical constancy, in turn a symbol of the constancy of spirit over matter.

EROS IN THE AGE OF AQUARIUS

The 1960s were important not only as years of scientific exploration of outer space but also as a period of intense social upheaval. In addition to protests against the war in Vietnam and the struggle for civil rights, which Cornell chronicled with clippings in his files, the decade was marked by increasing emphasis on sexual liberation. As *Playboy* was sold on public newsstands, the

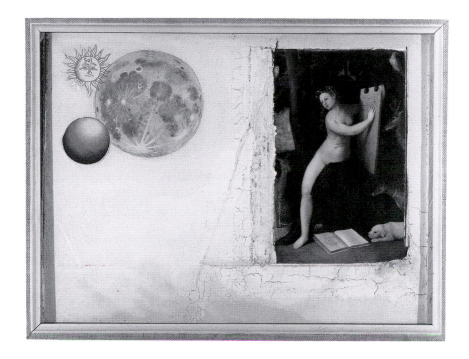

FIGURE 7.11.
Joseph Cornell, *Rapport de Contreras (Circe)*, 1966. Collage, 9 × 11 × ¹³/₁₆ in. Hirshhorn Museum and Sculpture Garden, Smithsonian Institution, Gift of Joseph H. Hirshhorn, 1972. Photo: Lee Stalsworth.

slogan "make love not war" made its way onto bumper stickers, and the musical *Hair* opened in 1968 with its infamous nude scene, Cornell turned to nude female bodies as elements for his celestial collages, in the process exploring, as he put it, the "quixoddities of Eros."[66]

By eroticizing the stars, Cornell sought to transform the real into the ideal, drawing upon the 1960s' ethos of sexual liberation to metamorphose not only anonymous sexy nudes but also actual individuals into traditional constellations. He repeatedly attempted to justify his interest in nudes as an innocent depiction of the glories of nature and eternal beauty. In his Marilyn Monroe dossier, he included a handwritten page, entitled "In the Sunlight." Written while sitting on a sidewalk bench a little over a week after Monroe's death, the note included a passage copied from George Ferguson's *Signs and Symbols in Christian Art*: "the difference between these 2 types of nudity might be explained as the quest for Eternal Bliss as opposed to the pursuit of Transient Bliss." A margin note added, "Nudites virtualis vs. N. Criminalis."[67] In 1970 he penned a rambling diary note about "nature returning in naked girl in 'nature's own array' sensual seeming but mystically more the wonder alone something sublime still exuding love + wistful pleasure—just such a thought like this who knows how deep and then the gift of stars in the evening sky."[68] Influenced by reading Irwin Panofsky's *Studies in Iconology* in the Flushing Public Library, Cornell drew a sharper distinction between the "sensual seeming" and the "mystically more," noting, "In Titian's 'Sacred + Profane Love',

OPPOSITE PAGE:
FIGURE 7.12.
Joseph Cornell, untitled,
c. 1970–71. Collage, 12 × 9
in. Smithsonian American
Art Museum, Gift of The
Joseph and Robert Cornell
Memorial Foundation.

the nakedness of 'Felicità Eterna' (Ficino's <u>Venere Celeste</u> or Eternal beauty) denotes her contempt for perishable Earthly things. The handsome + costly dress of 'F. Breva' (Ficino's <u>Venere Vulgare</u> or evanescent beauty) is emblematic of the ephemerality of mundane things."[69]

Perhaps it was his reading of Panofsky and his understanding of the role of the nude as a traditional image of spiritual purity in the history of art that led him to clip two nudes from a reproduction of the central panel of Hans Memling's *Last Judgment* and position them in the heavens. He may have envisioned them as sacred counterparts to Andromeda and Custos Messium—at the very least he positioned them together with star charts for Andromeda's rescuer, Perseus, and the constellations Aries and Triangulum, along an axis and on angled coordinates of carefully drawn pencil lines (fig. 7.12). Selecting from among the "saved" in Memling's *Last Judgment*, Cornell introduced a celestial double entendre, since the constellations to which the figures allude also participate in a mythological narrative about saving and being saved. By choosing nudes whose nakedness is sanctioned by the spotlessness of their souls, he could rise above the earthly desire such naked bodies could arouse by placing them among the eternal, transcendent, heavenly stars.

However, Cornell also cut and pasted overtly sexy nudes, making collages that straddled an adult divide between the pure and the pornographic. Back in the mid-1950s, Andromeda had appeared to him in the topless figure of Jackie Lane, viewed bare-backed from behind as a terrestrial embodiment of Hevelius's version of the constellation (see fig. 5.17), although the Jackie Lane allusion was limited to private notes in his source files. In the mid-1960s Cornell grew bolder, using this same Jackie Lane/Andromeda photograph for a constellation collage (fig. 7.13). With Aquila, the Eagle, Delphinius, the Dolphin, and Sagitta, the Arrow, above her in the sky, Andromeda hovers over a celestial blue winter landscape. Perhaps acknowledging the dangers to which her seminudity could lead, he paired her with a bare-legged boy holding a staff reminiscent of Custos Messium, the ever-constant guardian that he had also placed in his custodian boxes for Marilyn Monroe.

In addition to Cornell's fascination for chaste images of pubescent nude girls, during the 1960s and early 1970s the adult female erotic body frequently played a part in his celestial visions as a heated counterpart to the dry visual language of astronomy. For instance, another Jackie Lane collage is entitled *A Rainbow Is a Spectrum* (fig. 7.14). With a photograph of the film star emerging from a desert landscape and set against the backdrop of a rainbow-filled sky, the clipping from Zim and Baker's *Stars* illustrating the refraction of solar light in a raindrop seems strangely at odds with the sensual nude. The combination of an astronomy chart with a "girlie" picture points to a desire on Cornell's part to reconcile the visual representation of the nude female form— traditionally legitimized by art—with the schematic body typical of the shorthand language of scientific representation. With two different kinds of signs,

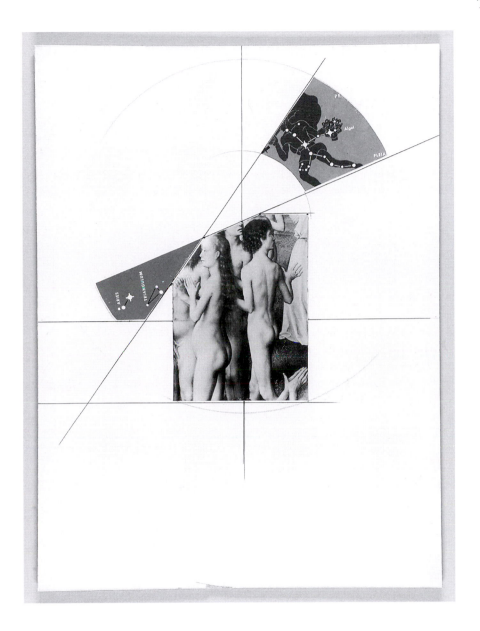

the collage bridges the gap between science and art, between mind and body, between the didactic and the erotic.

In late collages, Cornell applied this same approach to embodiments of the constellations. In one collage he pasted a photograph of a nude woman against a rough rock, positioning her beside the prow of a ship with hanging chains and above a star chart (fig. 7.15). Once again he presented Andromeda, now chained to the rock, with the shadow in the background assuming the shape

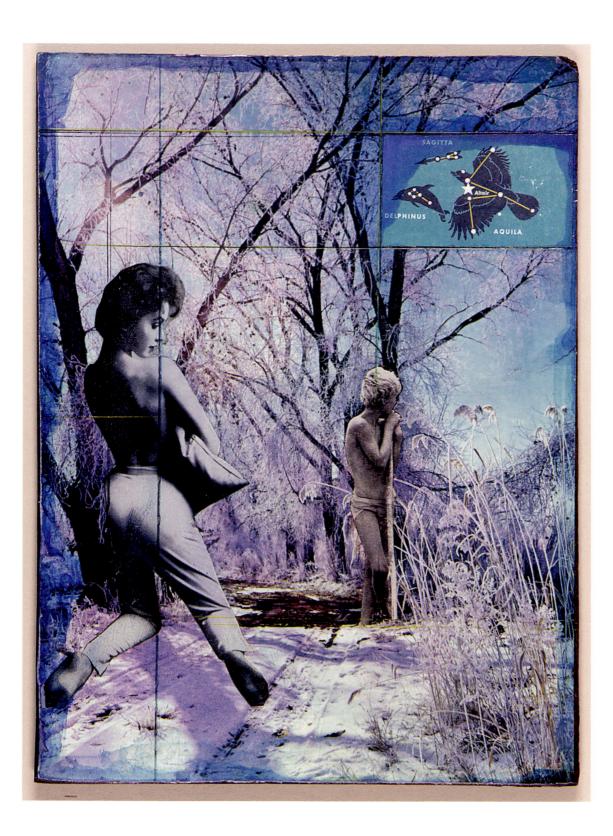

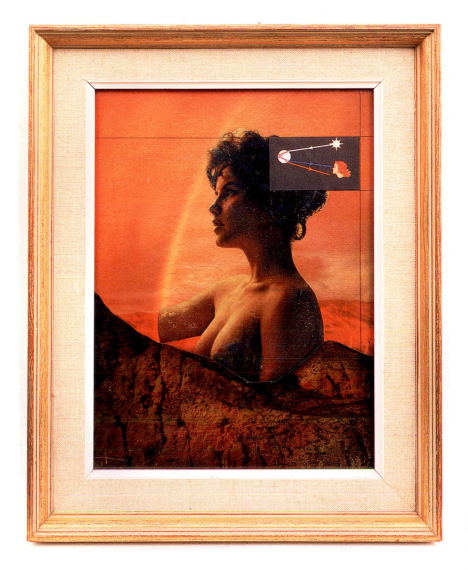

of the menacing sea monster. Her eventual fate as a constellation is presaged with the star configuration that appears in place of her lower body, where a connect-the-dots version of the constellation Hercules traces an hour-glass shape—providing a schematized shapely body for the one she lacks. From his early study of the constellation charts in Flammarion's *Les Etoiles*, Cornell knew that in seventeenth-century star atlases Andromeda was traditionally shown topless and enchained (fig. 7.16), and in some respects he was simply updating her image by using a realistic photograph in place of the idealized drawing.[70] But with that realism comes a sexual charge bordering on the kinky that was not lost on the artist: he positioned the personification of Hercules so

OPPOSITE PAGE:
FIGURE 7.13.
Joseph Cornell, untitled, c. 1964. Joseph Cornell, untitled, c. 1964. Collage on envelope labeled "Jackie Lane Cinema," 14 × 8 in. Smithsonian American Art Museum, Gift of The Joseph and Robert Cornell Memorial Foundation.

FIGURE 7.14.
Joseph Cornell, *A Rainbow Is a Spectrum*, c. 1964. Collage, 11½ × 8½ in. Photograph courtesy of PaceWildenstein, New York.

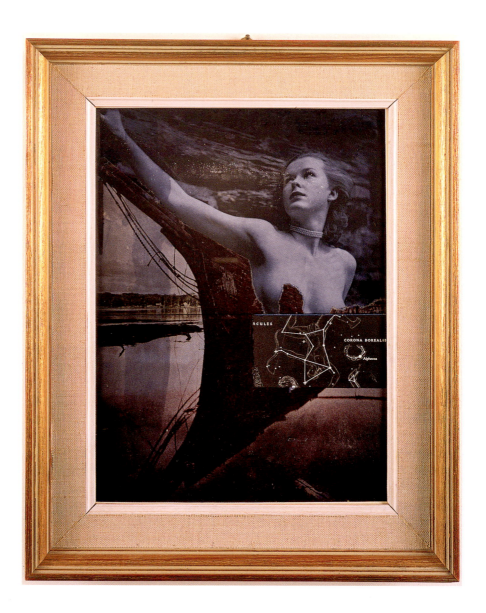

that his legs are spread open just below Andromeda's breasts, one of which has been roughly torn, leaving a phallus-shaped void.

In these collages Cornell repeatedly combined decidedly different visual images of the sensual body and the calculating mind to chart the starry sky. After a lifetime spent idealizing unattainable women—ballerinas, princesses, fairies, and stars of the silver screen—his willingness to make the eroticized female body an overt part of his work comes as something of a surprise. By the 1960s, however, he had developed a few tentative relationships with young women, although they invariably led to emotionally painful conclusions. Some

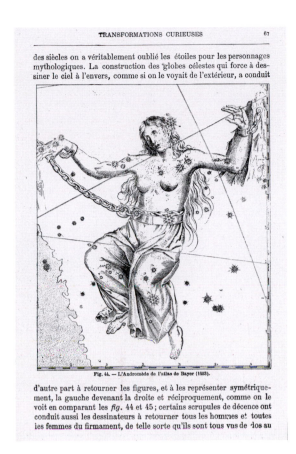

des siècles on a véritablement oublié les étoiles pour les personnages mythologiques. La construction des globes célestes qui force à dessiner le ciel à l'envers, comme si on le voyait de l'extérieur, a conduit

Fig. 44. — L'Andromède de l'atlas de Bayer (1603).

d'autre part à retourner les figures, et à les représenter symétriquement, la gauche devenant la droite et réciproquement, comme on le voit en comparant les *fig.* 44 et 45 ; certains scrupules de décence ont conduit aussi les dessinateurs à retourner tous les hommes et toutes les femmes du firmament, de telle sorte qu'ils sont tous vus de dos au

of these had erotic components, although apparently none was fully consummated.[71] In the early 1960s, Cornell's home situation, which involved caring for his mother, now in her eighties, as well as Robert, was not conducive to dating relationships with women. After his mother moved to Westhampton in 1964 and with Robert's death in 1965, Cornell may have finally felt free to acknowledge his own libido. Scholars have consistently interpreted collages like these as evidence of an easing of the sexual repression that characterized Cornell's adult life, and on an important level they are. At the same time, they should be viewed in the larger context of the 1960s.

Cornell was not alone in his willingness to dabble in erotica in the 1960s. As the "Age of Aquarius" announced a sexual revolution that challenged traditional values, Cornell was clearly aware of changing attitudes about sex, and he clipped a variety of articles that explored the topic. Some chronicled the lifestyles of hippies and runaways, while others discussed religious and ethical dimensions of sexual freedom.[72] A few, including several columns written by Dr. Joyce Brothers, discussed such subjects as homosexuality, impotence, and

FIGURE 7.16.
L'Andromède de l'atlas de Bayer (1603), in Camille Flammarion, *Les Etoiles* (Paris: C. Marpon et E. Flammarion, 1882).

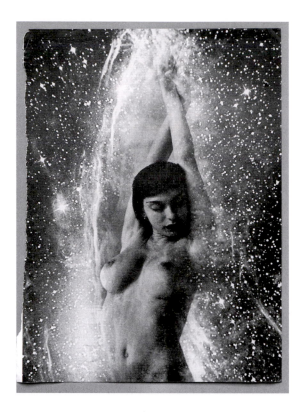

Figure 7.17.
Untitled nude, unidentified
magazine source. Joseph
Cornell Study Center,
Smithsonian American Art
Museum. Mark Gulezian/
Quicksilver Photographers.

celibacy.[73] Visual material in his clipping files also reflects the era's emphatic
liberation, and, from the late 1950s on, he saved magazine photographs of
nude women, especially "art photos" of women swimming or on the beach.
Illustrating how clearly Cornell's vision of *astronomia erotica* fit the context
of the times, a photograph of a nude posing against a star-filled sky also found
its way into his files (fig. 7.17).

Curves in Space

Freed by the liberated climate of the times and by his own erotic experiences,
Cornell continued to use clippings of nude women to embody constellations.
In a late collage, *Constellations of Spring / The Model* (fig. 7.18), he positioned
a magazine clipping of a nude woman standing in water, with a chart showing
a portion of Boötes at the upper right and, at the lower right, a yellow triangle
with a line leading to a point above it as a schematic representation of Leo.
Given these coordinates, the nude must be Virgo, the Virgin, whose chastity is
menaced by the sharp point of a spiral shell, perhaps meant to evoke one of the
spiral nebulae in Virgo described in the page devoted to her in Zim and Baker's

230

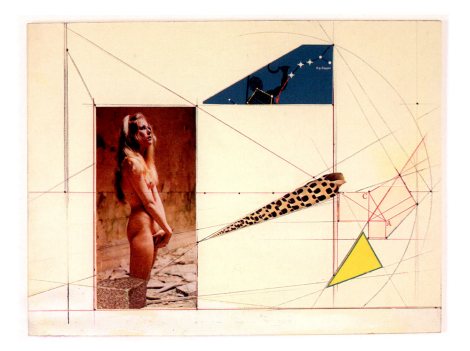

FIGURE 7.18.
Joseph Cornell, *Constellations of Spring / The Model*, May 3, 1970.
Collage, 9$\frac{1}{16}$ × 12 in.
Smithsonian American Art Museum, Gift of the Joseph and Robert Cornell Memorial Foundation.

Stars. A complex linear pattern of triangles and rectangles further locks the figure in a mathematically inflected space.

While the atmosphere of free love and sexual liberation that characterized the 1960s had a profound effect on Cornell's life and work during his final decade, his long-standing commitment to the past and present science of astronomy continued to influence his art. As manned space flight became a reality, writers in the popular press sought ways to explain how small moving objects could navigate their way through outer space with astonishing accuracy, to orbit and even land on the Moon. In the past, astronomers had been concerned with mapping the heavens, and figures like Tycho assumed towering importance because of their painstaking pin-point plotting of the locations of the stars. As seen in many of the star charts Cornell used in his collages, the positions of a planet or star was noted as a single point on a flat grid, regardless of its actual distance from Earth. But to explain the concept of the curvature of space, new systems of notation were needed, and, in place of points on a grid, complex non-Euclidean geometries visualized Einstein's ideas. In popular magazines like *Scientific American*, diagrams of the gravitational curvature of space-time pointed out the limitations of earlier star charts for conceptualizing the universe.

Cornell had his own way of visualizing the curvature of space: shapely nude figures positioned with old-fashioned star charts and a variety of geometrical shapes. He often fixed these nudes within an armature of clipped or

drawn polygons, grounding their bodies inside an abstract visual language for describing forms in space. But in *Constellations of Spring / The Model* and the untitled collage with nudes from Memling's *Last Judgment*, he drew his own diagrams over the figures, replacing the rectangular grids he superimposed over constellation figures in his Night Sky boxes with more elaborate geometrical diagrams.

Cornell's interest in mathematics was long-standing, and among his papers are references to Euclid and Descartes that date from the early days of his career. However, beginning in the mid-1950s, and especially in the 1960s, he became increasingly interested in the history of geometry, as well as current applications of geometry to astronomy. In his files he kept a *Scientific American* article by Morris Kline published in 1955 on the topic of "projective geometry."[74] Kline described how Renaissance painters had created projective geometry to represent three-dimensional reality, and how it had recently transcended Euclidean geometry to form an integral part of physics. He summarized the theories of seventeenth-century mathematicians Gérard Desargues and Blaise Pascal and the relevance of these theories to projective geometry, illustrating his overview with diagrams of their theorems.

By the mid-1960s, mathematics was a topic of increasing interest, as demonstrated by a special issue of *Scientific American* devoted to "Mathematics in the Modern World" that appeared on newsstands in September 1964. The cover featured a detail of a painting by Magritte showing clouds reflected on and seen through a French window, symbolizing, according to an editorial note, "that aspect of mathematics which makes outrageous new assumptions to erect new mathematical systems."[75] In an article chronicling developments in the history of geometry, Kline again discussed projective geometry, and once more he illustrated Desargues's theorem (fig. 7.19), together with diagrams of non-Euclidean concepts and even a photograph of a soap bubble that illustrated an aspect of differential geometry. Other articles in the issue emphasized the importance of mathematics in the history of astronomy, as well as its role in current astrophysical and atomic research.[76] Even though Cornell did not retain a copy of it for his papers, it would be hard to imagine him missing this issue of *Scientific American*, with its pictures ranging from Magritte's window to Kepler's model of the solar system and modern diagrams of the curvature of space. Indeed, Cornell's awareness of the complex diagrams of theorems derived by Desargues and Pascal reproduced in both of Kline's articles may explain the linear patterns the artist superimposed on the pasted materials in his late collages with nude figures, especially *Constellations of Spring / The Model* and the untitled collage with figures from Memling's *Last Judgment*. While neither linear design specifically copies one of Desargues's or Pascal's theorems, the lines Cornell drew on both collages convey the look of these complex systems of denoting three-dimensional

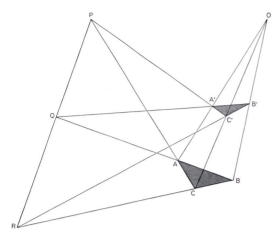

DESARGUES'S THEOREM illustrates the concern of projective geometry with properties common to a figure and its sections. The theorem states that any pair of corresponding sides of a triangle (*ABC*) and a section (*color*) will meet in a point—as, for example, the sides *BC* and *B'C'* meet in point *R*—and that the three points *P*, *Q* and *R* will lie on a line.

space. By introducing a note of cool, impersonal mathematical rationality alongside his hot-house nudes, he could keep the sensual bodies in their place, as part of a larger plan.

Cornell's inclusion of abstract diagrams in his art suited the spirit of the times. Abstract artists who were contemporaries of Cornell's boasted that they had adopted an analytic attitude to nature that resulted in a "pure" union of art and sculpture. In a *Christian Science Monitor* article that Cornell saved entitled "Science and art: a new relationship," the author, British artist Victor Pasmore, observed that recent scientific discoveries had changed people's picture of nature. Pasmore concluded that in this scientific age art needed to go beyond the sensual: "by itself sensibility is not enough; it must coordinate with the workings of the mind if form is to be achieved. It is the mind which provides the structure and organization."[77] This could best be achieved, according to Pasmore, through completely abstract works. Cornell clearly did not share Pasmore's commitment to abstraction. Having devoted himself to an art based on actual or represented things since the beginning of his career, his approach had been to engage the mind through things, like marbles and shells, and the interconnected ideas they might evoke, as well as through scientific sign systems that could easily be decoded, like constellation charts. Working in collage near the end of his life, he introduced an additional element—the eroticized female body—as a counterpart to the sterile language of science. In so doing, he privileged the heated "sensibility" that "cool" 1960s' artists denied, by literally humanizing abstract concepts of physical science and mathematics.

FIGURE 7.19.
Desargues's Theorem, in Morris Kline, "Geometry," *Scientific American* 211 (September 1965): 64.

233

FINITE AND INFINITE

While Cornell toyed with titillating celestial bodies in his collages, he did not abandon the deeper meanings that the stars and the cosmos held for him throughout his life. The dream of human flight had intrigued him since the days of his postwar *Celestial Theater* project and the amazing achievements of the U.S. and Soviet space programs during the 1960s enabled humans to look at the stars with wonder, instead of dread. As satellites, then space capsules and Moon rockets pioneered a new era of celestial navigation, Cornell combined the public realities of space exploration with his own visions of cosmic journeys.

In early 1966 he honored his brother with an unlikely memorial: an exhibition of Robert's childlike collages, along with a few of his own and some they did jointly, at Robert Schoelkopf's New York gallery. Now Cornell's collages increasingly conveyed the theme of longing for release from the bonds of life and the promise of spiritual voyage. In 1967 he composed an unsent letter to Robert, writing "in gratitude for the TRUTH of C.S. I pen again—and grateful for the never-ending 'sign' of nature—in the bright gold of a crescent Moon + a star in the clear deep blue of night after Sunset."[78] Later in that year he recorded a "'half-way' dream" about looking through a "greatly-elongated telescope," with its "exquisite clarity at the end of the sky and level of distant horizon." In his dream, he tried to persuade his mother "to look through the telescope—equivalent of getting her to yield to the healing truths of C.S."[79] As so often the case in his work, in this dream-vision astronomy provides a metaphoric link between earthly existence and a higher reality.

Earth, he staunchly believed, was merely a hotel for a temporary pause on that much larger voyage of eternal life that his mother and brother had already begun, "a stage on life's pathway, this way-station to eternity," as he put it in a note in 1971.[80] In space age terms, life was merely the countdown to the great experience of God's infinite Love. Such metaphors were popular ones in Christian Science parlance. Is it any wonder Cornell saved an article from the *Monitor* entitled "Man's Orbit of Perfection" that opens:

> The scene was a rocket-launching base. A huge rocket was about to be fired into space, and mounted at its nose was a device containing intricate scientific instruments. Suddenly the firing command was given, and seconds later, with a great burst of flame, the rocket began its ascent. Up, up, up, it roared, trailing a jet of fire in the night sky.
>
> Higher and higher the rocket climbed. Then, at a predetermined height and speed, the device with the instrument was projected by the rocket into an orbit around the earth below. There, held in balance between its own centrifugal force and the pull of gravity, the device became an earth

satellite, circling around the earth effortlessly and continuously at a speed of thousands of miles an hour.

Is there a spiritual orbit, in which mankind experiences well-being? That such an orbit exists and is possible of one's attainment is the affirmation of Christian Science. This Science, which is confirmed by the Scriptures, declares that the real man, God's image and likeness, exists in a perpetual orbit of perfection, of which God is the center and circumference.[81]

Images of longing to attain "a perpetual orbit of perfection" appear in Cornell's late collages, for instance in an untitled work in which a Sevres porcelain figure, seen from behind, looks past the nearby tree branches to a clear heaven beyond (fig. 7.20).[82] A nearly complete circle begins with her hands, encompassing a white dove that carries a star in its beak. Below the figure is a line of stenciled numbers; the same numbers appear at the top of the panel. While these mechanically produced numerals impart the feel of a Jasper Johns painting to Cornell's work, the visionary quality could not be farther from Johns's aesthetic. Purity and perfection are Cornell's themes, and, while the Sevres figurine and white doves wait for the circle to be completed, numbers are signs of God's divine permanence. As another article Cornell clipped from the *Monitor* put it:

When a mathematician applies the principle of continuity, he does not wonder whether it will still be available and work. He knows that it is the nature of mathematical principle to always be at hand; that it can be applied by him as well as by anybody else who knows how to use it; that it can be used anywhere and will never wear out. He also knows that this principle never was created but has always existed and always will exist completely aside from material conditions. These fundamental facts illustrate the truth of divine Principle, which rules all reality and keeps the spiritual universe in a state of harmony and perfection.[83]

Like the cosmos, mathematics was a symbol for God's infinite presence and the eternity of the spirit—concepts that Cornell alluded to in his late collages, as well as in his notes. In 1969 he drew a circular diagram, cut part of it away, and scrawled beside it: "'Geometry' God Robert."[84]

On July 16, 1969, a human stepped onto the Moon. Cornell followed the Apollo program with interest, clipping articles and penning notes about it. Of course, the Moon had been a focus of attention for him since his first soap bubble set, and he continued to make Moon boxes for most of his career, but during the late 1960s he also began a group of collages, referred to in notes as the "SUN (MOON)" series and "Moon collages." While it is not clear exactly which works belong under these headings, it is likely that included among them is an untitled collage that incorporates a picture of a golden sphere and

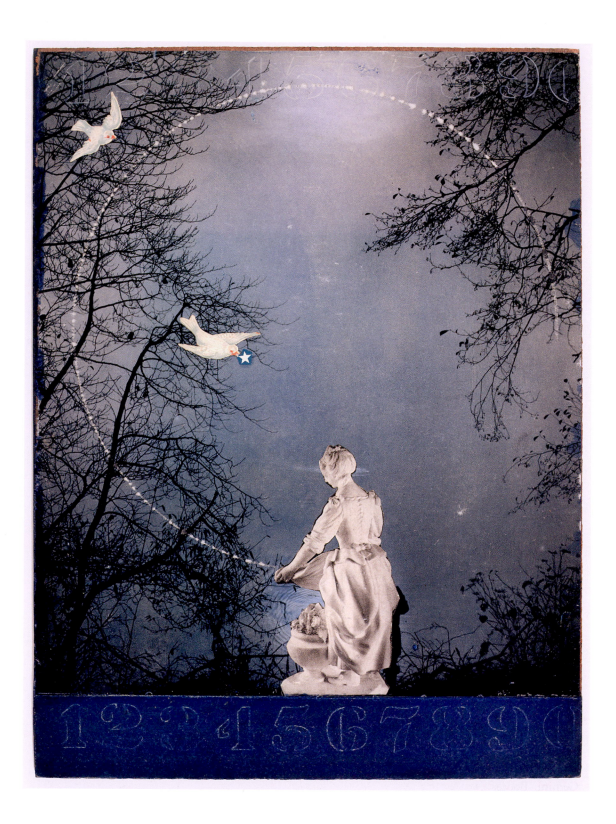

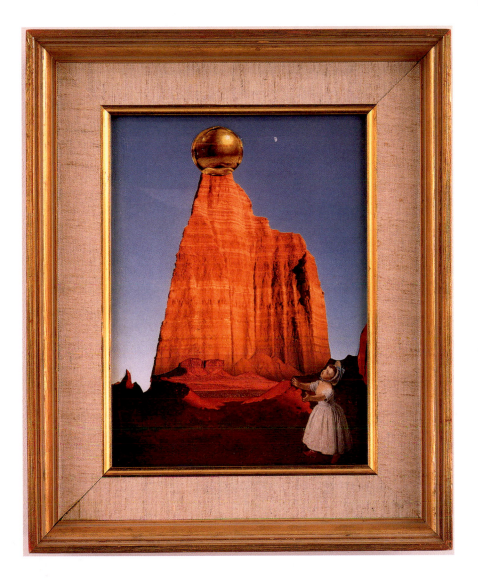

a distant Moon in a glowing *Arizona Highways* landscape (fig. 7.21). In the foreground a child stretches her arms toward a shining ball that seems perched atop a desert peak. As humans reached for the Moon, Cornell created a visionary dreamscape of longing, in which the Sun and the Moon are symbolic objects of perfection.

In the final years of his life, Cornell turned to the stars for companionship, noting with pleasure his sightings of constellations and individual stars. He described his gratitude for the harmony he felt as he surveyed the "starry spread." Cassiopeia, Orion's Belt, the Big Dipper, Taurus, Auriga, Cygnus, Gemini, Boötes, Andromeda, Perseus, the Pleiades, Vega, Altair, Deneb: all

OPPOSITE PAGE:
FIGURE 7.20.
Joseph Cornell, untitled.
Collage, 12 × 9 in. Joseph
Cornell Study Center,
Smithsonian American Art
Museum.

FIGURE 7.21.
Joseph Cornell, untitled,
late 1960s. Collage,
12 × 9 in. Photograph
courtesy of PaceWilden-
stein, New York.

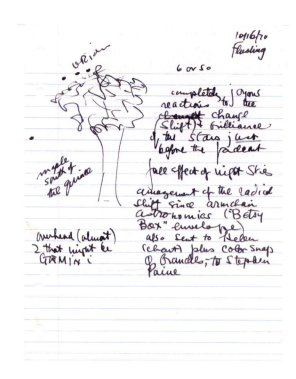

FIGURE 7.22.
Joseph Cornell, diary
entry, October 16, 1970.
Courtesy of the Joseph
Cornell papers, 1804–1986,
Archives of American Art,
Smithsonian Institution.

warranted repeated mention in his notes during his last three years. He recorded calls to the Hayden Planetarium to confirm the identification of constellations. He drew diagrams, including one showing Orion over the maple tree south of the quince in his yard, and he noted his "completely joyous reactions to the change (shift) + brilliance the stars, <u>just</u> before the fadeout" (fig. 7.22). As he fought depression, loss of appetite, and strange dreams and hallucinations, the stars were constant companions.[85] He scrawled in a note, "Constellations of Procyon (little Dog) and Gemini (Twins) lit.[erally] and fig.[uratively] swimming in remote realms. C.S. how can one ascertain from sheets like these the character of such diverse + shifting states of mind."[86]

One of the last collages Cornell made visualized his lifelong fascination with his "neighbors," the familiar constellations he loved (fig. 7.23). Dated March 2, 1971, this collage features a photograph of Cornell's backyard quince tree. The photograph has been stained dark brown with what appear to be fingerprints to create two distinct shapes whose meaning becomes clear when the back of the collage is examined. There, Cornell pasted a photostat of Flammarion's chart of *Les voisines du pôle*, with Camelopardalis, the Giraffe, and Custos Messium, the Custodian, striding through the heavens. A second look at the front of the collage reveals that the brown shapes are shadows of these same constellations, faithful to the end. On the back of the collage, along with his signature Cornell pasted the words: "RESIDENTS 05841/37-08 UTOPIA

PKWY/FLUSHING NY 11350." A decade earlier, he had envisioned Custos Messium as a protector for the spirit of a movie star. Now, he placed the Custodian over his own home, and over himself.

· · · · ·

At the end of the day, Cornell could be found beside a small house, standing in a yard beneath the stars, gazing heavenward. The familiar constellations were signposts that marked the seasons of the year, as well as the seasons of his life, from his early experiments with Surrealism to his final visions of the constellations. In one of his last diary entries, written on November 14, six weeks before his death on December 29, 1972, with a shaky hand he observed:

> *3 stars over the maple that*
> *used to stand sentinel companion*
> *to the white birch*
> *NW*
> *beaut. soft nebulous*
> *dark greys raining*
> *slightly*
> *PEACE at midnight*
> *and for the night!*[87]

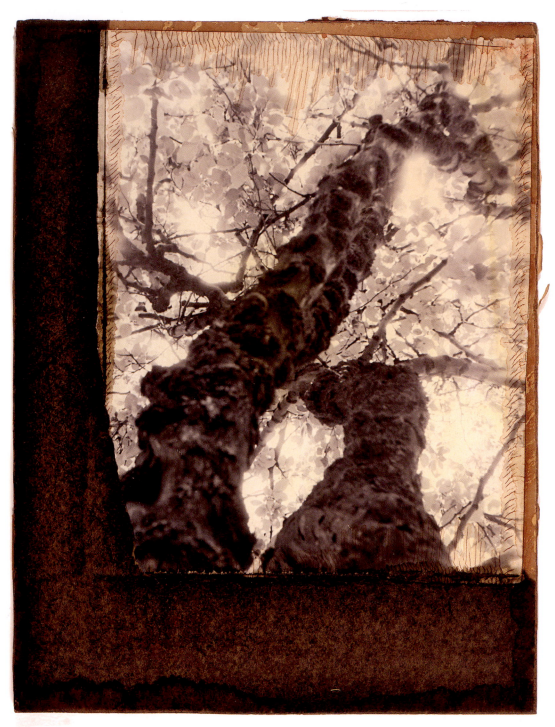

Figure 7.23.
Joseph Cornell, *Les constellations voisines du pôle*, May 2, 1971. Collage, recto and verso,
11^{15}/$_{16}$ × 9 in. Smithsonian American Art Museum, Gift of the Joseph and Robert Cornell
Memorial Foundation.

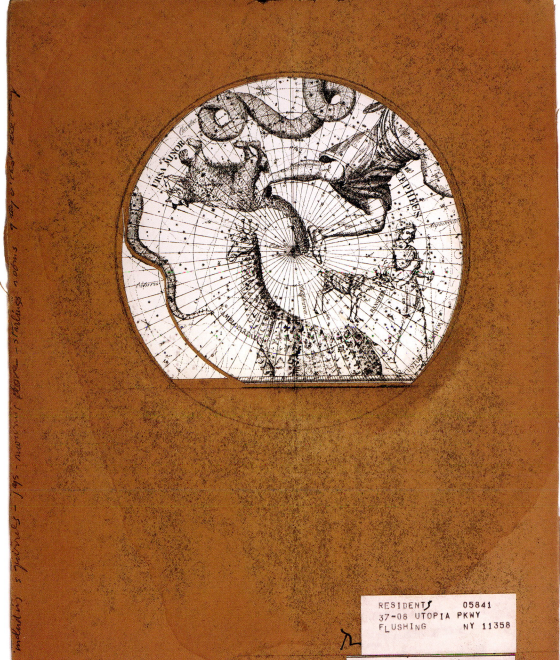

Les constellations voisines du pôle.

NOTES

Abbreviations

AAA Joseph Cornell papers, 1804–1986, Archives of American Art, Smithsonian Institution. References given as microfilm citation: reel number/frame number; digital scan citation: series number/box number/folder number/image scan number. In a few cases, material on microfilm has not been scanned. By permission of the Archives of American Art, Smithsonian Institution.

JCSC Materials in the Joseph Cornell Study Center, Smithsonian American Art Museum: Gifts of Mr. and Mrs. John A. Benton and the Joseph and Robert Cornell Memorial Foundation.

CSM Christian Science Monitor

NYT New York Times

Note on Transcriptions and Capitalization

I have attempted to transcribe Cornell's letters, diary entries, and other writing as accurately as possible, retaining his capitalization, underlining, and misspellings. When he has clearly struck out words or passages and substituted others, I include the stricken words if they are significant to the ideas under discussion. When they are unnecessarily confusing or impossible to replicate in text form, I have chosen the substituted words. When transcribing passes from *Science and Health with Key to the Scriptures*, I have retained the capitalization of words such as "Mind" and "Truth." In my own text, when referring to these Christian Science synonyms for God, I follow this capitalization convention.

Permissions

Leslie Nelson Hennings, "Telescope." Reproduced with permission from the September 29, 1948, issue of the *Christian Science Monitor* (www.csmonitor.com). © 1948 *The Christian Science Monitor*. All rights reserved.

Pearl Strachan Hurd, "In Orbit" (excerpt). Reproduced with permission from the April 5, 1958, issue of the *Christian Science Monitor* (www.csmonitor.com). © 1958 *The Christian Science Monitor*. All rights reserved.

Elisabeth Ritchie, "Metric Geometrics." Reproduced with permission from the December 28, 1969, issue of the *Christian Science Monitor* (www.csmonitor.com). © 1969 *The Christian Science Monitor*. All rights reserved.

Chapter I: Cross-Indexing the Cosmos

1. For Cornell's description of his kitchen as an observatory, see AAA (1062/815; 3.1/8/52/23).
2. AAA (1059/204; 3.1/6/6/43). Cornell's note appears in the margin of a letter written to him from the principal of the New York Institute for the Education of the Blind.
3. Herbert S. Zim and Robert H. Baker, *Stars: A Guide to the Constellations, Sun, Moon, Planets, and Other Features of the Heavens* (New York: Simon and Schuster, 1951, and New York: Golden Press, 1956).
4. A newly discovered scrapbook with clippings of articles compiled by Cornell dates to c. 1926–1930. See Lynda Hartigan, *Joseph Cornell, Navigating the Imagination* (New Haven: Yale University Press, 2007), 36–39.
5. Elijah H. Burritt, *Atlas Designed to Illustrate the Geography of the Heavens* (New York: Huntington and Savage, 1825). JCSC.
6. For a history of these unfamiliar constellations, see Morton Wagman, *Lost Stars: Lost, Missing, and Troublesome Stars from the Catalogues of Johannes Bayer, Nicholas-Louis de Lacaille, John Flamsteed, and Sundry Others* (Granville, OH: McDonald and Woodward, 2003).
7. Photostats were made using a camera that created images directly onto rolls of sensitized paper. A prism in front of the lens reversed the image. The result was a negative print, which could be rephotographed to make any number of positives. The resulting prints are commonly referred to as "photostats." Xerography replaced photostatting in the 1960s.
8. In a note, the artist remarked on "browsing experiences in which thru 'trouvailles' a 'life' is shaped up." JCSC.
9. AAA (1063/364; 3.1/9/13/40).
10. Elizabeth Cornell Benton interview, 1976 April 21, Archives of American Art, Smithsonian Institution, transcript pp. 9 and 10.
11. For Levy and photography, see Katherine Ware and Peter Barberie, *Dreaming in Black and White: Photography at the Julien Levy Gallery* (Philadelphia: Philadelphia Museum of Art; New Haven: Yale University Press, 2006).
12. AAA (1061/297; 3.1/7/48/11). In the margin Cornell added "La ricordanza" and "ca. 1934." Levy moved his gallery to 15 East 57th Street in mid-1937, indicating that Cornell had Flammarion's books before that date.

13. Camille Flammarion, *Astronomie Populaire, description générale du ciel* (Paris: C. Marpon et E. Flammarion, 1880); Camille Flammarion, *Les Etoiles et les curiosités du ciel, description complète du ciel visible à l'œil nu et de tous les objets célestes faciles à observer; supplément de L'Astronomie Populaire* (Paris: C. Marpon et E. Flammarion, 1882); Camille Flammarion, *Les Terres du ciel, Voyage astronomique sur les autres mondes et description des conditions actuelles de la vie sur les diverses planètes du système solaire* (Paris: C. Marpon et E. Flammarion, 1884). *Astronomie Populaire* was published in numerous editions well into the twentieth century. It was translated into English in 1894. See Camille Flammarion, *Popular Astronomy*, trans. J. Ellard Gore (New York: D. Appleton, 1894). Cornell owned French and English editions of the book.

14. Lynda Hartigan titles this work *Le Bouvier de l'atlas de Bayer* (1603), based on the caption from the illustration used in the collage. Cornell pasted this caption on the back of his collage, but it is unclear whether he intended this to serve as the title of the work. See Hartigan, *Joseph Cornell, Navigating the Imagination*, 365.

15. Cornell may have even intended his collage, in part, as a subtle response to Oscar Schlemmer's *Bauhaus Stairs*, on view at the Museum of Modern Art in the fall of 1933. In this painting, which was reproduced in the *Christian Science Monitor*, figures mount stairs in front of a wall with a rectangular grid. See "Moderns among the Rectangles," *CSM*, October 9, 1933, 12.

16. Cornell wrote to Hans Huth in 1953: "Actually I made collages of the Max Ernst genre (FEMME CENT TETES a specific influence)." Typescript of letter, JCSC. Cornell had many opportunities to study Ernst's work. As early as 1926, he could have visited the Société Anonyme exhibition at the Brooklyn Museum, where not only Ernst but also a wide variety of other European modern artists were represented. In May 1932 Ernst's work was included in a group show of European moderns at Marie Sterner's International Gallery in New York. Levy included collages by Ernst in the group "Surréalisme" exhibition in 1932, and again in Ernst's solo show at the gallery that November, which directly preceded Cornell's first one-man exhibition in December. Collages from Ernst's *La Femme 100 Têtes* were on view, although Cornell apparently saw them earlier, when he first met Levy in 1931.

17. See, for example, William Camfield, *Max Ernst: Dada and the Dawn of Surrealism* (Munich and New York: Prestel, 1993), and Charlotte Stokes, "The Scientific Methods of Max Ernst: His Use of Scientific Subjects from *La Nature*," *Art Bulletin* 62 (September 1980): 453–65. For Ernst's use of Flammarion's *Astronomie Popularie*, see Elza Adamowicz, *Surrealist Collage in Text and Image: Dissecting the Exquisite Corpse* (Cambridge: Cambridge University Press, 1998), 183.

18. For a comprehensive discussion of Ernst and alchemy, see M. E. Warlick, *Max Ernst and Alchemy* (Austin: University of Texas Press, 2001). For Ernst's Masonic and Rosicrucian references, see David Hopkins, "Hermetic and Philosophical Themes in Max Ernst's 'Vox Angelica' and Related Works," *Burlington Magazine* 134 (November 1992): 716–23.

19. Camfield suggests that in this collage Ernst drew upon scientific and alchemical illustrations to allude to the general theme of sexual impotence (the pneumatic dart is lodged in the wall, not the woman) and even cosmic impotence (the text tells

the reader, "for three hours there has no longer been any wind, for three hours gravitation has ceased to exist"). Camfield, *Max Ernst*, 120–21.

20. Samantha Kavky observes, "Loplop traverses the boundaries of subject and object, or interior and exterior, for he holds the liminal position of an outward projection of the interior workings of the artist's psyche." See Samantha Kavky, "Authorship and Identity in Max Ernst's Loplop," *Art History* 28 (June 2005): 359. In other words, Loplop exists in a space without limits, to which Cornell's metaphor of fantastic cosmic travel may cleverly allude.

21. AAA (1061/211; 3.1/7/45/29).

22. For an example of the way in which Cornell uses these terms, see AAA (1059/008; 3.1/6/3/8).

23. For a discussion of Cornell's encounters with art in the 1920s, see Hartigan, *Joseph Cornell, Navigating the Imagination*, 25–30.

24. Cornell to Barr, November 13, 1936. Archives of the Museum of Modern Art, New York.

25. D.A., "Surrealism, Theory and Practice," *CSM*, September 7, 1937, 8.

26. Balakian, JCSC and AAA (1061/502; 3.1/7/56/5); Breton, AAA (1062/239; 3.1/8/37/61); Eluard, JCSC.

27. AAA (1062/204; 3.1/8/37/66).

28. For Cornell's copy of Freud's book, see JCSC; for a typical comment on "hypogogic musings," see AAA (1059/030; 3.1/6/3/28).

29. AAA (1058/231–32; 3.2/10/30/22).

30. For Cornell's "Ondine" typescript, see JCSC.

31. For instance, in 1962 he transcribed the following from Balakian's *Surrealism*: "'. . . . the beauty of the flight of a royal kite, and that of the face of a child, rising sweetly above an open casket, like a water-lily piercing the surface of the waters.' Lautréamont." AAA (1061/502; 3.1/7/56/5).

32. AAA (1062/1407; 3.1/8/60/43).

33. AAA (1058/234; 3.2/10/30/24).

34. Leo T. Hurwitz, "Mice and Things: Notes on Pierre Roy and Walt Disney," *Creative Art* 8 (May 1931): 362. Work by Roy was included in Levy's "Surréalisme" exhibition in 1932, in a solo exhibition at the Brummer Gallery in 1933, and in "Fantastic Art, Dada, Surrealism," at the Museum of Modern Art in 1936.

35. See Salvador Dalí, *The Marriage of Buster Keaton*, 1925. Collage and ink on paper, 21.3 x 16.8 cm. Fundación Federico García Lorca, Madrid.

36. Dorothy Adlow, "Surrealists in Boston," *CSM*, March 16, 1937, 8.

37. This is also evident in remarks about Surrealism and science in the review of Morris Davidson's book, *Understanding Modern Art*, published in *Creative Art* in 1932. As the reviewer observes, "Now El Greco is beginning to rise in the public heaven along with the star of Einstein." The author also refers to Jeans, by name, and Eddington, by the title of his book, *The Nature of the Physical World*. See "Book Reviews," *Creative Art* 10 (January 1932): 69–70. Gavin Parkinson explores the topic of physics and Surrealism in *Surrealism, Art, and Modern Scence: Relativity, Quantum Mechanics, Epistemology* (New Haven: Yale University Press, 2008).

38. The parallels and interactions between Cornell and Duchamp were the subject of an exhibition at the Philadelphia Museum of Art and the Menil Collection, Houston,

in 1998–99. See the accompanying exhibition catalogue: *Joseph Cornell / Marcel Duchamp . . . in resonance* (Ostfildern-Ruit, Germany: Cantz Verlag, 1999). See p. 304 of the catalogue for a note on Cornell's role in the assembly of the *Boîte* editions.

39. Linda Dalrymple Henderson, *Duchamp in Context: Science and Technology in the Large Glass and Related Works* (Princeton: Princeton University Press, 1998). As Henderson proves, Duchamp's notion of "playful physics," a term he used in his notes for *The Large Glass* published in 1934 as *The Green Box*, is central to understanding the evolution and meaning of this important work, as well as his overall creative process.

40. For analysis of the use of alchemical references in explanations of modern scientific phenomena, see ibid., 27–28 and 231–32.

41. See Joseph Cornell, layout for "What Is Your Element," *Harper's Bazaar*, August 1942. Materials about Paracelsus, the history of alchemy, and tarot cards can be found in JCSC.

42. "The Poet's Alembic," *CSM*, September 21, 1953, 8. JCSC; AAA (1062/990; 3.1/8/54/51).

43. For overviews of Cornell and Christian Science, see Sandra Leonard Starr, *Joseph Cornell: Art and Metaphysics* (New York: Castelli, Feigen, Corcoran, 1982); Lindsay Blair, *Joseph Cornell's Vision of Spiritual Order* (London: Reaktion Books, 1998); Richard Vine, "Eterniday: Cornell's Christian Science 'Metaphysique,' " in *Joseph Cornell: Shadowplay Eterniday* (Washington, DC: Voyager Foundation, 2003), 36–49; and Erika Doss, "Joseph Cornell and Christian Science," in *Joseph Cornell: Opening the Box*, ed. Jason Edwards and Stephanie L. Taylor, 113–35 (Bern: Peter Lang, 2007). Doss points out that the "science" of Christian Science is understood as God's divine law. Doss writes that Eddy's "use of the term 'science' was congruent with its general meaning in the mid-nineteenth-century as a universal, certain, and infallible body of knowledge. In the twentieth-century of Einstein and Heisenberg, however, these understandings of science would radically change: from 'certainties' to 'probabilities'" (118).

44. Mary Baker Eddy, *Science and Health with Key to the Scriptures* (Boston: First Church of Christ, Scientist, 1871), 121. In no way do I mean to imply that Christian Science is an occult religion; however, there are significant parallels between the interest in the occult in early twentieth-century scientific and artistic circles and Cornell's Christian Science faith.

45. Doris Peel, "Fair Enough Friend?" *CSM* (date unknown). JCSC.

46. *Science and Health*, 119.

CHAPTER II: THE CELESTIAL SCIENCE OF SOAP

1. A portion of this chapter first appeared in my article "The Surreal Science of Soap: Joseph Cornell's First Soap Bubble Set," *American Art* 20, no. 1 (2006): 14–35. My thanks to Cynthia Mills, editor, for permission to reprint that material here.

2. This work is sometimes referred to as *Untitled (Soap Bubble Set)*. I have chosen to use the title "Soap Bubble Set," as it appeared in two publications in 1936. See Alfred H. Barr, Jr., ed., *Fantastic Art, Dada, Surrealism* (New York: Museum of

Modern Art, 1936), fig. 309, and Julien Levy, *Surrealism* (New York: Black Sun Press, 1936), fig. 64. Quotation from Joseph Cornell in memoradum to Hans Huth, 1953, Archives, Art Institute of Chicago, as quoted in Dawn Ades, *Surrealist Art: The Joseph and Lindy Bergman Collection* (New York: Thames and Hudson, 1997), 51.

3. It was not Cornell's first work to be shown in a museum. In 1935 he was among the artists included in Chick Austin's Three Centuries of American Painting and Sculpture exhibition at the Wadsworth Atheneum, where his *Crystallized Dream (Surrealist Object)*, on loan from the Julien Levy Gallery, was displayed in the sculpture section.

4. He did not make the box himself, nor was the interior of the box bright white, as Deborah Solomon states. Rather, he used a ready-made case, attached a frame to its front, and lined it with cobalt-blue silk held in place with thumbtacks. Exhibited for many years in bright sunlight, the silk has now faded to white, although the original color can be seen where the tacks covered the fabric. My thanks to Elizabeth Kornhauser of the Wadsworth Atheneum for showing me the original color of the silk and the conservation reports describing the deterioration of the material. See Deborah Solomon, *Utopia Parkway: The Life and Work of Joseph Cornell* (New York: Noonday Press, Farrar, Straus, and Giroux, 1997), 80.

5. Among the items in the photograph is a fragment of a photograph by Lee Miller, a portrait of Mary Taylor referred to as *Floating Head*. If Cornell knew it by this title, then its inclusion with the other "floating" soap bubble elements adds another level of wit to this object grouping. My thanks to Antony Penrose for his help in identifying this photograph.

6. The *Elements of Natural Philosophy* vitrine and its contents are not listed in Barr's catalogue, indicating that the decision to include these items was made after the catalogue went to press.

7. *Joseph Cornell Objects* (Beverly Hills: Copley Galleries, 1948), n.p.

8. Diane Waldman first suggested the autobiographical reading, as "a fairly plausible interpretation," with the cylinders representing Cornell and his siblings, the pipe his father, etc. In her most recent publication on Cornell, she presents this reading as a fact, one that is now consistently repeated by other scholars. See Diane Waldman, *Joseph Cornell* (New York: Solomon R. Guggenheim Museum, 1967), 12; Diane Waldman, *Joseph Cornell* (New York: George Braziller, 1977), 16; Diane Waldman, *Joseph Cornell, Master of Dreams* (New York: Harry N. Abrams, 2002), 25. Dore Ashton first proposed the theme of cosmic reverie, further explored by Dawn Ades and Lindsay Blair. See Dore Ashton, *A Joseph Cornell Album* (New York: Da Capo Press, 1974), 93; Dawn Ades, "The Transcendental Surrealism of Joseph Cornell," in *Joseph Cornell*, ed. Kynaston McShine, 32–33 (New York: Museum of Modern Art, 1980); Blair, *Joseph Cornell's Vision of Spiritual Order*, 174–202.

9. At the time of his death, Cornell owned reprint editions of C. V. Boys, *Soap Bubbles and the Forces Which Mould Them* (London: Society for Promoting Christian Knowledge, 1890), and C. V. Boys, *Soap Bubbles, Their Colours, and the Forces Which Mould Them* (London: Society for Promoting Christian Knowledge, 1912). He also possessed a copy of Tom Tit [Arthur Good], *La Science Amusante*, 3 vols. (Paris: Larousse, [1890–1906]). Loose pages torn from Boys's and Good's books can be found in Cornell's clipping files. First to closely examine these sources was Blair,

in *Joseph Cornell's Vision of Spiritual Order*, 174–81. In these books, bubbles and household objects form the basis of a study of elementary physics, and serious science lies behind the language of play. Using common items often found in Cornell's soap bubble sets—eggs, balls, clay pipes, wineglasses, dolls—the authors outline experiments exploring phenomena such as capillary action, gravity, and electricity that budding physicists can conduct with bubbles.

10. The majority of these engravings are found in JCSC, "Nat. Phil" folder. Penciled notations in margins of some pages indicate that Cornell may have initially compiled some of these materials as sources for patterns when employed as a designer at the Traphagen Commercial Textile Studio in New York.

11. William G. Peck, *Introductory Course of Natural Philosophy* (New York: A. S. Barnes, 1860), 37–38. Cornell included this page in his "Nat. Phil" folder, JCSC.

12. In more precise terms, Newton's law of universal gravitation is stated as follows: every object in the universe attracts every other object with a force directed along the line of centers for the two objects that is proportional to the product of their masses and inversely proportional to the square of the separation between the two objects. My thanks to solar physicist Rich Wolfson, Department of Physics, Middlebury College, for this succinct explanation.

13. "Nat. Phil." folder, JCSC, and AAA (1067/246; 4.3/18/11/45).

14. JCSC. Earlier Cornell alluded to center of gravity in a tiny globe encasing a horse and rider balanced on a cylinder. See *Untitled (Horse and Rider)*, c. 1932, reproduced in McShine, ed., *Joseph Cornell*, fig. 23. Cornell could have been further inspired to incorporate the concept of center of gravity in his work if he knew of Duchamp's interest in it. In Duchamp's conception of the *Large Glass* is the figure of "The Juggler of the Center of Gravity," also referred to as "Juggler/Handler of Gravity." See Henderson, *Duchamp in Context*, 155–58, 163–68.

15. See, for instance, the description of the ring plane crossing in a detailed article about a total eclipse of the Sun: Herbert B. Nichols, "Planes Poised to Scan Eclipse," *CSM*, June 18, 1936, 1. Cornell kept pages torn from an unidentified book explaining the ring-plane phenomenon. JCSC.

16. Simon Schaffer, "A Science Whose Business Is Bursting: Soap Bubbles as Commodities in Classical Physics," in *Things That Talk: Object Lessons from Art and Science*, ed. Lorraine Daston (New York: Zone Books, 2004), 163–65. Cornell may have also known of Plateau's creation of a "soapsuds" telescope, in which he adapted a Galilean telescope by using two rings with liquid glycerin laminar film in place of glass lenses. For further information about Plateau's contributions to science and technology, see http://users.telenet.be/thomasweynants/plateau-intro.html.

17. Schaffer, "A Science Whose Business Is Bursting," 164–65.

18. A phenakistiscon uses a disc carrying a series of images set in a ring around the circumference, with small slits between the images. When a rod is placed through the center of the disc and spun in front of a mirror, a person looking through the slits from the back of the disc sees a moving image reflected in the mirror. These devices are familiar to historians of the development of cinema (of whom Cornell was one), but, as Schaffer notes, their early application to study of the physics of soap bubbles is less well-known.

19. Quoted in Schaffer, "A Science Whose Business Is Bursting," 164–65. It should be pointed out that the parallels between bubbles and planets were drawn by Plateau, not Plato, as stated in Blair, *Joseph Cornell's Vision of Spiritual Order*, 180.

20. Other films by Méliès, such as *The Mysterious Retort*, make the alchemical connections even more clearly. Cornell collected Méliès films and arranged public screenings of them from time to time. See Annette Michelson, "Rose Hobart and Monsieur Phot: Early Films from Utopia Parkway," *Artforum* 11 (June 1973): 47–57.

21. Ernst appropriated the items named in his title from a book illustrating apparatus for chemistry and biology experiments. See Camfield, *Max Ernst*, 8.

22. Cornell's inclusion of this map of the Moon represents an early example of a life-long fascination with maps and mapping in his work. For further discussion of this topic, see James Housefield and Diana K. Davis, "Joseph Cornell, Geographer of Utopia Parkway," in *Joseph Cornell*, ed. Edwards and Taylor, 47–68. Housefield and Davis underscore the connections between mapping and Christian Science, describing the Mapparium at the Mother Church in Boston, a three-story-high globe built between 1932 and 1935.

23. Flammarion included a section on the history of mapping the Moon in *Les Terres du ciel*, with full-page illustrations ranging from Hevelius's map, first published in 1647, to collotype reproductions of photographs by J. M. Rutherford. He also devoted considerable space to a discussion of the mountains and craters of the Moon. See Flammarion, *Les Terres du ciel*, 459–67, 470–86.

24. See, e.g., the description of Cornell's soap bubble sets as resembling a "young scientist's kit" in Lynda Roscoe Hartigan, "Selected Works," in *Joseph Cornell: Shadowplay Eterniday*, 72.

25. Among the practical applications of specific gravity beads was testing the alcohol content of liquors. Cornell may have appreciated the double entendre of using philosophical bubbles to test for the proof of spirits.

26. For an overview of the role of metaphor in scientific thinking, see Theodore L. Brown, *Making Truth: Metaphor in Science* (Urbana: University of Illinois Press, 2003).

27. Waldemar Kaempffert, "Changing Conceptions of the Universe: A Riddle Still," *NYT*, April 17, 1932, XX4.

28. Herbert B. Nichols, "Interstellar Dust Clouds Balk Effort to Map Entire Universe," *CSM*, April 29, 1936, 1.

29. "Expands Like Soap Bubble," *NYT*, November 27, 1936, 23.

30. Waldemar Kaempffert, "A Scientific Crisis Reshapes Our Cosmic Conceptions," *NYT*, March 19, 1933, BR10.

31. The idea of the universe expanding like a giant soap bubble is somewhat misleading. Galaxies and other objects are not just flying apart; rather, space itself has been stretching. The universe should be imagined as a bubble with dots of the surface. As the bubble inflates, the dots become farther apart. As Einstein proved, even light is stretched in an expanding universe.

32. Gottfried Honegger and Peter van Kamp, *Space, the Architecture of the Universe* (New York: Dell: 1962), 9. JCSC.

33. Guillemin, *The Forces of Nature*, 366.

34. "General Science," *Catalogue of Phillips Academy, Andover, Massachusetts, May 1918* (Andover, MA: Andover Press, 1918), 51.

35. Additional loose pages from *De Augmentis Scientiarum* are in JCSC. For further discussion of Cornell's use of Bacon's text in this work, see Lisa Chuan-Lee Cheng, "The Noontide Sun Rises Higher: Astronomy, Science, and Religion in the Art of Joseph Cornell," master's thesis, Oberlin College, 1995.

36. Overflowing from the *Cabinet of Natural History* in the *Elements of Natural Philosophy* vitrine are additional related objects, positioned in front and beside the box. These include "specimen" bottles, as well as thin sheets of glass that resemble microscope slides and a cylinder wound with wire that recalls an electromagnet or a Tesla coil. Hartigan notes that labels on the bottles refer to the following scientists: Dominique-François Arago, Charles Caignard de la Tour, Sir William Herschel, Sir Isaac Newton, Blaise Pascal, and Evangelista Torricelli. See Hartigan, *Joseph Cornell, Navigating the Imagination*, 60. The Dolmabahçe Palace was in the news in 1938, when Ataturk died there.

37. For further discussion of this book object, see Lynda Roscoe Hartigan, "Joseph Cornell's Explorations: Art on File," in *Joseph Cornell/Marcel Duchamp . . . in resonance*, 238.

38. Here Cornell seems to have cleverly alluded to the agricultural associations in Duchamp's *Large Glass*, which the artist conceived of as an agricultural instrument or an agricultural machine. See Henderson, *Duchamp in Context*, 168–69.

39. André Breton urged his Surrealist colleagues to read Nerval, even quoting the author in his first *Manifesto of Surrealism*, published in 1924.

40. Robert Emmet Jones, *Gérard de Nerval* (New York: Twayne, 1974), 140.

41. Gérard de Nerval, *Aurélia*, trans. Kendall Lappin (Santa Maria, CA: Asylum Arts, 1991), 86.

42. Ibid., 67.

43. Ibid.

44. Ibid., 85.

45. Ingrid Schaffner and Lisa Jacobs, eds., *Julien Levy: Portrait of an Art Gallery* (Cambridge: MIT Press, 1998), 175.

46. Quoted in ibid., 76.

47. Mina Loy, "Lunar Baedeker," in *The Lost Lunar Baedeker*, ed. Roger L. Conover (New York: Noonday Press, Farrar, Straus, and Giroux, 1996), 77. The shards of glass may also have been a reference to lines in the poem "Lunar Baedeker": "Cyclones / of ecstatic dust / and ashes whirl / crusaders / from hallucinatory citadels / of shattered glass / into evacuate craters." See Loy, *The Lost Lunar Baedecker*, 82. Loy's poems were originally published as *Lunar Baedeker* (Paris: Contact, 1923) and *Lunar Baedeker and Time-Tables* (Highlands, NC: Jonathan Williams, 1958). Posthumous anthologies of her work appeared as *The Last Lunar Baedeker*, ed. Roger Conover (Highlands, NC: Jargon Society, 1982), and *The Lost Lunar Baedeker* in 1996.

48. Loy, *The Lost Lunar Baedecker*, 82.

49. Carolyn Burke, *Becoming Modern: The Life of Mina Loy* (New York: Farrar, Straus, and Giroux, 1996), 343. See also "Prize Lampshades from Nina [*sic*] Loy of Paris," *Arts and Decoration* (July 1927): 56.

50. Cornell to Loy, draft letter, July 3, 1951. Quoted in Mary Ann Caws, ed., *Joseph Cornell's Theater of the Mind: Selected Diaries, Letter, and Files* (New York: Thames and Hudson, 1993), 175.

51. For Loy and Christian Science, see Burke, *Becoming Modern*, and Richard Cook, "The 'Infinitarian' and Her 'Macro-Cosmic Presence': The Question of Loy and Christian Science," in *Mina Loy: Woman and Poet*, ed. Maeera Shreiber and Keith Tuma (Orono, ME: National Poetry Foundation, 1998), 457–65.

52. Loy, *The Last Lunar Baedeker*, 163–64. Cornell may have known this poem, published in three installments in *The Little Review* in 1923 and perhaps passed on to him by Julien or Joella Levy.

53. *Science and Health*, 547. Among the photographs Cornell collected during his lifetime is a cabinet card portrait of Agassiz. JCSC.

54. Ibid., 549–50.

55. Mary Baker Eddy, *Miscellaneous Writings, 1883–1896* (Boston: Trustees under the Will of Mary Baker G. Eddy, 1896), 328. Cornell could have been reminded of this line by reading "Bursting the Bubbles of Earth," *CSM*, October 9, 1936, 8.

56. *Science and Health*, 295.

57. Eddy, *Miscellaneous Writings*, 22–23.

58. Julien Levy, *Memoir of an Art Gallery* (Boston: MFA Publications, 2003), 78.

59. *Science and Health*, 589.

60. The combination of a child or angel in a snowy landscape against a backdrop of stars can also be found in Cornell's early box construction, *Untitled (Snow Maiden)*, c. 1933. Both works allude to Nathanial Hawthorne's story "The Snow Image," which recounts the tale of children who make a playmate out of snow. When their father insists she warm herself by the fire, the child melts. Cornell's interest in this fairy tale is intriguing. While he was clearly drawn to the story's message of belief in unseen forces over reliance on facts, he may also have chosen the tale of a melting child of snow to allude to recent research on the scientific principles that govern changes in states of matter. Images of snow would reappear in astronomical contexts in his film scenario, *Nebula, the Powdered Sugar Princess*, and in *The Crystal Cage, [portrait of Berenice]* (discussed in chaps. 3 and 4). There may even be parallels in Duchamp's interest in snow as an image of changing states of matter. Henderson writes: "Duchamp played with a number of ideas borrowed from the physics of changing states of matter and contemporary discussion of liquefaction, including the intense cold required for the liquefaction (and solidification) of gases. This phenomenon is the root of his references to 'frosty gas' and 'snow,' as well as the connecting link to the wintry landscape in the Readymade *Pharmacy*, which Duchamp associated specifically with the liquefaction in the Glass and which seems to have stood as a surrogate landscape for the Bachelors' surroundings." See Henderson, *Duchamp in Context*, 196.

61. For a perceptive meditation on Cornell's gender identity, see Jason Edwards, "Coming Out as a Cornellian," in *Joseph Cornell*, ed. Edwards and Taylor, 25–44.

62. The pipe was an informal attribute for the scientist in the twentieth century, and many physicists, including Einstein and Hubble, were often photographed with one at hand. Ads for pipes were common in *Scientific American*, including one published in 1942 promoting a Briar Root "Rare Rustic" pipe, billed as "a real he-man's pipe—rugged, hefty."

63. Quoted in John Russell, "Worlds of Boxes, Packages, and Columns," *NYT*, March 14, 1976, D29.

64. AAA (1059/038; 3.1/6/4/2). Caws incorrectly transcribes "phenakiston" as "phenomenon" in her *Joseph Cornell's Theater of the Mind*, 138.

65. Cornell could have encountered this statement in "Newton and Truth," *CSM*, June 3, 1938, 24. Around 1962 Cornell copied this passage onto a thin sheet of paper, noting at the bottom that he was working on a soap bubble set. JCSC.

66. Cited in "Commotion in the Sky," *CSM*, September 9, 1949, 20, and L. Bernard Cohen, "Isaac Newton," *Scientific American* 194 (December 1955): 78.

67. *Boys Blowing Bubbles*, reproduced in *CSM*, August 6, 1970, 10. JCSC. The painting is in the collection of the Seattle Art Museum.

68. "Cosmic Rays Open the Fair," in *The Hayden Planetarium and the New York World's Fair* (New York: *The Sky, Magazine of Cosmic News*, Hayden Planetarium, American Museum of Natural History, for the New York World's Fair, 1939), 2.

69. George Buchanan Fyfe, "Time and Space Dramatized at the World's Fair," in *The Hayden Planetarium and the New York World's Fair*, 3–4, 15.

70. Two reviewers used this term. See "Exhibition at Levy Gallery," *NYT*, December 6, 1940, 33, and Edwin Alden Jewell, "Americans," *NYT*, December 15, 1940, XII.

71. "Balanchine to Paris Opera?" *CSM*, September 18, 1945, 4, and Howard Devree, "Many, New, Diverse," *NYT*, December 15, 1946, X9. Devree continued to heap scorn on Cornell's works, referring two years later to his *Medici Slot Machine* as "a kind of peep-show." See "Collage and Leger," *NYT*, September 26, 1948, X9.

72. A label pasted on the back of the box indicates that the work entered William Copley's collection, probably at the time of the exhibition.

73. Arthur Miller, "In the Galleries," *Los Angeles Times*, October 3, 1948, D4.

Chapter III: Movie Stars

1. Levy, *Memoir of an Art Gallery*, 229–31.

2. Jodi Hauptman, *Joseph Cornell: Stargazing in the Cinema* (New Haven: Yale University Press, 1999), 90. For Hauptman's insightful discussion of *Rose Hobart*, see 85–115.

3. Ibid., 103.

4. Lynda Hartigan's description of Cornell's inclusion of "*East of Borneo*'s faked effects of a solar eclipse" is incorrect, since there are no eclipse scenes in Melford's film. Moreover, her assertion that "Rose Hobart is a 'trick film' that demonstrates what Cornell so appreciated about the medium: the 'defiance of the limitations of the physical world,'" overlooks the important astronomical underpinnings of the film. Hartigan, *Joseph Cornell, Navigating the Imagination*, 72.

5. Hauptman, *Joseph Cornell: Stargazing in the Cinema*, 106–7.

6. Ibid., 105. Hauptman notes that there were five solar eclipses and two lunar eclipses in 1935, followed by one solar eclipse in 1936 (actually there were a total eclipse of the Sun, a lunar eclipse, and an annular eclipse of the Sun in that year).

7. It is unclear exactly when Cornell decided on the music that would accompany the film. A diary entry from May 21, 1949, notes: "fresh reactions each morning to 'tropical' music for Rose Hobart film, anticipation, etc. purchasing player locally one morning on bike." AAA (3.1/6/6/17). Levy's description of Dalí's outburst at

the 1936 screening notes that "the silence was broken." See Levy, *Memoir of an Art Gallery*, 230.

8. Gordon Garbedian, "The Sun's Eclipse from a Far Isle," *NYT*, October 19, 1930, 137. See also "To Test Einstein Theory Astronomers Await Sun's Eclipse on Oct. 21 at Niuafou Island," *NYT*, September 30, 1930, 24.

9. "Full Eclipse of Sun to Be Studied Today," *NYT*, October 21, 1930, 26. Niuafou Island was part of the kingdom of Tonga, at this time the only self-governing state in the South Pacific. Thus the fictional island governed by a prince in Melford's *East of Borneo* may have been based on one very much like Niuafou in the kingdom of Tonga.

10. Gordon Garbedian, "Sun's Corona Yields a Clue for Science," *NYT*, January 4, 1931, XX4.

11. James Stokley, "Astronomers Talk of Coming Eclipses," *NYT*, September 9, 1932, 21; and "Tiny Pacific Isle to See Sun Eclipse," *NYT*, February 11, 1934, 34.

12. "Light Rays Bent Near Sun, Pacific Eclipse Indicates," *CSM*, February 15, 1934, 3.

13. Garbedian, "The Sun's Eclipse from a Far Isle," 137.

14. "Light Rays Bent Near Sun, Pacific Eclipse Indicates," 3.

15. Annette Michelson discusses Cornell's spatial system in his early objects and films as "the Surrealist space of the Encounter," with the frames of his boxes acting as proscenium arches. She notes that Lautréamont's "dissection table which is its ground must be seen as a stage, inscribed with the orthogonals of Renaissance perspective." See Michelson, "Rose Hobart and Monsieur Phot," 51. While this is true on one level—Cornell himself used the proscenium analogy when discussing his soap bubble sets—I believe Cornell also understood space as infinite and unfolding, and he looked for ways to express this modern idea in his boxes, films, and collages. Here my ideas intersect tangentially with those of Analisa Leppanen-Guerra, who examines the "transfiguring dimensions of time and space" in Cornell's adoption of "child-time" in his works inspired by fairy tales. See Analisa Leppanen-Guerra, " 'A Stage of His Own Making': Child-Time and Dream-Space in Joseph Cornell's Theatre of Hans Christian Andersen," in *Joseph Cornell*, ed. Edwards and Taylor, 175–87.

16. Victor Duruy, *Histoire des Temps Modernes* (Paris, 1881). This book object was purchased by Chick Austin for his private collection in 1939, at the time of the acquisition of the *Soap Bubble Set* for the Wadsworth Atheneum. The book was a gift to Cornell from Julien Levy, who may have purchased it on one of his trips to Paris. The book object may have been included in the Exhibition of Objects by Joseph Cornell at the Levy Gallery in December 1940. My thanks to Elizabeth Kornhauser at the Wadsworth Atheneum for showing me this work and sharing this information from the curatorial files. For further thoughts on Cornell's book objects, see Dickran Tashjian, "Paging Mr. Cornell: The Book and Its Double," in *Joseph Cornell*, ed. Edwards and Taylor, 159–74.

17. Hauptman, *Joseph Cornell: Stargazing in the Cinema*, 97.

18. "Tiny Pacific Isle to See Sun Eclipse," 34.

19. As one article reported, "Though much of the work accomplished during the brief two minutes available is rehearsed time and again—more carefully even than actors rehearse their lines—the Harvard-Tech expedition is taking no chances this

year. It has amassed the largest battery of automatic devices ever built. No doubt a few members still remember what happened four years ago at Gray, Maine, when everyone was so 'practiced up' in the motions of changing blank photographic plates in order that as many photographs as possible would be taken during the time available—that they forgot to load the plates when it came time for actual business. Weather, instruments, atmosphere and everything else were perfect, most of the plates that anxious fingers fed one after another into cameras were empty." "Planes Poised to Scan Eclipse, 40 Groups Eye Clouds in Asia; U.S. Weathermen Tap Sky," *CSM*, June 18, 1936, 1. Other articles described the anxiety experienced by so-called primitive peoples when they viewed the disappearance of the Sun.

20. Donald H. Menzel, "Science Again Turns to the Sun," *NYT*, June 14, 1936, SM8.

21. "Film Line Offers Limited Tour among Planets," *CSM*, March 27, 1935, 8; "Stars Set to Light New Planetarium," *NYT*, September 30, 1935, 19.

22. There is considerable confusion in the literature on Cornell's films about which titles should be assigned to the films in the trilogy. In a seminal essay on Cornell's films, P. Adams Sitney names *The Midnight Party* as the film that opens with the title "The End" appearing on screen upside down. He describes *Cotillion* as a film of equal length, and *The Children's Party* as the shortest film in the trilogy. In the filmography provided at the end of his essay, however, he lists *The Midnight Party* as the shortest film and *Cotillion* and *The Children's Party* as nearly equal in length. See P. Adams Sitney, "The Cinematic Gaze of Joseph Cornell," in *Joseph Cornell*, ed. McShine, 68–89. In a recent DVD edition of Cornell's films, *The Children's Party* is listed in the index provided on the inner paper cover, but on the DVD itself the title *The Midnight Party* appears on the electronic index for the film that opens with the words "The End." See *The Magical Worlds of Joseph Cornell* (Washington, DC: Voyager Foundation, 2004). Anthology Film Archives, the first repository for Cornell's films, lists the film that opens with the words "The End" as *The Children's Party* on a recently released DVD that includes the trilogy. See "The Amateur as Auteur, Discovering Paradise in Pictures," vol. 6 in *Unseen Cinema: Early American Avant-Garde Film 1894–1941* (New York: Anthology Film Archives, distributed by Image Entertainment, 2005). Because of its imagery and organization, the title *The Children's Party* seems most appropriate for this film, and in my discussion I will use the titles assigned by Anthology Film Archives. Cornell's films are now in the collection of the Museum of Modern Art.

23. On November 15, 1938, Cornell wrote Jay Leyda at the Museum of Modern Art that he had just completed "a rough (very rough, in fact) draft of the children's party film." It is not clear which film he meant. Cornell to Leyda, archives of the Anthology Film Archives. The three films were completed according to Cornell's directions by Larry Jordan between 1965 and 1968. Jordan's contribution was apparently limited to repairing splices and making freeze frames according to Cornell's direction. Sitney, "The Cinematic Gaze of Joseph Cornell," 88.

24. Gary Hunt, "A Few Notes on Zat Zam," http://illusionata.com. Hunt derives his information from a firsthand account published in *Al Munroe's Magical Miscellany* 13 (September 1945).

25. AAA (1070/0377; 4.3/13/22/12).

26. On the unnamed Our Gang comedy film, see J. Hoberman, "The Strange Films of Joseph Cornell," *American Film* (January/February 1980): 19.

27. See, for example, the diagram illustrating Newton's law of gravitation, in Flammarion, *Popular Astronomy*, 92.

28. For example, the following passage occurs in Peck's *Natural Philosophy*, opposite the engraving of the Leaning Tower of Bologna that Cornell used in his first *Soap Bubble Set*: "In the art of rope-dancing, the great difficulty consists in keeping the centre of gravity exactly over the rope. To attain this result the more easily, a rope-dancer carries a long pole, called a balancing pole, and when he feels himself inclining towards one side, he advances his pole towards the other side, so as to bring the common centre of gravity over the rope, thus preserving his equilibrium. The rope-dancer is in a continual state of unstable equilibrium." Peck, *Natural Philosophy*, 47.

29. JCSC.

30. The observatory scene is repeated in *The Midnight Party*, with additional footage of a large telescope. An intertitle reads: "The merest handpush is enough to turn the 7,000 lb. telescope in any direction," and action shifts to a large telescope moving toward the rectangular opening in the dome. Additional text tells us: "Photography is the best means of studying the heavens. Very long exposures are required," followed by another rapid intertitle, "A speed maniac in a world of speedsters,—a comet caught in the act." The next frames show a comet blazing a bright trail, followed by a view of an orb in a star-filled sky. The identity of the "nebula" is clarified as "The Amoeba" on one intertitle and, several frames later, as "The Stentor," a microscopic protozoan. This merging of the vast reaches of outer space with the microscopic world parallels the amoebic imagery in soap bubble sets from the late 1930s. A series of shifting allusions to the present and the past, as well as to the real and the imaginary, follows: a few seconds of rapidly moving machine parts give way to footage of the Godiva-esque child on horseback, then to a sequence featuring the ancient god Thor throwing lightning bolts, presumably at a modern house with firemen and loose electrical wires. After a quick view of a woman washing laundry in a wooden tub, the film ends with Thor throwing more lightning bolts.

31. These nuances also suggest intriguing parallels to ideas that had fascinated Duchamp two decades earlier. As Henderson has so convincingly shown, the narrative of Duchamp's *Large Glass* can be read as a kind of physics demonstration of such things as stable and unstable equilibrium, center of gravity, friction, and the movement of subatomic particles. From the start, popular entertainment was one of Duchamp's sources. In the *Box of 1914* preliminary notes, he mentions the Ferris Wheel at the 1900 Universal Exposition in Paris, and he alludes to games of strength and party whistles seen at a fair in Neuilly. In later notes he refers to amusement parks in England, and even Coney Island's Luna Park. In particular, he mentions "the decorative lighting of Magic City or Luna Park, or the Pier Pavillion at Herne Bay.—garlands of lights against a black background (or background of the sea. Prussian blue and sepia)/Arc lamps.—Figuratively a fireworks—In short, a magical (distant) back drop in front of which is presented . . . *the agricultural instrument*—." Quoted in Henderson, *Duchamp in Context*, 86 and n. 7. If by "agricultural instrument" Duchamp meant the constellation the Plow, better known as

the Big Dipper, then his transformation of fairground lights into stars is remarkably similar to Cornell's astronomical analogies in *The Children's Party*. Moreover, Duchamp wrote of the "round trip for the plow," perhaps alluding to the circuit the constellation makes in the night sky, a sky in which the Milky Way, another element in the *Large Glass*, can be observed. In fact, in a drawing of the *Large Glass*'s Milky Way, Duchamp overlaid a series of spirals, perhaps as an allusion to the spiral shape of the Milky Way galaxy. Henderson also underscores the importance of the concept of gravity for Duchamp, who, like Cornell, was interested in Newton's laws of motion and universal gravitation. She notes that in *The Large Glass* Duchamp roots the Bachelors in the three-dimensional world of gravity and weight, while he places the Bride in a fourth-dimensional realm free from gravity's pull. Moreover, as she explains, Duchamp considered including a figure he called the "Juggler/ Handler of Gravity," merging imagery of the circus with that of science. According to Henderson, the Juggler relates to the issue of balance and equilibrium, and he carries a pole like that of a tightrope walker. Although Duchamp did not include the Juggler in the final version of *The Large Glass*, he did include drawings of the figure in his notes and he devoted a separate work to him in 1947, *The Altar of the Tender of Gravity*. See Henderson, *Duchamp in Context*, 86, 163–68. In Duchamp's imagined universe, the Juggler of Gravity responds to the clockwork mechanism of the Boxing Match: perhaps Duchamp envisioned a showdown between Einstein's relativity, with its "juggled" gravity, and Newton's clockwork universe.

32. For Cornell's scenario, see AAA (1058/0325–0330; 3.2/10/31/33–38). For a typescript transcription, see "Nebula, the Powdered Sugar Princess," *October* 15 (Winter 1980): 40–48. All quotations from the scenario that follow are taken from the handwritten scenario in the Archives of American Art.

33. Thomas Lawson, "Silently, by Means of a Flashing Light," *October* 15 (Winter 1980): 58.

34. For Cornell's engagement with the ballet in his art, see Sandra Leonard Starr, *Joseph Cornell and the Ballet* (New York: Castelli, Feigen, Corcoran, 1983). For her comments on *Nebula, the Powdered Sugar Princess*, see 59–61. For further discussion of Cornell and Toumanova, see Hugh Stevens, "Joseph Cornell's Dance to the Music of Time: History and Giving in the Ballet Constructions," in *Joseph Cornell*, ed. Edwards and Taylor, 87–96. Of particular interest is Stevens's discussion of the political ramifications of Cornell's nostalgic emphasis on nineteenth-century Russian ballet during the Stalinist 1930s and 1940s.

35. Cornell was perhaps guided by the example of a collage by Ernst, *La puberté proche n'a pas encore enlevé la grâce tenue de nos pléiades . . .* , which also shows a figure floating in a blue aquatic-cosmic setting, although Cornell shied away from Ernst's use of a nude figure. Moreover, Cornell was intrigued by one genus of jellyfish in particular, named, *à la* Nerval, the *Aurelia*. He placed an illustration of it, torn from a book, in his source materials. JCSC.

36. JCSC.

37. Quoted in John Martin, "The Dance: Premiers," *NYT*, January 19, 1941, X2.

38. Lawson and others have suggested that Cornell's use of the French term, "La Voie Lactée" for the Milky Way is an implicit tip of the hat to Duchamp, who used the French term to describe the Bride's sexual aura in the notes he published in *The*

Green Box as a guide to his *Large Glass*. This may be so; however, it should be noted that most of the terms Cornell used to describe the setting for Nebula were French words. See Lawson, "Silently, by Means of a Flashing Light," 59.

39. Joseph Cornell, untitled collage, 10 × 7½ in., mounted on "La Grande nebuleuse d'Orion," Supplement Plate III, in Flammarion, *Les Etoiles*. The photograph may be a portrait of Mary Taylor by Lee Miller. Smithsonian American Art Museum, 2002.58.39.

40. Plates from Méry's *Les Etoiles* can be found in JCSC, and AAA (1070/410; 4.3/13/22/40). Cornell may have been introduced to the book by his friend Lincoln Kirstein, who donated a copy to the Metropolitan Museum of Art in 1970.

41. Also in the cast of *Ziegfeld Girl* was Rose Hobart, in the role of Mrs. Frank Merton. See Christopher Young, *The Films of Hedy Lamarr* (Secaucus, NJ: Citadel Press, 1978), 133–43.

42. AAA (1058/0881; 3.1/6/1/5). In this same entry, Cornell noted that Tamara Toumanova has sent him a ticket for her performance of *Swan Lake*, a role he had never seen her dance.

43. Cornell's letter is reproduced in facsimile in Caws, *Joseph Cornell's Theater of the Mind*, 97. Cornell would subsequently publish an ode to Hedy Lamarr: "Enchanted Wanderer, Excerpt from a Journal Album for Hedy Lamarr," *View* (December 1941). In the text he included a quotation from Parker Tyler that also located Lamarr in the terminology of Einstein's space-time continuum: "her hair of time falling to the shoulder of space." Cornell's emphasis on Lamarr's imagined "detachment" mirrors descriptions of the role of the narrator in the Planetarium's program that were reported when the facility opened in October 1935. At that time, the *New York Times* reported, "The lecturer's voice out of the darkness is the only thread that keeps one somewhat earth-bound, but after a while even that voice seems to be coming from great distances, like a voice in a dream." See William L. Laurence, " 'Tour of Sky' Opens Planetarium; 800 Get a New Vision of Universe," *NYT*, October 3, 1935, 1, 21. Cornell's comment about the celestial lecturer was more down to Earth: "The viewpoint of the whole thing is educational, and you're sunk if you let the lecturer get on your nerves." See AAA (1058/0881; 3.1/6/1/5).

44. Elijah Burritt, *The Geography of the Heavens and Class-Book of Astronomy: Accompanied by a Celestial Atlas* (New York: Sheldon, 1856), 143.

45. This work can be dated to c. 1936 based on Cornell's use of burned edges around the inner constellation image. He used this same technique of charring edges in 1936 when he reworked the exhibition announcement he originally designed for the Levy Gallery's 1932 exhibition, Surréalisme, for use as the cover of Levy's book, *Surrealism*. For a reproduction of Cornell's early Andromeda collage, see Isabelle Dervaux, *Surrealism USA* (New York: National Academy Museum, Hatje Cantz, 2005), plate 3.

46. *Science and Health*, 509.

47. The particular stars Leavitt initially studied were located in the constellation Cepheus; thus, they were termed "Cepheid."

48. Also on the same program was *Night Singing through Space*, which incorporated another Noguchi sack costume, this one with elastic tapes that could be manipulated by the dancer. In later performances, both ballets were programmed together

as *Two Songs of Space: Expanding, Swinging.* See John Martin, "Ruth Page Hailed in Modern Dances," *NYT*, January 30, 1933, 10, and John Martin, *Ruth Page, an Intimate Biography* (New York: Marcel Dekker, 1977), 81–84.

49. Fyfe, "Time and Space Dramatized at the World's Fair," in *The Hayden Planetarium and the New York World's Fair*, 3–4, 15.

50. "Nebulae" in "A Word a Day," *CSM*, June 7, 1939, 21.

51. Harry M. Davis, "Millions of Stars, They Form the Milky Way, Now to Be Seen at Its Best," *NYT*, September 21, 1941, SM13.

52. "Celestial Bodies Pictured in Color," *NYT*, December 31, 1938, 2; "Two Harvard Astronomers Find Nebula," *CSM*, November 2, 1939, 13; "Strolling among the Stars," *CSM*, December 20, 1941, WM8. Astronomical photography was advanced by the development of the "Schmidt-Type Telescope," which used a Schmidt camera for making detailed photographs with short exposures of large regions of the sky. See "Dedicate New Eye for Astronomers: Scientists Hail Schmidt-Type Telescope as a Harbinger of Great Advances," *NYT*, December 31, 1941, 11.

53. Lawrence E. Davies, "Finds Galaxy Goes 100 Miles a Second," *NYT*, May 18, 1939, 52; "'Window' through Milky Way Discovered by Dr. Shapley," *CSM*, April 27, 1936, 3.

54. William L. Laurence, "Core of the Milky Way," *NYT*, February 20, 1942, 12.

55. "Strolling among the Stars," *CSM*, December 20, 1941, WM8.

56. Herbert B. Nichols, "Who Counts the Shooting Stars?" *CSM*, January 19, 1940, 1.

57. Gordon Garbedian, "The Star Stuff That Is Man," *NYT*, August 11, 1929, SM1; "Circles Round the Moon," *NYT*, March 7, 1939, 17.

58. "Eddington Pictures Expanding Universe," *NYT*, September 8, 1932, 15.

59. Harry M. Davis, "An 'All-Star' Drama of the Skies," *NYT*, February 25, 1940, 100.

60. Jewel Spangler, "Reading and Interest the Full Price of Admission," *CSM*, December 24, 1940, 14.

61. Carr V. Van Anda, "The Higher Learning in the Nursery," *NYT*, July 1, 1930, 23. Anda was quoting Professor Henry B. Armstrong, as published in *Nature* (January 11, 1930), 46.

62. Herbert B. Nichols, "To Mars and Beyond," *CSM*, November 28, 1934, WM10. Cornell may also have had in mind the gala Beaux-Arts ball of 1936 held at the Astor Hotel in New York. The theme was "Fête de Rayon-Fantastique," and the two thousand guests wore appropriate cosmic costumes. "A Harmony of the Heavens," a pageant produced by Monte Woolley, included "The Jewels of the Heavens," "The Scintillating Stars," and even Mrs. S. Stanwood as "Silver Rain," in a neon-lighted costume. "The Eclipse of the Sun" featured Gypsy Rose Lee. See "Beaux-Arts Ball Is Cosmic Pageant," *NYT*, December 5, 1936, 14.

63. "'Waif' Discovered 40 Years Ago New Cinderella to Astronomers," *CSM*, June 24, 1935, 1.

64. "Unrolling of Nebulae Masses into Star Systems Described," *CSM*, October 17, 1935, 7. See also the profusely illustrated article by Clyde Fisher, "The Birth of the Solar System," *Natural History* 36 (October 1935): 220–28. The concept of the evolution of nebulae had been explored much earlier in the popular press. See W. J. Luyten, "Deeper into Infinity Astronomy Peers. Boundaries of Space Are Pushed Back and a New Story of the Evolution of Universes Is Revealed," *NYT*, March

27, 1927, SM 8–9, 23. Luyten's article was amply illustrated with photographs of nebulae in different stages of their evolution. Among the illustrations is "The Small Magellanic Cloud, a Galaxy in Its Last Stage, a Decayed Spiral Nebula Perhaps."

65. Cornell exhibited a work entitled *A Feathered Constellation (for Toumanova)* in December 1943 at the Julien Levy Gallery exhibition Through the Big End of the Opera Glass, which included works by Cornell, Duchamp, and Yves Tanguy. In an envelope he saved bits of Toumanova's costumes: gauze from *Giselle*, ribbon from *Nutcracker*, rosettes from *Sylphide*, and feathers from *Swan Lake*. JSCS, Box. 47.

CHAPTER IV: ASTRONOMIA FANTASTICA

1. Joseph Cornell, "The Crystal Cage [portrait of Berenice]," *View* ser. 2, no. 4 (January 1943): 10–16.

2. See John Bernard Myers, "Cornell: The Enchanted Wanderer," *Art in America* 61 (September–October, 1973): 76–81; Helen H. Haroutunian, "Joseph Cornell in 'View,'" *Arts Magazine* 55 (March 1981): 101–8; Sandra Leonard Starr, *The Crystal Cage [portrait of Berenice]* (Tokyo: Gatado Gallery, [1987]); Blair, *Joseph Cornell's Vision of Spiritual Order*, 126–39; Lynda Roscoe Hartigan, "Joseph Cornell's Explorations," in *Joseph Cornell/Marcel Duchamp . . . in resonance*, 227–28; Hauptman, *Joseph Cornell*, 163–87.

3. JCSC. The Herschels were in the news again in 1937, when the play *Miles of Heaven*, an eighteenth-century costume drama about William and Caroline Herschel, opened, and once more in 1939, when a new comet was found to be an exact match with one Caroline had discovered in 1788. Cornell even owned an autograph letter written by William Herschel's son John, an important astronomer in his own right, which he kept his *Celestial Theater* source material file. AAA (1070/378–79; 4.3/13/122/13).

4. Philena and Phebe McKeen, *A History of Abbot Academy, Andover, Mass., 1829–1879* (Andover: Warren F. Draper, 1880), 73–76.

5. "First Woman in Academy Honored," *NYT*, September 15, 1959, 22, and Elizabeth Fraser Torjesen, "Maria Mitchell and Her Island," *CSM*, May 4, 1959, 18. AAA (1068/0059,0051; not scanned). Cornell may also have recognized Mitchell as the translator of Amédée Guillemin's *The Wonders of the Moon*, published in 1872. He penciled her name on an undated [c. 1953] typed note with the heading "night-gazing—general YANKEE FOLK." JCSC.

6. Walter Hopps recalled a conversation with the artist around 1966, when the artist asked him if he had ever visited the observatory on Mount Wilson and then proceeded to discuss an experiment performed there by Albert Michelson to measure the speed of light in the 1920s. See Walter Hopps, "Gimme Strength: Joseph Cornell and Marcel Duchamp Remembered," in *Joseph Cornell / Marcel Duchamp . . . in resonance*, 72–73.

7. I believe Cornell's choice of the term "crystal cage" relates most directly to this ancient concept of cosmic order; however, he may also have had in mind the use of prisms in the study of light, the atmosphere surrounding Earth with clouds of frozen water crystals, as well as Raymond Roussel's novel and play

Impressions d'Afrique, which describes a scientific musical contraption housed in a large glass cage. There are occasional references to Roussel in Cornell's notes, especially to Roussel's preservation of a cookie in a star-shaped box. See AAA (1063/652; 3.1/10/19/2, 3, 5) and JCSC.

8. See, e.g., Waldemar Kaempffert, "A Star Explodes," *NYT*, November 22, 1942, E11.

9. The star was Gamma Cassiopeia, an erratic variable star that underwent slow but definite brightness changes during the twentieth century. See *Discovery Channel Night Sky* (New York: Discovery Books, 1999), 122.

10. For descriptions of Uraniborg illustrated with Tycho's woodcuts that Cornell could have consulted, see J.L.E. Dreyer, *Tycho Brahe: A Picture of Scientific Life and Work in the Sixteenth Century* (Edinburgh: Adam and Charles Black, 1890), 88–113; Robert S. Ball, *Great Astronomers* (London: Isbister, 1895), 57–59; and Charles D. Humberd, "Tycho Brahe's Island," *Popular Astronomy* 45 (March 1937): 118–25. Later in life Cornell clipped and saved an illustrated article about Uraniborg for his files. See John Christianson, "The Celestial Palace of Tycho Brache," *Scientific American* 204 (February 1961): 118–28. JCSC.

11. See Michael Moon, "Oralia: Hunger for Women's Performances in Joseph Cornell's Boxes and Diaries," *Women and Performance: A Journal of Feminist Theory* 8 (1996): 39–59; reprinted in Michael Moon, *A Small Boy and Others: Imitation and Initiation in American Culture from Henry James to Andy Warhol* (Durham: Duke University Press, 1998), 135–55.

12. Starr described the word tower as follows: "Berenice's Crystal Cage is the most transparent structure imaginable. It is an architectural variation of what Cornell called his *Metaphysique d'Ephemera*, which allowed him to create art which [in the words of Mary Baker Eddy] 'resolves *things* into *thoughts* and replaces the objects of material sense with spiritual ideas,' or at least ideas of the highest order." See Starr, *The Crystal Cage [portrait of Berenice]*, 41.

13. Elinor De Wire, "Turn on the Light! The Development of the Fresnel Lens," *Mariner's Weather Log* (Fall 1995): 39–41. In his papers Cornell included a photostat negative of a page taken from an unnamed book. The heading reads "A Place for Experiments," an illustration shows the exterior of the Cordoba lighthouse, and the text describes the work of Fresnel, "this patriarch of pharoses." AAA (1067/0221; 4.3/18/11/29).

14. Cornell collected extensive memorabilia about Blondin, including engravings and stereographs of him crossing Niagara Falls. He also clipped an article from the *Monitor* that detailed one of Blondin's Niagara crossings: "Without hesitation, the performer proceeded briskly, almost casually, to the center of the cable. There he seated himself with great composure and glanced complacently about him at the thronging shores. He did not look down, it was reported; that was something he had trained himself never to do. After a few seconds, he rose upright, strolling forward again for some feet, and again stopped. This time he stretched himself at full length upon the rope, lying upon his back, his balance pole horizontally across his chest. Another moment of suspense; then a feat of appalling rashness. He turned a back somersault upon the rope, came upright upon his feet, and walking rapidly to his landing stage, arrived as coolly as if he had no more than alighted from a bus." "Blondin Crosses Niagara Falls," *CSM*, November 8, 1951, 12 (quoted from Vincent

Starrett, *Bookman's Holiday* (New York: Random House, 1942). Article housed in *The Crystal Cage [portrait of Berenice]* valise.

15. Cornell later clarified this source in notes for his *Celestial Theater*, noting "the older discovery of Elia's essay on chimney sweepers, with the happy addition of iconography." Lamb wrote a series of essays under the pen name "Elia" that were published in 1823. See AAA (1070/256; 4.3/13/21/50).

16. For the history of Luna Park, see Jeffrey Stanton, "Coney Island—Luna Park," May 1, 1998, 1–27. Available at http://naid.sppsr.ucla.edu/coneyisland/articles/lunapark.htm. For the atmosphere of Coney Island, see Michael Immerso, *Coney Island, the People's Playground* (New Brunswick: Rutgers University Press, 2002).

17. Russian writer Maxim Gorky described nighttime at Luna Park like this: "With the advent of night a fantastic city all of fire suddenly rises from the ocean into the sky. Thousands of ruddy sparks glimmer in the darkness, limning in fine sensitive outline on the black background of the sky, shapely towers of miraculous castles, palaces and temples. Golden gossamer threads tremble in the air. They intertwine in transparent, flaming patterns, which flutter and melt away in love with their own beauty mirrored in the waters. Fabulous beyond conceiving, ineffably beautiful, is this fiery scintillation." Maxin Gorky, "Boredom," *Independent* 63 (August 8, 1907): 309. The lights turned Luna Park into an iridescent, glowing place that was also safe and welcoming, particularly for respectable women, transforming earlier associations of Coney Island as a dark hub of prostitution and vice into those of family entertainment. For further discussion of the social dimensions of Luna Park, see Woody Register, *The Kid of Coney Island* (Oxford: Oxford University Press, 2001), 132–35.

18. The undated note is headed "Seitz, answer to letter," suggesting it was written with William Seitz in mind. JCSC.

19. For details about the wartime lighting, see Stanton, "Coney Island—Luna Park," 25. Cornell had envisioned a blue-tinted film in his scenario for the never-produced *M. Phot*, published in 1936; he had already screened his film *Rose Hobart* through a pane of blue glass in the 1936 "Goofy Newsreels" night at the Julien Levy Gallery; and he imagined a variety of green-to-blue light effects for *Nebula, the Powdered Sugar Princess*. A visit to Luna Park at night under wartime light restrictions could have reinforced Cornell's fascination with the transforming effects of blue and purple light. Wartime blackouts proved to be a boon to astronomers, who could view the night sky without interference from local light. A *National Geographic* article that Cornell placed in his Crystal Cage valise observed: "The dim-out of coastal cities and towns has had its compensations for sky-gazing amateurs who, for the first time perhaps, are able to see relatively faint stars previously dimmed by city lights. Many an air-raid warden, on duty in a blackout, has noticed how bright the stars appear when man-made lights are off." See Donald H. Menzel, "The Heavens Above," *National Geographic*, July 1943, 97. Cornell later added another article on the topic to his *Celestial Theater* clipping file. See David Dietz, "War Dimouts Bared Stars by the Billions, Blackouts Helped Revise Estimate of Universe," *New York World-Telegram and Sun*, June 22, 1953. AAA (1070/306; 4.3/13/20/21).

20. As discussed in chapter 3, Cornell's fascination with the lights of Luna Park was shared by Duchamp, who wrote about the electric lights of Luna Park. Indeed, the

proposition stated in the *Green Box* "Preface" for *The Large Glass* can be read as an evocation of a trip to Luna Park, with its waterfall and brilliant electric (and even neon) lights: "Given: 1. the waterfall / 2. the illuminating gas, *in the dark.*" Duchamp's further mention of "the extra-rapid exposition," with its appearance of collisions seeming to succeed each other according to certain laws, evokes the seemingly chaotic but actually controlled mechanical rides of the amusement park, as well as the action of electrons. This "Given" proposition would, in turn, provide the title for Duchamp's 1946–66 assemblage, *Etant donnés*, a work that further recalls Luna Park's seedy Amusement Zone, with its striptease and peep shows.

21. Cornell may have associated Carolotta Grisi, who was known to have danced on horseback, with an equestrienne act seen at Luna Park. A diary note records "Carlotta Grisi—at Coney Island." AAA (1058/182; 3.2/10/29/10).

22. Helen H. Haroutunian first noted the link between Cornell's Berenice and the constellation Coma Berenices. See Haroutunian, "Joseph Cornell in 'View,'" 107. Perhaps Cornell also intended a wry allusion to F. Scott Fitzgerald's short story "Bernice Bobs Her Hair," written in 1920.

23. For a discussion of Cornell's use of Poe's "Berenice" within the context of American Surrealism, see Dickran Tashjian, *A Boatload of Madmen: Surrealism and the American Avant-Garde, 1920–1950* (New York: Thames and Hudson, 1995), 258–60. For the text of Poe's story, see *The Complete Poems and Stories of Edgar Allan Poe* (Garden City, NY: Doubleday, 1966), 171–77. It is worth noting that in Poe's story, Berenice is described as a young woman with a high forehead and curly dark hair, similar to the Berenice "portraits" Cornell included in the *Crystal Cage* collage and valise. The photograph of a Cornell object grouping, *Spent Meteor, Night of Feb. 10, 1843 (For E.A. Poe) J.C.* that appeared five pages after the conclusion of *The Crystal Cage [portrait of Berenice]* in *View* can be read as a visualization of the story in astronomical terms, complete with starry shards of broken glass that resemble the teeth that the narrator removes from the still-living, but presumed-dead Berenice in Poe's story.

24. See *Science and Health*, 199. The Eddy reference to Blondin was first noted by Sandra Starr in *The Crystal Cage [portrait of Berenice]*, 49. The conquering of fear is a predominant theme in Christian Science. At the end of his life, Cornell was still interested enough in the Christian Science denial of fear to save an article about the incompatibility of fear and spiritual understanding. See "I Am Not Afraid," *CSM*, August 8, 1970, 8. JCSC.

25. In imagining vaudeville performers as constellations, Cornell may have had in mind an earlier extravaganza performed at New York's Hippodrome, *A Yankee Circus on Mars*. A Vermont circus is whisked to Mars to perform on the pleasure-loving planet. They are met by a chorus of 300 Martians who proclaim the wonders of their planet. After the Yankee circus performs, the Martians conclude the show with the "Dance of the Hours" from Ponchielli's *La Gioconda*. With 150 women dressed in costumes representing times of the day and light effects for each hour, the effect was "breathless," according to the *New York Sun*. See Register, *The Kid of Coney Island*, 176–77.

26. Cornell could have been inspired to include King Kong by Garrett P. Serviss's aptly named novel *A Columbus of Space*, published in 1894. Although a copy of this

book is not in Cornell's library, he did include a quotation from another book by Serviss, *Astronomy with an Opera Glass*, in the checklist that accompanied his exhibition Winter Night Skies at the Stable Gallery in 1956. In *A Columbus of Space*, intrepid explorers in a dirigible-like balloon powered by interatomic energy travel to the planet Venus, where they encounter a resident of the dark side of the planet, "a creature shaped like a man, but more savage than a gorilla. . . . The great hairy head was black, but the stocky body was as white as a polar bear. The arms were apelike and very long and muscular, and the entire aspect of the creature betokened immense strength and activity." Later, Serviss describes a thwarted sacrifice, in which two gorilla-creature priests each carry a potential victim in their arms, a parallel that Cornell may have evoked with his inclusion of King Kong carrying Fay Wray in the lower left corner. See Garrett P. Serviss, *A Columbus of Space* (1894; reprint Westport, CT: Hyperion Press, 1974), 47–48, 67–68. The creature was illustrated in one of the four plates by Howard Heath in the Appleton edition of 1911. Cornell's inclusion of the figure of Columbus in the lower right corner of the collage strengthens the possible connection to Serviss's book, as do the dirigibles and balloons in the Berenice collage. In fact, with its inclusion of Columbus in the lower right corner, the entire collage might be seen as a visual pun on Serviss's title.

27. Henry Norris Russell, "Rotating Galaxies," *Scientific American* 167 (June 1942): 274–75.

28. JCSC.

29. *Science and Health*, 125.

30. Classical mythology does not associate Perseus with Pegasus; however, by the seventeenth century this relationship was firmly established, as seen in Peter-Paul Rubens's painting *Perseus and Andromeda*, 1620–21, now in the collection of the Hermitage, St. Petersburg, Russia. Cornell would have known this by reading his copy of Richard Hinckley Allen, *Star Names and Their Meanings* (London: G. E. Stechert, 1899), 320–31.

31. Cornell made the following note for his *Celestial Theater*: "poetic confusion in a child's mind of seeing the constellation of the Cat in astronomy bk. after animated Corticelli Silk cat & spool electric sign in old Times Square." AAA (1070/258; 4.3/13/21/52). He kept a photograph of the electric sign in his source materials. JCSC.

32. Sandra Starr notes that in 1849 Grisi danced the role of a star in the heavens in the ballet *Electra, ou la Pléiade Perdue*, and that Cornell described a drawing of Grisi by Brandard in *La Péri* as "looking for all the world like an equestrienne celeste." See Starr, *Joseph Cornell and the Ballet*, 40, 84, n. 19. The print of Grisi in *Giselle* that Cornell used as the source for the figures in his collage can be found in JCSC. There also exists an intriguing scientific parallel between Giselle and the action of minute electrons. As discussed by Henderson, an article in *Mercure de France* published in 1908 compared electrons to the fairy scene in *Giselle* in which the spirits dance around their queen like electrons around a nucleus, disappearing and recombining. See Henderson, *Duchamp in Context*, 19. There is no direct evidence that Cornell was aware of this article or other comparisons of the ballet *Giselle* with atomic theory; however, the parallel is intriguing. As seen in his scenarios for *Princess Nebula*, he was interested in the possibilities of using ballet to explore similarities between telescopic and microscopic worlds.

33. JCSC.

34. In fact, Cornell's references to the war in *The Crystal Cage* parallel those in Marianne Moore's antiwar poem, "A Carriage from Sweden" (1944), which Cornell praised for its "transcendent craftsmanship." See Jennie-Rebecca Falcetta, "Acts of Containment: Marianne Moore, Joseph Cornell, and the Poetics of Enclosure," *Journal of Modern Literature* 29, 4 (2006), 124–44.

35. Cornell may have chosen to include the headline for the office-boy story in his collage of Berenices because of its subheading: "Jobs Plentiful, Pay Is Higher, Only Rub Is Some Employers Find Girls Are Smarter." See "War Gives a Break to the Office Boy," *NYT*, April 14, 1942, 23.

36. See "Star Is Brightest Nova Found Since June, 1918," *NYT*, November 13, 1942, 16, and "Another Exploding Star Appears in the Heavens," *NYT*, September 27, 1942, E11.

37. Harry M. Davis, "More than Light from the Stars," *NYT*, April 26, 1942, SM16. In addition to describing how allied bombers used the stars for navigation, the article was illustrated with constellation charts, showing white figures on a black background, similar to those in Cornell's collage. The *National Geographic* article Cornell saved in the *Crystal Cage* valise described the use of the constellations during the war by sailors and pilots, while also relating the stories of various constellations, including Coma Berenices. See Menzel, "The Heavens Above," 97–128. Cornell seems to have been sympathetic to fighter pilots. He saved an article titled "The Heroes" from *Colliers*, August 4, 1945, for his files, illustrated with a drawing of a smiling pilot standing in front of a plane, as well as an article about paralyzed veterans, published in 1946 in an unidentified source, clippings showing fighter planes and pilots, JCSC.

38. Lana's airship was taken from *The History of Flight. A Descriptive Catalogue of Books, Engravings, and Airmail Stamps Illustrating the Evolution of the Airship and the Aeroplane* (London: Maggs Bros., 1936), no. 23. Cornell kept his copy of this catalogue in his "Celestial Theater Dossier." JCSC.

39. JCSC.

40. Henry B. Hersey, "The Menace of Aërial Warfare," *Century Magazine* 77 (February 1909), 627–30. The article described the work being done in Germany with aerial torpedos and warned that, with a suitable base near Montreal, attacks by dirigibles could be made on Boston and New York. AAA (1070/395–98; 4.3/13/22/26–29). Cornell may also have been thinking about the use during World War II of "barrage balloons," tethered balloons holding nets of cables designed to bring down dive bombers as they approached bombing targets. Their use was described in several articles in *Scientific American*, including R. G. Picinich, "Sky Sentries on Guard: Important U.S. Centers Are Protected by Barrage Balloons," *Scientific American* 170 (July 1943): 6–8.

41. Robert G. Aitken, "The Vivid Story Blazoned in the Skies: An Astronomer Tells Why Cares Vanish When One Gazes at the Stars," *NYT*, September 4, 1932, SM4, 12.

42. Max K. Gilstrap, "Wonders of Research: Stars, World's Astronomers Keep Up Friendly Contacts and Lift Gaze above International Strife," *CSM*, December 18, 1941, 8.

43. Pictures of the celestial globe and other illustrations of the Paris Exposition of 1900 can be found in JCSC.

44. Waldemar Kaempffert, "Changing Conceptions of the Universe: A Riddle Still," *NYT*, April 17, 1932, XX4.

45. Quoted by Cornell in the brochure that accompanied the exhibition Romantic Museum: Portraits of Women, Hugo Gallery, December 1946.

46. A detailed inventory of the box can be found in Starr, *The Crystal Cage [portrait of Berenice]*, 54–59.

47. For further discussion of Cornell's use of the term "innocent" as a form of sublimation, see Hauptman, *Joseph Cornell*, 179–80.

48. AAA (1070/256; 4.3/13/21/50). The editors of *Dance Index* subsequently announced it as "a special number on the Celestial Ballet and the Heavenly Spectacle." The magazine folded before Cornell's contribution could be published.

49. Dalí's *Dream of Venus* pavilion was a Surrealist architectural fantasy, complete with topless "mermaids" swimming in a tank of water. AAA (1070/258; 4.3/13/21/52).

50 JCSC.

51. Joseph Cornell, "The Celestial Theater," July 7, 1945. *Celestial Theater*, typed and handwritten notes, JCSC.

52. Ibid.

53. JCSC.

54. JCSC.

55. AAA (1070/257; 4.3/13/21/51).

56. *Celestial Theater* notes, JCSC.

57. See Edwin D. Neff, "Science at the Crossroads," *Natural History* (June 1946): 290–91; "Public Urged to Reassess Potentialities of Atom—for Peace, Not War," *CSM*, July 15, 1946, 11; William H. Stringer, "Bikini Shouts: Outlaw A-Bomb—Military Chiefs Cry: Enforce Ban," *CSM*, August 23, 1946, 11; "U.N. Atom Board to Speed Up Work on Control Study," *New York World-Telegram*, n.d.; David Bradley, "What Did Happen at Bikini?—Eyewitness Discloses Part of Story," *CSM*, March 11, 1949, 9; "A Thought for the Season," *NYT*, December 26, 1950, 19; "Needed: The Flash of Fact," *CSM*, April 23, 1952, 20; "Barrage of Publicity on Atomic Explosion Lifts Fear of Weapon," *CSM*, April 23, 1952, 1; "Brooklyn Housewife Helps Scan Skies for Enemy A-Bombers," *New York World-Telegram and Sun*, July 15, 1952, n.p.; "Hiroshima Today," unidentified source, September 10, 1952, n.p. AAA (1070/501–02; 4.3/13/24/30–31), (1070/491; 4.3/13/24/19), (1070/495; 4.3/13/24/52), (1070/573; 4.3/13/24/42), (1070/503; 4.3/13/24/40), (1070/274; 4.3/13/22/2), (1070/442; 4.3/13/23/25), (1070/455; 4.3/13/23/37), and (1070/499; 4.3/13/23/31).

58. JCSC.

59. AAA (1070/239; 4.3/13/21/44).

60. AAA (1070/238–39; 4.3/13/21/45). His immediate family shared his concern about the bomb. In an entry dated March 1, 1957, Cornell's brother Robert wrote in his diary in careful rounded script, "Last week Nell [their sister]—along with a lot of other people—was confused that Spring and crocus buds should "live side-by-side" (so to speak) with such things as H-bombs. Sure H bombs are terrific—Great clouds of dust heaving up to the sky. A dreadful threat hanging over us all. But let us see the promise the small crocus has for us. Life not death—eternity, not a sudden end. Why should we be confused when we have the Bible—Revelation is devoted to this subject." JCSC, Robert Cornell diary.

61. This photograph was originally published in the *Illustrated London News*, October 10, 1941, as an illustration of flak from German guns over Holland. The photograph was later used, with a different caption, in *Life* magazine, from which Cornell clipped it for the mounted version in his *Celestial Theater*. Cornell kept another copy of the photograph in his *Celestial Theater* source file, AAA (1070/524; 4.3/13/24/55). Additional copies can be found in JCSC.

62. JCSC.

63. JCSC.

64. Lewis Mumford, "Mirror of a Violent Half Century," *NYT*, January 15, 1950, BR1. In addition to the large star, Cornell drew lines above and below the words "Half Century." JCSC.

CHAPTER V: OBSERVATORIES

1. AAA, 1065/illegible frame number.

2. AAA (1059/216; 3.1/6/7/52).

3. "Commotion in the Sky," *CSM*, September 9, 1949, 20. Radio astronomy has its origins in the discovery in 1929 by the physicist K. G. Jansky of hisses in his radio receiver that could be traced to a source outside Earth.

4. Stuart Preston, "Diversely Modern," *NYT*, May 21, 1950, X6. In her biography of Cornell, Solomon claims that the artist "never kept reviews of his shows, never bothered to clip them from newspapers or magazines—a startling oversight for an artist who was always clipping and cutting, who was stirred by archival passions. . . . He made no effort to record his worldly accomplishments, as if somehow pained by the very notion of them." Solomon, *Utopia Parkway*, 250. Cornell did save reviews of his exhibits, sometimes circling or drawing a line in the margin after comments about his work. They can be found scattered throughout his papers and, in at least one case, even glued to the back of a box construction.

5. Stuart Preston, "Giacometti and Others, Recently Opened Shows in Diverse Mediums," *NYT*, December 17, 1950, X8.

6. AAA (1059/216; 3.1/6/7/52). Laurie Johnson, "Carrousel Burns in Central Park," *NYT*, November 9, 1950, 35.

7. AAA (1059/217; 3.1/6/7/53).

8. This metaphor had attained popular currency by the 1940s. For instance, in 1941 a writer in the *Monitor* had noted that the Sun and planets, "together with 28 moons, thousands of asteroids, comets, meteors and great clouds of gas comprise the solar merry-go-round." See "Strolling among the Stars," *CSM*, December 20, 1941, WM8.

9. AAA (1059/216; 3.1/6/7/52). Cornell kept multiple copies of a pamphlet about the astronomical mural in his *Celestial Theater* files. See AAA (1070/330–332; 4.3/13/20/45–46) and JCSC.

10. The temporal aspect of the work is further complicated on the back of the box, where a single page of text is covered with translucent white paint or whitewash. Although nearly illegible, it appears to derive from a novel featuring a countess, a marquis, and a marquise. The typography and quality of the paper indicate that it was removed from an eighteenth-century text.

11. Modern Earth-based telescopes, like the Hale Telescope on Mount Palomar, do not have lenses. Visual observation is made by studying the image of the sky reflected on a mirror, as recorded in detailed photographs. One of the first reflecting telescopes was designed by Newton to free his telescope from the chromatic aberration of a refracting lens.

12. Among the articles about reflecting telescopes in Cornell's *Celestial Theater* clipping files are Robert C. Cowen, "New Window on Universe," *CSM*, March 20, 1952, 19; Robert C. Cowen, "Charting the Universe," *CSM*, April 22, 1953, 13; Samuel Dutton Lynch, "Western Skies," *NYT*, January 17, 1954, XX19; Jonathan N. Leonard, "A Great Eye to See With," *NYT*, March 16, 1952, BR 28; Albert E. Norman, "A New Window on the Universe, " *CSM*, December 2, 1955, 13. See AAA (1070/293–94; 4.3/13/20/12), (1070/297; 4.3/13/20/15–16), (1070/302; 4.3/13/20/19), (1070/314; 4.3/13/20/23), and (1070/418–19; 4.3/13/23/5–6).

13. AAA (1059/287; 3.1/6/7/65).

14. Preston, "Giacometti and Others," *NYT*, December 17, 1950, X8. Cornell was apparently pleased enough with Preston's brief review to paste a clipping of it on the back of another box, *Planet Set, Tête Etoilée, Giuditta Pasta (dédicatrice)*, 1950, now in the collection of the Tate Gallery. See Jennifer Mundy, "An 'overflowing, a richness & poetry': Joseph Cornell's *Planet Set* and Guiditta Pasta," *Tate Papers* (Spring 2004), available at http://www.tate.org.uk/research/tateresearch/tatepapers/04spring/cornell_ paper.htm. Mundy links the article to Cornell's imagery, although she does not identify its source.

15. Cornell kept a copy of this page in a source material file, indicating that the passage was of special importance to him. JCSC.

16. AAA (1059/214; 3.1/6/7/47).

17. James S. Pickering, *The Stars Are Yours* (New York: Macmillan, 1948). For a review of the book see Herbert B. Nichols, "My Stars!" *CSM*, September 7, 1948, 18.

18. Waldemar Kaempffert, "A Cyclops Eye to Search the Cosmos," *NYT*, May 9, 1948, SM12.

19. Waldemar Kaempffert, "The Supreme Task of Science," *NYT*, October 24, 1948, SM16.

20. Quoted in Guy Halferty, "Astronomy Reaches for Stars and Facts. Physical Clues to Hint Metaphysics?" *CSM*, June 11, 1948, 13.

21. This work has a moveable panel that can be adjusted to reveal a constellation chart in place of the night sky, enabling both the modern and the mythological aspects of the heavens to be incorporated into a single box. See Hartigan, *Joseph Cornell, Navigating the Imagination*, 258–59.

22. Cornell had used this rounded construction earlier, in several aviary boxes from the late 1940s. However, in those boxes he usually used only one arc, and the opening at the top was wider. Perhaps he initially devised this type of fixture to evoke the rounded top of a bird cage, which, in turn, reminded him of the round dome of an observatory.

23. William L. Laurence, "Man's Biggest 'Eye' Will be Dedicated," *NYT*, June 3, 1948, 27.

24. *Galaxy* was shown at the Whitney Museum of American Art, *Annual Exhibition of Contemporary American Painting*, December 6, 1947–January 25, 1948;

Reflection of the Big Dipper, Comet, and *Shooting Star* were shown at the Betty Parsons Gallery in January 1948. For discussion of these paintings, see Kirsten Hoving, "Jackson Pollock's *Galaxy*: Outer Space and Artist's Space in Pollock's Cosmic Paintings," *American Art* 16 (Spring 2002): 82–93. Cornell kept clippings about Pollock, Miró, and Lippold, among other artists of this period, in his files, including an illustration of Lippold's *New Moonlight.*

25. Parker Tyler, "The Infinite Labyrinth," *Magazine of Art* 3 (March 1950): 93.

26. Boris Margo, "My Theories and Techniques," *Magazine of Art* 40 (1947): 273.

27. Pollock's notes can be found in Francis V. O'Connor and Eugene V. Thaw, *Jackson Pollock: A Catalogue Raisonné of Paintings, Drawings, and Other Works* (New Haven: Yale University Press, 1978), 4:253. The more finished text is excerpted from William Wright, "An Interview with Jackson Pollock," 1950, quoted in Ellen Johnson, *American Artists on Art from 1940 to 1980* (New York: Icon Editions, 1982), 5. For further discussion of postwar abstraction and the atomic bomb, see "The Atomic Sublime," in Gamwell, *Exploring the Invisible: Art, Science, and the Spiritual,* 259–79.

28. AAA (1059/344; 3.1/6/9/29 and 1059/346; 3.1/6/9/31).

29. AAA (1059/347; 3.1/6/9/32 and 1059/352; 3.1/6/9/37).

30. AAA (1059/352; 3.1/6/9/37 and 1059/360; 3.1/6/9/45). Nearly three years later, on April 29, 1954, he would think back to that night in Westhampton, when he listened to Beethoven's "Serioso" while looking at the stars. He also noted that he played this piece of music on February 8, 1953, "prep. to NIGHT VOYAGE exhibition at Egan Gallery." AAA (1059/1120; 3.1/6/17/16).

31. Here Cornell may have considered earlier uses of tickets in the context of avant-garde exhibitions, such as the bus tickets that numbered works of art on display at Max Ernst's first Paris exhibition in 1921 at the gallery Au Sans Pareil. Moreover, Cornell may have known of the full-page advertisement for the exhibition that appeared in *Littérature* that May that listed works by Ernst in a similar manner: "dessins mécanoplastiques plasto-plastiques peintopeintures anaplastiques anatomiques antizymiques aérographiques antiphonaires arrosables et républicains." See Adamowicz, *Surrealist Collage in Text and Image,* 1–2.

32. Stuart Preston, "From Far and Near," *NYT,* March 1, 1953, X8, and Sidney Geist, "Joseph Cornell," *Art Digest* 27 (March 15, 1953): 18.

33. A copy of a memo from Cornell to the Egan Gallery lists works and prices for the exhibition, but it does not match the works named in the announcement. Several items in the memo list are described as "unfinished." The work now called *Carrousel* may be the box listed as "Gemini-Orion." AAA (1067/385; 4.3/14/30/14).

34. In a variant on the 1952 *Carrousel,* the box known as *untitled (Hotel de l'Etoile)* (reproduced in McShine, ed., *Joseph Cornell,* fig. 218), Cornell used a larger photostat of the January, February, March page from the Burritt atlas. It included the obsolete constellation Telescopium Herschelli (Herschel's Telescope) in the upper left. Created by the Austrian astronomer and priest Abbé Maximilian Hell in 1781, this constellation honored William Herschel, the discoverer of Uranus. It is illustrated in Bode's *Uranographia* of 1801.

35. "'Sky Survey' Multi-Starred," unidentified article, JCSC. Pencil notation dated December 12, 1951.

36. Cornell's memo to the Egan Gallery lists "Camelopard" as "minus silver ring (box cracked in places)" and notes that it is "for sale but finished version will be in new case." AAA (1067/385; 4.3/14/30/14). He may have added the ring and chain, as well as the cylinder with the eclipse, after the exhibition. The solar eclipse image was clipped from Zim and Baker's *Stars*, 152. He trimmed the illustration and turned it 90 degrees.

37. JCSC.

38. There is an interesting parallel to Cornell's interest in zodiacal light in Duchamp's *The Green Ray*, exhibited at the International Exhibition of Surrealism in Paris in 1947. In this work, Duchamp incorporated the phenomenon of "green ray," an unusual optical phenomenon produced when, as it sets over the ocean, the rays of the sun are refracted, causing blue-green light to shine at the horizon. See Henderson, *Duchamp in Context*, 215.

39. "Magellanic Clouds Probed to Measure Cosmic Dust," *CSM*, December 4, 1950, 17. A simple explanation of zodiacal light appears in Zim and Baker, *Stars*, 134–35. Cornell clipped multiples pages of the explanation and put them in his "Zod. Light" paper bag, along with an article about the phenomenon published in *Scientific American* in 1960. JCSC.

40. AAA (1059/391; 3.1/6/10/28).

41. AAA (1059/296; 3.1/6/8/7).

42. Cornell kept an article describing the role of eclipse observation in proving Einstein correct. See Gerald Wendt, "New Vision of Universe as Seen by Einstein," *New York Herald Tribune Weekly Book Review*, January 16, 1949, VII 5. JCSC. On the dissemination of Einstein's theory of relativity in Europe and the United States, see Gamwell, *Exploring the Invisible: Art, Science, and the Spiritual*, 195–201.

43. Newspaper articles Cornell could have read about this eclipse and Einstein's theory include Robert C. Cowen, "Eclipse to Test Einstein Theory," *CSM*, February 13, 1952, 3; "Seeing Stars: Eye Catches Bent Light?" *CSM*, October 31, 1952, 2; "Tomorrow's Total Eclipse of the Sun," *NYT*, February 24, 1952, E9; Robert K. Plumb, "Eclipse in Africa Gives Scientists Split-Second Test of Key Theories," *NYT*, February 25, 1952, 1; "U.S. Can't See the Eclipse—Except in Planetarium," *NYT*, February 25, 1952, 9; "Fine Weather Aids Eclipse Scientists," *NYT*, Feburary 26, 1952, 13.

44. "Star Dust," *CSM*, August 14, 1948, 18.

45. AAA (1059/065; 3.1/6/4/30 and 1059/657; 3.1/6/17/11).

46. AAA (1059/662; 3.1/6/17/14).

47. The photograph of Lane appeared on the cover of *PIC* magazine's January 1957 issue. Cornell saved the cover as well as a smaller copy of the photograph, reproduced inside the magazine with text specifying Lane's height and measurements. JCSC. He also associated the dancer Pearl Lang with Andromeda, filing photographs of her together with a photostat of Helvelius' constellation figure. AAA, 1073/795–800.

48. Cornell probably found the griffon print in a book about Albrecht Dürer, who learned to draw animals from the pattern book that contained this and other animal images (also used by Cornell in other boxes). For discussion of Cornell's use of these animal images, see Ades, *Surrealist Art, The Lindy and Edwin Bergman*

Collection at the Art Institute of Chicago, 65. For discussion of Dürer's study of these images, see Colin Eisler, *Dürer's Animals* (Washington, DC: Smithsonian Institution Press, 1991), 9–10.

49. Charles A. Federer, Jr., "Scale of Universe Slated for Change," *NYT*, December 31, 1952, 16. This information was also included in Waldemar Kaempffert, "The Year in Science, Notable Achievements in Fields of Nuclear Physics, Astrophysics and Chemistry," *NYT*, December 28, 1952, E7. In these articles, Federer refers to the Andromeda "galaxy," while Kaempffert calls it a "nebula." The distance of the Andromeda Nebula was put at two million light years away in George W. Gray, "A Larger and Older Universe," *Scientific American* 188 (June 1953): 56–66. Cornell continued to build on this idea in another, perhaps unfinished, box entitled *A New Scale of Stellar Distances*, now in the collection of the Miami Art Museum.

50. George Gamow, "Modern Cosmology," *Scientific American* 193 (March 1954): 55.

51. Fred Hoyle, "Changing Concepts of the Universe, One Astronomer Discusses Signs That Forces of Expansion and Creation Are in Balance," *NYT*, June 1, 1952, SM12. JCSC. The theory of continuous creation had been proposed as early as 1930. See William L. Laurence, "Studies of the Cosmic Ray Point to Endless Creation," *NYT*, September 28, 1930, XX4.

52. Robert C. Cowen, "A Cosmologist Who Didn't Duck." Review of *The Nature of the Universe*, by Fred Hoyle, *CSM*, April 3, 1951, 9. AAA (1070/459; 4.3/13/23/41). Cornell also kept a 1955 review of Hoyle's next book, *Frontiers of Astronomy*: see "The Expanding Universe," review of Fred Hoyle, *Frontiers of Astronomy*, unknown source. AAA (1068/1069; 4.3/12/23/1). He made a diary note (AAA, 1058/ illegible frame) and saved a review of Hoyle's *Astronomy*, published in 1962. See Bernard Cohen, "Perspective on the Star-Gazers." Review of *Astronomy*, by Fred Hoyle, *NYT*, November 11, 1962, 313–14 . JCSC. Cornell also filed a review of Hoyle's *Galaxies, Nuclei and Quasars*. See Jonathan N. Leonard, "Space Is Full of Remarkable Things." Review of *Galaxies, Nuclei and Quasars*, by Fred Hoyle, *NYT*, December 19, 1965, BR7. Hoyle summarized his theory of a continuing universe in considerable detail for the general public in *Scientific American*. See Fred Hoyle, "The Steady-State Universe," *Scientific American* 195 (September 1956): 157–66.

53. AAA (1067/385; 4.3/14/30/14).

54. The writer further explained: "And yet Einstein's brilliant theory that 'energy equals mass times the speed of light, squared' exploded with devastating effect over Hiroshima." Unidentified clipping. JCSC.

55. Multiple copies of this printed quotation can be found throughout Cornell's papers, and he put it in his *Crystal Cage* valise. A typescript of it has a handwritten notation, "abandoned preface to NIGHT VOYAGE." AAA (1067/361; 4.3/14/30/9).

56. Records of Stable Gallery, Smithsonian Institution, Archives of American Art. Microfilm roll 5821.

57. AAA, 1059/1103, 1138, 939.

58. Garrett P. Serviss, *Astronomy with an Opera-Glass* (New York: D. Appleton, 1888; reprint 1908), 23. Cornell's quotation is not verbatim; he deleted an interior quotation. The parallel between Auriga and Christ was unusual. Neither Burritt nor Flammarion mentions it, and I have not seen it in any other source. As this quotation demonstrates, Auriga was clearly seen as a male figure, and there is no

basis for Solomon's description of Auriga as a female figure. See Solomon, *Utopia Parkway*, 240.

59. Stuart Preston, "About Art and Artists, Surge of Christmas Shows at Galleries Offers Varied Work to Public," *NYT*, December 17, 1955, 20.

60. Laverne George, "Joseph Cornell," *Arts Magazine* 30 (January 1956): 50.

61. Howard Griffin, "Auriga, Andromeda, Cameoleopardalis," *Art News* 56 (December 1957): 24–27, 63–65.

62. Ibid., 26–27.

63. In 1967 Cornell jotted a note: "review of material from 25 yrs ago—diversity—mags—toys own unfinished miniatures—etc. oppressiveness of so many possessions." JCSC.

64. Leslie Nelson Jennings, "Telescope," *CSM*, September 29, 1948, 8.

65. AAA (1060/814; 3.1/7/13/16).

66. Griffin, "Auriga, Andromeda, Cameoleopardalis," 27.

67. Stephane Mallarmé, *Collected Poems*, trans. Henry Weinfield (Berkeley: University of California Press, 1994), 12; quoted in Stevens, "Dance to the Music of Time," in *Joseph Cornell*, ed. Edwards and Taylor, 102.

68. AAA (1067/388, 389; 4.3/14/30/16).

69. Cecilia Payne-Gaposchkin, *Stars in the Making* (New York: Giant, in arrangement with Harvard University Press, 1959, first published 1952), xi–xii.

70. "Sculptor Wins $2000," *NYT*, January 17, 1957, 31, and "High Award Goes to Noguchi," *NYT*, December 2, 1959, 53.

71. *Science and Health*, 264. In a note dated 1962, Cornell penned these lines from *Science and Health*: "Neither the Substance nor the manifestation of Spirit is attainable through matter." JCSC.

72. *Science and Health*, 281, AAA (1058/442; 3.2/10/32/56).

73. *Science and Health*, 121.

74. Erwin D. Canham, "The World at Mid-Century: Natural Science Stirs with the Ferment of Inquiry and Enlightenment," *CSM*, December 23, 1950, WM3.

75. For instance, Cornell saved a page from the paper in one of his *Celestial Theater* source material files, where, between an ad for *Science and Health with Key to the Scriptures* and an illustration of Cepheus from a fifteenth-century Persian globe, there is a poem by Katharine Kennedy entitled "From Deep Space" that praises the beauty of the ancient constellations. The poem opens: "North of the zodiac the Herdsman, Boötes, / Shines on his flock, as Auriga the Waggoner / Moves up the Heavens, turning his fiery Wheel / Where stars mixed with nebulae blaze in deep space, forever," and it closes: "Who in the night of earth has felt them / through winter air, / Moving and singing in depths of space, / shining and singing forever" Katharine Kennedy, "From Deep Space," *CSM*, April 7, 1954, 12, AAA (1070/ 431; 4.3/13/23/17). Cornell also clipped a *Times* article: R. L. Duffus, "Faith Is a Star That Never Sets," *NYT*, December 25, 1955, SM5. JCSC.

76. "Lifted to the Stars," *CSM*, October 15, 1955, 18. JCSC.

77. AAA (1070/277; 4.3/13/22/5). See "A Window to the Stars," *CSM*, June 7, 1948, 26.

78. AAA (1070/280; 4.3/13/22/8). "Unfathomed Beauty," unidentified source, with typed note on page margin: "C. S. Monitor 1952–3?" A search of the *Christian Science Monitor* has failed to unearth this article.

79. Draft notes for a letter to de Kooning, dated October 15, 1951. In a more finished draft of the letter, marked "too rambling," he deleted mention of the Bible House façade and the new work it had inspired. AAA (1059/369, 370; 3.1/6/10/6).
80. The Astor Place Bible House building was demolished in 1956, an architectural loss Cornell mourned. The broken panes Griffin described in the window façade box, discussed in his *Art News* article in 1957, may have been added after the 1956 demolition. Cornell saved some debris, including broken glass, from the building after it was razed. He may even have made a film of the ruin, according to an ambiguous note dated May 7, 1957, that reads, "This morning cut films for *1st time since shot on selfsame day* as this was acquired on 9 St. Shorts teen-agers and Bible House demolition color 200 ft. Same morning as was glimpsed young woman in blue en route along Astor Place." JCSC.
81. AAA (1059/813; 3.1/6/20/21).

Chapter VI: The Science of the Stars

1. Harrison E. Salisbury, "Russian Astronomers Hold Theory of Cosmos Origin Surpasses West," *NYT*, July 14, 1949, 1, and "Marx and the Milky Way," *CSM*, July 16, 1949, 18.
2. Quoted in Charles Poole, "Books of the Times," *NYT*, March 24, 1951, 10.
3. "Marx and the Milky Way," 18.
4. "No Room for Amorality," *CSM*, January 15, 1953, 18.
5. Pearl Strachan Hurd, "In Orbit," *CSM*, April 5, 1958, 15.
6. JCSC.
7. Cornell saved an article from *Scientific American* that neatly explained early theories of epicycles. See George de Santillana, "Greek Astronomy," *Scientific American* 180 (April 1949), 44–47. JCSC.
8. "Poland Is Saluted at Copernicus Fete," *NYT*, May 25, 1943, 25.
9. C.J., "Reason for Rejoicing: Poles Recover Home of Famous Astronomer," *CSM*, August 25, 1948, 9.
10. Although this box bears the title *Soap Bubble Set*, it lacks the clay pipes found in all other examples of this genre. The open area at the bottom of the box and the missing clay pipe or pipes suggest that this work may be unfinished.
11. Descartes' theory of *tourbillons* may also lie behind another work by Cornell, *Untitled (Discarded Descartes)*, c. 1954–56, in which a box is divided into a grid, each compartment filled with a small rubber ball, about half of which are decorated with a swirling pattern, reproduced in McShine, ed., *Joseph Cornell*, fig. 180. In a note written in 1961, Cornell refers to a work, perhaps this one, as "Colombier Descartes." Cornell used the term "tourbillon" in the draft of a letter to Susan Sontag written in 1966 to describe an overexcited emotional state. AAA, 1062/240.
12. George Gamow, "Turbulence in Space," *Scientific American* 186 (June 1952): 26–30. Turbulence remained an issue of interest to physicists. On his deathbed in 1976, physicist Werner Heisenberg is reported to have said, with characteristic uncertainty, "When I meet God I am going to ask him two questions: Why relativity? And why turbulence?"

13. With a tip of the hat to Descartes, Cornell puckishly titled another work box *Video, ergo sum*. It was included in a one-man exhibition, Selected Works by Joseph Cornell: Bonitas Solstitialis and an Exploration of the Colombier, held at Bennington College in late 1959. Exhibition announcement, in *The Crystal Cage* valise.

14. For instance in 1950, in a book review of Herbert Butterfield's *The Origins of Modern Science*, a critic observed, "Marxists persistently try to explain away basic changes in our ideas about the universe by reference to their devil-angel notion of class struggle. Yet looming large in the seventeenth-century phase of the scientific revolution was the economy of thought provided by the union [formulated by Descartes] of geometry with algebra. This fact is certainly no less relevant than the mode of production of economic goods, if we are to understand the great scientific discoveries of that age." See "The Revolution of the Scientists," *NYT*, February 26, 1950, BR4.

15. Jacques Delille, *Les Trois Regnes de la Nature, par Jacques Delille. Avec des notes par M. Cuvier, de l'Institute, et autres savants*, 2 vols. (Paris: H. Nicolle, 1806), 44.

16. Ibid.

17. Ibid., 45–46. "Dans les mains d'un enfant, un globe de savon / Dès long-temps précéda le prisme de Newton; / Et long-temps, sans monter à sa source première, / Un enfant dans ses jeux disséqua la lumière; / Newton seul l'apperçut, tant le progrès de l'art / Et le fruit de l'étude est souvent du hasard!" [In the hands of a child, a globe of soap / Long ago preceded the prism of Newton; / And long ago, without turning to his first source / A child in his games dissected light; / Newton alone perceived it, so much for the progress of the art / And the fruit of study is often luck!], 46.

18. If we simply turn the box over and examine the outer bottom, we find an unexpected sight: a picture of a parakeet surrounded by a garland of yellow flowers. Perhaps this was an allusion to the theme of "Pasta's Parrot" that intrigued Cornell for two decades as he compiled a dossier devoted to the nineteenth-century bel canto singer Giuditta Pasta. He devoted a soap bubble set variant to her in 1950, *Planet Set, Tête Etoilée*, with a secondary title, *Giuditta Pasta (dédicace)*, and included pictures of a parrot with a card stamped with the words "Pasta's Parrot" in his Pasta dossier. Jennifer Mundy argues convincingly that Cornell linked the singer to the concept of the music of the spheres in the planet set box. And, perhaps a similar train of associations was triggered by Delille's invocation to Newton to "montre-moi les spheres éternelles" in the poem wrapped around the little box. For an extended discussion of the work and its relation to Pasta, see Mundy, "An 'overflowing, a richness & poetry': Joseph Cornell's *Planet Set* and Giuditta Pasta," n.p.

19. These works are often referred to in the Cornell literature as "sand trays." Cornell did use this term, although only rarely. His usual term was "sand boxes."

20. Cornell saved the cellophane-windowed lid of a "Leo's Cream Horn" box and noted in his diary in 1959, "LEO creme horn inspiration of 'motion' in boxes." JCSC. Typical of Cornell's widely woven net of associations, he also saved a page from a nineteenth-century book that described a poem by the ancient philosopher Lucretius, who argued that without motion the cosmos would collapse into chaos. An excerpt of the poem appears above a drawing of a series of nebulae in garlanded medallions. See *Scenery of the Heavens*, 178. JCSC.

21. Cornell could have learned these facts about Archimedes' *Sand-Reckoner* by reading Sir Thomas Heath, *Archimedes* (London: Society for Promoting Christian Knowledge, 1920), 45–49. JCSC. Near the end of his life he drafted a note listing some of the lost works of Archimedes, including his treatises on numeration and sphere making. See note to "Helen," dated April 24, 1972. AAA (1064/445; 3.1/10/16/25).

22. "For Finding Lost Moons or Lost Dollars," *Scientific American* 195 (September 1956): 144.

23. See, for instance, Adler, *Mathematics, The Story of Numbers, Symbols, and Space*, 17. Cornell clipped illustrations from this book, including ones showing a nautilus shell and cornstalk growth in this spiral pattern. AAA (1058/637; 3.2/10/26/13).

24. Cecilia H. Payne-Gaposchkin, "Why Do Galaxies Have a Spiral Form?" *Scientific American* 189 (September 1953): 89–99. This article was in an issue featuring "Fundamental Questions in Science." Cornell was interested in other types of spirals and saved the cover of an issue of *Scientific American* that featured the angled spiral configuration traced in a prime-number pattern. See *Scientific American*, 212 (March 1964): cover. JCSC.

25. AAA (1067/477; 4.3/16/15/10).

26. William L. Laurence, "Basic Pulse Beat of Universe Seen in Particle Born within the Atom," *NYT*, February 2, 1947, 4.

27. "Atom in a Whirl," *CSM*, December 16, 1952, 13. The term "atom smasher" was first used in the *Christian Science Monitor* in 1932 and in the *New York Times* in 1933.

28. Robert K. Plumb, "Dedication Held for Cosmotron," *NYT*, December 16, 1952, 40. A similar explanation was presented earlier when Herbert B. Nichols observed, "Whereas the atomic bomb changed small amounts of matter into energy (heat) by atomic fission, the production of mesons is substantially the reverse reaction, or the turning of energy into matter. Thus is Einstein's theory of the equivalence of mass and energy again vindicated." See Nichols, "Meson News Accents Secrecy of Russians," March 9, 1948, *CSM*, 15. The principle behind the cosmotron was explained in detail in Ernest D. Courant, "A 100-Billion-Volt Accelerator," *Scientific American* 188 (May 1953): 40–45.

29. JCSC. For a description and illustrations of the use of bubble chambers in photographing the submicroscopic world of the atom, see Donald A. Glaser, "The Bubble Chamber," *Scientific American* 192 (February 1955): 46–50. Cornell continued to save articles about the atom, including Robert C. Cowen, "Natural Scientists Quit Ivory Tower," *CSM*, March 22, 1958, 9, and Alton Blakeslee, "Find New Atomic Anti-Particle," *New York Mirror*, March 15, 1962, 4. JCSC. For a discussion of early twentieth-century research using cloud chambers to study "tracks" of atoms and its possible relation to works by Duchamp, see Henderson, *Duchamp in Context*, 20.

30. See Robert C. Cowen, "The World of Physics: A Cosmic Chess Game," *CSM*, April 23, 1958, 9, where the "Billiard Ball Theory" is discussed in detail. The baseball metaphor is used in Nichols, "Meson News Accents Secrecy of Russians," 15.

31. Herbert B. Nichols, "Length—Breadth—Space—Time," *CSM*, January 20, 1949, 11.

32. Research into the composition and forces determining the atom was a topic of great interest in the 1950s. Simple explanations of complex aspects of nuclear physics appeared in numerous articles in *Scientific American,* many of which included photographs and charts of subatomic particles, especially showing their star and spiral patterns. See, e.g., Herman Nagoda, "The Tracks of Nuclear Particles," *Scientific American* 194 (May 1956): 39–47; Emilio Segrè and Clyde Wiegand, "The Antiproton," *Scientific American* 194 (June 1956): 37–41; E. P. Rosenbaum, "Physics in the U.S.S.R.," *Scientific American* 195 (August 1956): 29–35; Sergio DeBenedetti, "Mesonic Atoms," *Scientific American* 195 (October 1956): 93–102. Articles about atom smashing appeared in *Scientific American* as early as 1941. See C. W. Sheppard, "Atom Smashing: Two Methods," *Scientific American* 164 (May 1941): 282–83. Cornell remained interested in mesons, saving an article published in 1970 about particle physicists, illustrated with a bubble chamber and spiral meson tracks. See "Particle Physicists: Probing the Cost of Research," *CSM,* September 5–6, 1970, 11.

33. W. P. Keashey, "Did You Ever Wonder How Ordinary Sand Can Be Made to Act as a Fluid?" *CSM,* May 25, 1942, 17.

34. Cornell wrote to J. B. Newmann on October 25, 1946: "From the way you spoke of Prof. Einstein, I got the impression that this gentleman is a friend of yours. And so I have been wondering if it might be in the realm of possibility to put before him a few of the new sand boxes for his pleasure and possibly a word or two of appraisal or commendation." Quoted in Ashton, *A Joseph Cornell Album,* 5.

35. Frank O'Hara, "Joseph Cornell and Landes Lewitin," *Art News* 54 (September 1955), 50. JCSC.

36. E. N. da Andrade, "The Birth of the Nuclear Atom," *Scientific American* 195 (November 1956): 93–102. JCSC.

37. In notes he placed in his Marilyn Monroe dossier, Cornell cited Max Planck's book, *Where Is Science Going?,* noting numbers of pages on which Planck discusses Bohr's model of the atom. JCSC. Cornell's reference is to Max Planck, *Where Is Science Going?* (London: George Allen & Unwin, 1933), 60–61.

38. Nancy Wilson Ross, "The Enormous Miracle," *Collier's* (February 1951), 136, 213. JCSC.

39. Emilie Tavel, "Moonwatchers Caught in Sputnik's Web," *CSM,* October 19, 1957, 9.

40. For a brief discussion of Cornell's space object boxes from an astronomer's viewpoint, see Charles Whitney, "The Cosmology of Joseph Cornell," in *Joseph Cornell Cosmic Travels,* ed. Beth Venn (New York: Whitney Museum of American Art, 1995), [4–6].

41. For discussion of the affinities between works of Cornell and Rauschenberg, see Anna Dezeuze, "Unpacking Cornell: Consumption and Play in the Work of Rauschenberg, Warhol, and George Brecht," *Papers of Surrealism* 2 (Summer 2004): 1–24.

42. I. M. Levitt, "Now the Space Age Opens," *NYT,* October 13, 1957, 19, 82–83. JCSC.

43. This box bears no date, although it was listed as "c. 1960" in McShine, ed. *Joseph Cornell,* plates 18, 19. The collage material appears to have come from the 1956 edition of Zim and Baker's *Stars,* in which the telescope has a brighter highlight

on its tube than it does in the 1951 edition. Given the *Sputnik* context, I would date its beginning to late 1957 or 1958. There is no indication as to when Cornell finished it.

44. "Sputnik Timetable Set," *CSM*, October 18, 1957, 5.

45. The diagrams clipped from Zim and Baker's *Stars* illustrate a shooting star, at the far left, and Halley's comet, next to it.

46. The picture of the sculpture was taken from an article, multiple copies of which Cornell saved for his files: Wilfred Sainsbury, "Soft-paste Biscuit of Vincennes-Sevres," *Antiques* (January 1956), 49–50. JCSC and AAA (1075/728–731; 4.3/18/6/6–11). A group of individually trimmed statues from this article can be found in the file "cameos." AAA (1070/21–24; 4.3/13/12/1–3). In a note written in 1970, Cornell confirmed that this figure was intended to represent the constellation: "Box with Cassiopeia on the bk. Prominent DOG STAR <u>Myth</u> figure of constellation." JCSC.

47. "Moonlet Craze Grows," *CSM*, October 12, 1957, 3.

48. "Sputnik in TV Drama," *NYT*, October 15, 1957, 67.

49. Thomas J. Hamilton, "World Seen Reaching a Balance of Terror," *NYT*, October 13, 1957, 183.

50. Robert C. Cowen, "The Great Space Adventure Begins," *CSM*, October 12, 1957, 13, and "'Big Brother' in the Sky?" *CSM*, October 14, 1957, 3.

51. William H. Stringer, "State of the Nations: Consequences of Second Best," *CSM*, October 15, 1957, 1.

52. "On Satellite's Meaning; Eisenhower's View," *NYT*, October 13, 1957, 181.

53. "Satellite 'Beeping' Has Lighter Side," *CSM*, October 9, 1957, 6, and "Soviet People Proud of Recent Successes," *NYT*, October 13, 1957, 185.

54. JCSC. This advertisement appeared in *Natural History* magazine in February 1960.

55. Housefield and Davis propose a similar geopolitical reading for several of Cornell's boxes that incorporate maps and references to current events, such as *Isabelle/Dien Bien Phu* (1954). See Housefield and Davis, "Joseph Cornell, Geographer of Utopia Parkway," in *Joseph Cornell*, ed. Edwards and Taylor, 47–68.

56. See, e.g., Cornell's box, *Trade Winds No. 2*, 1956–58, The Robert Lehrman Art Trust. Also on the back of the box are pages, probably taken from the same unknown book, with the heading "Spinoza."

57. Cornell was very interested in Heisenberg's work. Late in his career Cornell produced a collage entitled *The Uncertainty Principle*, and he clipped articles about Heisenberg's work for his files.

58. AAA (1070/0093; 4.3/13/15/10). Entry marked "For Cassiopeia," dated April 29, 1963. Cornell noted the source of the quotation as John Greene's *Death of Adam* [(Iowa: Iowa State University Press, 1959), 14]. In Greene's book, Aristotle's words, together with a quotation from Fontenelle's *Plurality of Worlds* of 1686, form an epigraph preceding chapter 2, "The Inconstant Heavens."

59. He saved a *Scientific American* issue with a detail of a painting by Leonardo on the cover to illustrate the issue's theme: "Innovation in Science." An article in that issue by Jacob Bronowski discusses the role of innovation in the work of creative thinkers, from Copernicus to Einstein. See Jacob Bronowski, "The Creative Process," *Scientific American* 189 (September 1958): 59–65. JCSC. Cornell's interest in

Leonardo and his use of mirror-writing is discussed briefly in John Coplans, "Notes on the Nature of Joseph Cornell," *Artforum* 1 (February 1963): 27–29. For a parallel discussion of Duchamp and Leonardo, see Henderson, *Duchamp in Context*, 72–75, 155–57.

60. She may have been a young woman named "Pauline" or "Anne-Marie"—diary entries relate both names to "Cassiopeia." See AAA (1070/47; 4.3/13/13/19 and 1070/82; 4.3/13/14/20).

61. AAA (1070/0035; 4.3/13/14/5).

62. AAA (1070/0036; 4.3/13/13/5, 1070/0048; 4.3/13/13/20 and 1061/288; 3.1/7/48/4).

63. AAA (1061/212; 3.1/7/45/31).

64. AAA (1061/266; 3.1/7/47/16).

65. AAA (1070/50; 4.3/13/13/22).

66. AAA (1070/31; 4.3/13/13/4 and 1070/51; 4.3/13/13/23).

67. AAA (1070/56; 4.3/13/13/28).

68. AAA (1070/0148; image not scanned; 1070/0109; 4.3/13/16/1).

69. AAA (1070/154; 4.3/13/16/28, 1070/145; image not scanned; 1070/146; 4.3/13/16/24, 1070/149; 4.3/13/16/25, 1070/192; 4.3/13/17/43).

70. Max Frankel, "Soviet Rocket Hits Moon after 35 Hours," *NYT*, September 14, 1959, 1, 16. JCSC.

71. "Russians Hailed Abroad for Achieving a Technological Breakthrough," *NYT*, September 14, 1959, 17; "U.S. Plans Advanced 'Guidance' for Lunar Rocket Next Month," *NYT*, September 14, 1959, 17; "Myths of Moon Survive the Ages," *NYT*, September 14, 1959, 17; "Lunar Life Held Unlikely," *NYT*, September 14, 1959, 17. JCSC; "New Soviet Space Triumph," *CSM*, October 5, 1959, 9. JCSC.

72. "What Mr. Khrushchev Won't See," *NYT*, September 10, 1959, 34. JCSC.

73. The box is dated c. 1957 in Ades, *Surrealist Art, The Lindy and Edwin Bergman Collection at the Art Institute of Chicago*, although there is no clear reason for this date. The date of the Bergman purchase is cited only as "October 1959."

74. A few years later, Cornell would save a review of poet Robert Lowell's *For the Union Dead* that compared Lowell's work with the story of Samson in the Book of Judges. In a paragraph that Cornell circled, the reviewer remarked, "No other English or American poet of his generation has, in his handling of language, the same sheer brute strength; no other poet is so deeply moved not only by moral but by physical horror and disgust (which can include self-disgust), and by a kind of blind Samson-like ferocity." G. S. Fraser, "Amid the Horror, A Song of Praise," *NYT*, October 4, 1964, BR 1. JCSC.

75. Such fantasies may have inspired the box construction *Reentry from Space*, with its plastic spaceman striding on a lunar landscape. On the inner back of the box is pasted a diagram of satellite reentry paths as they enter Earth's gravitational field, taken from a *Scientific American* article. Unidentified article in a file marked "Science." AAA, 1075/344; image not scanned. This box is so strangely un-Cornellian that without a clear provenance its attribution would be questionable. The back of the box is papered with pages from Lucretius but not pieced in varying orientations as in other boxes, and the signature is not reversed. Above all, the use of a toy spaceman seems oddly facile. Perhaps he made this box together with his brother

Robert, with whom he sometimes collaborated on collages. Regardless of the circumstances of its production, the box captures the spirit of the era preceding the first lunar landing.

76. Sydney Chapman, "Tides in the Atmosphere," *Scientific American* 190 (May 1954): 36–39.

77. JCSC and AAA (1060/0167; 3.1/7/21/30). (Cornell notes "the joys this AM playing PIPE DREAM—reprise 4 times a real poignancy." Dated 6/30/1959.)

78. JCSC and AAA (1060/1088; 3.1/7/20/7).

79. AAA, 1059/1327.

80. AAA (1059/230; 3.1/6/7/8).

81. AAA (1059/381; 3.1/7/1/18 and 1059/504; 3.1/7/7/17).

82. AAA (1059/229; 3.1/6/7/7).

83. "Serenity," *CSM*, June 13, 1956, 8.

84. AAA (1059/227; 3.1/6/7/5).

85. The owl coin is identical to a Greek coin reproduced in the special *Life* magazine reprint, "The Atom: A Primer for Laymen," *Life*, May 16, 1949. There the coin represents the element silver. Cornell owned multiple copies of this issue. JCSC.

86. Gladwin Hill, "Sun Study Begins with Rocket Shot," *NYT*, July 2, 1957, 4.

87. JCSC. While the box is undated, it postdates 1955, when the book from which the illustration was taken was published. See Rose Wyler and Gerald Ames, *The Golden Book of Astronomy* (New York: Simon and Schuster, 1955), 57. The interior of the box is painted yellow and contains scraps of white wood and bits of tin trimmed from the outer edge of an Il Sole antipasto can lid.

88. William L. Laurence, "Science Observes Sun 'Blow A Fuse,'" *NYT*, April 29, 1954, 33. See also J. P. Wild, "Radio Waves from the Sun," *Scientific American* 192 (June 1955): 40–44. In today's terminology, a "coronoscope" is called a "cornonagraph."

89. "Cosmic Rays Strike Imagination: What Is Shooting All About?" *CSM*, Nov. 20, 1950, 9, and "Sun Spots Called Islands of Calm Afloat in Turbulent Atmosphere," *NYT*, January 17, 1958, 8.

90. John W. Finney, "Satellite Finds New Solar Data," *NYT*, April 20, 1961, 8.

91. Present whereabouts unknown. Reproduced in Blair, *Joseph Cornell's Vision of Spiritual Order*, 200. Cornell may have been inspired to think of the Sun as a magnet by reading Arthur Koestler's *The Sleepwalkers*, a book he owned and admired. In Koestler's discussion of Kepler, the author explains Kepler's theory of solar magnetism and its role in Newton's development of his law of universal gravitation. See Arthur Koestler, *The Sleepwalkers* (London: Hutchinson, 1959), 499–500.

92. For discussions of the theme of navigation in Cornell's work, see Angela Kramer Murphy, "Imaginary Voyages," in *Joseph Cornell: Cosmic Travels*, [7–13], and Ursula Seibold-Bultmann, "Joseph Cornells Object (Rose des Vents) und das Thema der Imaginaren Reise," *Zeitschrift fur Kunstgeschichte* 57 (1994): 549–58.

93. Lt. Com. P.V.H. Weems, U.S. Navy, "Celestial Navigation," *The Sky, Magazine of Cosmic News* 1 (November 1936): 12–13, 24–25.

94. See Philip Benjamin, "Role of Computers in Astronomy Shown in Planetarium's Exhibit," *NYT*, September 13, 1958, 40. Cornell was interested enough in computers to add to his files a *Scientific American* cover story on mathematical machines.

See Harry M. Davis, "Mathematical Machines," *Scientific American* 180 (April 1949): cover and 28–39. JCSC.

95. "Radar Discovers New Venus Data," *NYT*, May 29, 1961, 19.

96. Robert C. Cowen, "New Astronomy Field Opens: Giant Radar Leap Hits Sun," *CSM*, February 5, 1960, 3.

97. Louis J. Battan, *Radar Observes the Weather, New Understanding of Cloud Physics* (New York: Doubleday, 1962), 113–27. Cornell's notes remain in his copy of the book, JCSC.

98. "E.C.F. Sauer, "Celestial Navigation by Birds," *Scientific American*, 42–47. JCSC, and W. H. Drury, Jr., et al., "The Migration of Angels," *Natural History* 70 (October 1961): 10–17. AAA, 1066/21–25.

99. He may have first read about this phenomenon in *Scientific American*. See Henry Norris Russell, "Algol's Eclipses," *Scientific American* 162 (February 1941): 86–87, and Henry Norris Russell, "Eclipsing Binaries," *Scientific American* 161 (November 1939): 274–75.

100. "The Astro-Twins on Red Earth," and Stuart H. Loory, "Were Astro-Twins Hurt?" *New York Herald Tribune*, August 16, 1962, 1. JCSC.

101. Murray Schumach, "Marilyn Monroe Funeral Is Held in Hollywood," *NYT*, August 9, 1962, 22. Marilyn Monroe Dossier, JCSC.

102. JCSC.

103. "Twilight of a Star: Mother Deserted and Ill, MM's Grief Started Early," *New York Daily News*, August 16, 1962, 34. JCSC.

104. This statement was clearly important to him. He also produced a typed version of it, adding ellipses and quotation marks. He wanted to convey the "tremulous, teeming symbolism of the stiles . . . the spectator not going through—this commonplace with its immense revelation," as he explained in a note. JCSC.

105. JCSC.

106. Cornell included one of his versions of *Custodian (Silent Dedication to MM)* in the 1967 exhibition of Marilyn Monroe-inspired work held at Sidney Janis Gallery. There critics responded positively, with Peter Schjeldahl writing in the *Times* that "it embraces the morbidity of the [exhibition's] theme only to resolve it in a kind of lyrical celebration." Peter Schjeldahl, "Marilyn: Still Being Exploited?" *NYT*, December 17, 1967, 40.

107. Allen's book was a Dover reprint, published in 1963, of G. E. Stechert's 1899 volume, *Star-Names and Their Meaning*. Cornell cited both editions in his notes. JCSC.

108. As Doss points out, Cornell originally considered titling his memorial for Monroe "The Flight from Laputa (for M.M.)." The title refers to a chapter in William Barrett's popular book, *Irrational Man: A Study in Existential Philosophy* (1958), which Cornell purchased on the day of Monroe's funeral. Barrett analyzes the floating island of Laputa in Jonathan Swift's *Gulliver's Travels*. According to Doss, "Driven by the power of an immense magnet, Laputa is named after the Italian word for 'whore' and consists of a population of odd creatures who have one eye turned inward, in constant self-reflection, and the other turned upward, in perpetual contemplation of the stars. Dressed in clothes decorated with symbols of the sun, moon, stars, and various instruments, the people of Laputa are so

lost in lofty thoughts about astronomy, math, and the 'science' of music, or so preoccupied with themselves, that their lives are completely out of balance. . . . While Cornell abandoned his original title because he perhaps considered 'Laputa" too vulgar a term for his intended evocation of feminine spirit, he sustained Swift's Counter-Enlightenment satire about irrational faith, and unharmonious existence, in his memorial boxes to Marilyn Monroe." See Doss, Joseph Cornell and Christian Science," in *Joseph Cornell*, ed. Edwards and Taylor, 133–34.

109. JCSC.

110. "The Only Blonde in the World," *Time* 80 (August 10, 1962), 45. JCSC.

111. Robert Nelson, "The Universe on TV," and "Right to Privacy," *CSM*, August 6, 1962, 9. JCSC.

112. Quoted in Hauptman, *Joseph Cornell: Stargazing in the Cinema*, 207. Hauptman discusses the *Custodian* box in terms of Cornell's view of his role as a caretaker of the movie stars he admired. She writes, "What we see most clearly in examining the artist's portraits and homages are extensive and complex desires and fantasies: in works devoted to Hedy Lamarr, Lauren Bacall, Rose Hobart, Greta Garbo, Jennifer Jones, Deanna Durbin, Margaret O'Brien, Virginia Weidler, and Marilyn Monroe, Cornell expresses, among others, his longing to hold on to the past, to return to childhood, to map the city, to come to terms with modernity, to purify himself into innocence, and to gaze freely upon the young female body. For this reason Cornell's caretaking always threatens to mutate into manipulation; the custodian's double is inevitably the master." But what artist is not master of his or her own creative vision, and what artist does not place his or her own imprint on the subjects of his or her works? Rather than seeing Cornell's response to these subjects as a threatened mutation into an unnatural position of power against now-defenseless film stars, I prefer to think of Cornell as an artist who took seriously the act of memorializing individuals he admired in his art. The planning and making of memorials provided him with some of his most fulfilling creative moments.

113. JCSC. Cornell listed the pages on which the following passage appears: "The profound depths of thought cannot be penetrated by ordinary intellect. And when we say that spiritual happenings are determined, the statement eludes the possibility of proof. It is of a metaphysical character, just as the statement that there exists an outer world of reality. But the statement that spiritual happenings are determined is logically unassailable, and it plays a very important role in our pursuit of knowledge, because it forms the basis of every attempt to understand the connections between spiritual events." See Max Planck, *The New Science* (Greenwich, CT: Meridan Books, 1959), 60–61.

114. JCSC.

115. Solomon describes Cornell's space object boxes as deeply autobiographical, writing: "The Space Object Boxes, despite their coded symbolism, are as autobiographical as any Cornell made. Their rolling balls suggest mobility and adventure, and stand in sharp contrast to the other elements in the boxes—particularly the broken clay pipes, with their hint of sexual impotence. The cordial glasses, too, have discomfiting associations; they're brittle, fragile, cold to the touch. All in all, Cornell's Space Object Boxes, with their gently rhyming circular shapes, hark back to his very

first shadow box, his *Soap Bubble Set* of 1936. Yet now the childhood bubbles have vanished; coldly orbiting planets appear in their place. The boxes hint at a longing for romantic attachment and a kind of sexual frozenness that makes romance impossible, except as experienced through the artist's solitary celestial navigations." Solomon, *Utopia Parkway*, 248–49. While such a reading of these boxes may, on one level, be legitimate, it ignores the context for the creation of these works and Cornell's avid interest in cold war politics and space race concerns.

Chapter VII: The Twilight Zone

1. Together with Duchamp, Cornell also participated in Art and the Found Object in 1959, an exhibition organized by the American Federation of Arts, and late in that year he was the focus of a one-person exhibition at Bennington College entitled Selected Works by Joseph Cornell: Bonitas Solstitialis and an Exploration of the Colombier. In 1962 Irving Blum presented a solo exhibition of Cornell's work at the Ferus Gallery in Los Angeles.

2. Harold Rosenberg, "Object Poems," *New Yorker* 43, June 3, 1967, 115.

3. John Ashbery, "Cornell: The Cube Root of Dreams," *Art News* 66 (Summer 1967): 63.

4. Ibid., 63.

5. Hilton Kramer, "The Poetic Shadow-Box World of Joseph Cornell," *NYT*, May 6, 1967, 27.

6. JCSC.

7. A note in Cornell's papers, dated June 25, 1963, indicates the visit of Charles Henri Ford, Andy Warhol, Robert Indiana, and James Rosenquist. AAA (1061/845; 3.1/10/1/48). Another note indicates a visit from Yoko Ono and John Lennon on June 27, 1971. AAA (1064/699; 3.1/8/6/9).

8. JCSC.

9. "Imagined Universe Stored in Boxes," *Life* 63, December 15, 1967, 52.

10. David Bourdon, "Enigmatic Bachelor of Utopia Parkway," ibid., 66.

11. Ibid.

12. Ibid.

13. On April 3, 1961, Cornell wrote: "Sense of relationship of unfolding experience—various 'images' yesterday—strangely wonderful dream image (sunny room sleeping upstairs) of esteemed figure of astronomer (?) holding a quadrant by side of head in frozen attitude as in a waxworks." AAA (1061/70; 3.1/7/41/3). On April 8, 1961, he described this as "vision of the sunlit astronomer." AAA (1061/84; 3.1/7/41/19). This vision was probably inspired by a memory, perhaps unconscious, of a print picturing the astronomer Hevelius standing beside a large quadrant that Cornell kept in his "Astronomy" file, JCSC. A similar illustration of an astronomer standing beside a large quadrant, captioned "Instruments astronomiques du temps d'Hévélius," appears in Flammarion, *Les Terres du ciel*, 120.

14. AAA, 1062/553.

15. Solomon plausibly suggests that he turned to collage after he badly cut his hand on a saw while making a box. Even though he had assistants to make the box shells, cut paper collages were easier to produce. See Solomon, *Utopia Parkway*, 275. He

seems to have begun making collages in earnest in 1959, when he produced one entitled *First Collage in a Long Time*. See *Shadowplay / Eterniday*, fig. 78.

16. Cornell also pursued a third direction in his art in the 1960s, creating a small group of nearly abstract paintings. Building up the surface of masonite panels with thick paint, he alluded to the cosmos in works such as *Birth of the Solar System*, 1964, reproduced in *Joseph Cornell: Dovecotes, Hotels, and Other White Spaces*, 35. Because these works have deteriorated severely, it is not possible to know what they originally looked like or why the artist produced them. He may have intended them as the background for collages, since a few have magazine pictures glued to the surface.

17. AAA (1061/966; 3.1/8/8/60).

18. AAA (1061/968; 3.1/8/8/62).

19. AAA (1061/967; 3.1/8/8/61).

20. Glenway Wescott, *Images of Truth* (New York: Harper and Row, 1962), 45. Cornell cited these lines in part and in full in a diary note. AAA (1061/955; 3.1/8/8/49).

21. AAA (1061/966; 3.1/8/8/60).

22. AAA (1061/53; 3.1/8/9/66).

23. AAA (1061/505; 3.1/8/27/21).

24. AAA (1061/189; 3.1/8/13/14).

25. AAA (1061/035; 3.1/8/9/48).

26. Irving Adler, *The Giant Golden Book of Mathematics, Exploring the World of Numbers and Space* (New York: Golden Press, 1958), 20. Cornell owned several copies of this book, as well as multiple copies of a shortened version, Irving Adler, *Mathematics: The Story of Numbers, Symbols and Space* (New York: Golden Press, 1958).

27. Thomas D. Jones and Michael Benson, *The Complete Idiot's Guide to NASA* (Indianapolis: Alpha Books, 2002), 89–91.

28. "Steps into Space—Ozma Joins TIROS," *CSM*, April 4, 1960, 1.

29. Courtney Sheldon, "Score Card on the Satellite Race," *CSM*, August 24, 1960, 16.

30. "Listener Aimed at Heavens," *CSM*, December 2, 1960, 8.

31. For example, see "2 Astronauts Down Safely after 4 Days," *NYT*, June 8, 1965, 1. JCSC; and the scrawled name, "John Glenn astronaut" in a diary note. AAA (1063/005; 3.1/9/7/30).

32. The photograph was included in an article about the mission published in the April 1966 issue of *National Geographic*. Cornell kept a copy of it in his files. See Kenneth E. Weaver, "Space Rendezvous, Milestone on the Way to the Moon," *National Geographic*, April 1966, 538–53. JCSC.

33. John Noble Wilford, "Gemini 7 Team Is Orbited for a Flight of 2 Weeks and Rendezvous in Space," *NYT*, December 5, 1965, 1; "Astronauts Report Puzzling Sights," *CSM*, December 7, 1965, 3; "Origin of Fireball Is Laid to Meteor," *NYT*, December 11, 1965, 30; John Noble Wilford, "Waiting Gemini 7 Tests Laser Beam," *NYT*, December 12, 1965, 78.

34. The fuzzy streaks of light on the right derive from a page clipped from Gottfried Honegger and Peter van Camp's book, *Space: The Architecture of the Universe* (New York: Dell, 1962), 44. It illustrates a spectrographic photograph of the star cluster Hyades.

35. "Castro Congratulations," *NYT*, December 17, 1965, 29, and "Rendezvous of Spacecraft Is Praised in Both East and West," *NYT*, December 17, 1965, 29.

36. Another collage features a variety of images of flight: a hummingbird, a bumblebee, a butterfly, and Leonardo's parachute from *The Giant Golden Book of Mathematics*. In the lower right a girl with one upraised arm sits in a chair: Cassiopeia. On the back, Cornell pasted part of the page from Adler's book, with the words "the Distance to the Moon" above his signature and beside a figure of an Egyptian looking skyward. Smithsonian American Art Museum, 1991.155.45. A similar collage includes the hummingbird and bumblebee, along with the words "de l'Etoile" on the front. On the back is the clipping from Adler, *Mathematics: The Story of Numbers, Symbols and Space*, with the title "Distance to the Moon" painted with light blue wash and positioned above Cornell's signature. Smithsonian American Art Museum, 1991.155.46.

37. Cornell remained interested in the Gemini program, and he saved newspaper articles about later Gemini missions for his files. See John Noble Wilford, "Loose Shield Blocks Gemini Docking," *NYT*, June 4, 1966, 1, and "Gemini 11 Team on Top of World," *Long Island Star-Journal*, September 14, 1966, 1. JCSC.

38. "United Nations Commemorative Announced," *CSM*, December 9, 1965, 27.

39. See, for example, an untitled, undated collage in the Smithsonian American Art Museum, 1991.155.242.

40. See an untitled collage in the Smithsonian American Art Museum, 1991.155.254. Articles in Cornell's files include Theodore Shabad, "Soviet Spaceship Enters New Orbit," *NYT*, June 7, 1971, 1, and Bernard Gwertzman, "3 Soviet Astronauts Are Dead; Bodies Discovered in Capsule When It Lands after 24 Days," *NYT*, June 30, 1971, 1, 8. JCSC.

41. For details of the NASA art program, now called "Copernica," see http://www.hq.nasa.gov/copernica.

42. Dorothy Kosinski, *Dialogues: Duchamp Cornell Johns Rauschenberg* (New Haven: Yale University Press, 2005), 24, 28.

43. See Ades, *Surrealist Art*, 91, fig. 46.

44. J. N. James, "The Voyage of Mariner IV," *Scientific American* 214 (March 1966): 42–52. JCSC.

45. AAA (1058/235; 3.2/10/30/25). The line is the second line of a two-line poem, "The Untold Want," written in 1871. The full text of the poem is: "The untold want by life and land ne-er granted, / Now voyager sail thou forth to seek and find." Cornell may also have thought of the Bette Davis film *Now Voyager*, which opened in 1942. This "weepie" about a dowdy spinster who is transformed into a glamorous woman and frees herself from a domineering mother had obvious parallels for Cornell. Davis's famous line in the final scene, "Don't let's ask for the moon, we have the stars," spoken to the married man with whom she has fallen in love on a cruise ship, would have resonated especially strongly with Cornell, whose own love life had been similarly limited. The possibility of this film as a source for Cornell was first raised in Frank Gettings, "Forum: Joseph Cornell's 'Now Voyager . . .'," *Drawing* 12 (July–August, 1990): 29–30. The suggestion is also made in Ades, *Surrealist Art*, 91.

46. "Exploration of Mars," *NYT*, July 11, 1965, E10.

47. James, "The Voyage of Mariner IV," 45. Cornell would later clip an article from the *Monitor* about further solar wind research. See "Pioneer 8 Orbit Charted to Test Solar-Wind Threat," *CSM*, December 4, 1967, 11. JCSC.

48. JCSC.

49. Walter Sullivan, "Is the Universe Eternal? A New Clue," *NYT*, May 18, 1965, 1–2. JCSC.

50. AAA, 1066/326.

51. JCSC.

52. AAA, 1066/342 and 1068/359.

53. Elisabeth Richie, "Metric Geometrics," *CSM*, December 28, 1968, 8. JCSC.

54. Solomon, *Utopia Parkway*, 290–91. According to Solomon, Cornell first met Schneeman when she was a student at Bard College.

55. Basing her account on Kusama's recollections, Solomon describes this relationship as including kissing, nudity, perhaps oral sex, but not consummation. According to Kusama, Cornell was "deeply impotent." Solomon, *Utopia Parkway*, 294. It should be noted that Cornell met Kusama when he was in his sixties, and that he was later hospitalized for prostate problems, which may account for his impotence.

56. Ibid., 288.

57. See, for example, the collage, dated 1962, titled *Vue par Tina (Mathematics in Nature)*, in which a chart illustrating the constellation Cassiopeia is pasted on a line drawing of a nude woman. Reproduced in McShine, ed. *Joseph Cornell*, fig. 260.

58. I. Bernard Cohen, *The Birth of a New Physics* (Garden City, NY: Anchor Books, 1960). Cornell placed notes referring to "Cass." between pp. 134 and 135, amid a discussion about Kepler. Arthur Koestler, *The Watershed* (Garden City, NY: Anchor Books, 1960). Cornell placed notes regarding "Tina" between pp. 208 and 209, in a chapter entitled "Tycho and Kepler." Another note with the words "antidoting nostalgia. T." can be found between pages 160 and 161, marking the opening of the chapter entitled "Kepler Depressed." On the inside back cover he wrote "became T's book 3/8/62 4:00 P.M. Opp. Hippodrome. A kind of revelation reading there taken casually from the clutter." JCSC.

59. In one note he recorded, "TINA = JOYCE since Wednesday 2/14/62." JCSC; Lincoln's birthday is mentioned in several notes, JCSC, and one records "Charlie giving J the Valentine package with Rudy Burckhardt coffee at the counter _____ associative of Lincoln's Birthday." JCSC.

60. The Pole Star chart appears on a page explaining the concept of "Precession," the oscillating motion of Earth compared with a top slowing down. The pennies illustration derives from a children's book about mathematics, where it explains the use of Pascal's triangle to compute probability. See Adler, *Mathematics, The Story of Numbers, Symbols, and Space*, 38–41.

61. Cornell read about the life of Kepler in Arthur Koestler's history of the great men of astronomy, *The Sleepwalkers*. Kepler's model of the universe and a detail of it are illustrated on pages 250 and 251. In that model, the dodecahedron is positioned between the spheres of Mars and Earth. The model is also illustrated in Adler, *The Giant Golden Book of Mathematics*, 38.

62. Solomon, *Utopia Parkway*, 298–99.

63. JCSC.

64. This Cassiopeia collage is titled *Rapport de Contreras (Circe)* because of a bit of type on a scrap of paper with the artist's signature. Other variants exist, attesting to the image's importance for the artist. Variants can be found in the National Gallery of Art, Washington, DC, and in the Seattle Art Museum.

65. As late as 1970 Cornell dedicated collages to Joyce Hunter. See, for example, *Hôtel de la Sonambule*, with the inscription "Sonambule for Joyce." Smithsonian American Art Museum, 1991.155.354.

66. AAA (1064/315; 3.1/9/48/10).

67. JCSC.

68. AAA, 1075/580–81. On the back of another collage featuring the astrological sign for Pisces and a crouching nude woman, he wrote: "sensual, mystical and totally misunderstood." The untitled collage is dated June 22, 1970. Smithsonian American Art Musuem, 1991.155.273.

69. AAA (1063/1490; 3.1/9/36/57). The parallel between eternal beauty and the Christian Science belief in the insignificance of matter would not have been lost on Cornell.

70. A negative photostat of this page from Flammarion's *Les Etoiles* can be found in Cornell's files. JCSC.

71. For speculation of the details of Cornell's sex life, see Solomon, *Utopia Parkway*.

72. See, for example, "Its Ugly Head: Ethos and Eros in Our Time," *Times Literary Supplement*, September 9, 1965, 1; D.J.R. Bruckner, "Sex Revolution Turning Sour" (unidentified source); William Graham Cole, "Sex and Religion: The Bible and the World of Dr. Kinsey (unidentified source). JCSC.

73. See, for example, Dr. Joyce Brothers, "Respect for Homosexual," *Long Island Press*, August 26, 1971, page unknown. JCSC.

74. Morris Kline, "Projective Geometry," *Scientific American* 192 (January 1955): 80–86. Projective geometry was also linked with modern theories of the fourth dimension, a topic that no doubt interested Cornell.

75. "The Cover," *Scientific American* 192 (September 1964): 4.

76. See, for example, W. V. Quine, "The Foundations of Mathematics," and Freeman J. Dyson, "Mathematics in the Physical Sciences, *Scientific American* 192 (September 1964): 112–27 and 128–47.

77. Victor Pasmore, "Science and Art: A New Relationship," *CSM*, December 14, 1965, 8. JCSC.

78. AAA (1062/902; 3.1/8/53/22).

79. AAA (1062/1153; 3.1/8/57/29).

80. AAA (1064/740; 3.1/10/2/41).

81. "Man's Orbit of Perfection," *CSM*, November 26, 1958, 12. JCSC.

82. This collage seems to be a later variant of a 1964 collage, *Interplanetary Navigation*, which features the same porcelain figure and doves. *Interplanetary Navigation* was included in the 1967 Guggenheim retrospective. See Waldman, *Joseph Cornell* (1967), 51.

83. "The Permanence of Principle," *CSM*, October 10, 1964, 8. Cornell circled the title of the article. JCSC.

84. AAA (1063/1399; 3.1/9/34/63). Another note, dated May 15, 1966, cites "Dr. Norman Vincent Peale's sermon about <u>God as a mathematician</u>." AAA (1062/298; 3.1/8/41/7).

85. His physical symptoms may have arisen from working with rubber cement in an unventilated setting. The effects of inhaling rubber cement and airplane glue include loss of appetite, hallucinations, depression, anxiety, eye problems, kidney problems, headaches, and distorted perception of reality and spatial relations. Cornell seems to have realized that rubber cement and airplane glue were having an adverse effect on him. In a note written in 1965, he recorded his "violent reaction to 'glue workings' on collage." JCSC.

86. AAA (1062/1735; 3.1/9/5/23).

87. AAA (1064/862; 3.1/10/25/31).

SELECTED BIBLIOGRAPHY

Archival Materials

Joseph Cornell papers, 1804–1986, Archives of American Art, Smithsonian Institution, Washington, DC.

Joseph Cornell papers, source materials, and related materials. Joseph Cornell Study Center, Smithsonian American Art Museum, Washington, DC. Gifts of Mr. and Mrs. John A. Benton and the Joseph and Robert Cornell Memorial Foundation.

Joseph Cornell: Books, Articles, Exhibitions, and Exhibition Reviews

Ades, Dawn. "Philadelphia and Houston Cornell and Duchamp." *Burlington Magazine* 141 (March 1999): 195–98.

———. *Surrealist Art: The Lindy and Edwin Bergman Collection at the Art Institute of Chicago.* Chicago: Art Institute of Chicago, and New York: Thames and Hudson, 1997.

———. "The Transcendental Surrealism of Joseph Cornell." In *Joseph Cornell*, edited by Kynaston McShine, 15–42. New York: The Museum of Modern Art, 1980.

"The Amateur as Auteur, Discovering Paradise in Pictures." Vol. 6 of *Unseen Cinema: Early American Avant-Garde Film 1894–1941.* New York: Anthology Film Archives, distributed by Image Entertainment, 2005. (DVD set)

Ashbery, John. "Cornell: The Cube Root of Dreams." *Art News* 66 (Summer 1967): 56–59; 63–64.

———. "Cornell's Sublime Junk." *Newsweek*, December 8, 1980, 110–11.

Ashton, Dore. *A Joseph Cornell Album.* New York: Viking, 1974; reprinted Da Capo, 1989.

———. "New York Commentary." *Studio International*, July 1966.

Blair, Lindsay. *Joseph Cornell's Vision of Spiritual Order.* London: Reaktion Books, 1998.

Bourdon, David. "Enigmatic Bachelor of Utopia Parkway." *Life* 63, December 15, 1967: 63, 66.

Brakhage, Jane. *The Book of Legends*. New York: Granary Books, 1989.

Brayndick, Michael. "Joseph Cornell and the Dialectics of Human Time." Ph.D. dissertation, University of Iowa, 1987.

Breton, Andre. *Manifestos of Surrealism,* translated by Richard Seaver and Helen R. Lane. Ann Arbor: University of Michigan Press, 1969.

Busang, Brett. "Painting in the Third Dimension." *American Artist* 57 (April 1993): 48–55.

Caws, Mary Ann. "Collecting and Containing: Joseph Cornell and Mallarmé." In *The Art of Interference*, 201–16. Princeton: Princeton University Press, 1989.

———. "Joseph Cornell: L'invention de la boîte surréaliste." *Etudes français* 26 (1990): 79–86.

———, ed. *Joseph Cornell's Theater of the Mind: Selected Diaries, Letters, and Files.* New York: Thames and Hudson, 1993.

Cheng, Lisa Chuan-Lee. "The Noontide Sun Rises Higher: Astronomy, Science, and Religion in the Art of Joseph Cornell." Master's thesis, Oberlin College, 1995.

"Collage and Leger." *New York Times,* September 26, 1948, X9.

Collection in Context: Joseph Cornell's Cosmic Travels, edited by Beth Venn. New York: Whitney Museum of American Art, 1995. Published in conjunction with an exhibition shown at the Whitney Museum of American Art.

Coplans, John. "Notes on the Nature of Joseph Cornell." *Artforum* 1 (February 1963): 27–29.

Cortesi, Alexandra. "Joseph Cornell." *Artforum* 4 (April 1966): 27–31.

Costello, Bonnie. "Joseph Cornell, Soap Bubbles and Shooting Galleries." In *Planets on Tables: Poetry, Still Life, and the Turning World,* 107–41. Ithaca and London: Cornell University Press, 2008.

Cunningham, Michael. "Joseph Cornell: Soap Bubble Set (Lunar Rainbow, Space Object), ca. 1950's." *Artforum* 37 (April 1999): 108–9.

Davis, Douglas, and Mary Rourke. "Souvenirs." *Newsweek,* March 1, 1976, 81.

Descutner, David. "Interiority: Thinking Inside the Box." *Wide Angle* 20, no. 4 (1998): 2–7.

Devree, Howard. "Many, New, Diverse," *New York Times,* December 15, 1946, X9.

Dezeuze, Anna. "Unpacking Cornell: Consumption and Play in the Work of Rauschenberg, Warhol, and George Brecht." *Papers of Surrealism* 2 (Summer 2004): 1–24.

D'Harnoncourt, Anne. "The Cubist Cockatoo: A Preliminary Exploration of Joseph Cornell's Homages to Juan Gris." *Philadelphia Museum of Art Bulletin* 74 (1978): 2–17.

Edwards, Jason, and Stephanie L. Taylor, eds. *Joseph Cornell: Opening the Box.* Bern: Peter Lang, 2007.

"Exhibition at Levy Gallery," *New York Times,* December 6, 1940, 33.

Falcetta, Jennie-Rebecca. "Acts of Containment: Marianne Moore, Joseph Cornell, and the Poetics of Enclosure." *Journal of Modern Literature* 29 (2006): 124–44.

Fantastic Art, Dada, Surrealism, edited by Alfred H. Barr, Jr. New York: The Museum of Modern Art, 1936. Published in conjunction with an exhibition shown at the Museum of Modern Art, New York.

Foer, Jonathan Safran, ed. *A Convergence of Birds: Original Fiction and Poetry Inspired by the Work of Joseph Cornell*. New York: D.A.P./Distributed Art Publishers, 2001.

Frank, Peter. "Tony Berlant and Joseph Cornell: LA Louver." *Artnews* 101, no. 2 (February 2002): 130.

Geist, Sidney. "Joseph Cornell." *Art Digest* 27, March 15, 1953: 18.

George, Laverne. "Joseph Cornell." *Arts Magazine* 30 (January 1956): 50.

Gettings, Frank. "Forum: Joseph Cornell's 'Now Voyager. . . .'" *Drawing* 12 (July–August 1990): 29–30.

Glueck, Grace. "From Serendipitous Materials to Joseph Cornell's Art." *New York Times*, January 2, 1983, 21, 23.

Goossen, E. C. "The Plastic Poetry of Joseph Cornell." *Art International* 3, no. 10 (1959–60): 37–40.

Griffin, Howard. "Auriga, Andromeda, Cameoleopardalis." *Art News* 56 (December 1957): 24–27, 63–65.

Haroutunian, Helen H. "Joseph Cornell in 'View.'" *Arts Magazine* 55 (March 1981): 101–8.

Hartigan, Lynda Roscoe. "Joseph Cornell: A Biography." In *Joseph Cornell,* edited by Kynaston McShine, 91–119. New York: The Museum of Modern Art, 1980.

———. *Joseph Cornell: An Exploration of Sources*. Washington, DC: National Museum of American Art, 1982. Published in conjunction with an exhibition shown at the National Museum of American Art, now the Smithsonian American Art Museum.

———. *Joseph Cornell, Navigating the Imagination*. Peabody-Essex Museum, in association with Yale University Press, 2007. Published in conjunction with an exhibition shown at Smithsonian American Art Museum, Peabody-Essex Museum, and San Francisco Museum of Modern Art.

———. "Joseph Cornell's Dance with Duality." In *Joseph Cornell: Shadowplay Eterniday,* 12–34. New York: Thames and Hudson, 2003.

———. "Joseph Cornell's Explorations: Art on File." In *Joseph Cornell/Marcel Duchamp . . . in resonance,* 221–43. Ostfildern-Ruit, Germany: Cantz Verlag: Distributed by D.A.P./Distributed Art Publishers, New York, 1998.

Hauptman, Jodi. *Joseph Cornell: Stargazing in the Cinema*. New Haven: Yale University Press, 1999.

Hennessey, Christine. "Joseph Cornell: A Balletomane." *Archives of American Art Journal* 23, no. 3 (1983): 6–12.

"High Award Goes to Noguchi," *New York Times*, December 2, 1959, 53.

Hoberman, J. "The Strange Films of Joseph Cornell." *American Film*, January/February 1980, 18–19.

Hopps, Walter. "Boxes." *Art International* 13, no. 2 (March 20, 1964): 38–42.

———. *An Exhibition of Works by Joseph Cornell*. Pasadena: Pasadena Art Museum, 1996. Published in conjunction with an exhibition shown at the Pasadena Museum of Art.

"Imagined Universe Stored in Boxes." *Life* 63 (December 15, 1967): 52–62.

Johnson, Ellen. "Arcadia Enclosed: The Boxes of Joseph Cornell." *Arts* 39 (September–October 1965): 35–37.

Jones, Malcolm Jr. "Joseph Cornell's Alchemical Boxes Still Beguile Us." *Newsweek,* December 28, 1992, 60.

Joseph Cornell. London: Waddington Galleries, 1987. Published in conjunction with an exhibition shown at the Waddington Galleries, London.

Joseph Cornell. Madrid: Fundación Juan March, 1984. Published in conjunction with an exhibition shown at Fundación Juan March, Madrid.

Joseph Cornell. New York: Allan Stone Gallery, 2002. Published in conjunction with an exhibition shown at the Allan Stone Gallery, New York.

Joseph Cornell, edited by Kynaston McShine. New York: The Museum of Modern Art, 1980. Published in conjunction with an exhibition shown at the Museum of Modern Art, New York.

Joseph Cornell: Años Cincuenta y Sesenta. Monterrey, Mexico: Museo de Arte Contemporaneo de Monterrey, 1992. Published in conjunction with an exhibition shown at the Museo de Arte Contemporáneo de Monterrey, Monterrey, Mexico

Joseph Cornell: Box Constructions and Collages. New York: C & M Arts, 1995. Published in conjunction with an exhibition shown at C & M Arts [now L & M Arts], New York.

Joseph Cornell: Box Constructions and Collages. West Palm Beach, FL: Norton Museum of Art, 1977. Published in conjunction with an exhibition shown at the Norton Museum of Art, West Palm Beach, FL.

Joseph Cornell: Collages, 1931–1972. New York: Castelli, Feigen, Corcoran, 1978. Published in conjunction with an exhibition shown at Castelli, Feigen, Corcoran, New York.

Joseph Cornell / Marcel Duchamp . . . in resonance. Ostfildern-Ruit, Germany: Cantz Verlag, 1999. Distributed by D.A.P./Distributed Art Publishers, New York, 1998. Published in conjunction with an exhibition shown at the Philadelphia Museum of Art and the Menil Collection, Houston.

Joseph Cornell: May 3–31, 1975, ACA Galleries. New York: ACA Galleries, [1975]. Published in conjunction with an exhibition shown at the ACA Galleries, New York.

Joseph Cornell Objects. Beverly Hills: Copley Galleries, 1948. Published in conjunction with an exhibition shown at the Copley Galleries, Beverly Hills, CA.

Joseph Cornell Portfolio, edited by Sandra Leonard Starr. New York: American Dovecote and Shooting Gallery, 1976. Published in conjunction with an exhibition shown at Castelli Gallery, New York.

Keller, Marjorie. *The Untutored Eye: Childhood in the Films of Cocteau, Cornell, and Brakhage.* Rutherford, NJ: Farleigh Dickinson University Press, and London: Associated University Press, 1986.

Kosinski, Dorothy. *Dialogues: Duchamp Cornell Johns Rauschenberg.* Dallas: Dallas Museum of Art, and New Haven: Yale University Press, 2005. Published in conjunction with an exhibition shown at the Dallas Museum of Art.

Kozloff, Max. "Art." *Nation* 204, May 29, 1967, 701–2.

Kramer, Hilton. "The Poetic Shadow-Box World of Joseph Cornell." *New York Times,* May 6, 1967, 27.

Lawson, Thomas. "Silently, by Means of a Flashing Light." *October* 15 (Winter 1980): 58.

Levy. Julien. *Memoir of an Art Gallery.* New York: Putnam, 1977; reprinted Boston: MFA Publications, 2003.

————. *Surrealism*. New York: Black Sun Press, 1936.

Lichtenstein, Therese. *Andromeda Hotel: The Art of Joseph Cornell*. Katonah, NY: Katonah Museum of Art, 2006. Published in conjunction with an exhibition shown at the Katonah Museum of Art, Katonah, New York.

McKeen, Philena and Phebe. *A History of Abbot Academy, Andover, Mass., 1829–1879.* Andover: Warren F. Draper, 1880.

Martin, Richard. "Some Lobsters, Some Elephants: Surrealist Reflections on Joseph Cornell's A Pantry Ballet, for Jacques Offenbach." *Arts Magazine* 60 (February 1986): 30–32.

Michelson, Annette. "Rose Hobart and Monsieur Phot: Early Films from Utopia Parkway." *Artforum* 11 (June 1973): 47–57.

Miller, Arthur. "In the Galleries." *Los Angeles Times*, October 3, 1948, D4.

"Moderns among the Rectangles." *Christian Science Monitor*, October 9, 1933, 12.

Moon, Michael. "Oralia: Hunger for Women's Performances in Joseph Cornell's Boxes and Diaries." *Women and Performance: A Journal of Feminist Theory* 8 (1996): 39–59.

Morris, Robert. "American Quartet." *Art in America* (December 1981): 93–104.

Mundy, Jennifer. "An 'overflowing, a richness & poetry': Joseph Cornell's *Planet Set* and Guiditta Pasta." *Tate Papers* (Spring 2004).

Murphy, Angela Kramer. "Imaginary Voyages." In *Collection in Context: Joseph Cornell's Cosmic Travels,* edited by Beth Venn, [7–13]. New York: Whitney Museum of American Art, 1995.

Myers, John Bernard. "Cornell: The Enchanted Wanderer." *Art in America* 61 (September–October 1973): 76–81.

————. "Joseph Cornell: It Was His Genius to Imply the Cosmos." *Art News* 74 (May 1975): 33–36.

"Nebula, The Powdered Sugar Princess." *October* 15 (Winter 1980): 40–48.

Niedenthal, Simon. "Learning from the Cornell Box." *Leonardo* 35 (2002): 249–54.

O'Doherty, Brian. *American Masters: The Voice and the Myth*. New York: Random House, 1973.

————. "Innocence and Experience." In *Joseph Cornell: Dovecotes, Hotels, and Other White Spaces*. New York: Pace Gallery, 1989. Published in conjunction with an exhibition shown at the Pace Gallery, New York.

O'Hara, Frank. "Joseph Cornell and Landes Lewitin." *Art News* 54 (September 1955): 50.

Pennington, Estill Curtis (Buck). "Joseph Cornell: Dime Store Connoisseur." *Archives of America Art Journal* 23, no. 3 (1983): 13–20.

Porter, David. "Assembling a Poet and Her Poems: Convergent Limit—Works of Joseph Cornell and Emily Dickinson." *Word and Image* 10 (July/September 1994): 199–221.

Porter, Fairfield. "Joseph Cornell." *Art and Literature* 8 (Spring 1966): 120–30.

————. "Joseph Cornell." *Art News* 52 (April 1953): 40.

Preston, Stuart. "About Art and Artists, Surge of Christmas Shows at Galleries Offers Varied Work to Public." *New York Times*, December 17, 1955, 20.

————. "Diversely Modern." *New York Times*, May 21, 1950, X6.

————. "From Far and Near." *New York Times*, March 1, 1953, X8.

————. "Giacometti and Others." *New York Times*, December 17, 1950, X8.

————. "Winter Night Skies." *New York Times*, December 17, 1955, 20.

Ratcliff, Carter. "Joseph Cornell: Mechanic of the Ineffable." In *Joseph Cornell*, edited by Kynaston McShine, 43–68. New York: The Museum of Modern Art, 1980.

Rosenberg, Harold. "Object Poems." *New Yorker* 43, June 3, 1967, 114–18.

Russell, John. "Worlds of Boxes, Packages, and Columns." *New York Times*, March 14, 1976, D29.

Schaffner, Ingrid. *The Essential Joseph Cornell*. New York: Harry H. Abrams, 2003.

Schaffner, Ingrid, and Lisa Jacobs, eds. *Julien Levy: Portrait of an Art Gallery*. Cambridge: MIT Press, 1998.

"Sculptor Wins $2000." *New York Times*, January 17, 1957, 31.

Seibold-Bultmann, Ursula. "Joseph Cornells Object (Rose des Vents) und das Thema der Imaginaren Reise." *Zeitschrift fur Kunstgeschichte* 57 (1994): 549–58;

Simic, Charles. *Dime Store Alchemy: The Art of Joseph Cornell*. Hopewell, NJ: Ecco Press, 1992.

Sitney, P. Adams. "The Cinematic Gaze of Joseph Cornell." In *Joseph Cornell*, edited by Kynaston McShine, 68–89. New York: The Museum of Modern Art, 1980.

Solomon, Deborah. *Utopia Parkway: The Life and Work of Joseph Cornell*. New York: Noonday Press, Farrar, Straus, and Giroux, 1997.

Starr, Sandra. *Box Constructions and Collages by Joseph Cornell*. Tokyo: Gatodo Gallery, 1987. Published in conjunction with the exhibition The Crystal Cage [portrait of Berenice] at Gatodo Gallery, Tokyo, Japan.

———. *The Crystal Cage [portrait of Berenice]*. Tokyo: Gatado Gallery, [1987]. Published in conjunction with the exhibition The Crystal Cage [portrait of Berenice] at Gatodo Gallery, Tokyo, Japan.

———. *Joseph Cornell and the Ballet*. New York: Castelli, Feigen, Corcoran, 1983. Published in conjunction with an exhibition shown at Castelli, Feigan, Corcoran, New York.

———. *Joseph Cornell: Art and Metaphysics*. New York: Castelli, Feigen, Corcoran, 1982. Published in conjunction with an exhibition shown at Castelli, Feigan, Corcoran, New York.

Tashjian, Dickran. *A Boatload of Madmen: Surrealism and the American Avant-Garde, 1920–1950*. New York: Thames and Hudson, 1995.

———. *Joseph Cornell: Gifts of Desire*. Miami Beach: Grassfield, 1992.

Waldman, Diane. *Joseph Cornell*. New York: George Braziller, 1977.

———. *Joseph Cornell*. New York: Solomon R. Guggenheim Museum, 1967. Published in conjunction with an exhibition shown at the Solomon R. Guggenheim Museum, New York.

———. *Joseph Cornell, Master of Dreams*. New York: Harry N. Abrams, 2002.

Whitney, Charles. "The Cosmology of Joseph Cornell." In *Collection in Context: Joseph Cornell Cosmic Travels*, edited by Beth Venn, [4–6]. New York: Whitney Museum of American Art, 1995.

Windham, Donald. *Aviary by Joseph Cornell*. New York: Egan Gallery, 1949. Published in conjunction with an exhibition shown at Egan Gallery, New York.

———. "Joseph Cornell's Unique Statement." *New York Times*, November 16, 1980, D27–28.

Vine, Richard. "Eterniday: Cornell's Christian Science 'Metaphysique.'" In *Joseph Cornell: Shadowplay / Eterniday*, 36–49. New York: Thames and Hudson, 2003.

Zlotsky, Deborah. "Pleasant Madness in Hartford: The First Surrealist Exhibition in America." *Arts Magazine* 60 (February 1986): 55–61.

Selected Books and Articles about Science, Mathematics, and Space Exploration

"2 Astronauts Down Safely after 4 Days." *New York Times*, June 8, 1965, 1, 22.

Adler, Irving. *The Giant Golden Book of Mathematics, Exploring the World of Numbers and Space*. New York: Golden Press, 1958.

———. *Mathematics: The Story of Numbers, Symbols and Space*. New York: Golden Press, 1958.

Allen, Richard Hinckley. *Star Names and Their Meanings*. London: G. E. Stechert, 1899.

Battan, Louis J. *Radar Observes the Weather, New Understanding of Cloud Physics*. New York: Doubleday, 1962.

Blakeslee, Alton. "Find New Atomic Anti-Particle." *New York Mirror*, March 15, 1962, 4.

Boys, C. V. *Soap Bubbles and the Forces Which Mould Them*. London: Society for Promoting Christian Knowledge, 1890.

———. *Soap Bubbles, Their Colours, and the Forces Which Mould Them*. London: Society for Promoting Christian Knowledge, 1912.

Bronowski, J. "The Creative Process." *Scientific American* 189 (September 1958): 59–65.

"Brooklyn Housewife Helps Scan Skies for Enemy A-Bombers." *New York World-Telegram and Sun*, July 15, 1952.

Burritt, Elijah H. *Atlas Designed to Illustrate the Geography of the Heavens*. New York: Huntington and Savage, 1825.

———. *The Geography of the Heavens and Class-Book of Astronomy: Accompanied by a Celestial Atlas*. New York: Sheldon, 1856.

Christianson, John. "The Celestial Palace of Tycho Brahe." *Scientific American* 204 (February 1961): 118–28.

Cohen, Bernard. "Perspective on the Star-Gazers." Review of *Astronomy* by Fred Hoyle, *New York Times*, November 11, 1962, BR7, 30.

"Cosmic Rays Open the Fair." In *The Hayden Planetarium and the New York World's Fair*. New York: The Sky, Magazine of Cosmic News, Hayden Planetarium, American Museum of Natural History, for the New York World's Fair, 1939.

Cowen, Robert C. "Charting the Universe." *Christian Science Monitor*, April 22, 1953, 13.

———. "Natural Scientists Quit Ivory Tower." *Christian Science Monitor*, March 22, 1958, 9.

———. "New Window on Universe." *Christian Science Monitor*, March 20, 1952, 19.

da Andrade, E. N. "The Birth of the Nuclear Atom." *Scientific American* 195 (November 1956): 93–102.

Davis, Harry M. "Mathematical Machines." *Scientific American* 180 (April 1949): 28–39.

Delille, Jacques. *Les Trois Regnes de la Nature, par Jacques Delille. Avec des notes par M. Cuvier, de l'Institute, et autres savants*. 2 vols. Paris: H. Nicolle, 1806.

Dietz, David. "War Dimouts Bared Stars by the Billions, Blackouts Helped Revise Estimate of Universe." *New York World-Telegram and Sun*, June 22, 1953.

Drury, Jr., W. H., et al. "The Migration of Angels." *Natural History* 70 (October 1961): 10–17.

Duffus, R.L. "Faith Is a Star That Never Sets." *New York Times*, December 25, 1955, SM5.

Flammarion, Camille. *Astronomie Populaire, description générale du ciel.* Paris: C. Marpon et E. Flammarion, 1880.

———. *Les Etoiles et les curiosités du ciel, description complète du ciel visible à l'œil nu et de tous les objets célestes faciles à observer; supplément de L'Astronomie Populaire.* Paris: C. Marpon et E. Flammarion, 1882.

———. *Popular Astronomy*, trans. J. Ellard Gore. New York: D. Appleton, 1894.

———. *Les Terres du ciel, Voyage astronomique sur les autres mondes et description des conditions actuelles de la vie sur les diverses planètes du système solaire.* Paris: C. Marpon et E. Flammarion, 1884.

"First Woman in Academy Honored." *New York Times*, September 15, 1959, 22.

"Gemini 11 Team on Top of World." *Long Island Star-Journal*, September 14, 1966, 1.

Glaser, Donald A. "The Bubble Chamber." *Scientific American* 192 (February 1955): 46–50.

Guillemin, Amédée. *Les Phénomènes de la physique.* Paris: Hachette, 1868.

Gwertzman, Bernard. "3 Soviet Astronauts Are Dead; Bodies Discovered in Capsule When It Lands after 24 Days." *New York Times*, June 30, 1971, 1, 8.

Hersey, Henry B. "The Menace of Aërial Warfare." *Century Magazine* 77 (February 1909): 627–30.

Honegger, Gottfried, and Peter van Kamp, *Space, the Architecture of the Universe.* New York: Dell: 1962.

Hoyle, Fred. "Changing Concepts of the Universe: One Astronomer Discusses Signs That Forces of Expansion and Creation Are in Balance." *New York Times*, June 1, 1952, SM12–13, 50–51.

James, J. N. "The Voyage of Mariner IV." *Scientific American* 214 (March 1966): 42–52.

Kennedy, Katharine. "From Deep Space." *Christian Science Monitor*, April 7, 1954, 12.

Koestler, Arthur. *The Sleepwalkers.* London: Hutchinson, 1959.

Leonard, Jonathan N. "A Great Eye to See With." *New York Times*, March 16, 1952, BR 28.

———. "Space Is Full of Remarkable Things." Review of *Galaxies, Nuclei and Quasars*, by Fred Hoyle, *New York Times*, December 19, 1965, BR7.

"Lifted to the Stars." *Christian Science Monitor*, October 15, 1955, 18. JCSC.

Loory, Stuart H. "Were Astro-Twins Hurt?" *New York Herald Tribune*, August 16, 1962, 1.

"Lunar Life Held Unlikely." *New York Times*, September 14, 1959, 17.

Lynch, Samuel Dutton. "Western Skies." *New York Times*, January 17, 1954, XX19.

"Magellanic Clouds Probed to Measure Cosmic Dust." *Christian Science Monitor*, December 4, 1950, 17.

"Man's Orbit of Perfection." *Christian Science Monitor*, November 26, 1958, 12.

Menzel, Donald H. "The Heavens Above," *National Geographic Magazine* (July 1943): 97.

Méry, Joseph. *Les Etoiles: dernière féerie.* Paris: G. de Gonet, 1849.

Nelson, Robert. "The Universe on TV." *Christian Science Monitor*, August 6, 1962, 9.

"New Soviet Space Triumph." *Christian Science Monitor*, October 5, 1959, 9.

Norman, Albert E. "A New Window on the Universe." *Christian Science Monitor*, December 2, 1955, 13.

"Particle Physicists: Probing the Cost of Research." *Christian Science Monitor*, September 8, 1970, 11.

Payne-Gaposchkin, Cecilia. *Stars in the Making*. New York: Giant, with Harvard University Press, 1959, first published 1952.

Peck, William G. *Introductory Course of Natural Philosophy*. New York: A. S. Barnes, 1860.

Planck, Max. *The New Science*. Greenwich: Meridan Books, 1959.

———. *Where Is Science Going?* London: Allen & Unwin, 1933.

Richie, Elisabeth. "Metric Geometrics." *Christian Science Monitor*, December 28, 1968, 8.

Santillana, George de. "Greek Astronomy." *Scientific American* 180 (April 1949): 44–47.

Serviss, Garrett P. *Astronomy with an Opera-Glass*. New York: D. Appleton, 1908 [1888].

Shabad, Theodore. "Soviet Spaceship Enters New Orbit." *New York Times*, June 7, 1971, 1, 13.

Sullivan, Walter. "Is the Universe Eternal? A New Clue." *New York Times*, May 18, 1965, 1–2.

Tom Tit [Arthur Good]. *La Science Amusante*. 3 vols. Paris: Larousse, [1890–1906].

Torjesen, Elizabeth Fraser. "Maria Mitchell and Her Island." *Christian Science Monitor*, May 4, 1959, 18.

Weaver, Kenneth E. "Space Rendezvous, Milestone on the Way to the Moon." *National Geographic*, April 1966, 538–53.

Wendt, Gerald. "New Vision of Universe as Seen by Einstein." *New York Herald Tribune Weekly Book Review*, January 16, 1949, VII 5.

Wilford, John Noble. "Loose Shield Blocks Gemini Docking." *New York Times*, June 4, 1966, 1, 10.

Zim, Herbert S., and Robert H. Baker. *Stars: A Guide to the Constellations, Sun, Moon, Planets, and Other Features of the Heavens*. New York: Simon and Schuster, 1951, and New York: Golden Press, 1956.

INDEX

Page numbers in italics refer to illustrations

Abbott Academy, *10*
Adams, Walter S., 95
Adlow, Dorothy, 21–22
Agassiz, Louis, 46–47
American Bible Society, 157
Americana Fantastica (View, 1943), 76, 89, *90–91*, *103*, *106–7*, *107*, 117
Archimedes, 98, 165–69, 275n21
Arcturus (star of Boötes), 15
Aristarchus of Samos (Alexandrian astronomer), 165; and heliocentric universe, 165
Arp, Jean, 20
Astronomie des Dames (J. J. Grandville, 1849), *94*
astronomy, public interest in, 9, 12, 53, 59, 104, 220
Aurélia (Gérard de Nerval), 42–44, 257n35

Bacall, Lauren, 43–44, 281n112
Bacon, Francis, 40, 186, 251n35; *De Augmentis Scientiarum* [The Advancement of Learning, 1623], 40, 186
Balanchine, George, 73–74
Balustrade (Balanchine ballet, 1941), 74, 79
Barr, Alfred, Jr., 19, 27, 29, 32, 246n24, 247n2, 248n6
Bataille, Georges, 20
Bellmer, Hans, 28
Bible House (Astor Place, New York), *156*, 156–57, 273n79
"Big Bang" theory, 38
Big Dipper. *See* constellations, Ursa Major

Blondin (Jean François Gravelet), 99, 103, 111, 115, 117, 261n14, 263n24; *Childhood of Blondin* (nineteenth-century print), 89
Bohr, Niels, 173, 276n37
Borman, Frank, 211
Boys Blowing Bubbles (Jacob van Oost, 1645), *51*
Boys, Charles Vernon, 30–31, 248n9
Brancusi exhibition (Brummer Gallery), 22
Breton, André, 20, 46, 49, 251n39
Brummer Gallery, 22, 246n34
Bunsen, Robert, 15
Burritt, Elijah, *Atlas of the Heavens* (1825), 3, 108, 125, 133, 269n34, 271n58; *Geography of the Heavens* (1856), 6, 80

Camfield, William, 15, 17
Campbell, William W., *95*
Cannon, Dr. Annie Jump, 93
Celestial Theater (Payne-Gaposchkin), 153
Cerrito, Fanny, *2*
Chien Andalou, Le (film), 20
child astronomer (Berenice). *See* Cornell, Joseph, works, *Crystal Cage [portrait of Berenice]*
Children's Party. See Cornell, Joseph, works, Children's Party trilogy
Christian Science Building, New York World's Fair (1939), 51
Christian Science Monitor, 54, 66, 67, 80, 82–83, 85, 110–11, 121, 139–40, 155, 159, 170, 178–79, 188, 200, 208, 233–35, 245n15

Colon, Jenny (actress, Nerval infatuation with), 43
Comrade X (film, 1940), 79
Comte de Lautréamont. *See* Ducasse, Isidore
Coney Island at Night (brochure), *101*
Coney Island. *See* Luna Park (Coney Island, New York)
constellations
—Andromeda, 8, 217, 224, 227; mythological character, 132, 140, 142, 156, 224–25, 237 ; nebula/galaxy, *80, 81, 83,* 104, 143, 144–45, 271n49
—Aquila, 188, 200, 222, 224
—Aries, 224
—Auriga, 8, 98, 140, 146, 156, 237; *8;* box, 146–47, 151, 153; as Good Shepherd, 146, 156, 271n58, 272n75; mythological character, 8, 108, 271n5
—Boötes, 12, *14,* 14–15, *103,* 103–4, 108, 230, 237, 272n75
—Camelopardalis, 132–33, 135, 146–47, 197–98, 238, 270n36
—Canis Major, 222
—Canis Minor, 108, 123, 125, 222, 238
—Cassiopeia, 9, 95–96, 104, *105,* 106, *107,* 108–9, 174, 177, 181, 197, 217, 220, 222, 237, 261n9, 277n46, 277n58, 284n36, 285n57; collages, 222, 286n64; mythological character, 80, 104
—Cepheus, 80, 104, 106, 135–36, 197–98, 258n47, 272n75
—Colomba, 116
—Coma Berenices, 72, 102, 104, 108, 111–12
—Custos Messium, 135, 197–98, 205, 224, 238, 241
—Cygnus, 71, 87, 98, 104, 106, 108, 116, 237
—Delphinius, 224
—Equuleus, *107,* 107–8
—Gemini, 3, 98, 104, 106, 123, 212, 237–38
—Lyra, 83; Vega (star), 237
—Mons Menalus (Mountain of Menalus), 14
—Noctua, 116, 222
—Orion, 67, *103,* 103–4, 108, 123, 134, 175, 177, 179–80, 237–38; collage, 154; nebula, 76, 83, 162, 175, 177
—Pegasus, 106, *107,* 108, 217, 264n30
—Perseus, 80, 106–7, 142, 194, 197, 224, 237, 264n30
—Pyxis Navis, 163
—Sagitta, 224
—Taurus, 12, *103,* 103–4, 123, 175, 177, 179–80, 237; Hyades, 60; Pleiades, 83, 237
—Telescopium Herschellii, 3, 269n34
—Triangulum, 224
—Turdus Solitarius, 116
—Ursa Major, 12, 67, 98, 104, 108, 192; Big Dipper, 67, 130, 192, 237, 256–57n31
—Ursa Minor, 135, 198
Copernicus, Nicolas, 1, 25, 31, 42, 115, 159–61, 182; *De revolutionibus orbium coelestium,* 160; heliocentric universe theory, 160–61; observation tower of, 161
Copley Gallery, Los Angeles, 29, 54, 56, 121, 160
Cornell, Elizabeth (Betty), sister, 10, 132, 266n60
Cornell, Joseph; and actresses, 1, 26, 43, 58, 79, 104, 140, 186, 197, 200, 205–6, 220, 223–24, 281n112; assemblage boxes of, 1, 3, 40, 205; astronomical charts in works of, *150,* 175; astronomy and science book collecting, 2–36, 44, 114; astronomy and science books in works of, 1–3, *4–5,* 6, 8–12, 15, 18, 20, 30–32, 35–37, 40, 70–71, 117, 123, 125, 137, 146, 155, 159, 175, 184, 221, 248–49n9; astronomy in the works of, 1–3, 8–9, 11, 23, 27, 29–30, 46, 53, 56–57, 67, 70, 73–74, 76, 87–89, 98, 109, 112, 114–15, 120, 127, 137–38, 149, 159–61, 163–65, 175, 185, 200–205, 207, 224, 231–32, 234, 282n13; and avant-garde art, 11, 22, 27, 57, 89, 119–20, 130, 132, 175, 203, 215; ballerinas, fascination with, 1–2, 48, 53, 69, 73, 74, 76, 102, 108, 228; celestial atlases, maps, and constellation charts in the works of, 3, 12, 89, 106, 108, 117, 163, 223, 233, 265n37; celestial navigation, interest in, 53, 121, 190, 192–93, 205, 210, 234, 281–82n115; celestial sand boxes of, 165–67, 169, 171–72, 174, 192, 274n19, 276n34; childhood of, 42, 99, 123, 281n112, children and childhood games in the works of, 1–3, 6, 29–30, 34, 42, 46, 60, 89, 113–14, 123, 125, 128, 155, 169, 179, 196–97, 200, 205, 207, 216, 237, 246n31, 252n60, 254n15, 256n30, 264n31 (*see also* works, The *Children's Party Trilogy; Crystal Cage [portrait of Berenice]*); and Christian Science, 24–25 ; 44–47, 93, 103, 106, 111, 154–56, 163, 169, 188, 196, 207–8, 219, 234–35, 247n, 250n22, 263n24, 280–81n108; circus in the works of, 67, 69–73, 99–100, 103–4, 108, 117, 154, 256–57n31, 263n25; clipping files of, 3, *4–5,* 10, 15, 18, 20–21, 32–33, 49, 92, 95, 100, 112–13, 115, 117, 119, 124, 130, 137, 151, 154–55, 159, 167, 170, *170–71,* 179, 182, 186, 196, 201, 204, 207–8, 213, 217, 222, 224, 230, 235, 244n4, 248n9, 261n10,

261n14, 262n19, 265n37, 267n61, 267n4, 268n12, 268–69n24, 270n36, 270n39, 272n73, 275n23, 284n36; collages, creation of, by, 1–2, 6, 9–12, 14–15, 17–19, 24, 27, 35, 42–43, 48, 57–59, 67, 73–74, 76, 79–80, 82, 85–86, 89, 96–97, 101, 103–4, 106, *107*, 108, 110, 112, 117, 120, 125, 140, *141*, 142, 149, 154, 175, 194, 196, 200–202, 205, *206*, 207–9, *209*, 210, *211*, 212–14, *214*, *216*, 216–20, 221, 222–23, *224*, *225*, *226–28*, 229–30, *231*, 231–35, 236–37, *238*, 239; and communism, 19, 182, 201; the cosmos in the art of, 1–3, 7–8, 10–11, 14–15, 19, 23, 26, 37, 44, 46, 49–50, 52, 55, 57, 60, 67, 71–73, 79, 81–84, 87, 95, 101, 108, 119, 127–28, 132, 149, 153–55, 158, 160, 164, 166, 172, 175, 180, 185, 188, 190–92, 197, 201, 205, 211, 217, 234–35, 274n20, 283n16; creative process of, 2, 9, 12, 18, 20–21, 29, 43, 50, 89, 109, 112, 121; critics and, 56, 159, "chi-chi infantalism," 56; cross-indexing process in the art of, 1–26, 30, 33, 44, 50, 59, 71, 106, 121, 169, 173, 186, 208, 217–19; custodian boxes of, 197, 224, 281n112; diary, 1, 9, 11, 20, 24, 43, 50, 72, 78, 98, 108, 113, 117, 120–21, 123, 125, 132, *135*, 138, 140, *144*, 151, 153–54, 157, 159, 168, 179–82, 196, 201, 203–5, 207–8, 217–20, 223, *238*, 239, 243n, 253n7, 263n21; education of, 2, 10; education at Phillips Academy, 10, 40, 93; fairy tales in the work of, 48, 53, 85, 254n15; and father's death, 10; film works of, 56–73, 98, 123, 135–36, 145, 156, 253n7, 254n15, 255n22, 256n30, 262n19, 281n112; final years of, 237–38, 241; and found-footage films, 1, 73; gender uncertainty of, 48; health, effects of his work on, 287n85; homosexual community, friendship with, 48; infinity, fear of, 10; and mother, 208, 229, 234, and mother's death, 202, 204, 206, 208; movie/film stars, in the work of, 24, 48, 57–88, 281n112 (*see also individual actresses*); Natural Philosophy materials in the works of, 2–3, 10, 31–32, 37, 40–41, 46, 50, 52, 71, 83; observatories in the work of, 49, 61–62, 64, 69, 72–73, 83, 92–94, 97–101, 109, 111–13, 115, 121–23, 125–28, 132–35, 140–42, 145–46, 149, 151, 154, 156, 159, 177, 205, 208, 256n30, 268n22 (*see also names of individual works*); personal life, 132, 229, personality traits of, 1–2, 9, 220, 230; photostat process in the works of, 7, *8*, 50, 54, 79, 123, 125, 140, 153, 188, 191, 196, 198, 238, 244n7,

261n13, 269n34, 270n47; play in the works of, 1, 24, 34, 56, 67, 109, 123, 125, 154, 174, 200, 249n9, 252n60; poetic elements in the works of, 1, 9–10, 19, 21, 29, 37, 43, 46, 50, 133, 137, 153, 264n31, 268n14; and Pop Art, 197, 203; popular culture and, 1, 26, 87–88, 93, 120, 159; solar sets by, *185–89*; space race concerns of, 175, 182–83, 188, 208, 214, 281–82n115; space-object boxes by, 1, 175, 281n115; spectral analysis of starlight, interest in, 15, 81, 207; stargazing by, 1, 9, 67, 121, 124, 181, 191; and Surrealism, 11, 17–21, 26–27, *28–30*, 32, 34, 37, 40–43, 47–51, 53, 57–60, 64–65, 67, 70, 82, 89, 120–21, 132, 154, 180, 206–7, 241, 246n31, 254n15, 258n45, 263n23, 270n38; and Surrealist film, 70; whimsy and wit in the works of, 24, 55–56, 96, 160, 210, 217; window façade boxes by, 146, 151, 157, 273n80; work as textile salesman, 10; yellow sand boxes/trays by, 171, 189; zodiacal light and, 137, *138*, 270n38

Cornell, Joseph, works
—*Andromeda box* (see *Untitled [Andromeda...]*)
—*Birth of the Nuclear Atom* (c. 1957), 173, *173–74*
—*Cabinet of Natural History (Object)* (1934, 1936–40), 29, 40–41, *41*, 251n36; as surreal natural history, 41
—*Carrousel* (1952), 134, 269n33
—*Cassiopeia #1* (box), 175, *176*, 176–77, 179–80, 182, 220, 277n58
—*Celestial Navigation* (c. 1956–59), 190, *191*, 192–93
—*Celestial Theater* (dossier), 72, 88, 115–20, *118*, 123–24, 128, 138, 147, 151, 154–55, 188, 234, 260n3, 262n15, 262n19 264n31, 265n38, 267n61, 268n12, 272n73
—*Central Park Carrousel, in Memorium*, 121, *122*, 123–25, 133
—*The Children's Party* trilogy, 67–68, *69–73*, 98, 123, 135–36, 145, 156, 255n22, 255n23, 256n30, 256–57n31
—*Constellations Voisines du Pôle* (c. 1951–53), 135–36, *137–38*, 191, 197
—*Constellations Voisines du Pôle, Les* (1971), 136–37, 240–41
—*Constellations of Spring / The Model* (May 3, 1970), 230–31, *232*
—*Copernicus box*, 163, 182
—*Crystal Cage [portrait of Berenice]* (1943), 49, 88–89, *90–91*, 92–95, 97, 99–106, *107*, 110–13, *114–15*, 117, 127, 165, 252n60, 260n7, 261n12, 262n19, 263n23, 263n24,

Cornell, Joseph, works; *Crystal Cage (cont.)*
265n34, 265n37, 271n53; and Christian
Science, 103; word tower observatory
in, 98–102, 108, 110, 112, 117, 165, 188,
261n12
—*Duchamp Dossier*, 23
—*Elements of Natural Philosophy* (1936–37),
29–30, 40–41, 57, 248n6, 251n36
—*Enchanted Wanderer, Excerpt from a
Journal Album for Hedy Lamarr, View*
(December 1941), 258n43
—*Feathered Constellation (for Toumanova),
A* (1943), 260n65
—*Flash Gordon* montage, *114*
—*Gemini* capsule collage, 213
—"Goofy Newsreels," 57, 66, 262n19
—*Hommage à Tamara Toumanova*, 74–75
—*Hôtel du Nord* (c.1953), 132, 140,
147–48, 149
—*How to Make a Rainbow (for Jeanne
Eagels)* (1963), 205, *206*, 207
—*Imperious Jewelry of the Universe (Lunar
Baedecker): Portrait of Mina Loy*
(Daguerreotype object, 1936), *45*
—*Jackie Andromeda* notes, 140, *143*
—*Marilyn Monroe* dossier, 223, 276n37
—*Nebula, the Powdered Sugar Princess*
(ballet-film, 1941), 73–77, 80, 82–83, 106,
167, 169, 252n60, 257n32, 257n34, 262n19,
264n32
—*Night Songs* (exhibition, 1950), 120–21,
125, 128, 132
—*Night Voyage* (exhibition, 1953), 132–33,
140, 146, 153, 269n30, 271n53
—*Now Voyager II* (collage), *216–18*,
284n45
—*Observations of a Satellite I*, 208
—*Observatory Columba Carrousel* (1950),
125–26, 133
—*Observatory Corona Borealis Casement*
(1950), *128–29*, 130, 133
—*Ondine* dossier, 20
—"*Penny Arcade*" series re Autumnal (1964),
132, 203, 220, *221*
—*Radar Astronomy* (early 1960s), *192–93*, 210
—*Rainbow Is a Spectrum* (c. 1964), 224, *226*
—*Rapport de Contreras (Circe)* (1966), *206*,
223, 286n64
—*Rose Hobart* (film), 57–67, 70, 253n4,
253–54n7, 254n15, 262n19; bending of
light in, 62
—*Soap Bubble Set* (1936), 11, 27–28, 29,
31–50, 53–56, 98, 120–21, 141, 159–60,
164, 169, 173, 175, 182, 184–86, 188,
190, 192–96, 235, 247nn1 and 2, 256n28;

variants of, 50–51, 53–57, 55, 98, 120–21,
159–61, 169, 173, 175, 182–86, *183*,
188, 190, 192–94, *194*, 196, 200, 204–5,
247n2, 248n5, 248–49n9, 250n24, 253n65,
254nn15 and 16, 256n30, 273n10, 274n18,
281–82n115
—*Story without a Name—for Max Ernst*
(c. 1934–35), *18*
—*Suzy's Pipe Dream* boxes (1957–60), 186
—*Suzy's Room (In Mem. Judy Tyler)* (1957),
186–87, *188–89*
—*Tamara Toumanova Scrapbook*, 74
—*Theater of Hans Christian Anderson
(Dance Index)* (1945), 54
—*Town and Country* cover (1939), 7
—*Untitled (Andromeda; Grand Hôtel de
l'Observatoire)*, 140, 142–43, *145–47*, 228,
258n45
—*Untitled (Blue Sand Box with Starfish)*
(c. 1952), *167*
—*Untitled (Blue Sand Box)* (early 1950s),
169, *171*
—*Untitled (Boötes, c. 1934)*, *14*
—*Untitled (Celestial Fantasy with Tamara
Toumanova)* (c. 1941), 85, *86*
—*Untitled (Custodian II, Silent Dedication to
MM)* (1962–63), *197–99*, 280n106
—*Untitled (Discarded Descartes)* (c. 1954–56),
273n11
—*Untitled (for Tamara Toumanova)*
(c. 1940), *87*
—*Untitled (La Cassiopée)* (1930s), *12–13*, 97
—*Untitled (Phases de la lune)* (c. 1957–59),
185–86
—*Untitled (Soap Bubble Set: Système
de Descartes)* (c. 1952), *161*, 182, 185
—*Untitled (Solar Set)* (c. 1956–58), *189*
—*Untitled (Triangles and the Distance to the
Moon)* (c. 1965–72), *213–14*
—*Untitled (Window Façade)* (c. 1953), 151,
152, 153, 157
—*Untitled [Ship with Nude]* (mid-1960s),
228
—*Untitled [Yellow Sand Tray, Sun and Planet
Images]*, *165–66*
—*Untitled* book object *(Histoire des Temps
Modernes)* (1939), *64–65*, 254n16
—*Untitled* cardboard box, *163–64*
—*Untitled* (1930s), *48*
—*Untitled* (c. 1964), *227*
—*Untitled* (c. 1966), *212*
—*Untitled* (c. 1970–71), *224*
—*Weather Satellites* (1965), 210
—*Winter Night Skies* (exhibition, 1955),
132–33, *146–49*, 263–64n26

Cornell, Robert (brother), 46, 73, 132, 206, 218, 229, 234–35, 278–79n75 ; death of, 204, 208, 210, 219, 229; diary of, 266n60

cosmic rays, 52–53, 158, 168, 169, 174

cosmic soap bubble, 38–39, 81, 83, 144, 158, 160, 195, 250n31. *See also* expanding universe

Cotillion. See Children's Party trilogy

Dada, 17, 21, 27, 32, 35, 54, 58–59, 82 ; Dada film, 57

Dalí, Salvador, 19–21, 51–52, 58, 67, 115, 253–54n7; Dream of Venus Pavilion, New York World's Fair, 1939, 51–52, 115, 266n49; *Marriage of Buster Keaton,* 21

de Chirico, Giorgio, 207; *Toys of the Prince,* 207

de Kooning, Willem, 120, 138–39, 157, 273n79

Dee, Frances, 113–14

Desargues, Gerard, 232; theorem, 233

Descartes, René, 64, 159, 161–63, 167, 232, 273n11; theory of tourbillons, 273nn13 and 14

Devree, Howard, 54

Ducasse, Isidore, 20

Duchamp, Marcel, 11, 19, 22–24, 35, 42, 44, 89, 109, 120, 121, 180, 202, 247n, 251n38, 252n60, 257n38, 260n65, 262–63n20, 264n32, 270n38, 275n29, 277–78n59, 282n1; *Anémic Cinéma,* 58; *Boîtes-en-valise,* 22, 109, 112; *Bride Stripped Bare by Her Bachelors, Even (The Large Glass),* 23; and Cornell, 109; *The Green Ray,* 270n38; *Large Glass,* 42, 151, 247n39, 249n14, 251n38, 252n60, 256–57n31; "Juggler of the Center of Gravity," 249n14, 256–57n31; and playful physics, 23–24, 247n39; *With Hidden Noise,* 164

Durbin, Deanna, 114

Eagels, Jeanne, 205–6, 207, 220

East of Borneo (film), 58–63, 67, 253n4, 254n9

eclipses (lunar and solar), 21, 52, 55, 58–67, 73, 78–79, 137–39, 149, 151, 189, 193–94, 211, 249n15, 253nn4 and 6; 254–55n19, 270n36

Eddington, Sir Arthur, 21–22, 59–61, 111, 246n37; *Nature of the Physical World, The,* 22, 246n

Eddy, Mary Baker, 24–25, 44, 46–47, 81, 103, 106, 154–55, 207 247n43, 261n12; disagrees with Agassiz, 47; *Miscellaneous Writings,* 47; *Science and Health with Key to the Scriptures,* 25, 46, 81, 106, 188, 243n, 247n44, 263n24, 272nn71 and 75

Egan Gallery, 120–21, 125, 127, 132, 140, 146, 203, 269n33, 270n36

Einstein, Albert, 3, 37–38, 50, 52, 60–63, 82, 95,138–40, 158, 172, 204, 231, 252n62, 276n34; theory of relativity of, 2, 59–63, 113, 138, 256–57n31, 258n43, 270n42, 271n54, 275n28; theory of deflection of starlight, 61–63, 138–39

Eisenhower, Dwight D., 178, 184

Eluard, Paul, 15, 17, 20

Ernst, Max, 1, 15, 17, 19, 21, 24, 27, 35, 59, 138, 245n16, 245–46n19, 257n35, 269n31; *La Femme 100 Têtes,* 11, 15, 17, 245n ; *Mon Petit Mont Blanc,* 15, 17

eroticism, in Cornell, 15, 23, 67, 140, 205, 223–230, 233 in Duchamp, 23; in Ernst, 17

expanding universe, 14, 30, 37–39, 72, 81, 144–45, 154–55, 250n31

Faraday, Michael, 34

Flammarion, Camille, 8, 10–12, 13, 14–15, 136, 140, 271; *Andromède de l'atlas de Bayer (1603),* 229; *Andromède de l'atlas d'Hevelius (1690),* 142; *Astronomie Populaire (1880),* 12, 15, 17, 31, 35, 42, 93, 95, 115, 245n13; *Constellations Voisines du Pôle, Les,* 135–36, 137, 191, 197, 238; *Etoiles et les curiosités du ciel, Les (1882),* 12, 13, 15, 76, 80, 96, 102, 106, 123, 135, 137, 140, 142, 146, 191, 197; *La Pluralité des mondes habités (1862),* 12; *Les Terres du ciel (1884),* 12, 15, 17, 33, 250n23, 282n13

Flash Gordon's Trip to Mars (film, 1938), 114

Floating Head (portrait of Mary Taylor, photograph by Lee Miller), 248n5

Flushing Public Library (New York), 206, 223

Ford, Charles Henri, 76, 89, 282n7; "Ballet for Tamara Toumanova" (1943), 76, 77

Fosdick, Raymond B., 128

Freud, Sigmund, 19; *Interpretation of Dreams, The,* 19

Gagarin, Yuri, 209

Galileo Galilei, 1, 15, 22, 30–42, 93, 155, 159, 161, 217; study of the Moon by, 30, 35, 36, 44, 217, 227, 229; telescope of, 34–36, 217

Gamow, George, 38, 143, 162; "Turbulence in Space," 162, 273n112

Garbo, Greta, 281n112

Garcia Lorca, Federico, 196

Gemini-Orion. See Cornell, Carrousel

Giacometti, Alberto, 20

Giant Golden Book of Mathematics (Irving Adler), 207–8, 213, 218, 221–22, 283n26, 284n36, 285n60

Glenn, John, 209

Golden Book of Astronomy (Rose Wyaler and Gerald Ames), 184, 189, 279n87
Golden Nature Guide, 2
Granger, Maud (actress), 25–26
gravitational phenomena, 70; 170, 174, 231, 256–57n31; earth, 31, 278n75; pull of Moon and Sun, 186; of "dark companion," 200
gravity, 3, 23, 30–37, 54, 71–72, 82, 99, 162, 234, 248–49n9, 256–57n31; in *Celestial Theater*, 119; center of, 30–32, 32, 71, 159, 249n14, 256nn28 and 31; in *Central Park Carrousel*, 123; in *The Children's Party*, 70–71, 98, 123; in *Christian Science*, 47, in *Crystal Cage*, 99, 102; interaction of, with light, 139; Newton's laws of, 70–71, 136, 144, 249n12, 256n27; in *Rose Hobart*, 64; in *Soap Bubble Set*, 31, 36 98, 159. *See also specific gravity beads*
Grisi, Carlotta, 99, 101, 108, 263n, 264n32
Guggenheim, Peggy, 46
Guillemin, Amedée, *Phénomènes de la physique, Les (Forces of Nature, The, 1873)*, 31, 39; *Le Ciel*, 54

Hale telescope. *See* Mount Palomar Observatory
Hale, George Ellery, 127, 190
Halley's Comet, 177
Hartigan, Lynda Roscoe, 42
Hauptman, Jodi, 58–59, 64, 200; *Joseph Cornell: Stargazing in the Cinema*, 253nn2 and 6, 281n112
Hayden Planetarium (American Museum of Natural History, New York), 23, 36–37, 52–53, 59, 67, 78–79, 82, 139, 159, 190, 192, 238
Heavenly Bodies (Ruffino Tamayo), 130
Heisenberg, Werner, 180, 247n, 273n12, 277n57
Henderson, Linda Dalrymple, 23
Herschel, Caroline, 93–94, 102, 260n3
Herschel, William, 15, 17, 93–94, 260n3, 269n34
Herschel's telescope, 112, 269n34
Hobart, Rose (actress), 58–67, 258n41
Holiday in Brazil (recording, Nestor Amaral), 60–61
Hooker telescope. *See* Mount Wilson Observatory, Pasadena, California
Hubble, Edwin P., 49–50, 81–83, 85, 87, 93, 94–95, 143, 252n62
Hugo Gallery, 54

Illuminations (Arthur Rimbaud), 137
International Astronomical Union, 3

International Geophysical Year (IGY, 1957–58), 174–75, 177, 189
Introduction to the History of Science, An (Walter Libby, 1917), 40

J. J. Grandville (Jean Ignace Isidore Gérard), *L'Etoile du Soir*, 1849, 76
Jackie Lane Cinema. *See Untitled, c. 1964*
Jeanne Eagels (film), 205
Jeans, Sir James, 21–22, 83, 246n37; *Universe around Us, Through Space and Time, The*, 22
Johns, Jasper, 235
Jones, Jennifer, 281n112
Journal d'Agriculture Pratique et Journal de l'Agriculture (1911), 42
Judson Memorial Church (New York), 220
Julien Levy Gallery, 11–12. 19, 21, 27, 44, 53, 57, 66, 73, 120, 248n3, 254n16, 258n45, 260n65, 262n19

Kepler, Johannes, 1–2, 42, 95, 121, 285n61; conception of the universe of, 221–22, 232, 285n58; star notations by, 184; theory of solar magnetism, 279n91
Khrushchev, Nikita, 178, 184
King, Arthur S., 95
Kirchoff, Gustav, 15

Lacaille, Nicolas de, 163
Lamarr, Hedy, 78–79, 82 89, 114, 258n43, 281n112
Lane, Jackie, 140, *143*, 224, 227, 270n47
Lang, Pearl, 270n47
leaning towers, 31–32, 159; Bologna, 31, 256n28; Pisa, 31
Leonov, Alexei, 214
Levy, Joella, 44, 46–47, 252n52
Levy, Julien, 11–12, 17, 34, 44–45, 47, 244n12, 245n16, 246n34, 252n52, 253–54n7
Lichtenstein, Roy, 203
Loplop (character in Ernst works), 17, 246
Losap Island (Pacific), 62–65
Lovell, James, 211
Lowell, Robert, 278n74
Loy, Mina, 44–47, 251n47; "Apology of Genius," 44–45; L'Ombre féerique," 46; "Lunar Baedeker," 44–45; paintings of Moon by, 44
Lucretius, 177, 274n20, 278n75; *De Rerum Natura*, 180
Luna Park (Coney Island), 69, 99, *101*, 115, 143, 256n31, 262nn16, 17, 19, 262–63n20, 263n21
Lynes, George Platt, 27, 29

Magritte, René, 20, 89, 232

Malheurs des immortels, Les (Max Ernst and Paul Eluard, 1922), 15, *17*

Mallarmé, Stéphane, 2, 153, 202; *Les Fenêtres* (poem), 153

Mariner III, 218

Mariner IV, 217–18

Martinet, François Nicolas, *Système de Descartes* (1761), 3, 161–62, *163*

Marx, Karl, 19, 158–59, 163, 274n14

Maxwell, James Clerk, 33

Mayer, Walther, *95*

Méliès, Georges, 34, 57, 59, 73, 76, 78, 250n20; *L'Eclipse du soleil en pleine lune [The Eclipse (The Courtship of the Sun and Moon) 1907]*, 34–35, 59, 73, *78*; *Le Voyage dans la lune* (1902), 34, 73

Meninas, Las (painting, Diego Velasquez), 209

Méry, Joseph, *Les Etoiles* (1849), 76–77, 93

Midnight Party. See *Children's Party* trilogy

Milky Way (galaxy), 80–81, 83, 98, 106, 134, 256–57n31

Milky Way (Janet Sobel, 1946), 130

Miller, Arthur (critic), 56

Millman, Bird (tightrope artist), 69–71, 99, 117–18; and constellation Cygnus, 71

Miro, Joan, 20, 28, 130; *Constellations*, 130

Miss Expanding Universe (Isamu Noguchi, 1932), *82*

Mitchell, Maria, 93

Monroe, Marilyn, 53, 196, *198*, 200, 205–6, 220, 223, 224, 280n106, 280–81nn108 and 112

Moon, 1–2, 17, 21, 27, 29–31, 34–36, 46, 52–53, 67, 70, 98, 100, 112, 138, *155, 166, 177,* 182–83, 186, 193, 200, 213; in *Americana Fantastica,* 108; in *Celestial Theatre,* 116; in *Children's Party,* 70, 72; in *Circe and Her Lovers,* 222; in *Crystal Cage,* 89, 112; and death of Marilyn Monroe, 200; eclipse of, in *Rose Hobart,* 62, 64; Galileo's study of, 30, 35, 44, 217; in Nerval's *Aurelia,* 43; as refuge for souls, 43; and *Soap Bubble* sets, 34–35, 37, 44–47, 49, 55, 160, 182, 184, 194–96, 235; in solar sets, 189; Soviet spacecraft landing on, 183–84; as symbol of perfection, 237; as symbol of Space Race, 183–84, 208, 212, 234–35, 237; in *Untitled (Phases de la lune),* 185; in *Untitled (Triangles and Distance to the Moon),* 214; U.S. program to land on, 213, 231, 235; in works of Mina Loy, 44–46

Moon, mountains of, 15, 35, 98, 250n23

Motherwell, Robert, 49

Mount Palomar Observatory, *49,* 94, *124, 127,* 132, 134, 143–46, 149, 155, 162, 219, 268n11

Mount Wilson Observatory (Pasadena, California), 38, 81, 94–95, 124, 190, 260n6

Mumford, Lewis, 119

Musée des Arts et Metiers, 23

Museum of Modern Art (New York), 21, 27, 29, 38, 48, 58, 121, 125, 202, 245n, 255n22

NASA, 208, 209–11, 214, 218

National Gallery (Washington, DC), 52, 286n64

National Geographic, 3, 190, 262n19, 265n37, 283n32

National Geographic Society, 134, 139

Nerval, Gérard de, 42–43. See also *Aurélia*

New Moonlight (Richard Lippold, 1947–48), 130

New York Times, 8, 38, *39, 59,* 61, 82–83, 85, 111, 119, 121, 125, 128, 144, *145,* 147, 154, 168, 175, 178, 183, 217, 258n43

New York World's Fair, 1939, 115, 205; 1964–65, *215*

Newton, Isaac, 6, 15, 30–31, 37–38, 40–42, 47, 50–51, 59, *70–72,* 144–45, 162–63; laws of gravitation, 136; laws of motion, 71

Niuafou (Pacific island), 61–65; 254n9

Noguchi, Isamu, 82, 258–59n48

Novak, Kim, 205

Now Voyager (film, 1942), 284n43

Now Voyager (poem, Whitman), 218

O'Brien, Margaret, 281n112

observatories, 1, 3, 10, 32, 38, 49, 83, 85, 93, 96, 98, 110–11, *124,* 128, 130, 132, 134, 137, 139, 145–46, 161, 204, 260n6, 268n11, 270n42. *See also names of individual astronomers and observatories*

Odets, Clifford, 200

O'Hara, Frank, 172–73

Page, Ruth, 82, 258–59n48

Pagode de Chantaloupe, 92–94, 97, 101, 112–13. See also Cornell's *Crystal Cage*

Panofsky, Irwin, 223–24; *Studies in Iconology,* 223

Paris Observatory, 12

Pascal, Blaise, 20, 232; theorem, 233

Peck, William B., 31, 256n28; *Introductory Course of Natural Philosophy for the Use of High Schools and Academies* (1860), 31

Perseus and Andromeda (Peter Paul Rubens, 1620–21), 264n30

philosophical toys, 34, 138, 174, 177

Pierre Matisse Gallery (New York), 130
Pipe Dream (musical play), 186
Plateau, Joseph, 33, 50, 249n16, 250n19; phenakistiscope, 33, 50
playful astronomy. *See* Cornell, play in the works of
Playhouse 90 (television show), 178
Pleiades. *See* constellations, Taurus
Poe, Edgar Allan, 41, 92–93, 99; "The Balloon Hoax," 92–93; "Berenice," 103, 110, 263n23; Israfel, 99
poems, poetry and poets, 2, 8, 15, 20, 24–25, 29, 39, 44, 46, 76, 92, 99, 116, 137, 149, 153, 155, 159, 163, 196, 217–19, 251n47, 265n34, 268n14, 272n73, 274n18, 278n74, 284n45
Pollock, Jackson, 128, 130–31; *Comet* (1947), 130; *Galaxy* (1947), 131; *Reflection of the Big Dipper* (1947), 130; *Shooting Star* (1947), 130
Posidonius (Greek geographer), 195
Procyon. *See* constellations, Canis Minor
Project Gemini, 209–16; *Gemini VI*, 209–11; *Gemini VII*, 209–14
Project Mercury, 209
Ptolemy, 195

rainbows, 41, 98, 149, 205
Rauschenberg, Robert, 175, 203, 214–15, 276n41; *Skyway*, 215
Ray, Man, 19, 21, 28, 44, 58, 89; *Electricity—The World (Electricite—Le Monde*, 1931), 21; *L'Etoile de mer*, 58
Republic of Togo, 214
Ringling Brothers, Barnum and Bailey Circus, 99, 117
Robert Schoelkopf Gallery (New York), 234
Rockefeller Foundation, 128
Roy, Pierre, 21, 28, 246n; *Electrification of the Country*, 1930, 21–22
Rutherford, Ernest, 173

Saqui, Madame (Marguerite Antoinette Saqui), 99
Saturn, rings of, 15, 17, 30–34, 52–54, 194
Schneeman, Carolee: Cornell relationship with, 220, 285n54; *Meat Joy* (Happening, 1964), 220
Science Amusante (Arthur Good aka "Tom Tit"), 30, 248n9
Scientific American, 3, 8, 106, 138, 143, 162, 166–67, 171–72, 173, 181, 184–85, 186, 190–91, 193, 208, 211, 217, 231–32, 233, 265n40, 270n39, 271n49, 273n12, 275n28, 276n32, 277n59

Schwitters, Kurt, 202
Sidereus Nuncius [Starry or Sidereal Messenger, 1610], 35–36
Sky Reporter, The, 3, 53, 190–91
soap bubbles and astronomy, 28–34, 37–39, 43, 46, 54, 83, 144, 158, 160, 169, 193, 232, 249nn16 and 18, 250n31; and Christian Science, 47; lunar, 27; and Newton's study of light, 164; and Saturn's rings, 33, 53–54; and the study of atoms, 169, 173, 275n29, 276n32. *See also* expanding universe
Soap Bubbles (Jean Simeon Chardin, 1733/34), 52
Sobral, Brazil, 61
solar eclipse, 21, 52, 58–67, 79, 137–39, 211, 253n4, 253n6, 270n36
solar merry-go-round, 267n8
solar turbulence, 162–63, 273n12
Soviet Union, 158, 175, 178, 180, 182–83
Space and the Architecture of the Universe (Gottfried Honegger and Peter Van Kamp), 39
Space Construction (László Moholy-Nagy, on cover of *Art News*, 1947), 130
space race. *See* Cornell, space race and
specific gravity beads, 36, 38, 250n25
"Spelterina," La Signorina Maria, 99
Sputnik, 174, 177–80, 183, 185, 191, 201, 208, 276–77n43; *Sputnik I*, 175
Stable Gallery (Eleanor Ward), 132, 146, 172–73, 263–64n26
stargazing, 1, 49, 67, 99, 188
stars, Altair (in Aquila), 200, 237; Deneb (in Cygnus), 237; Hyades (*see* constellations, Taurus); Vega (*see* constellations, Lyra)
Stars: A Guide to the Constellations, Sun, Moon, Planets, and Other Features of the Heavens (Herbert Zim and Robert Baker), 2, 149, 151, 177, 186, 188, 192–93, 207, 217–18, 220, 222, 224, 230–31, 270nn36 and 39, 276–77n43
Sultan Abdul-Mecid I's Dolmabahçe Palace, Istanbul, 41
Sun, 60–63, 134, 137–38, 160, 162, 165–66, 180, 190, 193, 196, 210, 216–17, 267n8; in Cornell's *Now Voyager*, 217–18; Cornell's personal and spiritual parallels to, 188, 207; in Cornell's *Radar Astronomy* box, 193; in Cornell's sand boxes, 165–66, 188; in Cornell's sun boxes, 185–86, 188–89, 203; in Cornell's *Triangles and Distance to the Moon*, 213; in Cornell's *Voyager*, 217; corona of, 62, 65, 138, 190; in *Crystal Cage*, 89; in Duchamp's *The Green Ray*, 270n38;

in *Les Constellations*, 136; magnetic field of, 190; pull of on starlight, 62–63; in *Rose Hobart*, 58–67; size of, 195; in *Soap Bubble* sets, 55, 188, 190, 195. *See also* Cornell, solar sets

Sunrise Semester (television show), 204

sunspots, 53, 189–90

Surrealism exhibition, 1932, 245n16

Suzanne de Bourbon in Prayer (painting by Jean Hey, the Master of Moulins, late 15th), 188

Tchelitchew, Pavel, 73–74, 79, 89

Telescope (poem by Leslie Nelson Jennings, CSM), 149

telescopes, 3, 10, 15, 32 34, 37, 49, 69, 76–77, 81, 83, 93–95, 111–12, 124, 127, 145, 155–56, 169, 177–78, 186, 210, 217, 219, 234, 256n30, 268n11, 276n43; Galileo's telescope, 34–36, 217, 249n16; Herschel's telescope, 93, 112, 269n34

Theater of Time and Space, New York World's Fair, 1939, 52–53, 82

tides, 55; effects of sun and moon, 29, 186

tightrope dancers and dancing, 69–71, 89, 99,100, 103–4, 115, 117, 119, 137, 144–45, 156, 256n28, 256–57n31, 261n14

Toumanova, Tamara, 73, 74–75, 79, 85, 87, 257n34, 258n42

toys for adults, 34, 53. *See also* Cornell and Surrealism

Trois Regnes, Les (Jacques Delille, 1806), 163

Troubador of the Stars (1940), 121

Twilight Zone (television show), 205, 212

Tycho Brahe, 1, 15, 17n, 35, 94–96, 96n, 102, 121, 184, 231; Observatory of, at Uraniborg, 94–95, 96, 97, 261n10; *Soap Bubbles and the Forces Which Mould Them*, 31

Tycho's nova (1572), 95–96, 110, 175, 177, 180, 222

Tycho's star, 106, 177

Tyler, Judy (actress), 186, 188

Tyler, Parker, 89, 130, 258n43

Uranographia (Bode, Johann, 1801), 3, 14, 107, 108, 197, 269n34

Uranographia (Hevelius, Johannes, 1690), 3, 8, 106–7, 140, 142, 143, 146–47, 224, 250n23, 282n13

Uranometria (Johann Bayer, 1603), 3, 12

Uranus, 15, 17, 93, 269n34

von Frauhofer, Joseph, 15

Voskhod II (satellite), 214

Wadsworth Atheneum (Hartford, Connecticut), 22, 29, 50, 248nn3 and 4, 254n16

Ward, Fanny, 104

Warhol, Andy, 197, 203, 214

Watershed, The (Koestler, Arthur, 1960), 2, 220, 279n91, 285n58

weather satellites, 208–10; TIROS, 208, 210

Webb, Mary, 112

Weidler, Virginia, 114, 281n112

Werner Heisenberg's principle of indeterminancy, 1927, 180

White, Edward, 214

World War II, 54, 110, 158; radar research and use during, 193

Zat Zam (Aztec Sun Worshipper), 69–70; 255n24

Ziegfeld Girl (film, 1941), 78–79, 82, 87, 258n41